PROSTHETIC GODS

OCTOBER BOOKS

George Baker, Yve-Alain Bois, Benjamin H. D. Buchloh, Leah Dickerman, Hal Foster,
Denis Hollier, Rosalind Krauss, Annette Michelson, Mignon Nixon, and Malcolm Turvey,
editors

Broodthaers, edited by Benjamin H. D. Buchloh

AIDS: Cultural Analysis/Cultural Activism, edited by Douglas Crimp

Against Architecture: The Writings of Georges Bataille, by Denis Hollier

Painting as Model, by Yve-Alain Bois

The Destruction of Tilted Arc: Documents, edited by Clara Weyergraf-Serra and Martha Buskirk

Techniques of the Observer: On Vision and Modernity in the Nineteenth Century, by Jonathan Crary

Looking Awry: An Introduction to Jacques Lacan through Popular Culture, by Slavoj Žižek

Cinema, Censorship, and the State: The Writings of Nagisa Oshima, by Nagisa Oshima

The Optical Unconscious, by Rosalind E. Krauss

Gesture and Speech, by André Leroi-Gourhan

Compulsive Beauty, by Hal Foster

Continuous Project Altered Daily: The Writings of Robert Morris, by Robert Morris

Read My Desire: Lacan against the Historicists, by Joan Copjec

Fast Cars, Clean Bodies: Decolonization and the Reordering of French Culture, by Kristin Ross

Kant after Duchamp, by Thierry de Duve

The Duchamp Effect, edited by Martha Buskirk and Mignon Nixon

The Return of the Real: The Avant-Garde at the End of the Century, by Hal Foster

October: The Second Decade, 1986–1996, edited by Rosalind Krauss, Annette Michelson,
Yve-Alain Bois, Benjamin H. D. Buchloh, Hal Foster, Denis Hollier, and Silvia Kolbowski

Infinite Regress: Marcel Duchamp 1910–1941, by David Joselit

Caravaggio's Secrets, by Leo Bersani and Ulysse Dutoit

Scenes in a Library: Reading the Photograph in the Book, 1843–1875, by Carol Armstrong

Neo-Avantgarde and Culture Industry: Essays on European and American Art from 1955 to 1975,
by Benjamin H. D. Buchloh

Bachelors, by Rosalind Krauss

Suspensions of Perception: Attention, Spectacle, and Modern Culture, by Jonathan Crary

Leave Any Information at the Signal: Writings, Interviews, Bits, Pages, by Ed Ruscha

Guy Debord and the Situationist International: Texts and Documents, edited by Tom McDonough

Random Order: Robert Rauschenberg and the Neo-Avant-Garde, by Branden W. Joseph

Decoys and Disruptions: Selected Writings, 1975–2001, by Martha Rosler

Prosthetic Gods, by Hal Foster

PROSTHETIC GODS

HAL FOSTER

AN OCTOBER BOOK

THE MIT PRESS

CAMBRIDGE, MASSACHUSETTS

LONDON, ENGLAND

MIT Press books may be purchased at special quantity discounts for business or sales promotional use. For information, please e-mail special_sales@mitpress.mit.edu or write to Special Sales Department, The MIT Press, 5 Cambridge Center, Cambridge, MA 02142.

Publication of this book has been aided by a grant from the Publications Committee, Department of Art and Archaeology, Princeton University.

This book was set in Bembo by Graphic Composition, Inc., and was printed and bound in the United States of America.

Library of Congress Cataloging-in-Publication Data

Foster, Hal.
 Prosthetic gods / Hal Foster.
 p. cm.
 "An October book."
 Includes index.
 ISBN 0-262-06242-9 (alk. paper)
 1. Modernism (Art) 2. Modernism (Aesthetics) 3. Psychoanalysis and art. 4. Creation.
I. Title.

N6494.M64F67 2004
709′.04—dc22 2004040291

Man has, as it were, become a kind of prosthetic God. When he puts on all his auxiliary organs he is truly magnificent; but those organs have not grown on to him and they still give him much trouble at times.

—Sigmund Freud, *Civilization and Its Discontents* (1930)

Contents

On the one hand, a tottering world in flight, betrothed to the glock-
enspiel of hell; on the other: new men.

—Tristan Tzara, *Dada Manifesto* (1918)

How to imagine not only a new art or architecture, but a new self or subject adequate to them? In the first instance this book is concerned with such imaginings in work and writing by key modernists like Paul Gauguin and Pablo Picasso, F. T. Marinetti and Wyndham Lewis, Adolf Loos and Max Ernst, Paul Klee and Jean Dubuffet. These figures are diverse, but they are all fascinated by fictions of origins that are at once aesthetic and subjective. Sometimes these beginnings are seen as primordial, and cast onto a distant field of primitive life; sometimes they are viewed as futuristic, and dreamt as a new form of technological being. Often these fantasies are primal in a few senses of the word: not only basic to the styles that they serve as origin myths, but also fundamental to the artists insofar as they ask questions of first and last things—the beginnings of subjectivity and sexuality, the ends of art and imagination. "Where Do We Come From, Who Are We, Where Are We Going?" became a great catechism of modernist art, but it also remains a great enigma.

In the first chapter I revisit the primitivist fictions of Gauguin and Picasso, in part through the psychoanalytic notion of the primal scene, that is, according to Freud, visual scenarios that we invoke to tease out the riddles of our own origins. The second chapter focuses on the purist obsessions of Loos, who insists on the proper, in architecture and craft, dress and demeanor, as the very opposite of the primitive—an opposition that steeps him in the primitive nonetheless. In the third chapter I turn to the technophilic images of "new egos" proposed in the early works of Marinetti and Lewis, while the fourth chapter considers the satirical complements of these prosthetic gods, the "bachelor machines" produced by Ernst in his Dadaist years. Although these first four chapters are written almost as case studies, I do not psychoanalyze these men; rather, I see them as self-conscious model makers of modern subjects in a tumultuous period of tremendous change—of imperial expansion, military devastation, political revolution, and technological transformation (World War I is a crux of several careers here). This project of self-making is common to all my figures, but they contrive very different subject positions—rational and irrational, thrown back into obscure pasts and thrust forward into bright futures—and they do so through a variety of artistic mediums, aesthetic commitments, ideological investments, and national formations.[1]

The next four chapters open onto related problems of modernist aesthetics and masculine subjectivity. Chapter 5 considers various extrapolations from the art of the mentally ill in the early work of Ernst, Klee, and Dubuffet, who sometimes suggest an intuitive connection between the deranged body images in this art and the disturbed body politics of the period. Chapter 6 turns to a different derangement of the body image, the manipulations of the female figure in the surrealist photography of Brassaï, Man Ray, Hans Bellmer, and others. The final two chapters push the concerns of the book toward the present. Chapter 7 offers an idiosyncratic survey of the impulse to dissolve the conventions of art altogether, to touch the real as such, from various representations of Medusa to the drip paintings of Jackson Pollock, the process art of Robert Morris, and the earthworks of Robert Smithson. The final chapter sketches another broken

genealogy, in this case of objects of desire and enigma, loss and mourning, from Marcel Duchamp and Alberto Giacometti to Robert Gober.[2]

Besides world war and political revolution, the first part of the twentieth century was subject to two great shocks: the heterogeneity of cultural forms that imperial expansion brought to the European metropoles, and the "scientific management" of laboring bodies that industrial expansion enforced among the working classes. Many modernists felt compelled to address these shocks somehow—to aestheticize them or to accelerate them, to mock them or to militate against them—and often they did so through figures of the primitive and the machine.[3] These are the principal fetishes of this art, because they allowed its makers to treat these two major developments in the imperial-industrial epoch— cultural alterity on the one hand, bodily instrumentality on the other.[4] As fetishes, the primitive and the machine permitted intensive projections, but they also limited these projections, sometimes in ways that put the artists in double binds. As we will see in chapter 1, primitivists such as Gauguin and Picasso seek to be both opened up to difference through the primitive and reconfirmed in identity against the primitive; and, as we will see in chapter 3, modernist elaborations of the machine are often compelled as well as constrained by a paradoxical view of technology as both extension and constriction of the body. Articulated in various ways in various contexts (Gauguin's Paris, Loos's Vienna, Marinetti's Milan, Lewis's London, Ernst's Cologne . . .), these double binds are social and political as well as aesthetic and psychological (the methodological challenge is to mediate these diverse registers effectively). At some times the crises that emerge in my case studies point to cracks in the symbolic order of the period. At other times they indicate closures in this same order, for in large part my modernists are drawn to fictions of new beginnings as a way to reclaim, or at least to reimagine, a degree of autonomy in a world of monopolies, bureaucracies, and mass parties that appear to foreclose it. (This concern is especially evident in writings by Gauguin, Loos, and Lewis, where the desire for autonomy sometimes prompts stories of art and self that are almost autogenetic in nature.)

Nearly all of the artists I discuss are men, but most are men in trouble, and frequently they appear more desperate than subversive.[5] Often, under the

pressures of the time, they act out masculinity in volatile ways, especially in a violence of rhetoric (Marinetti is only the extreme example). Often, too, this violence is directed at women, and yet it cannot be seen as outright mastery, not least because it is so desperate, so rhetorical. One motive of this book, then, is to complicate the old charge that modernism is dominated by a direct discourse of masculinist power. Another incentive is to question the old equation of the avant-garde with transgression, for, again, the critical moment in modernist art is often a stressing of a given fracture in the symbolic order. In fact some of my figures do not strive to critique this order at all, but, rather, struggle to make it over, or at least to shore it up (this is most apparent in some art of the mentally ill). For these reasons I have taken my title from a famous passage in Freud: however familiar it may be today, no other phrase quite captures the unsteady compound of anxiety and hubris, of loss and compensation, of narcissistic wounds and phallic fantasies, that characterizes several of my modernists. In their hands art, too, becomes a kind of ego prosthesis, an "auxiliary organ" at once magnificent and troubled.

For the most part, my methodological ambition is to set modernist works and psychoanalytic notions to resonate with one another—not to impose theory on art, but to see how one might implicate the other. Thus Gauguin is queried in relation to the dynamics of the dream, Picasso vis-à-vis the structure of the primal scene, Loos in relation to the formation of the anal character, Ernst vis-à-vis the complications of schizophrenic representation, and so on, but the psychoanalytic notions are tested in these encounters as well.[6] As we know, psychobiographical accounts and symbolic readings can be reductive—often they obscure rather than elucidate the complex mediations that obtain between an art object and an art subject (artist or viewer)—yet neither kind of interpretation is on offer here. I do not read my artists by the book of Freud; rather, I focus on points of connection, conscious and not, between modernism and psychoanalysis—on common interests in origin stories and heroic fictions, in moments of regression and reaction, in imbrications of enigma and desire, in relays between traumatic events and psychological defenses (fetishistic and apotropaic representations appear frequently in this book).

It is true that Freudian psychoanalysis favors verbal expressions: founded as a "talking cure," it attends to the symptomatic language of the dream, of slips of the tongue, of the free association of the analysand, and so on. So, too, Freudian psychoanalysis regards much culture as a working out of the conflicted desires of the Oedipus complex, and this narrative is not obviously suited to static forms of visual art. To complicate matters further, the Lacanian reading of Freud is also biased toward the verbal: with its axiom that the unconscious is structured like a language, it regards the psychic processes of condensation and displacement as structurally one with the linguistic tropes of metaphor and metonymy. Together, then, these emphases seem to disqualify psychoanalysis as an appropriate method for visual art. Yet psychoanalysis also sees the ego as first and foremost a bodily *image,* and regards the crucial events of subjective formation as *visual* scenes. As Jacqueline Rose reminds us, these are moments "in which perception founders," as when sexual difference is first discovered, "or in which pleasure in looking tips over into the register of excess," as when a child first witnesses (or imagines) sex.[7] These scenes reveal that visual space is never transparent, and that its pictorial elaborations must also be complex—not only informed by conventions and influenced by precedents, but also disturbed by memories, riven by desires, pressured by repressions. Some of the artists under consideration here, both modernist and contemporary, consciously exploit this fractured layering of image, space, and time.

As I consider a little of what modernism and psychoanalysis might tell us of each other, I also hope to sketch a little of the epistemological field that they share. In this respect, my project complements the rereading of cubism in the light of structural linguistics developed by Rosalind Krauss and Yve-Alain Bois over the last decade, for this time of modernist experimentation is a moment not only of innovative research into the sign but also of deep exploration of the unconscious. If Picasso and Saussure share a semiotic *episteme,* so too might Ernst and Freud, or Duchamp and Jacques Lacan, share a psychological *episteme.* In fact, this tracing of conceptual affinities across diverse fields—whereby contemporaries are read in terms of each other, related retroactively in a way that they could not foresee—was performed by Lacan in his own revision of Freud

through Ferdinand de Saussure.[8] In my own work in modernist studies, I have also attempted to make conceptual connections between different practices, such as the rereading of surrealism in relation to the death drive in *Compulsive Beauty* (1993); in some ways this book is a companion to that one.

Today, however, modernist art of the prewar period appears in a different light than it did only a decade ago: however familiar, it has become more remote, more inert to contemporary art, let alone to contemporary culture. Moreover, the once productive recovery of avant-garde devices by neo-avant-garde artists in the 1960s and 1970s, and the once incisive opposition of postmodernist artists to modernist paradigms in the 1980s and 1990s, have also become fatigued. Perhaps the neo-avant-garde was too optimistic about its historical reclamations, and postmodernism too absolute about its historical breaks. In any case, I now feel some difference from all these positions, and in this book I am drawn to problems that persist, and to forms that recur, through much of the last century and beyond.[9]

Critical theory is also in a different place today from a decade ago. In the backlash against theory in the 1990s, psychoanalysis was attacked with particular rancor and, in the eyes of most commentators, routed on the question of its truth value. For my purposes here, however, it is no great contradiction that this manifold mode of interpretation might be both critically insightful and ideologically blinded, and I attempt to hold to a double focus: to view psychoanalysis historically, in a discursive field often shared with modernist art, and to apply it theoretically, as a method of understanding aspects of this art. In this way I try to critique psychoanalysis even as I move to employ it, encouraged by the notion that its "moments of theoretical collapse" might be one with its moments of "psychoanalytic truth."[10] My arguments are often speculative and sometimes tendentious; if they seem petulant, too, it might be out of pique with all the phobias about theoretical work that have settled in as common sense in many academic departments, university publishers, and media accounts at large.

★

The beginnings of this book date to the late 1980s. Since then, too many people have aided me to acknowledge adequately here (sometimes this "me" also seems plural). Nonetheless, though I hesitate to implicate them again, some friends and colleagues must be singled out. The historical insights and critical commitments of my coeditors at *October* (Yve-Alain Bois, Benjamin Buchloh, Denis Hollier, Rosalind Krauss, Annette Michelson, Mignon Nixon, George Baker, Leah Dickerman, and Malcolm Turvey) continue to challenge me. The same is true of my closest interlocutors at Princeton (Carol Armstrong, Eduardo Cadava, Beatriz Colomina, Stanley Corngold, Anthony Grafton, Michael Jennings, Stephen Kotkin, Thomas Levin, Alexander Nehamas, Anson Rabinbach, Carl Schorske, Sandy Tait, and Michael Wood). The work of friends further afield has also guided me (T. J. Clark, Jonathan Crary, Thomas Crow, Michel Feher, Briony Fer, Kenneth Frampton, Michael Fried, Martin Jay, Greil Marcus, Eric Santner, Kaja Silverman, Anne Wagner, and Mark Wigley). I am thankful to the journals that published the first attempts at some of these texts—*October, Critical Inquiry, Modernism/Modernity,* and *Res*—as well as to the institutions that commissioned others—the Drawing Center, the Los Angeles Museum of Contemporary Art, the National Gallery of Art, and the Tate Modern.[11] The work of writing and revising was begun on a fellowship from the Guggenheim Foundation in 1998, and completed on a fellowship at the Center for Advanced Study in the Visual Arts in 2003. I am also grateful for timely leaves from Princeton, for a publications subsidy from the Department of Art and Archaeology, and for the assistance of Gordon Hughes and Johanna Burton. Finally, this book is for Tait and Thatcher, with thanks for their laughter.

PROSTHETIC GODS

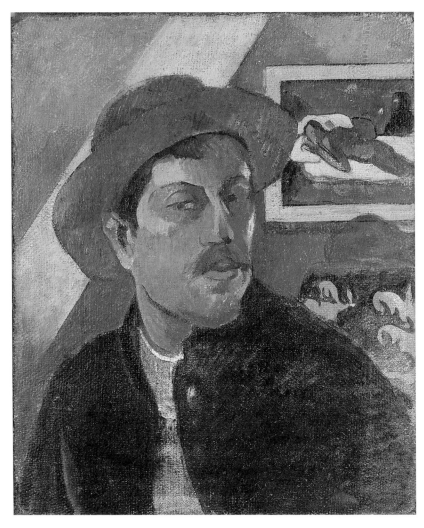

1.1. Paul Gauguin, *Self-Portrait with Hat,* 1893–94. Oil on canvas, 18 × 15 in. Musée d'Orsay, Paris. © Réunion des Musées Nationaux/Art Resource, New York.

1

Primitive Scenes

"'Dirty nigger!' Or simply, 'Look, a Negro!'" These are the first words of "The Fact of Blackness," the central text of *Black Skin, White Masks* (1952) by Frantz Fanon, the great analyst of colonial subjectivity, and they restage a primal scene of imposed identity that "fixes" Fanon in two ways at least: through the look of the white subject ("Look, a Negro!") and the association of blackness with dirt ("Dirty nigger!").[1] Here I want to consider this look and that association in the context of the primitivist painting of Paul Gauguin, Pablo Picasso, and Ernst Ludwig Kirchner. This painting is also a primary instance of the secret sharing between modernist art and psychoanalytic theory.

In the original scene a white boy, startled by the presence of Fanon, cries out with these words. In such scenes Fanon feels objectified, and yet, "in the eyes of the white man," he lacks this "ontological resistance" too. He lacks this resistance, Fanon suggests, because he does not cohere: "in the white world the man of color encounters difficulties in the development of his bodily schema" (*B* 110). There is an echo of Jacques Lacan on "the mirror stage" here, and Fanon means these "difficulties" literally: in the mirror of the white man the image of the black man is disturbed, the formation of his I impaired. This is so, according to Fanon, because a "historico-racial schema" is projected "below" his corporeal schema in a way that interferes with it: "a thousand details, anecdotes, stories" transform him into a scattered congeries of racist stereotypes. "My body was given back

to me sprawled out, distorted, recolored, clad in mourning in that white winter day" (*B* 110–113). This violated (non)subject is left to pick up the pieces, and Fanon takes it as his psychopolitical task to make them over into a different "schema" altogether.[2]

Such is the trauma of this primal scene of "blackness." But what of the boy who provokes it with his cry, "Mama, see the Negro! I'm frightened!" (*B* 112). What of his trauma of identity, his sudden subjectification as not-black, his "schema"? Obviously there is no symmetry here: the power in this encounter is radically uneven. Yet we might miss a critical insight into the colonial subjectivity that the boy represents if we ignore him altogether. If blackness is a "fact" even when it is revalued and embraced (as in political movements of the 1960s and 1970s), or bracketed and deconstructed (as in critical discourse of the 1980s and 1990s), it is also a "fantasy," one with great effectivity as such. In "The Fact of Blackness" Fanon does not really explore this other side of the fantasy; I want to do so here in relation to the primitivist encounters of Gauguin, Picasso, and Kirchner at the turn of the twentieth century.

WHERE DO WE COME FROM?

Confronted by the irrational force of colonial racism, Fanon turned to Freudian psychoanalysis, and I will follow his lead. Yet in matters of race as of gender this turn is always ambiguous, for psychoanalysis cannot be removed from its imperial context any more than from its heterosexist assumptions. A primitivism is inscribed in psychoanalysis too, one that correlates fantasies of racial otherness and female sexuality.[3] And yet, since fantasy is one of its primary concerns, psychoanalysis is also crucial to the critique of primitivism—as long as its own primitivist fantasies are questioned at the same time.

The imbrication of primitivism in anthropology, the other great human science of otherness, has been much discussed in the last two decades. Ever since "'Primitivism' in 20th Century Art," the 1984 exhibition concerning "affinities" between modern art and tribal art staged by the Museum of Modern Art, this critique has considered primitivist art of the twentieth century as well.[4] Yet the

imbrication of primitivism in psychoanalysis is still not much remarked upon. This primitivism involves, first, an association of racial others with instinctual impulses and/or symptomatic conflicts, as in the subtitle of *Totem and Taboo* (1913): "Some Points of Agreement between the Mental Lives of Savages and Neurotics." Often it also includes a further association of tribal peoples with pregenital orders, especially oral and anal stages, an association in which adult genitality is correlated with proper civilization as achievements somehow beyond the reach of "savages," as in an early line from *Totem and Taboo:* "their mental life [is] a well-preserved picture of an early stage of our own development."[5] What work do these primitivist associations do in Freud? How bound up is his psychoanalysis with the racialist discourses of the nineteenth century? How are these connections confirmed and/or contested in modernist art? For other schools of psychoanalysis, some of these questions are moot: followers of Melanie Klein dispense with developmental "stages" in favor of structural "positions," and students of Lacan disdain the analogies between the infantile, the neurotic, and the primitive as part of the early ("biological") Freud. Nevertheless, a primitivism remains inscribed in much psychoanalytic theory, and thus, given its discursive importance still today, in much critical theory as well.

It is a familiar question: how to use and to critique a theory at the same time? Here I will retain the conception of stages in Freudian psychoanalysis, but not its association with tribal peoples. Or, more precisely, I will reverse the import of this association—to see "primitive anality" not as the property of any tribal people, for example, but as the projection of particular kind of modern subject onto such societies. The question then becomes not: what is primitive anality? but: why is such a notion fabricated in the first place—out of what desires and fears?

Freud also associated the base instincts with social others, particularly the proletariat. This, too, is a typical association of his time, which encompasses other figures as well, such as women (especially prostitutes) and Jews. From the normative position of the white bourgeois male, all these figures are deemed primitive in psychosexual development, moral aptitude, and civilizational capacity.[6] Despite his ambivalence (particularly as a Jew), Freud participated in this

ideological association, which implies that the sublimation of the instincts—as the very labor of art, the very purpose of civilization—all but necessitates the sublimation of these primitive figures too, a process from which they are then excluded, or at least rendered marginal.[7] In what ways do these figures threaten the bourgeois norms of white masculinity under which Gauguin, Picasso, and Kirchner also lived? And, because ambivalence is at issue here, in what ways do they entice these artists as well (fig. 1.1)?

Clearly, this ambivalence concerns sexuality, and it does not begin with Freud or, for that matter, with racialist discourses of the nineteenth century. Consider the old binary of the noble savage and the ignoble savage. Long crucial to the European construction of cultural otherness, these figures were often split between Oceania and Africa, the Arcadian paradise of the South Seas and the barbaric sexuality of the "dark continent" (a metaphor which Freud also used to evoke female sexuality).[8] These binary figures continued in the nineteenth century, often with the noble savage presented, in neoclassical style, as a stray version of the antique ideal, and the ignoble savage presented, in romantic style, as a primary instance of cultural nativism. During this time the savage was still understood according to a few fixed practices, such as cannibalism and incest. At least since *The New Science* (1725) of Giambattista Vico, these primitive practices have marked the limits of human society, and in modern thought, too, they are conceived as fundamental taboos by Freud, Lacan, Claude Lévi-Strauss, Georges Bataille, and others. Yet precisely as taboos they are also ambivalent, sometimes transgressive fantasies: we civilized neurotics are attracted to the idea of such instinctual gratification—such complete oral freedom as cannibalism, such total genital freedom as incest—even as we are also revolted by it.[9] In this way the fantasmatic figure of the savage elicits an oscillation between esteem and disgust, with murderous envy somewhere in between, an oscillation that might underpin the opposition between noble and ignoble types.[10]

What do these ambivalent fantasies have to do with modernist art? Often they are active in its primitivist painting as well, and sometimes in the primitive scenes of Gauguin, Picasso, and Kirchner they pressure a particular construction of white masculinity to the point of crisis. I intend "primitive scenes" here to

resonate with "primal scenes" in Freudian psychoanalysis—that is, scenes in which the child witnesses or imagines sex between his or her parents, or, more generally, scenes in which the subject riddles out its origins (they are all but universal, according to Freud). Such pondering of origins is frequent in Gauguin, most explicitly in his *summa* of 1897–98, *D'où venons nous? Que sommes nous? Où allons nous?* (Where Do We Come From? What Are We? Where Are We Going?; fig. 1.2, pl. 1), a painting concerning the cycle of life and death made following a suicide attempt. For Freud, such questions involve "primal fantasies" of other traumatic origins as well, such as the origin of sexuality as imagined in the primal fantasy of seduction, and the origin of sexual difference as imagined in the primal fantasy of castration. Might the first trauma of seduction and sexuality be evoked in another fundamental painting by Gauguin, *Mana'o tupapa'u* (Spirit of the Dead Watching, 1892; fig. 1.3, pl. 2), the image of his frightened girl-bride Teha'amana naked on her bed? And might the second trauma of castration and difference be treated by Picasso in his even more epochal painting, *Les Demoiselles d'Avignon* (1907; fig. 1.4, pl. 3), the image of a fraught encounter with five prostitutes? My verbs—"evoked," "treated"—are imprecise, but this imprecision hedges against any reading of the paintings as direct representations of such fantasies. Rather, my claim is that the paintings and the fantasies share certain elements of psychological motivation, pictorial imagination, and historical *episteme.*

For Freud the primal fantasies about the origins of identity, sexuality, and sexual difference are often mixed in our psychic lives, and they are evoked in similar fashion in the primitive scenes that interest me. There are other origins at issue here as well. On the one hand, these scenes might involve the founding of a new *subject* (for example, Gauguin hoped that *Spirit of the Dead Watching* would convey his savage identity to the Old World); on the other, they might also concern the founding of a new *style,* sometimes announced in a specific work (Gauguin treated *Spirit* as the artistic manifesto of his first South Pacific sojourn, 1891–93, and *Where Do We Come From?* as the testament of his second, 1895–1903). On occasion the stylistic founding invokes the subjective founding, and vice versa, as if the one impelled the other into being, or as if, in retrospect, they

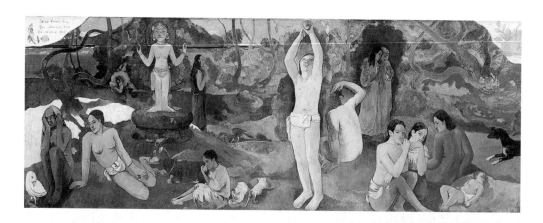

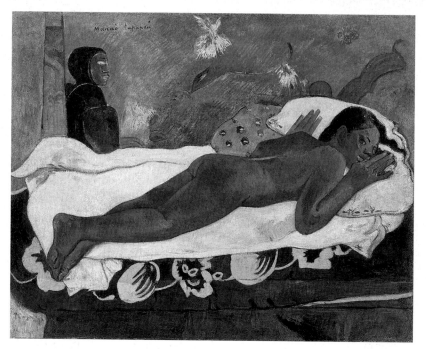

1.2. Paul Gauguin, *Where Do We Come From? What Are We? Where Are We Going?*, 1897–98. Oil on canvas, 54¾ × 147½ in. Museum of Fine Arts, Boston, Tompkins Collection. Photograph © 2003 Museum of Fine Arts, Boston.

1.3. Paul Gauguin, *Spirit of the Dead Watching,* 1892. Oil on canvas, 28½ × 36⅜ in. Albright-Knox Art Gallery, Buffalo, N.Y., A. Conger Goodyear Collection, 1965 (1965:1). Photo: Albright-Knox Art Gallery, Buffalo, N.Y.

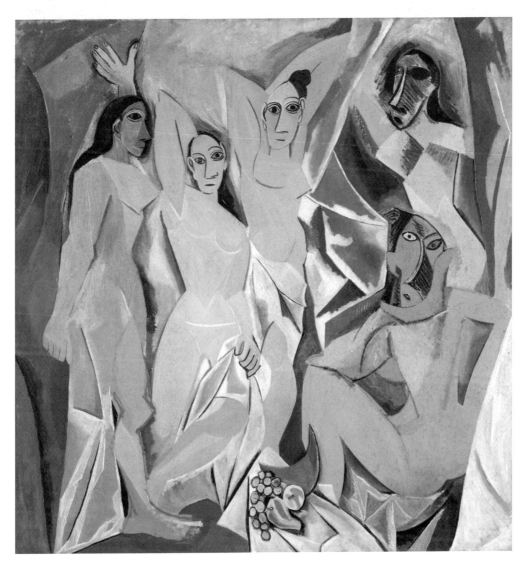

1.4. Pablo Picasso, *Les Demoiselles d'Avignon,* 1907. Oil on canvas, 96 × 92 in. The Museum of Modern Art, New York: the Lille P. Bliss Bequest (333.1939). © 2003 Estate of Pablo Picasso/Artists Rights Society (ARS), New York. Digital image © The Museum of Modern Art/Licensed by SCALA/Art Resource, New York.

could be understood only in terms of each other (for example, Picasso looked back at *Les Demoiselles* not only as a stylistic break but as a personal epiphany, his first "exorcism painting").[11] In their primitive scenes, then, Gauguin and Picasso tease out questions of identity in terms both psychological and aesthetic, and they do so at a time when conceptions of both psyche and art were transformed, not least by colonial encounters.[12] Sometimes in these scenes various differences (cultural, racial, sexual . . .) are mapped onto one another in a conundrum of op-positions of European and other, white and black, male and female, active and passive, pure and perverse, heterosexual and homosexual. This overdetermina-tion does not stabilize these oppositions; on the contrary, it volatilizes them. Not only are the artists both attracted and repelled by the primitive (this ambivalence is especially evident in Picasso), but they also both desire the primitive, often as an erotic object, and identify with it, often as an alternative identity (this am-bivalence is especially evident in Gauguin). Again, these tensions are sometimes so great that they threaten to crack the oppositions that supported normative sub-jectivity at the time.

I want to stress this cracking in part to complicate the feminist critique of the masculine mastery of the primitivist avant-garde.[13] To insist on the fragility of this mastery, to underscore the volatility of its fantasies, is not to diminish the realities of power and the effects of domination underscored by these critiques. To be sure, the primitivist avant-garde was politically ambiguous at best, and at the very least it helped to manage conflicts and resistances provoked by the im-perial dynamic of capitalist modernity. Yet this avant-garde was also ambivalently critical: its partial identification with the primitive, however imaged problem-atically as dark, feminine, and perverse, remained a partial disassociation from white, patriarchal, bourgeois society, and this disassociation should not be dis-missed as insignificant.

SPLINTERED UP

In order to explore the crisis in masculinity that is sometimes intimated in prim-itivist painting, I want to draw on the classic text on the primal scene in Freud,

"From the History of an Infantile Neurosis" (1918), written in 1914–15, only several years after the art works at issue here. The "Wolf Man" case history, an analysis of a young Russian aristocrat named Sergei Pankejeff, is a privileged text in critical theory, and there are readings richer than my account. For me here its chief importance lies in its detailed deconstruction of a particular formation of male subjectivity; whether it can be adapted to other subjects of the time—such as Gauguin and Picasso in moments of crisis—is a question I leave open.[14]

Freud refers the neurosis of the Wolf Man to several events of his early childhood. Three are most important: a great fear of wolves provoked by nursery tales; an enigmatic seduction by his sister around the age of three, with the boy in the passive position; and a later seduction of his nurse, with the boy in the active position, but with the seduction refused. At this point, Freud claims, the young Wolf Man was "thrown back" to a pregenital order of the drives, specifically to an anal sadism, which was later exhibited in his marked cruelty to servants and animals alike (note the tell-tale association of the two [*W* 170]). His sadism was also turned around in masochistic fantasies of his own beating, according to Freud, and in this manner an extreme ambivalence developed—an oscillation between active and passive positions, between sadistic and masochistic scenes—played out most intensely in relation to his father. In his active mode, Freud argues, the Wolf Man identified with his father; in his passive mode he desired his father—that is, desired to be *his* object of desire.

At this point Freud presents the famous dream (which he dates to age four) along with an explanatory drawing by the Wolf Man; compared to the dream, the drawing seems vapid, but perhaps it is protectively so (fig. 1.5). The boy dreams of six or seven wolves in a tree (only five appear in the drawing), all with bushy tails, utterly still, silently staring. Freud relates the traits of the dream to the wolf phobia of the boy as imaged through his nursery tales. But the "dreamwork" has turned these traits inside out: such is the force of his anxiety that they are not simply distorted but completely reversed. Thus the abundant tails point to no tail at all, that is, to his own feared castration; the stillness of the wolves indicates the sexual activity of his parents; and the silent stare of the wolves reflects his own

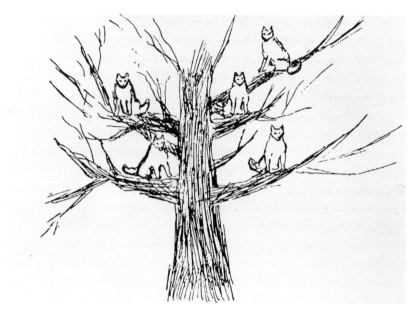

1.5. Drawing of the dream of the wolves by "the Wolf Man," n.d.

fixed gaze within the primal scene. In short, the dream radically restages the most important elements of his primal scene proper (dated to age one-and-a-half), in which the young Wolf Man witnessed his parents in coitus *a tergo,* from the rear, with the genitals of both exposed—necessarily so for Freud, so that the little boy could see that his mother lacked a penis.

This account is open to question, of course, especially as a (re)construction, and a very tendentious one. However, for Freud the primal scene need not be actual; even if it is completely imagined, its traumatic effect can be real enough. Moreover, this effect develops over time, through deferred action (*Nachträglichkeit*), retroactively. For the boy cannot understand this scene in the first instance; it becomes traumatic only after his own sexual researches begin; it is only then (again, around age four) that he dreams his dream, only then that he remembers (or believes that he remembers) his father upright like the wolf in the nursery tale, and his mother "bent down like an animal" (*W* 183). Significantly, Freud terms this sexual position of *more ferarum* "phylogenetically the older form" (*W* 185), and, implicitly in his evolutionist correlation of the sexual formations of individual and species, it is the primitive that serves as the marker of this prior stage, of this psychosexual regression (again, "a well-preserved picture of an early stage of our own development").[15] According to Freud, this position provokes a lifelong anal eroticism in the Wolf Man, which renders him precisely primitive. More, this primitive position, this primal scene, "splinters up" his sexual identity (*W* 187), divides him between his love for his father and his anxiety about the castration that he imagines to be necessary for its consummation. Finally, it is this anxiety that is figured in the wolves of the dream, whose gaze threatens his own vision (for Freud, fear of blindness often signifies fear of castration).

The analysis does not end there; in fact, it never ends for this expert patient, who gives up the couch only for the deathbed. However, its key aspects are all in place for my reading: faced with a castrative threat or a genital crisis, the subject regresses to a pregenital order, in which he oscillates between an anal *eroticism,* a passive masochistic mode (associated, as usual in Freud, with the feminine and the homosexual), and its active complement, an anal *sadism*—an oscillation that indicates a great ambivalence of psychosexual position.[16] My intention is not

to impose this profile on Gauguin, Picasso, and Kirchner, but, rather, to use its analysis of ambivalence to explore the dynamic of their primitivism. Yet how are we to locate such ambivalence in art? One danger is to move too directly between the presumed unconscious of the artist and the given work of art in a way that occludes the different determinations of each.[17] Another danger is to conflate the historical artist and the contemporary viewer in a way that collapses their different formations as well. Is the ambivalence of the primitivist encounter immanent in the image, activated in its address, or both? At least one point seems clear: this ambivalence exceeds the individual psyche of the primitivist artist. In fact, it is already inscribed in the two principal traditions out of which such artists work: avant-garde representations of the nude and exoticist representations of the other (especially in Orientalist and *japoniste* painting).

Consider first the avant-garde nude, which *Olympia* (1863; fig. 1.6) exemplified for Gauguin, Picasso, and Kirchner alike.[18] Here, as we know, Manet crossed the high genre of the nude with the low figure of the prostitute in a "desublimation" (an opening of the art work to bodily drives and/or social associations deemed base) that his primitivist followers competed to outdo. To this end, Manet also adapted a given sign of marked sexuality in nineteenth-century Europe: the black female servant who attends Olympia. The cultural historian Sander Gilman has related this figure to "the Hottentot Venus," a fantasmatic image extrapolated from an actual African woman named Saartjie Baartman. According to Gilman, this figure represented an excessive black sexuality as part of a nineteenth-century ideology of absolute racial difference—a difference marked physically on her body in her large buttocks.[19] This sign of an excessive black sexuality was then incorporated in some representations of the dangerous white prostitute, as Gilman suggests through a juxtaposition of the Hottentot Venus and the rotund *Nana* (1877) of Manet. This incorporation in turn abetted the conflation of primitive and prostitute that became common in avant-garde studios (not to mention in police reports) well into the twentieth century. *Les Demoiselles d'Avignon* is only the most extreme instance of this "perfect image of the savagery that lurks in the midst of civilization," as Baudelaire put it in "The Painter of Modern Life" (1863).[20] A prime token in the mimetic rivalry of

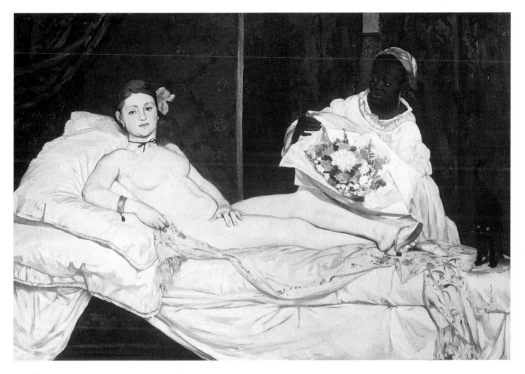

1.6. Édouard Manet, *Olympia,* 1863. Oil on canvas, 51⅜ × 74¾ in. Musée d'Orsay, Paris. Photo: Erich Lessing/Art Resource, New York.

primitivist modernists, the image of the primitive-prostitute was filtered through diverse styles, and it provoked such different temperaments as the moderate Matisse in his *Blue Nude* (*Memories of Biskra,* 1907; fig. 1.7), whose hips are rotated in a way that protrudes her buttocks excessively, and the theatrical Kirchner in his *Girl under a Japanese Umbrella* (c. 1909; fig. 1.8, pl. 4), where this "primitivist contrapposto" is even more extreme.[21]

To cast these women in such poses is to refer them to an animalistic nature, and it can be decried as a pictorial act of gender subjugation. But are images like *Spirit of the Dead Watching* and *Les Demoiselles d'Avignon, Blue Nude* and *Girl under a Japanese Umbrella* straightforward expressions of masculine mastery, or are they not fraught elaborations that bespeak a feared *lack* of this mastery? Do masterful subjects force such aggressive moves, or do these images not suggest an anxious ambivalence—which is thereby managed, perhaps, but not completely so? (André Salmon wrote that Picasso experienced great anxiety during the composition of *Les Demoiselles;* and Matisse shied away from the psychological implications of paintings like *Blue Nude:* "Above all I do not create a woman, *I make a picture.*")[22] A critique that does not allow for this psychological ambivalence, let alone its pictorial transformation, might totalize more than deconstruct a particular construction of white masculinity. It also might mistake a will to mastery for the real thing, and so bestow on this masculinity a phallic authority that it did not (does not) possess.

The ambivalence of these artists toward the primitive often seems multiple. First, even as the primitive is privileged in this art, it remains the sign of the primal and the regressive. Second, the artist might aim to become the primitive as well as to possess it; again, the primitive might be an object of identification as well as of desire. Finally, the very desire here might be double—a desire for mastery over the primitive as well as a desire for surrender to it. In *Les Demoiselles,* for example, does Picasso position his masculine viewers (of which he is the primary one) to dominate his prostitutes or to be dominated by them? It is not clear: the painting is a stand-off, a stare-down. It is this overdetermined ambivalence that I want to examine, in part through the model presented in the Wolf Man case history, of eroticism shot through with sadism.

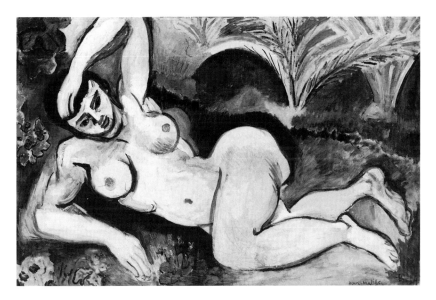

1.7. Henri Matisse, *Blue Nude (Memories of Biskra),* 1907. Oil on canvas, 36¼ × 55 in.
The Baltimore Museum of Art: the Cone Collection (BMA 1950.228). © 2003 Succession
H. Matisse, Paris/Artists Rights Society (ARS), New York. Photo: The Baltimore Museum
of Art.

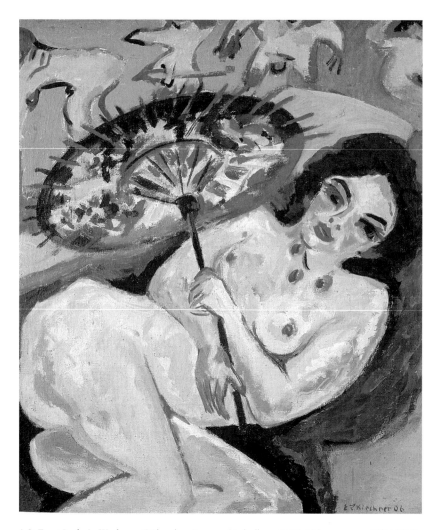

1.8. Ernst Ludwig Kirchner, *Girl under a Japanese Umbrella,* c. 1909. Oil on canvas, 36¼ × 31½ in. Kunstsammlung Nordrhein-Westfalen, Düsseldorf. © Ingeborg & Dr. Wolfgang Henze-Ketterer, Wichtrach/Bern. Photo: Erich Lessing/Art Resource, New York.

Ambivalence is also in play in the other tradition that adumbrates primitivist painting: the exoticist tradition. Often in Orientalist art and sometimes in *japoniste* art, racial others are presented as passive, feminine, given over to the masculine viewer, even (or especially) when the figures are male. A colonial gaze doubles a sexual gaze in a manner that seems to confirm masculine mastery. But here, too, this mastery hardly seems secure; again, it would not require such displays of submission if it were. The visual theatre of Orientalist painting often plays on voyeurism and exhibitionism as well as on sadism and masochism in ways that it does not always control. In this regard consider two prime instances of Orientalist painting, early and late: *The Death of Sardanapalus* by Delacroix (1827; fig. 1.9), a romantic scene with sadomasochistic currents if ever there was one; and *The Snake Charmer* by Gérôme (c. 1880; fig. 1.10), an illusionistic exhibition designed for our voyeuristic gaze. The Delacroix stages an erotic fantasy of a harem under the knife, as the doomed Assyrian king made famous by Byron gazes down indifferently on the murder of his concubines, with a fantasy of an orgy compounded by a fantasy of a massacre. The Gérôme advertises its erotic promise in its very title: a shapely boy stands in the foreground, wrapped in nothing but a massive snake, which he holds erect for the depicted audience of Muslim men in front of him, but also, with his rear exposed, for the actual audience of European viewers behind him. The Delacroix is a double fantasy of absolute power and abject submission: contemporary viewers could both identify with the sexual authority of the king and delight in his political downfall (a perfect compromise for an audience still concerned, in 1822, about royal despots).[23] The Gérôme is a homoerotic scene, but with the homoeroticism projected onto the exotic other, where it might be both privately enjoyed and publicly denounced—as the perverse practice of an immoral people in need of colonial correction (this moral might be extracted from *The Death of Sardanapalus* as well).[24] However, even when Orientalist painting aims to reassure the European viewer in these ways, its very appeal to erotic fantasy might produce a volatile ambivalence: identification and desire might tangle, masculine and feminine positions blur, active and passive aims cross.

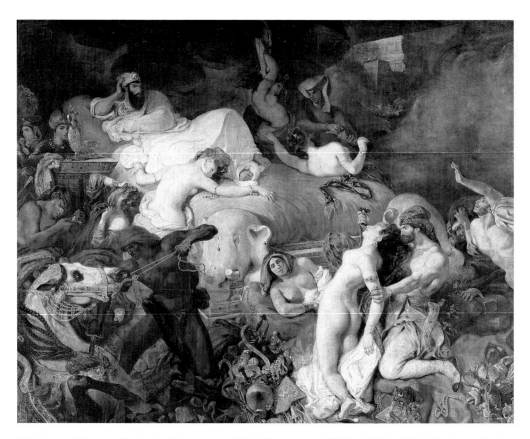

1.9. Eugène Delacroix, *The Death of Sardanapalus*, 1827. Oil on canvas, 153⅜ × 195¼ in. Musée du Louvre, Paris. Photo: Réunion des Musées Nationaux/Art Resource, New York.

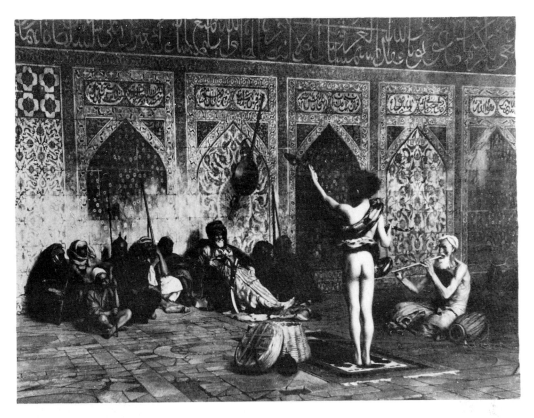

1.10. Jean-Léon Gérôme, *The Snake Charmer*, c. 1880. Oil on canvas, 33 × 48 in. Sterling and Francine Clark Art Institute, Williamstown, Massachusetts.

Such ambivalence is more intense in primitivist painting, perhaps because the primitive was associated more directly with the unconscious and the infantile. (The Near East could not be denied civilizational status in the same way, while the Far East was often portrayed as a third term, at once civilized and primitive, decadent and childlike.) Of course the valences of West and other are also different in primitivist discourse; in his Tahiti writings, for example, Gauguin often presents the European ego as the perverse term and the savage other as the pure.[25] Nonetheless, the structure of values persists in this very reversal, as does the discourse of pathology (terms like "degeneration" and "decadence" abound in Gauguin as well); moreover, the ambivalence centered on the (anally) erotic is even stronger in primitivist art than in exoticist art. On the one hand, in primitivist discourse there is an explicit desire to break down the cultural oppositions of European and other (white repression and dark sexuality, culture and nature), as well as the psychic oppositions held to underlie them (active and passive, masculine and feminine, heterosexual and homosexual), a desire that is very pronounced in Gauguin. On the other hand, there is a reactive insistence on these same oppositions, a revulsion at any such crossings over, a reaction that is very pronounced in Picasso. This contradiction cannot be resolved, because the primitivist seeks both to be *opened up to difference*—to be taken out of the self sexually, socially, racially—and to be *fixed in opposition to the other*—to be established once again, secured as a sovereign self.

Might this psychological ambivalence also inform the political ambiguity of primitivist personae? At once bourgeois and bohemian, Gauguin arrived in Tahiti in a cowboy hat inspired by Buffalo Bill, and his activities there were sometimes mocked on the indigenous side and often condemned on the colonial side. In his own terms, he was both "sensitive" and "Indian," Parisian dandy and Peruvian savage (his maternal grandmother, Flora Tristan, a socialist bluestocking with whom Gauguin identified, was from an old Peruvian family, and he spent six years of his childhood in Lima); and he tended to see his psychological and political conflicts in these physical and racial terms—as a direct result of his "two kinds of blood, two races" (*WS* 236).[26] Moreover, might this tension between the desire for an ecstatic difference and the need for a stable identity-in-opposition

contribute to the aggressivity frequent in the primitivist encounter—an aggressivity intermittent in Gauguin and overt in Picasso? Again, this ambivalence can be so intense as to involve a cracking in this masculinity, in its genital heterosexuality; hence the importance of a theoretical model whereby such a subject, faced with a threat deemed castrative, is "thrown back" to a conflictual anal phase, with both active sadistic components—components of mastery over the other—and passive masochistic components—components of surrender to the other.[27] This is not to psychologize the art or to pathologize the artists; it is only to suggest the traumatic knot that some primitivist art might work over.

VIOLENT HARMONIES

I have deferred the particular narratives of primitive scenes in Gauguin, Picasso, and Kirchner in order to prepare them theoretically, lest they be taken as iconographic keys to the art. In fact these stories are suspect as accounts of specific works, but then the primitivist painting is always a working over of multiple encounters—artistic precedents, prior schemes, imaginary scenes, actual events. Crucial here is that the artists were compelled to contrive such origin myths in the first place, and to do so in a melodramatic idiom of desire and fear. More is at stake, then, than the usual portrait of the artist or legend of the avant-gardist, for the primitive scene is a performative act of a special sort, often a staging of rebirth sited in the field of the other (again, in a way that speaks to the popular imagination of imperial subjects at home). As might be expected, these sitings are national: Gauguin travels to French territories (first to Martinique and Panama, twice to Tahiti, and finally to the Marquesas), while Picasso favors objects that flow to Paris from French territories in Africa and Oceania, and Kirchner is especially drawn to a beam frieze from Palau, a German colony in Micronesia.

The Gauguin story is from *Noa Noa,* his 1893 memoir of his first stay in Tahiti. It tells of his rite of passage into "savage" life, but it reads like an account (to paraphrase Freud) of "some psychical consequences of the anatomical distinction" between different bodies. Although the story is well known, it is too resonant not to quote at length:

I have a native friend [who] comes to watch me whenever I work. . . . This young man ["Totefa" in later versions of *Noa Noa*] was thoroughly handsome and we were very friendly. Sometimes . . . he questioned me as a young savage wanting to know many things about love in Europe, and I was often at a loss to know how to answer him.

One day I wanted to obtain a rosewood trunk, fairly large and not hollow, from which to make a sculpture. "For that," he told me, "you have to go into the mountains, to a certain place where I know several fine trees that might suit you. If you like, I'll take you there and we'll bring it back together."

We left early in the morning. The Indian paths in Tahiti are difficult for a European: between two mountains that cannot be climbed is a cleft where water emerges through rocks. . . . On either side of the cascading stream, the semblance of a path, trees pell-mell, monstrous ferns, all of the vegetation growing wilder, becoming more and more impenetrable as we climbed toward the center of the island.

Both of us were naked with a loincloth about our waists and an ax in our hand, crossing and recrossing the river to rejoin a bit of path that my companion seemed to follow by scent alone, it was so shady and hard to see. Total silence, only the sound of the water groaning over the rocks, monotonous as the silence. And there we two were, two friends, he a very young man and I almost an old one, in both body and soul, made old by the vices of civilization, and lost illusions. His supple animal body was gracefully shaped, he walked ahead of me sexless.

From all this youthfulness, from this perfect harmony with the natural surroundings, emanated a beauty, a perfume (*noa noa*) which enchanted my artistic soul. From this friendship, which was so well cemented by the mutual attraction between the simple and the compound, love was blossoming within me.

And there were only the two of us.

I had a sort of presentiment of crime, desire for the unknown, awakening of evil. Then too a weariness of the role of the male who must always be strong, the protector having to bear the weight of his own heavy shoulders. To be for one minute the weaker being, who loves and obeys.

I drew nearer, unafraid of laws, my temples pounding.

The path had come to an end, we had to cross the river; my companion turned just then, his chest facing me.

The hermaphrodite had disappeared; this was definitely a young man; his innocent eyes were as limpid as clear waters. Suddenly my soul was calm again, and this time I found the coolness of the stream exquisite, reveling in the feel of it.

"*Toe toe*" ("It's cold"), he said to me.

"Oh, no!" I replied, and that negation, answering my earlier desire, resounded in the mountain like a sharp echo.

I plunged eagerly into the bush, which had become increasingly wild; the child continued on his way, with that limpid gaze. He hadn't understood a thing; I alone bore the burden of an evil thought, an entire civilization had preceded and had instructed me in it.

We reached our goal. . . . Several trees (rosewood) spread their enormous boughs. The two of us, both savages, began to chop at a magnificent tree. . . . I wielded the ax furiously, and my hands were covered with blood as I cut with the pleasure of brutality appeased, of the destruction of I know not what. In time with the sound of the ax I sang: "Cut down the entire forest (of desires) at the base. Cut out love of self from within you. . . ." All the old residue of my civilized emotions [was] utterly destroyed. I came back serene, feeling myself another man from now on, a Maori. Together we carried our heavy burden gaily, and again, but calmly this time, I could admire the graceful lines of my young friend as he walked ahead of me,

lines as robust as the tree we were carrying. The tree smelled like a
rose; *noa noa*.

By afternoon we had returned, tired.

He asked me: "Are you content?"

"Yes." And inside myself I said again: Yes. No doubt about it,
I was at peace with myself from then on.

Every stroke of my chisel on this piece of wood brought back
memories of a sweet tranquility, a fragrance, a victory, and a rejuve-
nation.[28]

There are many twists in position here. Totefa comes to Gauguin with
questions above love in Europe, but Gauguin is the novice in secrets of the island.
The landscape is gendered feminine, a wilderness of clefts and ferns, and Totefa
is intimate with her (he leads "by scent alone"), while Gauguin is not ("the In-
dian paths in Tahiti are difficult for a European"). Although they are united as
two men on a quest ("naked with a loincloth . . . an ax in our hand"), this soli-
darity breaks down into differences of age and culture—the corrupt, old, "com-
pound" European versus the pure, young, "simple" native—and Gauguin marks
these differences sexually: as Totefa delves deeper into feminine nature, he be-
comes degendered, "sexless." At this point Gauguin appends, in the margin of his
manuscript, two extraordinary notes: "1. The androgynous side to the savage, the
little differentiation of sex among animals. 2. The purity brought about by sight
of the nude and the freedom between the two sexes. The way vice is unknown
among savages." This primitivist association of savage, animal, and androgyne is
pronounced in Gauguin, and he often celebrates the affinity between the sexes
in Tahiti. Far from "sexless," this affinity is erotic for him, and he is aroused ("un-
afraid of laws, my temples pounding"). As Totefa is degendered—or, more pre-
cisely, regendered as androgynous—Gauguin retains a masculine position, but
only for a moment, as he wearies "of the role of the male." Here, in another ex-
ceptional note, Gauguin admits a desire that he cannot name in the text: "Desire,
for one instant, to be weak, a woman."[29] Apparently he can imagine sex between

men only as androgynous, as passive, and finally as feminine (remember that he is behind Totefa on the path). Yet Gauguin cannot tolerate this conundrum for long, and soon he condemns his desire as homosexual "vice," "crime," "evil." At this point Totefa turns, and "the hermaphrodite" disappears; lest his own identity be utterly confounded, Gauguin moves abruptly to reclaim a masculine position. His return is marked by a plunge into water: this singular feeling "negates" his promiscuous vision.[30]

The landscape remains coded as feminine, however, and the initiation ends, conventionally enough, with its violation; penetration is here displaced onto nature ("I plunged eagerly"). No longer rendered androgynous, let alone homoerotic—that was too dangerous—Totefa is remade as innocent ("limpid as clear waters"), even infantile ("the child . . . hadn't understood a thing"). In the end he must be the novice, for, along with the feminine coding of nature, this positioning reestablishes Gauguin in his dominant identity, his European masculinity, at the very moment when he believes it to be shed. The situation is not yet stable, however, and at this point his sexuality betrays its sadomasochistic tendencies ("I wielded the ax furiously . . . my hands were covered with blood"). This act of cutting purges him somewhat, and "with the pleasure of brutality appeased," he returns "serene." (Gauguin painted this activity in *The Man with the Ax* [1891; fig. 1.11], here sited on a beach.) Along with a purging of desire, perhaps the cutting of wood represents a reclaiming of difference, a restoring more than a destroying of identity, of "love of self," through the very act of cleaving. For in the end Gauguin is "serene" only in his difference, precisely because of his dominance, not as a result of an overcoming of either. He can sublimate the primitive, internal as well as external, whose "graceful lines" he now "admires" more than desires, and he looks forward to carving as the means of this sublimation. (Perhaps, if cutting reestablishes difference, carving sublimates it.) Already the "presentiment of crime" is a memory to be recalled in "tranquility."

However, this "peace" is temporary, even illusory; his ambivalence is never resolved in his art, thematically or formally: with its different cultural references, discordant color schemes, and bizarre spatial constructions, it remains conflicted

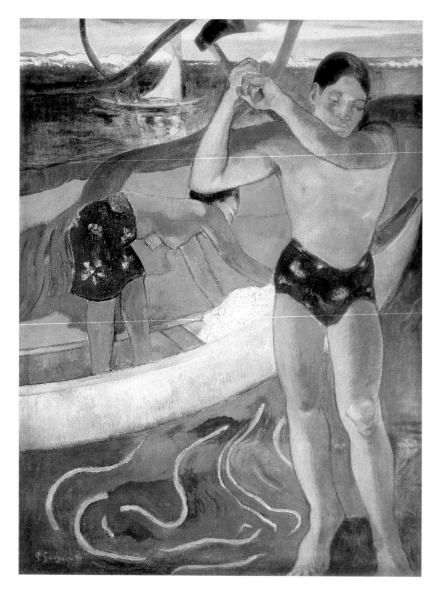

1.11. Paul Gauguin, *The Man with the Ax,* 1891. Oil on canvas, 36¼ × 27½ in. Private collection, Bridgeman Art Library. Photo: Bridgeman Art Library.

to the end. As Gauguin said of his writings, his paintings are, "like dreams, as like everything else in life, made of pieces."[31] Or, as August Strindberg once remarked, Gauguin is like a "child who takes his toys to pieces so as to make others from them."[32] Yet his ambivalence is not expressed so directly in the heterogeneity of his art; among other mediations, it is run through the various operations of his symbolist aesthetic. Often Gauguin writes of his "synthetist" fusions of color and drawing and memory and perception, and sometimes he does so in terms of a synesthetic mixing of the "high" faculties of the visual and the visionary with the "low" senses of touch and smell. "I dream of violent harmonies," he wrote famously of *Where Do We Come From?*, "in the natural scents which intoxicate me."[33] These allusions to harmony and scent are in keeping with symbolist notions of the time—of music as the paragon of the arts, and of smell as the sense of affinities—but the "violence" of this "intoxication" is distinctive. For the most part Gauguin seeks to elevate the low senses, associated as they are with the primal and the primitive, the other gender and the other race, and this act of sublimation points to the ideological role of smell in primitivist thought (as we will see, this role is pronounced in Picasso too).

For the historian Alain Corbin, the degradation of smell is part of a bourgeois code of the senses that became dominant only in the nineteenth century. Only then was the odor of waste deemed a threat to social order—a threat associated first with the peasant, then with the proletariat, and finally with the primitive.[34] None of these figures could escape this cultural association with smell; it was a double bind: they were regarded as either sensitive to smell, and so natural in the sense of pure, as Totefa is, or insensitive to it, and so natural in the negative sense, as primitive. In *Noa Noa* and elsewhere, Gauguin seeks to revalue this affinity, to see the primitive as a figure not only of smell but of fragrance (such is the meaning of *noa noa* for him), and it is an important aspect of his synesthetic ideal—indeed, of his symbolist aesthetic in general. Yet this "unsettling of all the senses" (as Rimbaud famously termed it) has other implications as well. At once primal and refined, this fragrance, this *noa noa,* is intended to confound the order of European sense and, implicitly, to question the social hierarchy that sub-

tends this sensuous order. Even if Gauguin only elaborates on the old French fantasy of Tahiti as a place of free love, gift exchange, and so on (already a received idea when Diderot wrote his *Supplement to Bougainville's "Voyage"* in 1771), he also speaks to the historically specific desire that the depleted sense of old Europe be "rejuvenated," even "intoxicated," and that capitalist divisions of labor, property, and class be slightly assuaged thereby.[35] This connection between synesthetic sense and fantasmatic freedom from the division of labor, property, and class is essential to the primitivist vision, and, however compromised by Club Med familiarity, this vision still has psychological force.[36] Might Gauguin mean to extend this imaginary freedom to another division, that of sex? That is, might release from sexual difference be the unconscious goal not only of the notion of *noa noa* in his text but, more importantly, of the androgynous figures and amorphous passages in his paintings—a seductive blind, a lush surface resistant to the depth of vision, of its incisive, even castrative effects? Might synthetist fusing and symbolist mixing bespeak a desire not only for synesthetic sensuality but also for polymorphous sexuality?[37]

In his *Early Manuscripts* (1844), Marx relates the refinement of the senses to the development of society, to the division of labor in particular; in this sense, too, "sublimation" goes hand in hand with "civilization." Even as Gauguin participates in this sublimatory project, he also works to complicate it, in part to reverse it. Perhaps this tension is another expression of his ambivalence, for he seeks refinement as well as regression in the senses and in the drives alike. That is, he seeks an aesthetic in which to sublimate is to not to moderate desire so much as to heighten it, to "sublime" it, and both sublimation and desublimation are at work in his "violent harmonies."[38] Here again, *noa noa* is an overdetermined term, for it seems to signify—to comprehend, to suspend—both base smell and fine fragrance, both regression and refinement.[39] It is as if the term captured a primary conflict of desire in Gauguin: to nuance difference in art as much as possible, *and* to undo difference in life altogether. As we will see, it also points to a deep fantasy: to arrive at an origin in which difference is not yet (or no longer) traumatic.

EXORCISM PAINTING

Like Gauguin, Picasso seems to undergo an epiphanic transformation in his primitive scene, but his initiation is framed as a warding away of primitive "spirits" more than a coming into "savage" life. Here ambivalence is even stronger, less subject to management, than in Gauguin; certainly Picasso does not share in the synesthetic ideal of *noa noa*. Stirred by the power of the tribal objects in his primitive scene, he is also disgusted by the putative smell of the primal other, and the senses as well as the drives activated in his primitivist work seem to resist extensive sublimation.

As celebrated as the Gauguin tale, the Picasso story recounts his visit to the Musée d'Ethnographie du Trocadéro in Paris in June 1907 (then called the Musée de l'Homme). As is well known, Picasso reworked *Les Demoiselles d'Avignon* soon after this encounter with tribal objects; in particular he "primitivized" the faces of three of the five prostitutes, the two on the right side, squatting and standing, and the one at the far left, in profile, the most Gauguinian in style.[40] Formally, the painting is a palimpsest of two different conceptions: an "Iberian" composition completed after many studies in late May and/or early June (fig. 1.12), which included two male figures, a sailor in the center and a medical student at the far left (this version was influenced by a Louvre exhibition of Iberian sculpture in winter 1905–06, as well as by a Gauguin retrospective at the Salon d'Automne in 1906); and an "African" composition completed in early July, in which the transformed prostitutes alone remain—the sailor drops out, and the student metamorphoses into the prostitute in profile. The two central prostitutes retain Iberian visages, however, and according to European conventions of beauty they appear almost comely in contrast with the prostitutes masked in an African manner—a tension between attraction and repulsion that Picasso worked to achieve. Psychically, the painting is also a telescoping of two different scenes: a visit to a Barcelona bordello, which he treated as a traumatic sexual encounter, read through the visit to the Trocadéro, which he experienced as a traumatic racial encounter.[41] Thus the "montage" in the painting is at once temporal and spatial in a manner closer to the Freudian structure of the primal scene than

1.12. Pablo Picasso, study for *Les Demoiselles d'Avignon,* 1907. Pencil and pastel on paper, 18¾ × 25 in. Öffentlich Kunstsammlung, Basel. © 2003 Estate of Pablo Picasso/Artists Rights Society (ARS), New York.

any other primitivist work. Moreover, the old conflation of primitive and prostitute inherited from Gauguin appears complete, as do the crossings of desire and identification, objectification and personification. This ambivalence was still active when Picasso recounted his Trocadéro visit to André Malraux in 1937:

> Everybody always talks about the influences that Negroes had on me. What can I do? We all of us loved fetishes. Van Gogh once said, "Japanese art—we all had that in common." For us it's the Negroes.
>
> When I went to the old Trocadéro, it was disgusting. The Flea Market. The smell. I was all alone. I wanted to get away. But I didn't leave. I stayed. I stayed. I understood that it was very important: something was happening to me, right?
>
> The masks weren't just like any other pieces of sculpture. Not at all. They were magic things. But why weren't the Egyptian pieces or the Chaldean? We hadn't realized it. Those were primitives, not magic things. The Negro pieces were *intercesseurs;* ever since then I've known the word in French. They were against everything—against unknown, threatening spirits. I always looked at fetishes. I understood; I too am against everything. I too believe that everything is unknown, that everything is an enemy! Everything! Not the details—women, children, babies, tobacco, playing—but the whole of it! I understood what the Negroes used their sculpture for. . . . All the fetishes were used for the same thing. They were weapons. To help people avoid coming under the influence of spirits again, to help them become independent. Spirits, the unconscious (people still weren't talking about that very much), emotion—they're all the same thing. I understood why I was a painter. All alone in that awful museum, with masks, dolls made by the redskins, dusty manikins. *Les Demoiselles d'Avignon* must have come to me that very day, but not all because of the forms; because it was my first exorcism-painting—yes absolutely![42]

This is only one account of *Les Demoiselles,* of course, and it comes late, thirty years after the event, in the context of surrealism (which is also to say of psychoanalysis) that must have influenced the vocabulary of trauma here ("Spirits, the unconscious [people still weren't talking about that very much]"). Nevertheless, despite its blindnesses, such as the simple equation of "Negro" and "fetish," this reading has its insights, such as the consideration of the tribal objects in terms of ritual value. Like Freud and anthropologists from James Frazer to Mary Douglas, Picasso regards the primitive as intimate with the sacred—indeed, as sensitive to the imbrication of the sacred with the defiled; and he locates the tribal objects in this confused realm of taboo and pollution as agents endowed with fetishistic power—as *intercesseurs* and "weapons."[43] (Incidentally, this is why the tribal objects are "magic things" for him, while "the Egyptian pieces or the Chaldean," courtly artifacts of the sort that Gauguin favored, are not. The latter are "primitive" only in the old art-historical meaning of the word, that is, outside the classical canons of Western art.) At the same time, Picasso shares in the ambivalence also imputed to the primitive by Freud, Frazer, and others, for he wants both to participate in this power and to be distanced from its effects, among which he counts not only spirits, the unconscious, emotion, but "women, children, babies." In short, Picasso seeks to use the tribal objects apotropaically (as he imagines, in part rightly, that they were used): he wants to deploy the primitive, however, to ward away the primitive, to array spirits to defend against spirits—to turn the unknown and the indistinct against these same threats.[44] More explicitly than Gauguin, Picasso displays the ur-primitivist ambivalence between a desire for desublimation and regression ("something was happening to me, right?") and a demand for sublimation and autonomy ("to help people . . . become independent").[45] In fact he stakes this autonomy directly against the desublimatory threat of the feminine ("women, children, babies") as well as against the fetishistic debasement of the other ("the Negro pieces").[46]

On the one hand, Picasso associates the tribal objects with dust and smell, and reacts against this realm of dirt and shit with disgust. Such "matter out of place" threatens him with indistinction, and this association of indistinction with femininity and blackness makes the scene regressive for him.[47] On the other

hand, he is drawn to this regression, for it seems to promise subjective release as well as artistic innovation: it is a *regressive* realm that might be put to *transgressive* use. Perhaps from a retrospect of thirty years, Picasso could claim this point: that *Les Demoiselles* had forced a break not only with the academic tradition of figure painting (desublimation of the nude and activation of the gaze are more radical here than in *Olympia* or *Spirit of the Dead Watching, Blue Nude* or *Girl under a Japanese Umbrella*) but also with the very structure of Western painting as understood since the Renaissance. Picasso initiates this break in both the stylistic diversity and the spatial complexity of *Les Demoiselles;* and yet, as Yve-Alain Bois has argued, it is fully achieved only in the semiotic multiplicity of the collages and constructions that he developed five years later, perhaps in a relation of deferred action to the primitivist painting.[48] Crucial here, however, is that this move of avant-garde transgression is underwritten by an impulse toward psychic regression that is perceived, by Picasso no less than by Freud, as anticivilizational, that is to say, as primitive.

In *Civilization and Its Discontents* (1930), Freud relates the development of civilization to the formation of the subject: the renunciation and/or sublimation of the drives is essential to both processes, but even more fundamental is the reaction against dirt and shit, against any anal-erotic involvement in these things. For Freud, this "reaction-formation" is the sine qua non of civilization and subject alike, and it is the crux of his own origin myth in *Civilization and Its Discontents*. When "man" first stood erect, Freud speculates there, his orientation both to the body and to the world changed utterly, and one result was the subordination of the anal and the olfactory in favor of the genital and the visual.[49] This reaction against shit and smell, dirt and disorder, is also at work in art: to defy its order is literally to mess with it. "Anal eroticism," Freud writes elsewhere, "finds a narcissistic application in the production of defiance," a formula that might be adapted for avant-garde defiance too, given all the anti-aesthetic gestures, from Dada to "abject art" in the 1990s, that have invoked dirt and shit.[50] Of course Picasso does not push his avant-garde defiance to the point of utter desublimation; in his primitive scene he flees this point—he hates the dirt and the smell projected there. Thus, however taken he may be by the potency of this disorder, he

reacts against it fiercely; he is desperate for distinction, eager for mastery—to the point of an aggressivity, even a sadism, that he also projects onto the primitive ("they were against everything . . . I too am against everything").

Again the question arises: how is this ambivalence registered pictorially? Even less than with Gauguin can it be referred to the stylistic diversity of *Les Demoiselles,* for, as Leo Steinberg has shown, its abrupt shifts in manner are all purposive.[51] Nevertheless, the double encounter with the prostitutes and the tribal objects was traumatic for Picasso, syphilophobic and superstitious as he was. The painting also came at a time of erotic crisis, prompted not only by fears about venereal disease but also by conflicts with his lover Fernande Olivier, and it is often read in these biographical terms. I have noted his anxiety during its making and the terror of others upon its viewing.[52] Yet *Les Demoiselles* does not resolve this anxiety or temper that terror. If it is "a form of visual abreaction," a discharge of traumatic affect, as William Rubin suggests, it is not complete as such; rather, the painting (re)enacts this anxiety, and this (re)enactment is essential to its disruptive effect.[53]

How is this effect achieved? In the final version, Picasso transformed not only the content but also the address of *Les Demoiselles,* and here again the tribal objects at the Trocadéro must have influenced him. As Rubin has demonstrated, Picasso shifted the painting from a narrative register—perhaps an allegory of syphilis with the sailor and the student (as in the Basel study; fig. 1.12)—to an iconic register, in which these surrogates for Picasso and/or his imagined viewer are elided (as in the Philadelphia study; fig. 1.13). In linguistic terms, this is a shift from a neutral mode of indirect narrative (as in history painting) to an active mode of direct discourse.[54] Rubin sees this shift from narrative to iconic as a gradual achievement of Picasso over this period (it is already advanced in *Two Nudes,* 1906): "a progressive detachment from anecdote, an increased emphasis on frontality, a shift from dispersal to intense concentration in the play of pictorial forces, and a movement toward verticality in the format."[55] As Gauguin remarked of his own figures, so Salmon commented of *Les Demoiselles:* they are neither "allegorical nor symbolic," and the breakdown of these modes in the move to a more

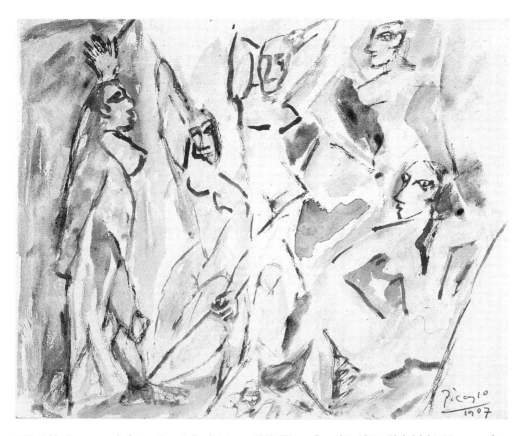

1.13. Pablo Picasso, study for *Les Demoiselles d'Avignon,* 1907. Watercolor, 6 ¾ × 8 ¾ in. Philadelphia Museum of Art: A. E. Gallatin Collection. © 2003 Estate of Pablo Picasso/Artists Rights Society (ARS), New York. Photo: Philadelphia Museum of Art.

direct address is crucial to the breakthrough in high-modernist painting to a more immediate visuality—more frontal, flat, and abstract.[56]

"They are naked problems, white numbers on the blackboard," Salmon also remarked of the prostitutes. "Thus Picasso has laid down the principle of the picture-as-equation." This statement is usually taken to underscore the abstractive aspect of *Les Demoiselles,* radical enough for its time to be conveyed by a mathematical simile, as well as its conceptual aspect, which was supported by the example of the African objects. But this trope might also point to another aspect of *Les Demoiselles,* its modeling of the picture after an imaginary projection or psychic "equation." For in the shift to the iconic register, *Les Demoiselles* becomes not only more direct in address but also more hallucinatory in effect: it becomes the encounter of the viewer as well. For us the stare of the prostitutes has some of the force that the stare of the wolves had for the Wolf Man: our look is doubled, both taken over and thrown back, and, male or female, we might well be suspended between desire and identification, attraction and anxiety. In short, more is at work in this epochal transformation of pictorial models than "proto-cubist" faceting, stylistic diversity, and direct address; there is also an intuitive tapping of the psychic force of such events as the primal scene.[57]

Some of the similarities between the dream of the Wolf Man and the painting of the prostitutes are superficial, such as the odd coincidence of five figures arrayed in an ambiguous space (with the penile tree of the dream matched in part by the penile gourd in the painting), but others might be more profound. For instance, in both dream and painting there is a confusion of human and animal (as in the nursery tales recalled by the Wolf Man and the African masks seen by Picasso). This bestial debasement is extreme in the squatting prostitute: with her back to us, head rotated and legs spread, she is, like the mother in the Wolf Man primal scene, "bent down like an animal."[58] The other figures also undergo violent transformations—above all the two prostitutes in the middle, who, though prone on a disheveled bed, are thrust upright to the picture plane. Here, as Steinberg has argued, *Les Demoiselles* proposes "a reciprocity of engulfment and penetration" that "insinuates total initiation, like entering a disordered bed": the space is made to heave, to draw us in and to push us back, in a phenomenological

———

mimesis of the sexual act.[59] So too, as in the primal scene, there are confusions of subject position in the painting—not only in the process of its making (for example, the student transformed into a prostitute) but, more importantly, in the terms of its viewing. As we look, all eyes are fixed on us (even, or especially, the frontal eye of the prostitute in profile): like the Wolf Man before his scene, we are utterly still, silently staring. If the "similitude of sexual energy" seems to shatter the space of the painting, with each prostitute "singly encapsulated," then this doubled gaze seems to lock it back together.[60] It also sets up a charged exchange of ambivalent effect—of actual immobility and imagined mobility, passivity and aggressivity, eroticism and sadism, castrative threat and fetishistic defense.[61] And what does this traumatic relay evoke if not the structure of the primal scene, which, for all its motility, is also framed like a picture and riveted by an exchange of silent stares? In the painting, as in the primal scene, there is an intense crossing not only of the optical and the tactile but of the active and the passive, to the point where the viewer might begin to feel almost as "splintered up" as the Wolf Man, all civilized hierarchy of senses and sexes confounded.

This is quite different from Gauguin; and yet one must ask of Picasso as of Gauguin: to what end is this staging of ambivalence performed if not in part to manage the masculine anxiety of such a primitive scene?[62] Picasso acknowledges that the primitive-prostitutes are apotropaic "weapons" against the very sexual-racial otherness that they otherwise represent, and the fact that he provides such "exorcism" might explain some of the cultural privilege granted both the painting and the painter for the performance. Nevertheless, this palliative aspect of *Les Demoiselles* hardly cancels its disruptive effect.

PRIMITIVE ENVY

There is no Kirchner story like the Gauguin and Picasso tales. The primitivism of *die Brücke* was bohemian in spirit, a matter of life styles as much as of art styles (of a new relation to nature and sex in particular), and the expressionists who did travel to the South Seas, such as Max Pechstein and Emil Nolde, did so mostly in emulation of Gauguin. But then primitivism is always second-degree, even

with Gauguin, and a late start did not prevent Kirchner from fervid involvement in its visual world, especially from 1909 to 1911. If Picasso pushed primitivism to a pictorial extreme, Kirchner took it to a performative limit; perhaps there was no alternative, given the rapid acculturation of the primitive during this time.[63]

In these years Kirchner visited the tribal displays at the ethnological museum and the zoological gardens in Dresden. In one letter he writes about tribal objects one moment and a zoo exhibit of "Samoans and Negroes" the next.[64] This slippage between tribal art and racialist entertainment was common among primitivists, at least since Gauguin had visited the colonial displays at the Universal Exhibition of 1889, but it was pronounced in Kirchner, as was the mapping of primitive onto prostitute. This figure involved Kirchner more than any other primitivist, and its frequent siting in urban milieus hardly diminished its primitivity for him; on the contrary, it suited the contemporary discourse of the city as a place not only of modern dynamism but of primitive degeneration.[65] Moreover, Kirchner stressed the anal sign of primitive sexuality more than any other primitivist (with the possible exception of the squatting prostitute in *Les Demoiselles d'Avignon*). In November 1909 he filled his little Dresden studio with related images—batik curtains covered with roundels of bathers and lovers, often viewed from the rear and often bordered by animal images, punctuated by wood sculptures of primitivistic nudes set on stands (fig. 1.14). There, too, he acted out a private theater of dancing and playing with friends and models (including two black jazz dancers known only as Sam and Milli).[66]

But where is his primitive scene? In a sense, it is acted out across these studio pictures and theatrical performances, which were clearly important to Kirchner (he photographed them extensively). Yet one image, a sketch sent as a postcard to fellow expressionist Erich Heckel in June 1910, suggests a particular fantasy at work here. In his visits to the ethnological museum, Kirchner was drawn to two beam friezes from a bachelor house in Palau in western Micronesia, which show schematic figures (similar to the ones in his studio decorations) involved in various activities, both everyday and mythological. In his sketch Kirchner focuses on one scene depicting a myth of coitus *a tergo* involving a man with a giant penis (fig. 1.15). Might this be a special sign of primitive sexuality for

1.14. Ernst Ludwig Kirchner, decorations and sculptures in his studio, Dresden, c. 1909.
© Ingeborg & Dr. Wolfgang Henze-Ketterer, Wichtrach/Bern.

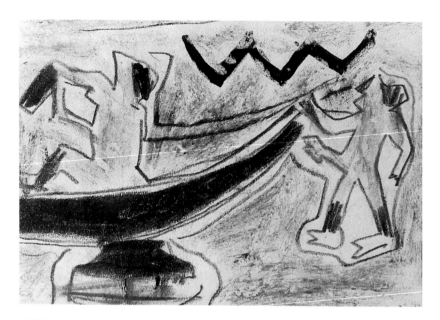

1.15. Ernst Ludwig Kirchner, postcard drawing after a Palau frieze, c. 1910. Maler Erich Heckel, Dangast b/Varel, Oldenburg. © Ingeborg & Dr. Wolfgang Henze-Ketterer, Wichtrach/Bern.

him? In his version the penis is even larger, the buttocks of the woman are even bigger, than in the frieze, as if under the force of an anal-erotic fantasy. Kirchner repeated the image around his studio; it is there, too, above his greatest primitivist figure, *Girl under a Japanese Umbrella* (fig. 1.8, pl. 4), perhaps produced before the postcard (it is dated c. 1909, though dating in Kirchner is problematic). This figure appears under a Japanese parasol, studio emblem of all the exoticisms that prepare the primitivisms of Gauguin, Picasso, and Kirchner; more importantly, she appears under the sign of anal eroticism, and in the most extreme of primitivist contrappostos (Kirchner also deployed this radical contrapposto in several sculptures).

In his art, Kirchner tended to elide the phallic figure of his postcard sketch, as did the other primitivists. Perhaps this fantasmatic figure of a superior masculinity produced too much anxiety. ("At the extreme," Fanon writes, "I should say that the Negro, because of his body, impedes the closing of the postural schema of the white man" [B 160].) Perhaps this figure had to be elided so that the artist could take his place in the primitivist scenario—for only then could the artist assume this greater sexuality without too much risk, only then could he act out his racialist version of "male penis envy." What I mean here is that the sexual ambivalence of a primitivist like Kirchner (or, indeed, Gauguin or Picasso) might be compounded by a racialist ambivalence—a conflict between a presumption of racial superiority and a suspicion of sexual inferiority. Again, the sexual power projected onto the black other was rarely acknowledged as such; rather, it was registered in displaced terms like "the magic" of the African tribal artist, or "the power" of the American jazz performer. But the projection seems active nonetheless, and it betrays a split in the self-image of the primitivist. As Woody Allen once remarked, Freud was wrong about penis envy: it is not a problem for little girls so much as it is for little boys, that is, for all men who suspect that they are little—and that is all men at one point or another. Moreover, this male penis envy often has a strong racial coloration.[67] This racial version of penis envy might compound the ambivalence of the primitivist, bind him even further to a conflicted hierarchy: on the one hand, to an overt paternalism regarding the other (as racial inferior), and, on the other, to a secret obeisance regarding the other (as sexual

superior). This imaginary hierarchy also suggests why it was difficult to feminize the primitive male in the manner of Orientalist and *japoniste* representations of exotic men. Sexual-racial anxiety could not be so assuaged in this case; hence the figure had to be elided, the position evacuated—but, again, with the effect that the white subject might also stand in his stead. In this respect, the primitivist identification with the black man involved his erasure, which is essential to the enactment of the primitivist fantasy.[68]

However partially, Gauguin was able to sublimate his ambivalence in his synthetist aesthetic, and Picasso to work over his anxiety in his apotropaic invention—to hold psychic regression at the point of artistic transgression. Perhaps Kirchner was more pressured by historical events than the others; in any case, he often seems to display his ambivalence more openly in his work. Called up for World War I, Kirchner had a nervous breakdown; hysterically paralyzed for a time, he depicted his own body image as severely disrupted in his famous *Self-Portrait as a Soldier* (1915; fig. 1.16), a symbolic automutilation of the most graphic sort. Here, in the severely angular style of his Berlin years, Kirchner appears in military uniform; pressed to the picture plane, his sickly face stares out blankly, his eyes nearly in line with the breasts of the naked woman behind him (a model? a prostitute? a fantasm?), his amputated hand nearly in line with her sex. Contrary to art-historical legend, Kirchner was quite productive in his Swiss exile after 1917; though he was also often institutionalized, this crisis was hardly terminal. At the same time, he lived through a Nazi armoring of masculinity posed in outright reaction against ego disturbances of the sort evoked in *Self-Portrait as a Soldier*—an armoring that, in life as in art, insisted on a phallic body purified of all primitive sexualities (see chapters 3 and 4).[69] Like its political regime, this new aesthetic brooked no turn to the primitive; as is well known, all figures associated with the primitive were branded "degenerate"—Jews, communists, gypsies, homosexuals, prostitutes, the insane, and many others. Similarly branded in the infamous "Degenerate 'Art'" exhibition of 1937, Kirchner committed suicide in June 1938. And for all intents and purposes, modernist primitivism met its literal catastrophe, its culmination and its counter, in the very different atavisms of the Nazis.[70]

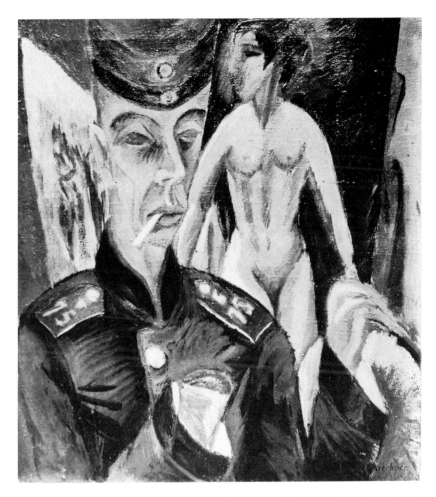

1.16. Ernst Ludwig Kirchner, *Self-Portrait as a Soldier,* 1915. Oil on canvas, 27¼ × 24 in. Allen Memorial Art Museum, Oberlin College, Ohio: Charles F. Olney Fund, 1950. © Ingeborg & Dr. Wolfgang Henze-Ketterer, Wichtrach/Bern.

MARVELOUS EQUATION

To conclude, I want to return to Gauguin, to his version of beginnings and endings in such paintings as *Where Do We Come From?,* and to explore further the pictorial structure developed there (fig 1.2, pl. 1). So familiar is the painting that we forget how odd it is, with figures that are disconnected, colors discordant, and spaces discontinuous. And yet, as often in Gauguin, this disunity is countervailed, made articulate, by a greater unity, one that is analogous, in some respects, to the paradoxical unity of the dream, with its broken narrative that is at once fragmentary and fluid. As with my reading of *Les Demoiselles* in terms of the primal scene, I speak here only of formal analogy, not of symbolic interpretation (much less of direct representation); nevertheless, I think the parallel illuminates some of the force of the paintings.

The analogy between art and dream was common in symbolism. More than once Gauguin describes his texts as "sparse notes, lacking continuity, like dreams, as like everything else in life, made of pieces," and this description holds for some of his paintings too.[71] It is not only his fragmentary "pieces" that evoke the dream; his citational "notes," drawn from various sources (including his prior images), do so as well. Yet if they lack "continuity," what frame holds the paintings together? Gauguin liked to relate his images to friezes and frescoes; and in "Le Symbolisme en peinture: Paul Gauguin," an important essay of 1891 that preceded the Tahitian paintings, the critic Albert Aurier makes a similar allusion. "One might sometimes be tempted to take them for fragments of enormous murals," Aurier writes of the Breton paintings of the late 1880s, "and they almost always seem ready to burst the frames that unduly contain them."[72] This allusion to frames "ready to burst" is telling. "All the ambient material realities have gone up in smoke, have disappeared," Aurier remarks of *The Vision after the Sermon* (1888), the great painting of the Breton maids huddled in the foreground who, inspired by a sermon, behold Jacob wrestling the Angel in the background. This bursting of the pictorial frame or burning away of "material realities" is in keeping with the idealist ambition of symbolism in general, but it also intimates a specific sublimation of the physical support that allows the painting to approximate

"a marvelous equation"—another trope from Aurier that suggests a spatial projection of images, as in a dream.[73]

These notions, which Gauguin might have originated, circle back to him as well. In a letter of February 1898 to Daniel de Monfried, he compares *Where Do We Come From?* to "a fresco whose corners are spoiled with age, and which is appliquéd upon a golden wall"—a further intimation of a broken story of the past translated into a vivid projection in the present, with the intense visuality and enigmatic narrativity of the dream.[74] This model is also implicit in the contrast that he draws to Puvis de Chavannes. "He is Greek whereas I am a savage," Gauguin tells Charles Morice in a letter of July 1901.[75] That is to say, Puvis invokes a classical (sometimes bibilical) frame of cultural reference that allows his paintings to be read in "allegorical or symbolic" terms, whereas he, Gauguin, has no such consistent code. Of course, Gauguin often states his desire to create such a mythic code (to be cobbled in part out of biblical allusions too, hence all his native Tahitian Eves and Marys), but much of the power of the Tahiti paintings stems from the fact that they sustain enigma rather than solve it. "The unfathomable mystery remains what it was, what it is, what it will be—unfathomable," Gauguin writes in a manuscript titled "Catholicism and the Modern Spirit" (drafted in 1897–98, in the same period as *Where Do We Come From?*). "The wise man will seek to enter into the secret of the parables, to penetrate their mystery, to imbibe the enigmatic element in them" (*WS* 163–164). Above all else, desire is the enigmatic element in his new myth, and enigma and desire are bound up in Gauguinian primitivism as much as they are in Freudian psychoanalysis.[76]

There are other similarities to *The Interpretation of Dreams* (1900), which Freud drafted in 1896, the year Gauguin returned to Tahiti after his two-year stay in Paris. Aurier relates the Breton paintings to "hieroglyphic texts"; Freud uses the same analogy in the dream book. Yet more suggestive here is his account of the dream as "a picture-puzzle," a rebus of characters to be read not directly as manifest content but symbolically in relation to "real and imaginary events."[77] Rhetorical parallels also exist between the dreamwork according to Freud and the art of painting according to Gauguin. In Freud four "factors" govern the double mission of the dream to express desire and to avoid censorship, and all

are pertinent to Gauguin. There are the operations of "displacement," whereby psychic energy connected to one idea (image, event, or fantasy) is conducted to another idea along an associative chain, and "condensation," whereby one idea is invested with the psychic energy of several associative chains at once. And there are the constraints of "conditions of representability," whereby the ideas selected for a dream are shaped into images, and "secondary revision," whereby these idea-images are arranged so as to form a continuous (if not coherent) narrative. It is not that Gauguin was Freudian *avant la lettre,* much less that Freud was somehow Gauguinian, but rather that Freud thinks the dream, in quasi-symbolist manner, as a kind of picture, just as Gauguin thinks the painting, in quasi-psychoanalytic manner, as a kind of dream. Indeed, the notions of "conditions of representability" and "secondary revision" seem to be modeled on pictorial practice.[78]

What kind of dream does Gauguin privilege in his Tahiti paintings? Two of the most important, *Mahana no atua* (The Day of the God, 1894; fig. 1.17, pl. 5) and *Where Do We Come From?* (1897–98; fig. 1.2, pl. 1), concern the enigma of origins and ends explicitly. "You have to return to the source, to the childhood of mankind," Gauguin remarks in a 1895 interview (*WS* 110), and both paintings do evoke primordial states and uncanny correspondences that query the primary differences of male and female, nature and culture, human and divine.[79]

Three feet wide, *The Day of the God* is divided into three roughly equal bands that correspond to three roughly distinct spaces. In the background, under a pale sky streaked with cumulus clouds, we see blue sea and white surf; to the right lies a yellow beach with a brown hut, and three figures in a brown outrigger and one on a black horse. In this distant area, then, Gauguin sketches various interfaces of nature and society. The middle ground, on a slight rise, is a mostly human realm, yet it is governed by a dark idol that represents Hina, Polynesian goddess of the air and the moon. On the left of this central idol (whose small body is overwhelmed by a massive headdress) are two women in profile, twinned in light-blue sarongs, who carry an offering for the god on their heads, while a man with a pipe sits under a spindly tree. On the right of the idol a couple embraces, two more twinned women in orange-red sarongs dance, and a woman

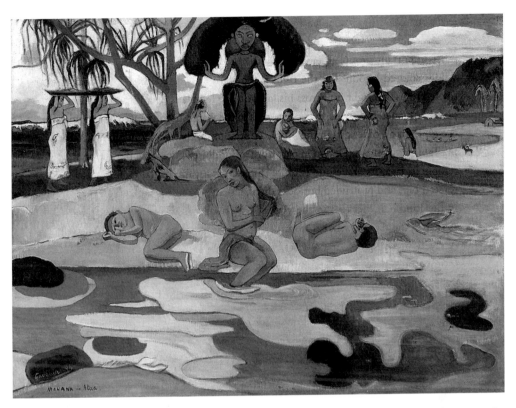

1.17. Paul Gauguin, *The Day of the God (Mahana no atua)*, 1894. Oil on canvas, 26⅞ × 36 in. The Art Institute of Chicago: Helen Birch Bartlett Memorial Collection (1926.198). Photograph © 1997 The Art Institute of Chicago.

gazes out to sea. In this middle area, then, is a sequence of individuals and couples involved in secular and sacred activities. Below this frieze of figures appears the most important group: three youths on rose-pink sand that slopes down to a wildly colored lagoon. On the right is a boy, in almost fetal position, his back turned to us, his right fist across his face; on the left is his near twin, in a similar pose but turned toward us, eyes open, toes in the water. In the center, in line with the idol, sits an older girl in the supple contrapposto that Gauguin often uses for his Tahitian women. (Drawn in part from a Buddhist figure from the Borobudur temple in Java, its arabesque is quite different from the brutal contrapposto of rotated hips and protruded buttocks discussed above.) She gazes at us, one hand in her long hair, her feet in the water, as an orange-red cloth (the same color as that of the dancers) snakes from her lap across her loins down to the lagoon. Arrayed in complementary poses, these figures suggest ambiguous states of (non)being—between dreaming and waking, between near-androgynous pre-pubescence and sexual difference.

Below these figures lies the foreground, a bizarre lagoon painted in lurid pools of discordant colors—yellows, reds, and oranges, greens, blues, and blacks. They can be understood as water and rock, refractions of the bottom and reflections of the sky, but the primary effect is of a primal formlessness, or, more precisely, of a thermal mixing-into-form of spermatic and oval shapes. As we scan up the painting and back into its spaces, a passage is thus suggested from the inchoate life of the lagoon to the sexual latency of the children, to the differentiated world of the adults involved in secular and sacred activities, to the village, sea, and sky beyond—a passage from the amnionic through the human and the cultural, back to the oceanic.[80]

In *The Day of the God* there is a double focus on the two central figures, the girl and the god, situated between water and sky. The girl is captured at a crucial moment in the ritual passage between childhood and adulthood (the red cloth across her loins might suggest the onset of menstruation). If she is in sexual transformation, the god appears beyond sex—or rather, sex is displaced here to the huge headdress, at once phallic and ovarian in shape; in this light she is another Gauguin androgyne, perhaps the primary one. (Gauguin elevated Hina beyond

her importance in Polynesian cosmogony, perhaps because of her frequent combination with the god Ta'aroa as a single androgynous deity.)[81] With her outstretched arms and upturned hands, this figure of in/difference seems to orchestrate—at once to divide and to connect—the different grounds of the painting, the various traditions of its sources, the diverse activities of its figures. Perhaps *The Day of the God* represents a ritual "day of the god" that reenacts the creation of the world, of its original division into difference. But if so, it also suspends this moment (as a painting it cannot do otherwise), and this suspension of origin at the point of difference—of difference before it divides, as it were, traumatically—seems to be the great desire of Gauguin here. Indeed, throughout his primitivist work he evokes various states of in/difference both in terms of gender (paintings of women alone, of men alone, of both together, different and alike) and through interfaces of nature and culture and man and god. Again, as in his primitive scene, his art often puts difference under pressure in a way that suggests a great ambivalence regarding its founding and its unfounding alike. Like Freud, Gauguin sees life, not death, as the great force of discontinuity, and eros as an essential way, in life, to restore the continuity that life otherwise disturbs (this also anticipates Georges Bataille).[82]

The Day of the God represents a cycle of differences and indifferences, of correspondences and comminglings, in a world that is "oceanic." Freud considers this term in the first pages of *Civilization and Its Discontents*. In response to his prior book, *The Future of an Illusion* (1927), his friend, the French author Roman Rolland, had written Freud that "the true source of religious sentiment" lies in a "sensation of 'eternity' . . . limitless, unbounded—as it were, 'oceanic.'"[83] Freud is skeptical of the notion: "I cannot discover this 'oceanic' feeling in myself." And his own myths of origin do center on the founding, not the unfounding, of difference: difference from the animal, as in the rising-upright of man in *Civilization and Its Discontents*; difference as articulated in language, religion, and other symbolic systems, as in the guilt-ridden expiation following the murder of the primal father in *Totem and Taboo*; and so on. In a sense, Gauguin hedges the positions of Rolland and Freud in his primitivist work; that is, he seeks the point between oceanic oneness and symbolic division, again as if to hold the two prin-

ciples in suspension. Such suspension is imaged in the inchoate lagoon of *The Day of the God* and in similar passages throughout the Tahiti paintings. It is there, for example, in *The Man with the Ax* (fig. 1.11), where, as in his primitive scene, difference is figured as both destructive (a literal cleaving) and creative (a symbolic making and/or marking). In *Noa Noa* Gauguin writes of the "long serpentine metallic-yellow leaves" that appear "on the crimson ground" in this painting. They are literally, deeply, of the earth, yet at the same time he regards them as "a whole Oriental vocabulary, the alphabet (it seemed to me) of some unknown mysterious language" (*WS* 80). It is this tension—between the autochthonous and the fabricated, the formless and the differentiated, the presymbolic and the symbolic—that Gauguin treats, especially in *Mahana no atua*, as a fundament of all creation, personal, pictorial, universal: "It seemed to me they spelled that word of Oceanic origin, *atua*, 'god.'"[84]

Painted some three years after *The Day of the God*, *Where Do We Come From?* is over four times larger; its size alone suggests the grandeur of the last testament that Gauguin intended it to be. Once more he gives us a sequence of figures, solitary and grouped, almost all female, set in the midst of domestic animals and wild birds "on the bank of a river in the woods."[85] Hina reappears with a similar gesture, but she is more feminine, less fierce, than in *The Day of the God* (her headdress is reduced, and her color is lighter). "She seems to point to the next world," Gauguin writes in his famous letter concerning the painting to Monfried (*WS* 160); and she does recede in favor of the human figures, especially the man reaching for fruit in the center. Here the day of the god, of ritual creation, has passed to the time of man, of the human pondering of creation: where from, what, where to? As commentators have long suggested, the painting is a riddle about life and death: from the sleeping infant on the right, free of care, to the old woman on the left, her head in her hands—from obliviousness to "resignation" or, perhaps, from helplessness to "futility" (this is how Gauguin describes her attitude). Yet, like the passage from lagoon to sea in *The Day of the God*, this movement from right to left implies a cyclical return (a left to right movement would have suggested a closed narrative of life to death). "Man, they say, trails his double after him," Gauguin writes in *Avant et après*, his "intimate journals"

written a few months before he died in May 1903. "One remembers one's child-hood; does one remember the future?"[86]

Along with seven other paintings, *Where Do We Come From?* was exhib-ited in July 1898 at the Ambroise Vollard Gallery in Paris, where it was deemed obscure, fragmentary, a mélange of parts. This is true enough; yet these attributes are also in keeping with its dream logic, with some figures semi-allegorical, and others not, with some "out of all proportion, and intentionally so," and others not. The painting is "a philosophical work on a theme comparable to that of the gospel," Gauguin told Monfried, but it was not understood at the time, in large part because of its very insistence on enigma. Again, no code is offered, only ci-tations of other art: the old woman is drawn from his own *Breton Eve* (1889), while the man picking fruit evokes both a tempted Eve and a crucified Christ (he is probably based on a study of *Christ at the Pillar* by Rembrandt). Gauguin per-forms this rewriting of "the gospel" in a primitivist idiom in other paintings as well; but here as elsewhere he leaves us between myths, neither in the old nor yet in the new. If *The Day of the God* suspends the creation of the world in its ritual reenactment, *Where Do We Come From?* combines Paradise and Fall, with more resignation than redemption (the old woman outweighs the sleeping infant in this respect).[87] In his famous letter to the critic André Fontainas (which includes the line "I dream of violent harmonies"), Gauguin sees the painting as an "imag-inary consolation for our sufferings" that stem from "the mystery of our origin and our future." He also states that its questions—of origin, identity, and fate—are "not so much a title as a signature."[88]

This identification is key: it suggests that the painting is less a gospel than a riddle, perhaps along the lines of the Oedipal riddle, with Gauguin in the po-sition of the Sphinx and the viewer in that of Oedipus.[89] The Sphinx asks Oedi-pus: What animal walks on all fours in the morning, on two feet at midday, and on three in the evening? Gauguin asks us: What animal sleeps in the morning, strives at midday, and huddles in the evening? Like Oedipus, like Gauguin, we know the answer in the abstract—"man"—but not the individual destiny, and that, Gauguin suggests, is our condition. Again: "The wise man will seek to enter

into the secret of the parables, to penetrate their mystery, to imbibe the enigmatic element in them" (*WS* 164). Not to solve them but to survive them.[90]

Note that Gauguin asks "*what* are we?," not "*who?*"—*que,* not *qui*—as if the subject here is not yet (or no longer) formed, as if it were still (or once again) in the inchoate realm of enigmatic signifiers (see chapter 8). This is true, too, of *The Day of the God,* but *Where Do We Come From?* is less inchoate, more discordant, than *The Day of the God:* creation as division, as traumatic difference, has already occurred here; there is no ritual re-creation of the moment of origin, only a resigned waiting for the coming of the end. But after the end, as before the beginning, there is a release from difference, from ambivalence. Close to death, Gauguin wrote in *Avant et après:* "I dreamed I was dead and, oddly enough, it was the true instant when I was living happily. . . . I have begun to think, to dream rather, about that instant when everything was absorbed, asleep, overwhelmed, in the original slumber" (*WS* 296). It is a dream of existence, *avant et après,* free of difference.

Dieser Bild ist ähnlichen
in der selbst! Adolf Loos

O K 13. II. 1916

2.1. Oskar Kokoschka, *Portrait of Adolf Loos,* 1916. Silver pencil. Photo: Albertina, Vienna (ALA 999). © 2003 Artists Rights Society (ARS), New York/ProLitteris, Zurich.

2

A Proper Subject

"The human embryo in the womb passes through all the evolutionary stages of the animal kingdom. When man is born, his sensory impressions are like those of a newborn puppy. His childhood takes him through all the metamorphoses of human history. At two years of age he sees with the eyes of a Papuan, at four with those of an ancient Teuton, at six with those of Socrates, at eight with those of Voltaire . . ." Thus begins one of the most acerbic of modernist manifestos, "Ornament and Crime" (1908), by the Viennese architect and critic Adolf Loos (fig. 2.1).[1] "The child is amoral," Loos continues. "To our eyes, the Papuan is too. The Papuan kills his enemies and eats them. He is not a criminal. But when modern man kills someone and eats him he is either a criminal or a degenerate." What is this all about? What does ornament have to do with crime, let alone cannibalism, not to mention tattooing, which Loos brings up next? The Papuan tattoos everything, Loos claims, but, like cannibalism, this practice is customary in his culture, almost natural in this sense. For "modern man" to do the same is again criminal or degenerate—a verdict that Loos supports with the rumor that prisoners and aristocrats favor tattoos.

What are we to make of this bizarre story of evolution and devolution? How bizarre is it for its time? What discussions—biological, anthropological, or psychoanalytic—does it presume? What kind of subject does it project? To what ends (besides provocation) is it put forward? As I take up these questions, I will

focus on Loos the critic more than Loos the architect; I do so in part because I want to present him as a particular type of modernist, the modernist as critic (of course, this type includes artists as well).[2] This is the critic as iconoclast ("Ornament and Crime" was mostly read as "Ornament is Crime"), often as puritan (Carl Schorske, the distinguished historian of fin-de-siècle Vienna, calls Loos and Karl Kraus, his fellow scourge of its culture, "the last puritans of Austria"), sometimes as nihilist (Loos was delighted when his Museum Café in Vienna was dubbed "Café Nihilismus").[3] But above all, it is the modernist as critic of the language of his own practice or discipline—in the familiar sense that Ludwig Wittgenstein, another Viennese scourge, conceived philosophy as a *Sprachkritik* or language critique of philosophy ("all philosophy is a 'critique of language,'" *Tractatus Logico-Philosophicus,* 4.0031), or that Arnold Schoenberg composed music as a critique of the language of tonality that he deemed in crisis.[4] Importantly for this modernist-as-critic, "ethics and aesthetics are one and the same" (as Wittgenstein puts it in the *Tractatus,* 6.421), as are culture and critique.[5] In my terms here, they are also one and the same in the making of a model self.

This imperative of self-critique was pronounced in fin-de-siècle Vienna. Led by Schorske, historians have referred it to a crisis in the Austro-Hungarian Empire, to the morbid interregnum of a Vienna caught between an old liberal order and a new mass politics. Politically, Austria was at once chaotic and stagnant, as evoked by Robert Musil in *The Man without Qualities* (1930–43):

> The government was clerical, but everyday life was liberal. All citizens were equal before the law, but not everyone was a citizen. There was a Parliament, which asserted its freedom so forcefully that it was usually kept shut; there was also an Emergency Powers Act that enabled the government to get along without Parliament, but then, when everyone had happily settled for absolutism, the Crown decreed that it was time to go back to parliamentary rule.[6]

Culturally, too, it was chaotic and stagnant, an "ungovernable mélange of Germans, Ruthenes, Italians, Slovaks, Rumanians, Czechs, Magyars, Slovenes, Croats,

Transylvanian Saxons and Serbs."[7] It is no surprise, then, that "a work of clarifi-
cation" (Wittgenstein again) was deemed urgent, a work of critique (more than
politics) that was often framed in linguistic terms—as a search for an essential
language whereby each discipline might be rendered both more grounded and
more autonomous. The first task was to strip away the superfluous (*überflüssig* is
a favorite term of abuse among these Viennese modernists): for Kraus to rid jour-
nalism of clichéd metaphor, for Wittgenstein to rid philosophy of metaphysical
mystification, for Schoenberg to rid music of decadent tonality, and for Loos to
rid design of superficial ornament.[8]

If these critiques of the superfluous are specific to this Vienna, the proj-
ect is not so limited, as the influence of these figures alone attests. Loos profiled
the modernist-as-critic in significant ways, for he turned his particular opinions
about art, craft, and architecture into general theses that became almost canoni-
cal among subsequent modernists like Le Corbusier. First, in his corrosive con-
tempt for superficial ornament, Loos advanced not only the cause of abstraction
fundamental to modernist art and architecture, but also the critique of kitsch cru-
cial to modernist criticism.[9] Second, in lieu of kitschy ornament, he elevated cer-
tain objects of everyday use as stylistic models of design, in a manner also adopted
by many other modernists. Loos chose objects somewhere between handicraft
and industry, such as tailored clothes, shoes, luggage, saddles, Thonet chairs, and
wine bottles. This intermediary position reflects the mixed nature of the Aus-
trian economy of the time; it also positions him, chronologically and ideologi-
cally, between the arts-and-crafts advocacy of William Morris, who wished to
reform craft with art, to return "joy in work," and the machine-age advocacy of
Le Corbusier, who wanted to elevate select objects of industry as "type-objects"
for design models (some of which he also used as ideal motifs in his purist paint-
ings).[10] For Loos, the point was precisely *not* to confuse art with craft or with in-
dustry, not to aestheticize either. Third, in his elevation of everyday (bourgeois)
products as design models, Loos advanced the clear articulation of materials as a
new form of beauty and truth appropriate to modernity, to a modern *Kunst-
wollen* or "artistic will" that craftsmen and engineers were more likely than artists
and architects to express purely because they would do so unconsciously (or so

57

he thought).[11] And, finally, fourth, Loos advanced all these positions not as a rupture with the tradition of European art and architecture (which he viewed as predominantly neoclassical) but, on the contrary, as its recovery, even its refinement, after the amnesiac eclecticism of nineteenth-century styles (he regarded this historical pastiche as "degenerate" above all else). "At the beginning of the nineteenth century we abandoned tradition," Loos writes in 1913; "it is at that point that I want to renew [anknüpfen] it."[12] This relation to tradition is also characteristic of a wide range of modernists from Le Corbusier through Clement Greenberg; many took this chiasmic relation between modernism and (neo)classicism as doctrine.[13]

In the end, however, Loos does more than profile a particular type of modernist; he also models a general type of subject, one concerned above all else with what is *proper*—not only to his materials and medium, his person and profession, but to his culture and society at large (I hope "proper" will resonate here in its various registers—correct, clean, possessive, reflexive . . .). This modeling is an important effect of his work, and I want to consider some of its psychological implications and social presuppositions. For this reason I bring psychoanalysis into account—both as a fledgling discourse in the Vienna of his time, and as a critical optic on his work in the present.

THE OUTSIDER

Born in 1870 in the industrial city of Brno, one hundred kilometers north of Vienna (today in the Czech Republic), Loos was peripatetic in his training: he studied arts and crafts, building technology, and architecture, in Brno, Dresden, and Vienna respectively, but he never completed his degree. This was not the career path of elite architects in Vienna such as Otto Wagner, whom Loos revered, and his students Joseph Maria Olbrich and Josef Hoffmann, whom he derided; but this formation did ground Loos in craft and construction (that his father was a stonecutter and sculptor is also relevant here). In this same mode of the pragmatic outsider, he traveled to the United States rather than to Italy and Greece (as was still customary for young architects of the time). During this sojourn

(1893–96) he visited the Columbian Exhibition in Chicago (where he encountered the architecture of Louis Sullivan) and worked in poverty in New York, Philadelphia, and St. Louis. More importantly, he developed his intense enthusiasm not only for the practical objects of Anglo-American manufacture, which influenced subsequent modernists in Europe like Erich Mendelsohn, Walter Gropius, and Le Corbusier, but also for the pragmatic codes of living and working that he witnessed in the States, and found among European peasants and engineers as well.

Absent during the final flowering of arts and crafts in Art Nouveau, the twenty-six-year-old confronted this pan-European bloom (or blight, as he saw it) on his return to Vienna in 1896, and it became his principal object of attack.[14] This polemic, which culminates in 1908 with "Ornament and Crime," begins with articles from 1897–1900, many of which were written for *Neue Freie Presse,* the great liberal newspaper of Vienna, as weekly reviews of craft and trade displays at the Jubilee Exhibition of 1898, a six-month celebration of the fifty-year reign of Emperor Franz Josef held in the Prater. In wide circulation as reviews, these articles were not published as a book until 1921, and then first in Paris. This circumstance speaks to the influence of Loos in France, where Le Corbusier published "Ornament and Crime" in 1920 in the second issue of his magazine *L'Esprit Nouveau* (an abridged translation first appeared in 1913 in *Cahiers d'Aujourd'hui*). But it also speaks to the "untimeliness" of Loos in Austria and Germany, where, over the years, he battled nearly all the major players in his field—from the Vienna School of Arts and Crafts, through the Vienna Secession (the Art Nouveau group which, led by the artists Gustav Klimt and Koloman Moser and the architect-designers Olbrich and Hoffmann, had seceded from the Art Academy in 1897) and the Vienna Werkstätte (the craft workshops founded by Moser, Olbrich, and Hoffmann in 1903), to the German Werkbund (the association of artists, designers, and industrialists founded by Hermann Muthesius and others in 1907).

With his characteristic immodesty Loos signaled this outsider status in the titles of his collection of these early reviews, *Ins Leere gesprochen* (Spoken into the

Void), his short-lived journal of 1903, *Das Andere* (The Other; fig. 2.2), and his collection of later essays, *Trotzdem* (In Spite of Everything), which gathered "Ornament and Crime" and other important texts like "Architecture" (1910).[15] This self-image is also typical of the modernist-as-critic (with the title of his journal, *Die Fackel* [The Torch], Kraus shared it): it is the Nietzschean self-image of the prophet without honor in his own land, who speaks both *in* a void—that is, in the absence of an enlightened public—but also *to* a void—that is, in the anticipation of a transfigured future.[16]

In the words of Kraus, the Jubilee Exhibition was meant "to make foreign countries aware of the high level of our productive capacity in the crafts"; in this respect it was similar to other exhibitions in Europe intended to promote national design at a time of international competition and imperial confrontation.[17] This agenda of design promotion prompted Loos in his caustic critique of superficial ornament—both the historically eclectic ornament of the arts and crafts movement and the graphically effusive ornament of Art Nouveau (whether organic, as in most manifestations of this style, or geometric, as in the Vienna Werkstätte). As a counter-model Loos advocated the practical aspect of Anglo-American design. In all this position-taking, his Jubilee reviews, like the Exhibition as a whole, looked ahead to the Universal Exhibition in 1900, which Loos foresaw as a stylistic showdown. "It is in Paris," he writes on May 29, 1898, "that the most burning question of our time will probably be solved, the one that is worrying the crafts industry at present: which will prevail, the old style or the modern style?" (*SV* 17). Certainly he knew which should prevail: "The new phenomena of our culture (railroad cars, telephones, typewriters, and so forth) must be resolved without any conscious echoes of a formal style that has already been superseded" (*SV* 16).[18]

Although focused in theme, the reviews collected in *Spoken into the Void* range in subject—from crafts and trades to building materials and methods, from shoes and fashion to interior design and furniture. Full of blague and provocation, they often appear contradictory. On the one hand, Loos finds a new beauty in the proper crafting of sound materials into practical objects of use; again, this

2.2. Adolf Loos, cover of *Das Andere,* no. 1, 1903. Photo: Albertina, Vienna. © 2003 Artists Rights Society (ARS), New York/VBK, Vienna.

is key to the modern *Kunstwollen* that he is concerned to define and to promote. On the other hand, he insists on the absolute separation of art, architecture, and craft, which is also crucial to this *Kunstwollen* ("the modern individual," Loos will later assert, "considers mixing art with objects of everyday use as the greatest humiliation possible").[19] Yet this is less a paradox than a double move that structures his argument from start to finish: architecture and craft are to be modeled on the practical object, which can serve as a model for all such design precisely because it is *not* artistic in intention, that is, because its principle of pragmatic making and functional use will help to focus each discipline on its proper materials and methods. And this principle will set art apart as well, and so support its autonomy too.[20]

It is this double move that leads Loos to his critique of all stylistic imitation as deceptive, even degraded, and to his attack on all superficial ornament as regressive, even degenerate. (This condemnation does not include a structural use of classical ornament, which he often affirms in his writing and practices in his architecture.) As we will see, this critique of costuming in art and design is supported in *Spoken into the Void* by an analogy between modern fashion and architecture, between proper clothing (*Kleidung*) and cladding (*Bekleidung*). And this analogy in turn supports a division almost as important to Loos as that between art and design: the division between exterior and interior in architecture—and, implicitly, in the self as well. (This division distinguishes Loos from subsequent modernists for whom the principles of "structural transparency" and "truth to materials" mandate that the exterior surface somehow express the interior space, or feign to do so.) Such oppositions of art and design, of interior and exterior, inform his work, both critical and architectural, and they do so insistently, almost obsessively. In fact Loos seems driven by an anxiety about a lack of structure, about an *indistinction* in all things—material and stylistic, historical and social. Perhaps this anxiety is also active in his embrace of an oppositional stance and an outsider status; in any case, it seems psychological at root, to do with indistinction in the subject, and it might inform this modernist type of critic in general.[21] To understand his anxiety about indistinction, however, we must first understand his manifest concerns, which, broached in *Spoken into the Void,* come

to a head in "Ornament and Crime" (the later article is foreshadowed in early reviews and recapitulated in later essays). Schematically put, these concerns are: the truth to be found in materials and the degradation in imitation, the propriety in dressing (of buildings and people alike), and the protection of interiority (again in architecture and self alike). I will take them up in that order.

A PLACE FOR EVERYONE

In his first article on the Jubilee Exhibition (May 15, 1898), Loos denounces the stylistic imitation of Austrian arts and crafts as a "philistine sham," and with the confidence of a new *Kunstwollen* he presents this modernist redefinition: "Our time places more importance on correct form, solid materials, precise execution. *This is what is meant by arts and crafts!*" (*SV* 8; original emphasis). This is his mantra throughout the Jubilee reviews: correct form, solid materials, precise execution. In an article on interiors three weeks later (June 5), it takes the form of a tale of "honest craftsmen" led astray by "scholarly archaeologists" and "silk and velvet" upholsterers—that is, by historicists and ornamentalists (*SV* 20). In a review of furniture two weeks later still (June 19), it is carpenters who are led astray by architects, and here Loos first defines beauty in terms of the expression of practical purpose. By the end of the summer, in an important text on "The Principle of Cladding" (September 4), he arrives at his ur-modernist formulation: "Every material possesses its own language of forms, and none might lay claim for itself to the forms of another material. . . . Art has nothing to do with counterfeiting or lying. Her paths are full of thorns, but they are pure" (*SV* 66).

This formulation suggests a corollary that Loos also delivers in "The Principle of Cladding": not to use materials properly, that is, singularly and truly, is not only to deceive but to degrade as well. (A week before, on August 28, he had offered several examples of this deception-as-degradation: paper tricked up to resemble silk, wood treated to pass as stucco, iron painted to look like bronze, cement fashioned as if it were stone.)[22] It is in similar terms that Loos condemns the historicist architects of the Vienna Ringstrasse, the redevelopment of the city

center begun in 1858 (roughly contemporaneous with the transformation of Paris under Baron Haussmann), with different public buildings dressed in different historical styles—the parliament house in Greek revival, the city hall in Gothic revival, the university in neo-Renaissance, the theater in neo-baroque, and so on. Liberal politically, this project was not progressive stylistically, and its pastiche, Loos complains in "The Principle of Cladding," continues unabated in the present: "Imitation and surrogate art still dominate architecture. Yes, more than ever" (*SV* 67). For Loos the sin of stylistic imitation compounds the crime of material deception: together they produce a "spirit of self-degradation" [*Selbstentwürdigung*] (*SV* 64). Note that this degradation is referred to "the self," which underscores the connection between aesthetics and ethics in Loos: impurity in the one threatens impurity in the other.

The principles of pure materials and distinct forms, the critiques of ornament as superfluous and imitation as degraded, are familiar to students of modernism. Presented as objective criteria, they are also subjective values concerning decorous distinctions, and they are defended by modernist critics like Loos to the extent that they appear threatened by forces that are social, political, and economic in nature. In this respect Loos foreshadows another influential modernist who would emerge forty years later: Clement Greenberg. In his essay "Toward a Newer Laocoon" (1940), Greenberg condemns the contamination of one material or medium with the effects of another, and refers this condemnation to the neoclassical position of Enlightenment philosophers like Gotthold Lessing, author of the older *Laocoön* (1766). Moreover, what Loos excoriates as "surrogate art"—cheap copies of expensive materials and facile imitations of historical styles—is what Greenberg condemns as "kitsch" in his essay "Avant-Garde and Kitsch" (1939). For Greenberg, kitsch is an ersatz version of academic art produced for consumption, not for contemplation, as a substitute for the folk culture lost to the proletariat in its coming to the industrial city on the one hand, and as a surrogate of high culture sold to the petite bourgeoisie in its bid to climb socially on the other hand.[23] Initially Loos is vague about the class determinations of "surrogate art"; he first derides all Austria as "parvenu" (*SV* 64).[24] But in two

pieces published outside the series of *Neue Freie Presse* reviews—the first before the Jubilee Exhibition, the second in its midst—he implicates the "social conditions" behind this "imitation of old forms and styles."

In the first article, a review of furniture copies at the Austrian Museum (December 18, 1897), Loos offers this broad overview of European culture in the turbulent wake of the French Revolution:

> The barriers erected by the royalty against the high nobility, and by the high nobility against the lower nobility, and by the lower nobility against the bourgeoisie, had collapsed, and everyone could furnish his home and dress according to his own taste. Thus it can really be no surprise to us that every house servant wanted to furnish his home like those in the court, and every waiter wanted to dress like the Prince of Wales. It would be wrong, however, to see progress in this situation. (*SV* 92)

This is typical of Loos: he supports the political franchise of democracy in the abstract, but decries its cultural effects as "superficiality, hollowness, and that horrible monster, imitation" (*SV* 92), with "imitation" understood as both stylistic and social (the former as an index of the latter). Although he points to an incipient critique of capitalist kitsch, it does not arise from the socialist sympathies either of the elderly William Morris, who saw arts-and-crafts reform as a partial solution to kitsch, or of the young Greenberg, who saw modernist art as a partial refuge from it. In social terms Morris viewed kitsch mostly from below, in identification with the worker, while Greenberg regarded it primarily from outside, in identification with a bohemian avant-garde. Loos sees this "parvenu" problem mostly from above, in identification with "the English gentleman," a figure whom he projects as a perfect resolution of aristocratic distinction and bourgeois sincerity, of taste and truthfulness. Here the social referent of the Loosian aesthetic-ethic of "correct form, solid materials, and precise execution" is less the "honest craftsman" than the upper-class gentleman. Or rather, Loos imagines that he can reconcile both figures in his own position, perhaps even embody

craftsman and gentleman in his own person(a), as is implied by his self-definition of the architect as "a stonemason who has learned Latin," as well as by his self-association with the "intellectual aristocrat" who sides with the good worker: "I am preaching to the aristocrat, I mean the person who stands at the pinnacle of mankind and yet has the deepest understanding for the distress and want of those below" (SV 94).[25]

But how is his "English gentleman" both aristocratic and bourgeois? In his account of the bourgeois revolution, Loos argues that "the English [gentleman] forswore princely luxury and princely splendor," and that this renunciation of privilege attests to "a self-assured and independent bourgeoisie," one that is "destined soon to bring the bourgeois style in the home to its fullest flower" (SV 92). This bourgeois style "demands absolute truth," and underwrites absolute "individuality": "That means, in general, that the king furnishes his home like a king, the bourgeois like a bourgeois, and the peasant like a peasant" (SV 94). This "bourgeois style" is old-school English: it is the hypocritical vision of a hierarchical "democracy" based (as the saying goes) on "a place for everyone and everyone in his place." And for Loos "it is the task" of modern designers to serve this paternalistic order, "to raise the taste of the multitude in its various characteristic class gradations; in doing so they are fulfilling the needs of the intellectual aristocracy at any given time" (SV 94). Once more, this position might be specific to Viennese modernists like Loos. "The Austrian aesthetes were neither as alienated from their society as their French soul-mates nor as engaged in it as their English ones," Schorske has argued. "They lacked the bitter anti-bourgeois spirit of the first and the warm melioristic thrust of the second."[26] But this position is also more characteristic of this modernist type than the other national versions are. For it is a position that manages some of the contradictions of social modernity in the displaced form of artistic modernism, that permits the persistence of the old regime, as it were, in the very presentation of a new culture.[27]

If this first article points to the social conditions of "parvenu" kitsch in Austria, which Loos implicitly refers to the lack of a bourgeoisie "self-assured and independent" enough to maintain a proper culture of its own, then the second article elaborates the stylistic manifestations of such "surrogate art." Published in

the July 1898 issue of *Ver Sacrum* (Sacred Spring), the journal of the very Secession that Loos would soon attack, this piece uses the conceit of Vienna as a "Potemkin City"—an allusion to the "villages of canvas and pasteboard" (*SV* 95) constructed in 1787 by the Russian Field Marshal Grigori Aleksandrovich Potemkin in order to make Russia appear more prosperous to Catherine the Great than it was.[28] For Loos, the Vienna of the Ringstrasse is a similar exercise in architectural deception, dressed up like "a city of nothing but aristocrats" (*SV* 95). And the confusions that follow from this "inauthenticity" (*SV* 96) run the gamut from the material and the formal (cement that pretends to be stone), to the stylistic and the historical (the modern *Kunstwollen* obscured by historical pastiche), to the ethical and the social, for like cheap or lowly materials that attempt to pass for expensive or high stuff, the parvenu (city or citizen) confuses the proper order of things. "Poverty is no disgrace," Loos writes. "Not everyone can come into the world the lord of a feudal estate. But to pretend to one's fellow men that one has such an estate is ridiculous and immoral" (*SV* 96).

As noted above, Loos advocates a refounding of culture in craft, which is egalitarian in implication, only to insist on a separation of art from craft in this refounding, which is elitist in implication. Here he critiques stylistic deception in the name of bourgeois "authenticity," only to maintain the old social distinctions through this same authenticity—the king is to live like a king, the bourgeois like a bourgeois, and so on, all authentically.[29] In his version of a "place for everyone," everyone is free to dress and furnish as they like, as long as they do so precisely as they should, that is, as long as no one crosses class lines wantonly. This is the familiar catch of the bourgeois criteria of "sincerity and authenticity," which the literary critic Lionel Trilling once glossed in this way: "the person who accepts his class situation, whatever it might be, as a given and necessary condition of his life will be sincere beyond question. He will be sincere *and* authentic, sincere *because* authentic."[30] Again, Loos believes in the bourgeois revolution, but he wants to limit its democratic franchise to the bourgeoisie—a contradiction that is not only distinctive to the bourgeoisie but characteristic of this modernist type as well. According to Marx, this contradiction forced the bourgeoisie, in its moment of political truth, to restrict its democratic franchise, to draw back from

its own social ideals and cultural principles, in order to preserve its economic rule; this is how he understood the apparent self-surrender of the French bourgeoisie when it embraced the imperial rule of Napoleon III after the proletarian revolts of 1848.[31] For all the differences of the Austrian context, Loos also lives and works in the wake of this self-surrender of the European bourgeoisie (as we will see, it is actually a self-*defense*). And this holds true for subsequent modernists like Greenberg, for whom the self-surrender of the bourgeoisie, its inability "to justify the inevitability of its particular forms," prompted the avant-garde in first place. Forever marked by the ambivalence of this founding, the avant-garde, according to Greenberg, contests this class for its cultural decadence (as manifest in kitsch) on the one hand, even as it assumes its defaulted commitment to high art on the other.[32]

Recall that, for Loos, the Ringstrasse was the sign of a bourgeois society that wanted to pass as aristocratic, a bourgeois society without a "self-assured and independent bourgeoisie." But might this passing or deception also be characteristically bourgeois? There are two ways to understand this hypothesis. The first is straightforward: far from a lack of self-assurance, the pastiche of the Ringstrasse is the sign of a bourgeoisie self-assured enough, even brazen enough, to appropriate the historical styles of past regimes as its own (medieval Church, Renaissance prince, and so on). The second way, which follows Marx, is more complicated: this pastiche is indeed the sign of a lack of self-assurance, of a bourgeoisie that sacrifices its distinctive style and assumes a historical disguise in order to continue its economic rule, but also of a bourgeoisie that seeks to become self-assured once more through this very disguise. Perhaps we do not need to decide between the two versions; perhaps they can work in concert; and in any case, the pastiche exemplified by the Ringstrasse still counts as a "bourgeois style." What, then, of the modernist style advocated by Loos—abstract, uniform, free of historical ornament? It is not a break with "bourgeois style"; again, Loos wants to (re)establish this very thing. Might it be a further bourgeois style, a later disguise of a bourgeoisie, one no longer camouflaged in historical styles but *hidden behind a uniform of abstraction,* or, more precisely, behind a bourgeois neoclassicism recovered and redefined in abstract form? Here the value of equality espoused by

a self-assured bourgeoisie has become, a century later, the mask of uniformity presented by a deceptive bourgeoisie—and another way both to conceal and to extend its class rule culturally.[33]

In play in these ruminations on class style is an analogy that operates in Loos from the beginning: an analogy between proper architecture and dress or, more exactly, between proper cladding and clothing. After truth to materials and degradation in imitation, this is the third persistent concern of his Jubilee reviews. Later, in "Architecture," Loos will formulate the analogy in this way: "Have you never noticed the strange correspondence between the exterior dress of people and the exterior of buildings? Is the tasseled robe not appropriate to the Gothic style and the wig to the Baroque? But do our contemporary houses correspond to our clothes? Are we afraid of uniformity?"(AL 107). Again implicitly, Loos refers this decorous correspondence of "uniformity" to the bourgeois revolution with its democratic ideal. "Our century," he writes in a review of "Men's Fashions" (May 22, 1898), "has done away with dress code regulations" tied to class (SV 11). This is a social sort of categorical imperative similar to the one applied to furnishings: everyone is now free to dress as they like, as long as they do so as they should. "What does it mean to be dressed well?" Loos asks in the same text. "It means to be dressed correctly," that is, to be "dressed *in such a way that one stands out the least.* . . . In good society, to be conspicuous is bad manners" (SV 11; original emphasis). Just as to be authentic is to appear true *to* class, to be correct is to be inconspicuous *in* class. It is not that everyone should look alike; in a review of underclothes (September 25) Loos insists that his ideal is not "to put the whole world into a uniform" (SV 71). Nor is it quite that everyone should be camouflaged in a class uniform; in the same review Loos condemns "costume" as "clothing that has frozen in a particular form" based on class (he scorns the nostalgic fixation on peasant dress in particular [SV 71]). His implication is ideologically more subtle: everyone should assume the bourgeois principle of inconspicuous uniformity. "Inconspicuous" does not mean "invisible"; again, it means to look proper (as we will see, for Loos churches should look reverential, government buildings powerful, and so on); it is a form of hiding in plain view. And in the analogy between dress and architecture, he focuses this prin-

ciple on the home: "the house has to look inconspicuous," he writes in "Architecture" (*AL* 107).[34] In a sense, for Loos identity *is* this inconspicuous uniformity, this decorous "correspondence" of personal appearance (dress, furnishing, house) both to social position and to historical period (as in the passage in "Architecture" cited above about Gothic robes, baroque wigs, and so on). This correspondence is a form of respectability, a propriety of property, and so, perhaps paradoxically, a kind of distinction too. As the historian George Mosse has taught us, this ideal of respectability was spread by the bourgeoisie to other classes. Fueled by the Protestant revivals of the late eighteenth and early nineteenth centuries (strongest, of course, in Germany and England), this ideal scorned "personal ornamentation" as an obstacle to "inward piety."[35] All these currents run through Loos: a neoclassical sense of architectural order, a neo-Enlightenment sense of aesthetic decorum, a bourgeois sense of social respectability.

This propriety is structured by gender as well as by class, and here we might return to the statement "Our century has done away with dress code regulations." To a degree Loos anticipates the position of another Viennese critic, the psychoanalyst J. C. Flügel, who, in his *The Psychology of Clothes* (1930), argues that "decorative dress" declined after the French Revolution (at least in "most advanced countries"), since it was keyed to the "distinctions of rank and wealth" in the ancien régime.[36] The self-assured bourgeoisie called for both a "greater uniformity of dress," indicative of its democratic ideal, and a "greater simplification of dress," indicative of its pragmatic spirit (*PC* 112). Both changes signaled the new status of work, which was scorned in the old aristocratic order, as expressed in its impractical dress, but honored in the new bourgeois order, whose "simple costume" attested to "commercial and industrial values" (*PC* 111–112). For Flügel this transformation focused on men of "rank and wealth"; women of this position remained in the role of ornamental objects for the erotic interest of men.[37] But rather than a great feminine subjugation, he understands this transformation as a "great masculine renunciation" whereby men had to sacrifice elaborate dress for "'correct' attire." "Man abandoned his claim to be considered beautiful," Flügel concludes. "He henceforth aimed at being only useful" (*PC* 111).

Again, some of these historical developments—the shift from elaborate to austere attire, the revaluation of beauty in relation to use—were glimpsed by Loos, who wanted to secure them as transhistorical values. As the critic Peter Wollen has remarked, he sought to extend the "great masculine renunciation" in dress to other aspects of design—indeed, to all areas of culture.[38] And yet, just as the great bourgeois revolution mostly reinscribed the old cultural hierarchy, this great masculine renunciation mostly reinforced the old sexual hierarchy. In architecture as in dress, the Loosian ideal of inconspicuous uniformity served to mask—that is, both to pronounce and to conceal, as a mask does—not only bourgeois rule but masculine domination as well. (I will suggest below that the blank facade of this bourgeois uniform, again in architecture as in dress, also encoded this domination.) Like Flügel, Loos presents this political ploy as an arduous achievement. "In earlier eras," he argues in "Ladies' Fashion" (August 21, 1898), "men also wore clothing that was colorful and richly adorned"; they "had to fight for the right to wear pants" (*SV* 102). And Loos agrees with Flügel that men are better suited than women for this "sacrifice of narcissism" (as Flügel puts it): endowed with a "more rigid conscience," they are more capable of "psychic inhibition" (*PC* 113–116), more capable, finally, of civilization. In this opinion, these two Viennese gentlemen are joined by a third, Freud, who takes a similar position in *Civilization and Its Discontents* (1930) and related texts.[39] That woman remains bound to ornamental dress is proof enough for Loos: it "demonstrates to us that woman has fallen behind sharply in her development in recent centuries" (*SV* 102). Moreover, in his egregious account, the subordination of woman to man is not only her fault; it is also her ruse. Here Loos offers an origin myth that anticipates the pseudo-biological story that Freud concocts in *Civilization and Its Discontents.* "If man had remained a beast," Loos writes, "then the love in his heart would have been aroused once a year [i.e. when he goes into rut]. But our sensuality, which we can restrain only with great effort, makes us capable of love at any time" (*SV* 99). Unlike Freud, however, Loos scorns this sensuality as "unnatural," and condemns woman for its exploitation through wiles that will include ornamental dress. Through her provocative covering, he continues, "she became a riddle to man," a sexual riddle that "implant[ed] in his heart the desire

for [its] solution" (*SV* 99).[40] Here ornamental dress is more than a deception; it exploits perversion, or the turning of sexuality from natural sex into unnatural "eros," into "frightful aberrations and scandalous depravities" (*SV* 99).[41]

This sort of perversion is a prime target not only of Loos and his Viennese colleagues, but of this modernist type in general. But first there is a fourth theme of his writings to consider—the separation of exterior and interior—which follows on the third theme, the analogy between architecture and dress. In "The Principle of Cladding," Loos sketches another origin story: "In the beginning was cladding," and this "covering is the oldest architectural detail," "older even than structure" (*SV* 66–67). Here he follows Gottfried Semper, for, like the nineteenth-century German architect and theorist, Loos implies that architecture originated in coverings made of "animal skins or textile products" (*SV* 66) that became enclosures (e.g. woven screens) and eventually hangings (e.g. wall tapestries).[42] For Loos, clothing and cladding appear primordially connected as forms of protection, and he understands this protection as both physical shelter and psychological mask. Again, unlike subsequent modernists who expect the exterior somehow to express the interior, Loos insists on a division between outside and inside, especially in domestic architecture (a prime example is his famous Steiner House of 1910 in Vienna [figs. 2.3, 2.4]). The premium on protection might help to explain why this division is so important to him, for it allows the exterior to mask, and so to protect, the interior—of the house, of the family, but also of the self, of "interiority" as such. "The house can be silent on the outside," Loos writes; "all its riches are manifest in the interior."[43] And for the most part he follows this principle, puts his theoretical oppositions (interior and exterior, private and public, feminine and masculine, and so on) into architectural practice.

In doing so, finally, Loos reclaims a "bourgeois style" in another sense, for the two sides of his domestic architecture conform to the two sides of "respectable" appearance—an often uniform, even taciturn exterior and an often rich, even sensuous interior, which are coded conventionally in terms of gender. It is as if the bourgeoisie could not maintain its ideal of transparency, of sincerity and authenticity, after its apparent self-surrender, and as if, in its actual self-defense,

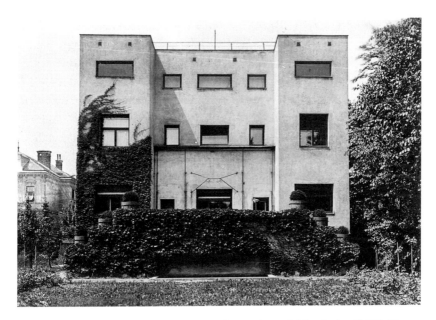

2.3. Adolf Loos, Steiner House, Vienna, 1910. © 2003 Artists Rights Society (ARS), New York/VBK, Vienna. Photo: Albertina, Vienna (ALA 2576).

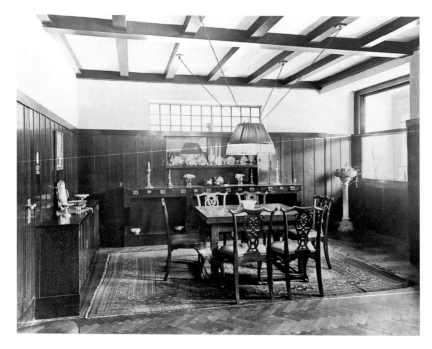

2.4. Adolf Loos, Steiner House (dining room), 1910. © 2003 Artists Rights Society (ARS), New York/VBK, Vienna. Photo: Albertina, Vienna (ALA 2580).

it hid its public face in order to protect (to rescue) its private life, its interiority. Further, it is as if Loos designed for this late-bourgeois arrangement, and as if the modern architecture that he did so much to advance does so too: it serves a bourgeoisie withdrawn into its interiority, respectable on the outside, comfortable on the inside (or so it hopes).

EXCREMENT AND CRIME

These are the concerns of *Spoken into the Void*. Even as they prepare the polemic of "Ornament and Crime," however, they do not explain the history that begins it: "The human embryo in the womb passes through all the evolutionary stages of the animal kingdom" (*OC* 19). This is a popular version of "the biogenetic law," associated with the German zoologist Ernst Haeckel, according to which "ontogeny is the short and rapid recapitulation of phylogeny."[44] Long discounted in our time, this law was axiomatic to many contemporaries of Loos, Freud prominent among them, for whom it possessed a psychological truth that he could never relinquish. As Freud would soon do more elaborately, Loos extends this law to cultural history, transforms it into a sociogenetic law whereby, as the embryo recapitulates natural evolution, so the child recapitulates human history: "At two he sees with the eyes of a Papuan, at four with those of an ancient Teuton, at six with those of Socrates, at eight with those of Voltaire" (*OC* 19).[45] Obviously provocative, this history is not entirely parodic, for, again, it was not exceptional in its time. Along with associates like Sándor Ferenczi, Freud speculated in terms both phylogenetic and sociogenetic, and this psychoanalytic interest might suggest what is stake in Loos as well: a story of the formation of the ego, of the proper ego, or, more precisely, a story of history *as* the formation of this proper subject, a story that, however fantastic to us, is naturalized for them through the biogenetic analogy.[46]

The second paragraph of "Ornament and Crime" begins with the association of child and Papuan as "amoral" ("to our eyes"). These primitives can be excused for smearing walls and tattooing skin, respectively, on account of this

natural amorality, this civilizational immaturity; if "modern man" does the same things, "he is either a criminal or a degenerate." Again, however excessive it may seem to us, this rhetoric is in keeping with a pervasive discourse of the time, in this case the discourse of "degeneration," in which the association not only of child and primitive, but also of criminal and deviant, was standard.[47] This discourse was developed in the 1870s by the Italian physican Cesare Lombroso, who argued that physical degeneration caused the immorality of criminal and insane alike. Loos might not have read Lombroso, but he would have known of his Hungarian follower, Max Nordau, whose long tirade *Degeneration* (1892), written in German, was in wide circulation at the time. In Paris in the 1880s, Nordau applied the social diagnostic developed by Lombroso to cultural manifestations, especially symbolist art and literature, the "decadence" of which appalled him. He associated this decadence with another vague diagnostic, "hysteria," and referred both to a third category, "neurasthenia," the nervous stress ascribed to modern life. This web of ideologies, held together with the thread of "degeneration," was spun throughout fin-de-siècle Europe, and many terms were caught in it (primitive, criminal, Jew, homosexual . . .), all seen as symptomatic of a degeneration that moved from the physical through the psychological to the moral. "That which nearly all degenerates lack," Nordau concluded, "is the sense of morality and of right and wrong."[48]

In two short paragraphs, then, Loos has crammed a biogenetic hypothesis regarding the individual and a sociogenetic hypothesis regarding all civilization. In the third paragraph he shifts, just as abruptly, from the pseudo-biological rhetoric of degeneration to the implicitly psychoanalytic language of regression.[49] His story of origins also takes a psychological turn, as he offers a third hypothesis, a psychogenetic one regarding art: "The urge to ornament one's face and everything within reach is the start of plastic art. It is the baby talk of painting. All art is erotic." The ideologies at work in the first two paragraphs were common coin at the time; this psychoanalytic notion was not yet current. Here, in effect, Loos grafts an old art-historical theory, that art is ornamental in origin, onto a new psychoanalytic proposition, that it is erotic in origin as well. The first

ornament was a simple cross, Loos asserts, which we might interpret as the primary mark of a vertical figure against a horizontal ground; however, with the egregious heterosexism that was also common coin, he interprets it as the primordial sign of the heterosexual act: "A horizontal dash: the prone woman. A vertical dash: the man penetrating her."[50] Like this first cross, according to Loos, all subsequent art is driven by "surplus energy" that demands release: "The man who created it felt the same urge as Beethoven; he was in the same heaven in which Beethoven created the Ninth Symphony." This statement is also psychoanalytic in implication: what separates "erotic symbols on the walls" from the Beethoven Ninth is the degree of sublimation in the two acts, a term that Loos does not use but often suggests. (Freud first employed the word around this time—in *Three Essays on the Theory of Sexuality* [1905]—but it remained vague throughout his work.)

What is at stake in this web of ideologies is the proper evolution of subject and society; for Loos they are at risk of reversal into regression and degeneration respectively. (In *Vers une architecture* [1923], Le Corbusier would propose a famous ultimatum: "Architecture or Revolution"; the implicit precedent in Loos is "Architecture or Devolution.") This double risk is why civilization must move ever further beyond its erotic-ornamental origins in smeared walls and tattooed skin—an imperative that Loos condenses in this infamous formula: "the evolution of culture is synonymous with the removal of ornament from utilitarian objects."[51] Here Loos caps his fantasy of sublimatory evolution with a vision of a utopian city, a new "Zion" whose streets will "glisten like white walls," with all smearing, tattooing, and other degenerate activity cleaned up: "Then fulfillment will be come."

However, once more in the voice of the prophet without honor in his own land, Loos complains that this vision was not only misunderstood but counteracted by "clerical gentlemen" for whom "mankind was to go on panting in slavery to ornament." The Church is not alone in this superstitious subjugation, Loos avers; in league with "the black albs," the State has abetted "the ornament disease" with "state funds." More than "retrograde" culturally, this support is wasteful economically. With reinforced concrete and metal construction, ornament

had become literally superfluous, no longer structural in any way.[52] In this sense, ornament *is* waste for Loos, "a waste of human labor, money, and material"; it adds to the first, drains the second, and ruins the third. Here he seems to accept the economic rationality of capitalist industry, and elsewhere Loos embraces its severing of the artistic and the utilitarian: "We are grateful to the nineteenth century," he writes in "The Superfluous" (also 1908), "for the magnificent accomplishment of having separated the arts and the crafts once and for all."[53] For Loos, this separation liberated art and craft alike, allowed each to develop autonomously; and, again, he both differs from predecessors like Morris and opposes contemporaries like Olbrich and Hoffmann primarily on this point: rather than deny the separation, Loos accepts it, even exploits it. Yet the rationality that he embraces is less economic than aesthetic; or rather, like some subsequent modernists (e.g. in the Bauhaus), he conflates the two—mistakes the look of the functional object for the logic of capitalist industry. Loos might not grasp this logic fully, for rather than proceed critically from the primacy of exchange value, he still hopes for the priority of use value, and in this regard he is back in line with Morris, Olbrich, and Hoffmann. Once again we see Loos caught between artisanal craft and capitalist industry, which is another reason why his critique of capitalism does not extend much beyond its kitschy effects.

Clearly "ornament" is an excessive signifier for Loos, a mobile placeholder for different objects of anxious contempt. We know that it represents the superfluous, the extrinsic, and the improper. In a reversal of expectations characteristic of his rhetoric, these associations render ornament not a refined thing but a primitive one that, in a modern context, becomes degenerate, even criminal—and this in two ways at least. However appropriate once, it is not so in a capitalist context, for reasons that are technological and economic, stylistic and social. Although its erotic origins might be forgiven, they are now surpassed, and so to pursue ornament in the present borders on the pornographic (hence the allusion to bathroom graffiti).

In "ornament," then, the modern and the primitive touch. This point is an ambivalent one for many modernists (as we will see again in chapter 3), but it is taboo for Loos, for he associates ornament not only with vulgar kitsch and

feminine fashion but also with fetishistic "slavery," that is, with an irrational sub-jugation to material things. Here, though born a Catholic, Loos thinks like a Protestant, for he implicates the Catholic Church in this "slavery to ornament." Discursively the figure that underlies this association of primitive subjugation and Catholic Church is the *fetish,* which was long seen in Protestant arguments as the emblematic instrument of superstitious enslavement. Elaborated from early reports regarding "trade" in Africa, first by Portuguese sailors, then by Dutch mer-chants, this term was used in the religious wars against the Catholics to signify a primitive investment of divine power or value in a mere thing (in the African context, "fetishes" were thus exempted from trade, often to the exasperation of the Europeans—hence the pejorative associations of the term in the first in-stance). The connection to superstitious enslavement was carried forward into the Enlightenment (as in the 1760 text *Du culte des dieux fétiches* by the French ju-rist Charles des Brosses), and it operates in this register in critical arguments from Kant and Hegel through Marx and Freud (one is mystified by the commodity fetish, compelled by the sexual fetish) and beyond.[54] Ornament is also a fetish for Loos (in "Architecture" he connects the two directly),[55] and one must be free of it in order to be enlightened: "We have fought our way through to freedom from ornament," he writes early in "Ornament and Crime"; and then again at its end: "Freedom from ornament is a sign of spiritual strength" (*OC* 19, 24).

As Loos intimates in his discussion of feminine fashion, fetishism is more than an irrational subjugation to material things; it is an unnatural perversion of sexual desire as well. (Perversion was discussed in these years as much as degen-eration, and the two were often associated: Richard Krafft-Ebing published his *Psychopathia sexualis* in 1892; Havelock Ellis his *Studies in the Psychology of Sex* in 1897; and Freud soon followed with his *Three Essays on the Theory of Sexuality* in 1905.) If propriety is the deepest stake for Loos and his fellow Viennese critics, then perversion is the greatest danger, and it is projected on the level not only of sexuality, as a deviation from natural sex to "eros," but also of language, as a de-viation from direct meaning to metaphor. In his pithy way Kraus captures the chiasmic relation between these registers, a relay that is also a reinforcement, a year after "Ornament and Crime": "In literature we call it a metaphor when

something 'is not used in its literal sense,'" he writes in *Sprüche und Widersprüche* (1909). "Metaphors are the perversities of speech and perversities the metaphors of love."[56] Understood in this way, perversion might be the central target of the Viennese critics in general, as it is more dangerous than mere superfluity. In Loos it appears on the manifest level of a deviation from a proper relation to material, function, and structure into ornament, but there are latent levels where it operates as well.

In all these respects—the general attack on ornament, the specific stress on economy, the pervasive disgust about perversion—this polemic is puritanical, which aligns it with contemporaneous critiques beyond Vienna. Some commentators have related it to the analysis of "conspicuous consumption" in *The Theory of the Leisure Class* (1899) by Thorstein Veblen; others to *The Protestant Ethic and the Spirit of Capitalism* by Max Weber (first published 1904–05). These texts also concern waste, and both a political-economic argument, as in Veblen, and a religious-cultural argument, as in Weber, are also in play in "Ornament and Crime," but neither argument motivates Loos primarily.[57] More fundamental is his aesthetic-ethical aversion to waste: "Throwing gold coins instead of stones," Loos remarks in a dandyish critique of dandyism, "lighting a cigarette with a banknote, pulverizing and drinking a pearl, create an unaesthetic effect" (*OC* 23). Yet another motivation drives the psychology of this essay (and others as well) more profoundly: if ornament is waste for Loos, it is not only financial or aesthetic waste; it is *excremental* waste.

"Ornament and Crime" was published in the same year as "Character and Anal Erotism," where Freud first writes of "the anal character," specifically of its "reaction-formation" against dirt and shit, which (as we saw in chapter 1) he regards as a fundament of "civilization."[58] In this respect alone Loos might qualify as an anal character, yet there are discursive connections as well. In a sense, Freud states directly what Loos implies indirectly: on the one hand, that *art* involves a sublimation of sexual energy, implicitly of anal eroticism (thus his story of the "surplus energy" in primitive and Beethoven alike); and, on the other, that *civilization* is founded in a renunciation of this sexuality supported by a reaction against anal eroticism.[59] A tension exists between these two principles or pro-

cesses, art and civilization, which might also bear on the strict separation in Loos between art and architecture, with architecture placed on the side of civilization—that is, on the side of renunciation and reaction.[60] ("Renunciation" refers to the civilized forgoing of sexual interests; however discontented, it is not as violent as "reaction," which is a conscious counter to an unconscious investment, in this case an investment in anal eroticism.) In defense of this speculation note, first, that anality was much discussed in psychoanalytic circles after the initial article by Freud—so much so that Kraus began to refer to analysts as "psychoanals."[61] Recall, too, that Musil dubbed Austria "Kakania," a scatological contraction of *kaiserlich-königlich* (imperial-royal) that evokes both a senile emperor and an infantile empire, as if Austria had become a kind of pre-Oedipal playpen, an excremental kindergarten. And remember, finally, the Schorske diagnosis of fin-de-siècle Vienna as steeped in a "crisis of the liberal ego," "a crisis of culture characterized by an ambiguous combination of collective oedipal revolt and narcissistic search for a new self."[62] Schorske has in mind the Art Nouveau aesthetes against whom Loos reacted, and clearly Loos saw the Secession as regressive too. In this way cultural regression was on the minds of many intellectuals in Vienna, and excremental indistinction on the minds of at least a few.

In the years between the Jubilee reviews and "Ornament and Crime," Freud was at work on his famous conception of infantile sexuality, as first formulated in *Three Essays.* Over the next decade he would posit three stages in which sexual energy or libido passes through three zones: the oral, the anal, and the phallic (at which point the child "knows only one genital: the male one"); the final stage, the genital proper, is not reached until later.[63] In "Character and Anal Erotism" Freud focuses on the anal character, and he refers its traits—"orderly, parsimonious, and obstinate"—to a reaction against the eroticism of this stage. Such reaction lies at the center of the anal character, but partial repression of anal eroticism is primary for every child, Freud suggests in a 1920 amendment to *Three Essays,* with a "decisive effect on his whole development."[64] For it is here that the child first encounters prohibition against pleasure (the periodic absence of the breast is qualitatively different from the persistent interdiction against messing),

with the result that "what is 'anal' remains the symbol of everything that is to be repudiated and excluded from life."[65] At the core of the anal character, this reaction is also at the root of civilization, for its manifestations, "shame, disgust and morality, . . . rise like dams to oppose the later activity of the sexual instincts."[66] Not only is the moral sense bound up with anal eroticism for Freud; so too, for early pychoanalysts, are artistic inclinations. Again, the moral is referred to a reactive renunciation of anal eroticism, the artistic to its ambiguous sublimation— that is, to a diversion of libidinal interest in excrement to a cultural manipulation of other materials that leads eventually to painting, sculpting, and so on.

While Freud focused on the first, moral aspect, the second, artistic aspect was treated by followers like Ernest Jones, Karl Abraham, and Ferenczi, for whom "aesthetics in general has its principal root in repressed anal erotism."[67] In "Anal-Erotic Character Traits" (1918), Jones locates a "primitive smearing impulse" as the basis of all "molding and manipulating," "painting and printing."[68] And in "The Ontogenesis of the Interest in Money" (1914) Ferenczi sketches a phylogenetic development of "copro-symbols"—whereby the child plays with excrement, then mud, sand, and pebbles in a sequence of ever more pure materials—that is almost Loosian in its implicit origin story of sculpture and architecture. Again in "Ornament and Crime" and elsewhere, Loos intimates both operations, reactive renunciation and ambiguous sublimation, but he privileges the first and associates architecture with it. Might this be the psychological difference that underlies his distinction between art and architecture? In "Architecture," Loos suggests as much: art is "private," "responsible to none," to do with comfort rather than with need, and it involves sublimation ("the purpose of art is to take man further and further, higher and higher, to make him more like God" [AL 108]); architecture is the opposite of art on all these counts, which seems to align it with the rigors of renunciation. According to Freud, the artist is released from much of the renunciation that the rest of us must accept; such is his psychological service to us—to express the fantasies that we must forgo.[69] Loos does allow art (thus defined) into his work, but only in his interiors. And here he has the architect (over)compensate for the artist, for if the artist performs

sublimation, especially in his lavish interiors, the architect practices—in a sense, *designs*—renunciation, especially in his austere exteriors. It is on this renunciation that his conceptions of proper architecture and proper subject converge most intensely.

After "Character and Anal Erotism," Freud complicates his notion of anal eroticism clinically in the two case studies concerning "the Rat Man" (1909) and "the Wolf Man" (1914/18), and theoretically in the essay "On the Transformations of Instinct as Exemplified in Anal Erotism" (1915/17), where he first posits an active-passive polarity in the anal stage. Freud refers this polarity to the very architecture of the anus: on the one hand to the musculature that actively controls the sphincter, on the other to the canal whose mucous membrane is passively stimulated. This difference allows him to distinguish between two sexual inclinations rooted in this stage: a "sadistic" one associated with control, and an "erotic" one associated with stimulation. As often in Freud, however, the relation between the two is less a strict opposition than an ambivalent relay; indeed, in his account ambivalence as such arises during the anal stage. Spurred by this line of inquiry, analysts like Jones and Abraham speculate on the psychosexual implications of this biphasic functioning of the sphincter alone. Abraham, for example, argues that anal sadism should be divided into two aspects: the first linked to evacuation and the drive to *destroy* the object; the second linked to retention and the drive to control the object, that is, to *preserve* it.[70]

As noted in chapter 1, psychoanalytic criticism tends to connect psyche and culture too directly, but Loos invites such connections, and makes several of his own. First, he devotes entire essays to plumbing and bathing, the very architecture of the "orderliness" and "cleanliness" that Freud deems fundamental to civilization. In an early article on "Plumbers" (July 17, 1898) that is only semi-ironic, Loos narrates civilization as a quest for hygiene, of which "the plumber is the pioneer" (*SV* 49); and in a later article on "Culture" (1908), he ranks different nations according to this same criterion, with Germanic culture urged to move away from the lax Latin model toward the fastidious Anglo-American example. Obsessed with purity, Loosian modernism might be seen as a reaction for-

mation against everything associated with the anal (on this score Le Corbusier is even more extreme).[71] Second, his modernism manifests an ambivalence of destructive and preservative impulses, especially regarding tradition, an ambivalence that, again, early analysts would not hesitate to relate to the anal. "If human work consists only of destruction," Loos once remarked, "it is truly human, natural, noble work"; and obviously this paradox of an avant-garde that destroys in order to preserve extends far beyond him.[72] Third, this ambivalence suggests that to react against the anal is also to be engaged with it, even to remain steeped in it; in this sense, too, it might be said (with apologies to Yeats on love) that Loosian architecture pitches its tent in the place of excrement. For Freud the proximity of the genital and the anal vexes the relation between the two, and he sees the separation between these stages as late and incomplete; as a result, the anal can be especially disruptive to the genital, the genital especially reactive to the anal.[73] "The pleasure in the clear object," Ferenczi asserts, "becomes a cover for satisfaction of the most primitive anal erotism"—a remark that suggests the secret pleasure to be had in renunciation in general, and bears on many pristine visions in modernism in particular: the new Zion of Loos, the "white cathedrals" of Le Corbusier, and so on.[74] In "Ornament and Crime," Loos positions the "white walls" of his new city in stark contrast to the smeared walls of the infantile primitive and the criminal degenerate; these walls stand as imaginary bulwarks against the primordial origin represented by the first and the present regression represented by the second.[75]

A fourth connection between Loos on ornament and Freud on excrement: both men narrate the progress of individual and civilization in an origin story that turns on the anal. In 1913, the year that Freud first posited an anal stage, he also introduced a German translation of a book titled *Scatologic Rites of All Nations* (1891) by an American soldier-turned-ethnographer named John G. Bourke. In his preface, Freud develops the phylo-sociogenetic fantasy that, first sketched in an 1897 letter to Wilhelm Fliess, is elaborated in *Civilization and Its Discontents* (1930). "Every child of man undergoes in his own individual development," Freud writes in 1913, "all those changes in the realm of the excremental which

the whole evolutionary history of man shows, and which probably originated when Homo Sapiens rose up from Mother Earth."[76] According to Freud, this speculation is supported by "the science of folklore" represented by Bourke: "It has arrived at the same results as psychoanalytic investigations. It shows us how imperfectly various peoples have succeeded in repressing their scatologic tendencies and how the treatment of the excremental functions on various levels of civilization approaches the infantile stage of human life."[77] For Freud, "changes in the realm of the excremental" are due to different levels of sublimation and repression, renunciation and reaction, and here he has at least two points in common with Loos: first, Loos invokes a related recapitulation in "Ornament and Crime," and, second, he also measures cultural levels vis-à-vis the excremental, with primitives and children placed at the bottom.[78]

In his preface Freud intimates a passage in civilization that each individual recapitulates, a passage that he will soon specify as a development through three stages to the proper genitality of adult life—a goal that, in his account, primitives only approach and children do not reach by definition. As we saw in chapter 1, this passage is doubled by another, not a development through the stages but an ascent through the senses. When man still walked on all fours, Freud speculates, smell was the most important sense, and excrement was not yet debased. However, when man became erect, vision became privileged, and the olfactory and the excremental degraded—indeed, repressed. The fullest version of this fantastic passage comes in two famous footnotes in *Civilization and Its Discontents,* which build on "Character and Anal Erotism" and other aforementioned texts. First as to the consequences of "erect posture":

> From that point the chain of events would have proceeded through the devaluation of olfactory stimuli and the isolation of the menstrual period to the time when visual stimuli were paramount and the genitals became visible, and thence to the continuity of sexual excitation, the founding of the family and so to the threshold of civilization. . . . With the assumption of an erect posture by man and with the depreciation of his sense of smell, it was not only his anal

erotism which threatened to fall a victim to organic repression, but
the whole of his sexuality, so that since this [moment], the sexual
function has been accompanied by a repugnance which cannot fur-
ther be accounted for, and which prevents its complete satisfaction
and forces it away from the sexual aim into sublimations and libidi-
nal displacements.

Then as to "the cultural trend towards cleanliness":

> The incitement to cleanliness originates in an urge to get rid of ex-
> creta, which have become disagreeable to the sense perceptions. We
> know that in the nursery things are different. The excreta arouse no
> disgust in children. They seem valuable to them as being a part of
> their own body which has come away from it. Here upbringing
> insists with special energy on hastening the course of development
> which lies ahead, and which should make the excreta worthless, dis-
> gusting, abhorrent and abominable. Such a reversal of values would
> scarcely be possible if the substances that are expelled from the body
> were not doomed by their strong smells to share the fate which
> overtook olfactory stimuli after man adopted the erect posture. Anal
> erotism, therefore, succumbs in the first instance to the "organic re-
> pression" which paved the way to civilization.[79]

However obliquely, Loos suggests both movements, a development
through the stages and an ascent through the senses, in his account of the proper
subject of civilization. Implicitly, in his allusions to the orality of the "cannibal"
and the anality of the "Papuan" in "Ornament and Crime," he associates pre-
Oedipal stages with the primitive in the manner of Freud (see chapter 1), but he
does so before Freud, or at least outside his obvious influence. Loos suggests an
ascent through the senses as well, and his own exteriors display an insistent super-
ficiality that privileges the visual. These abstract facades also seem to encode, as
Freud suggested of our "erect posture," a phallic disposition (Flügel argued the

same about the erect attire that Loos also favored); so, too, they appear to project a moral rectitude, a kind of architectural superego arrayed against all that is degenerate.[80] And in fact Loos insists that architecture produce iconographic "effects" that, as he describes them, underwrite social authority. Thus in "The Principle of Cladding" (1898) he urges effects of "fear and horror if it is a dungeon, reverence if it is a church, respect for the power of the state if a government palace, piety if a tomb, homeyness if a residence, gaiety if a tavern" (*SV* 66). A similar list is offered twelve years later in "Architecture," where Loos adds that the task of the architect is "to make those sentiments more precise" (*AL* 108). His credo, then, is not only "a place for everyone," but also "a sentiment for every place." But how does this insistence on traditional effects square with his rejection of ornamental semantics? Again, might the very abstraction of his architecture be a uniform that masks—both pronounces and conceals—such sentiments?[81]

Urn and Chamberpot

Exactly what does Loos react against—or, rather, what in anality repels him? The anal zone is ambiguous in another way that Freud does not fully explore. On the one hand, he intimates in *Civilization and Its Discontents,* excrement is the basest of all materials, presymbolic stuff "before" civilization. On the other, he argues in "On the Transformations of Instinct as Exemplified in Anal Erotism," excrement is the most charged of symbols, a wild sign that the infant might take as a penis, a baby, a gift, money, and so on, all terms that are "ill-distinguished" and "interchangeable" in the anal zone.[82] The anal-excremental, then, seems to oscillate between the physically literal and inert and the symbolically arbitrary and volatile—a difficult oscillation psychologically. Moreover, in either register the anal zone suggests an *indistinction* that is also difficult to bear. In "the anal universe," the psychoanalyst Janine Chasseguet-Smirgel has argued, "all differences are abolished," and "confusion and chaos prevail."[83] To regress to this zone is to be literally perverse, to turn away (*per-verse,* etymologically, is to turn away) not only from proper genitality but also from the paternal law, its symbolic order of differences, that depends on this genitality.[84] Loosian modernism "rises up like a

dam" to oppose this "anal universe," and to support that phallic order in all its so-
cial authority.

Thus behind the Loosian insistence on decorum might lie an anxiety
about indistinction, one that cuts across many levels—physical, material, and
stylistic, psychological, social, and historical.[85] Perhaps this anxiety is what is
most indecorous, most in need of correction; in any case, it prompts Loos to stark
oppositions that, however aggressive in rhetoric, remain defensive in purpose.
Underwritten by binaries of gender and sexuality, these oppositions are articu-
lated most strongly in terms of space (interior and exterior, private and public)
and practice (art and craft, art and industry, art and architecture).[86] Anything ap-
plied is misapplied; all mixing is impure by definition.

Perhaps this is why Art Nouveau is so dangerous to Loos—because it turns
indistinction into an aesthetic-ethic. For Loos this indistinction is a matter of
place (Art Nouveau is neither art nor architecture) as well as purpose (it exists
somewhere between the useless and the utilitarian). It occurs at the level of con-
tent too, as Art Nouveau is engulfed by its own motifs of vegetal imbrication and
aquatic submersion that suggest a regressive world without definition (even the
rectilinear ornament of the Werkstätte is potentially limitless).[87] This indistinc-
tion also exists at the level of technique; especially galling to Loos is that "the art
of building has been degraded by the [Art Nouveau] architect into a graphic art"
(*AL* 105). More is at stake here than a category mistake between building and
drawing: what Loos rejects in "the mediumistic language of line" in Art Nou-
veau is what its advocates relish—its "expression of personality," its writing of
subjectivity on the very surface of architecture.[88] Finally, Art Nouveau points to
the ultimate transgression of distinction, of the law of decorum, for, beyond all
these other mixings, Art Nouveau seeks a blurring of art and life, and it does so
through a will to total design that is also a will to total power of the architect.[89]

Loos attacks this aspect of Art Nouveau in 1900 in the form of another al-
legorical skit, "a story about a poor little rich man." This parvenu commissions
"a famous architect," a Secession designer like Olbrich or Hoffmann, to put "Art
in each and every thing" (fig. 2.5):

> Each room formed a symphony of colors, complete in itself. Walls, wall coverings, furniture, and materials were made to harmonize in the most artful ways. Each household item had its own specific place and was integrated with the others in the most wonderful combinations. The architect has forgotten nothing, absolutely nothing. Cigar ashtrays, cutlery, light switches—everything, everything was made by him. (*SV* 125)

The figure of totality here is music, specifically Wagnerian opera (the house also boasts "electric chimes" with "Beethoven and Wagner motifs," a parodic extreme of "art in the utilitarian object" that mocks the deification of these two composers by the Secession [*SV* 126]). Yet this *Gesamtkunstwerk* does more than conflate art and craft; it confuses subject and object: "the individuality of the owner was expressed in every ornament, every form, every nail" (*SV* 125). For the Art Nouveau designer, this is perfection: "You are complete!" he exults to the patron. But the poor little rich man is not so sure; such completion "taxed [his] brain" (*SV* 126). Here Art Nouveau is drawn into a web of associations around neurasthenia (just a step away from degeneration in "Ornament and Crime"); rather than a sanctuary from modern stress, the Art Nouveau interior is a symptom of it.[90]

> The happy man suddenly felt deeply, deeply unhappy. . . . He was precluded from all future living and striving, developing and desiring. He thought, this is what it means to learn to go about life with one's own corpse. Yes indeed. He is finished. *He is complete!* (*SV* 127)

For Art Nouveau designers, this completion reunites art and life, subject and object; for Loos, however, this triumphant overcoming of limits is a catastrophic loss of the same—the loss of the objective constraints required to define a proper subjecthood. Far from a transcendence of death, then, this loss of finitude is a death-in-life, as figured here in the ultimate trope of indistinction: to live "with one's own corpse."

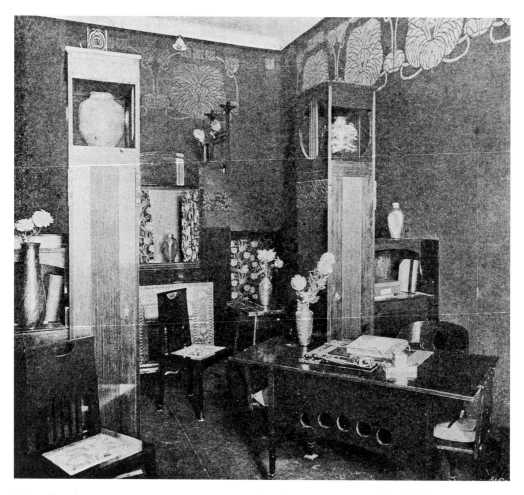

2.5. Josef Hoffmann, Art Nouveau study for an exhibition of the Vienna Secession, as published in *Kunst und Kunsthandwerk,* no. 2, 1899.

Such is the malaise of the poor little rich man. What he lacks, in his very completion, is difference or distinction. Ten years later, in a December 1912 statement in *Die Fackel,* Kraus called this lack of distinction, which precludes "all future living and striving," a lack of "running-room":

> Adolf Loos and I—he literally [*wörtlich*] and I linguistically [*sprach-lich*]—have done nothing more than show that there is a distinction between an urn and a chamber pot and that it is this distinction above all that provides culture with running-room [*Spielraum*]. The others, the positive ones [i.e. those who fail to make this distinction], are divided into those who use the urn as a chamber pot and those who use the chamber pot as an urn.[91]

This remark is as condensed as his comment about the perverse nature of metaphor. However, the referent of "those who use the urn as a chamber pot" seems clear enough: Kraus means those who want to infuse art (the urn) into the utilitarian object (the chamberpot)—that is, Art Nouveau designers like Olbrich and Hoffmann. The referent of those who do the reverse is more obscure, but Kraus probably means those who want to elevate the utilitarian object into art—figures such as Hermann Muthesius, the leader of the German Werkbund. In any case, the two travesties are symmetrical—both confuse use value and art value—and both are perverse for Kraus and Loos inasmuch as both risk an excremental indistinction. This is the specific point here; the general one is to underscore the need for objective limits that allow "the running-room" necessary to structure a proper subjecthood. This is why Loos opposes not only the total design of Art Nouveau but also its empathic subjectivism ("individuality expressed in every nail").[92]

In this regard, the allusion to tattooing in "Ornament and Crime" is less odd than it first appears. Art Nouveau line was sometimes described as tattooed, but there is more here too.[93] Alongside the analogy between dress and architecture, another is implied between face and facade. Again, for Loos this face must be a blank mask; to allude to Art Nouveau line as tattooing is thus to evoke a

barbaric defacement, an obscene expression (or inscription) that cannot be removed—the opposite of a uniform mask that is separate from what lies behind it, and so protective of it. In this way Art Nouveau violates the first rule of domestic architecture: that "the house does not have to tell anything to the exterior"; in Art Nouveau, on the contrary, "the house appears as the expression of personality."[94] Beyond an indiscretion of the private made public, the trope of tattooing suggests an awful turning outside of the inside (like excrement smeared on the walls), and this might be another reason why Loos insists on decorous objectivity.

Why, finally, are these relations of subject and object, interior and exterior, so important to him? When it is not "assessed by the extent to which its lavatory walls are smeared," culture can be judged, according to Loos, by its degree of "balance between the inner and outer being of man that alone guarantees rational thought and action" (*OC* 19; *AL* 104). This balance of subject and object is a central aim of bourgeois humanism (in Kant, of course, aesthetic judgment is one way to reconcile the divided realms of value and fact), but by the moment of "Ornament and Crime" this project was in deep trouble—philosophically, politically, socially. To take but one local indicator: also in 1908, Kraus published *Sittlichkeit und Kriminalität* (Morality and Criminality), a collection of texts from *Die Fackel,* the title essay of which addresses what Kraus sees as the great divide in Viennese life between private and public morals. Again, the bourgeois promise of sincerity and authenticity, of transparency between private and public, was broken, and Loos accepts this disconnection as a fait accompli. More, as noted above, he designs for this late-bourgeois arrangement of a private life secluded behind a public mask.

In the 1930s Theodor Adorno and Walter Benjamin detect a symbiosis between bourgeois interiors and bourgeois interiority—Adorno in his thesis on Kierkegaard, Benjamin in his notes on Baudelaire (in particular the 1935 exposé of the *The Arcades Project*).[95] Explicitly Benjamin correlates the emergence of the private citizen with that of private space—with its division between living and working, domestic and financial. In this new interior, he argues, outside interests, social as well as economic, were "repressed," and "from this [repression]

spring the phantasmagorias of the interior. For the private individual the private environment represents the universe. In it he gathers remote places and the past. His drawing room is a box in the world theater."[96] This first stage of the bourgeois interior appears to correspond to the historical eclecticism of the nineteenth century, to the first version of the bourgeois *posthistoire* condemned by Loos as a "Potemkin" deception. Abruptly, however, Benjamin shifts to a second stage, the further withdrawal of the bourgeois subject as exemplified in Art Nouveau:

> About the turn of the century the interior is shaken by Art Nouveau. Admittedly the latter, through its ideology, seems to bring with it the consummation of the interior—the transfiguration of the solitary soul appears its goal. Individualism is its theory. In [Henry] van de Velde the house appears as the expression of personality. Ornament is to this house what the signature is to a painting. The real meaning of Art Nouveau is not expressed in this ideology. It represents art's last attempt to escape from its ivory tower, which is besieged by technology. . . . About this time the real center of gravity of living space is transferred to the office. The derealized individual creates a place for himself in the private home. Art Nouveau is summed up by *The Master Builder* [of Henrik Ibsen]—the attempt by the individual to do battle with technology on the basis of his inwardness leads to his downfall.[97]

Here Benjamin sees Art Nouveau as a contradiction to work through dialectically: the "consummation" of the bourgeois interior is also its "shaking," the "inwardness" of the subject precipitates his "downfall," the "expression of personality" is one with its "derealization." Might Loos intuit this "shaking" in Art Nouveau, and strive to repair it in his own conception of architecture? Unlike Art Nouveau according to Benjamin, Loos does not attempt to reclaim technology for art; he leaves this task for architecture alone. Then he moves to shore up

the breached walls between public and private, office and home, exterior and interior, and to restore the illusion of interiority, the safety of withdrawal, which he works to protect through the masking of abstraction (no more "expression of personality"). However, Loos still regards this interiority as strong; indeed, he presents his masking, in architecture as well as in attire, as a *dampening* of an "individuality" that has become "immensely strong" (*OC* 24). Yet if it were strong, why would it need masking in the first place?

As Benjamin intimates, the strength of individuality is largely an illusion of interiority, or, more precisely, a compensatory construction in a modern world dominated by monopolies, bureaucracies, and mass politics in a way that has squeezed out "the running-room" of liberal individualism. "A world of qualities without a man has arisen," Musil writes in *The Man without Qualities,*

> of experiences without the person who experiences them, and it almost looks as though ideally private experience is a thing of the past, and that the friendly burden of personal responsibility is to dissolve into a system of formulas of possible meanings. Probably the dissolution of the anthropocentric point of view, which for such a long time considered man to be at the center of the universe but which has been fading for centuries, has finally arrived at the I itself.[98]

This is the world of Loos, too; and if Art Nouveau resists the dissolution of these "qualities," of refined senses and tastes, then Loos resists the dissolution of this "man," of the old individualist subject—a dissolution evoked by Musil. Yet what if the bourgeoisie masked the public face of this man in order to protect his private life, only to discover that there was no one left at home, no private being "immensely strong" in his "individuality" to protect? No face behind the mask, only the mask as the face? "It is hardly possible or necessary to live the right way any more," Ernst Bloch writes in the early 1930s. "The empty ego forms no shell any more to hide the one inside who is not home anyway."[99] The further irony here is that, when modernists like Mies move to expose this interiority, to produce

the modernist version of transparency, perhaps of sincerity and authenticity, there might be no one home to expose; all that might be declared is the triumph of technology.[100]

Loos does not (cannot?) see this historical possibility, for, again, he assumes the late-bourgeois arrangement of divided public and private spheres as given. But how, then, does he design for this divide? How does he acknowledge the split between interior and exterior? "From the first he designed from the inside out," Henry-Russell Hitchcock remarked long ago.[101] But to the extent that this is the case, Loos does so in a way that the exterior—usually a stark composition of various boxes cut by different windows—"does not express," as Massimo Cacciari had argued, for only this lack of expression can "safeguard the interior" as a private realm.[102] This divide between interior and exterior follows the split between private and public, yet frequently Loos complicates it as well. In his domestic architecture he reworks some private spaces in a quasi-public fashion, primarily through his *Raumplan* or spatial plan. This method works to open up space across levels of a house in a way that frees the plan somewhat from the plane, sometimes with diagonal vectors and/or spiraling paths that cut across rooms. The result is that the rooms are not so regimented by function, and private and public areas communicate with each other (fig. 2.6). In his domestic architecture, then, "social space" is sometimes "surrounded by private sub-spaces."[103] Conversely, in his commercial architecture, private sub-space is sometimes surrounded by social spaces; this is especially true of his cafés and bars, where such an arrangement is "proper" enough. Finally, in his mixed-use designs, these two kinds of space might be juxtaposed, with a distinctive propriety for both public and private areas. Consider his most notorious building, the eight-story Goldman & Salatsch Tailors & Outfitters on Michaelerplatz (1909–11; fig. 2.7): in keeping with the Viennese typology of bourgeois apartment buildings—homes above, offices below—the lower, commercial floors of this "Looshaus" are fronted with a Tuscan order faced in marble, as is proper for a public space, while the upper, residential floors are ornamentless, masked, as is proper for a private space. There is no attempt to resolve this public/private split; if anything is "expressed" here, it is this split.[104]

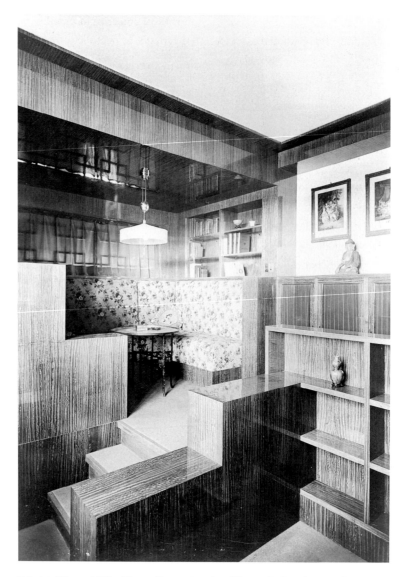

2.6. Adolf Loos, Müller House, Prague, interior *(Zimmer der Dame)*, 1930. © 2003
Artists Rights Society (ARS), New York/VBK, Vienna. Photo: Albertina, Vienna
(ALA 2474).

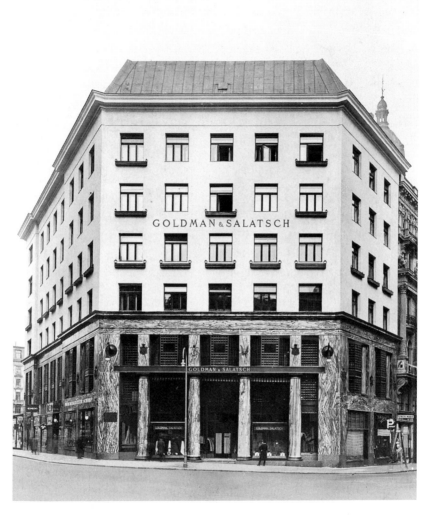

2.7. Adolf Loos, Goldman & Salatsch Building, Vienna, 1909–11. © 2003 Artists Rights Society (ARS), New York/VBK, Vienna. Photo: Albertina, Vienna (ALA 2408).

This split might help to clarify how Loos could be both embraced and rejected by avant-gardists like the Dadaist Tristan Tzara and the surrealist Salvador Dalí. In part the embrace is due to a misreading of Loos as an avant-gardist mocker of the fine arts ("Ornament and Crime" is still often received in this way).[105] Less difficult to understand is the rejection of Loos, but it is pertinent here, for it does underscore the superegoic aspect of his architecture. In 1933, the year of his death, both Tzara and Dalí published critical essays on modern architecture in the surrealist journal *Minotaure* that implicate Loos. "As hygienic and stripped of ornaments as it wants to appear, modern architecture has no chance of living," Tzara proclaims in "D'un certain automatisme du goût."[106] For Tzara such architecture survives only because it expresses the "transitory perversions" of the "bad conscience" produced by "capitalist oppression." But it cannot last long, for the same reason; moreover, this bad conscience produces a "self-punitive aggressivity" that is reflected in this architecture in its "complete denial of the dwelling place." According to Tzara, the ideal "dwelling place" is "the prenatal comfort" of the mother; and so, against the "aesthetics of castration called modern," he calls, outrageously enough, for an "architecture of the womb." Here he trumps Loosian rhetoric with his own phylogenetic story of architecture as an "envelope of a body" that develops from cave through yurt to hut.[107] In fact Tzara turns this rhetoric inside out when he substitutes, as an origin of such architecture, an intrauterine fantasy for the "castrative" reaction formation of Loos. Rather than a simple regression here, Tzara sees his "architecture of the womb" as "true progress, based on the potential of our strongest desires," which modern architecture has only "dispersed" and "weakened." Not Architecture or Devolution as with Loos, then, but a dialectic of progress through regression.

Dalí, for his part, critiques Loos indirectly, by way of a celebration of his old nemesis Art Nouveau. Supplanted by Loosian architecture, Art Nouveau had become outmoded by the late 1920s, and so a perfect polemical counter for Dalí. First, in a 1929 article titled "L'Âne pourri" (The Rotten Ass), he opposes the "aesthetics of castration called modern" with Art Nouveau, with its hysterical aesthetic of "solidified desires" and its "cruel automatism" of "infantile neurosis."[108] For surrealists like Dalí, hysteria was a subversive ideal; indeed, a primary

model for surrealist art was the hysterical production of symptoms understood as bodily expressions of conflicted desires. To underscore this celebratory connection with hysteria, Dalí places his 1933 article on Art Nouveau, "De la beauté terrifiante et comestible, de l'architecture Modern style," next to his *The Phenomenon of Ecstasy,* a montage of photographs of mostly ecstatic women and fetishistic ears (from a police typology of criminals) juxtaposed with an Art Nouveau ornament (fig. 2.8). As if to spite Loos directly, Dalí celebrates the mix of styles in Art Nouveau ornament as a phantasmagorical dream of historical metamorphosis ("the Gothic metamorphoses into the Hellenic, into the Far Eastern and . . . into the Renaissance).["][109] And, most outrageously, he celebrates what Loos dreaded in Art Nouveau above all else, its "flagrant ornamental coprophagy," its "blossoming of the sado-anal complex."[110]

Given this great antipathy, how are we to explain the fact that Loos moved in surrealist circles in Paris, and designed a house for Tzara in Montmartre in 1926–27 (fig. 2.9)? Perhaps Tzara detected in the Loosian opposition between severe exteriors and sensuous interiors an ambivalence between an ethics of renunciation and an aesthetic of regression. Certainly this sensuous side is pronounced in some Loos interiors—both early, as in his bedroom for his wife Lina, with its luscious sensuality (fig. 2.10), and late, as in his project house for jazz dancer and sexual icon Josephine Baker, in 1928, with its almost intrauterine interior (replete with pool) à la Tzara.[111] Given his taste for ornate materials, especially in the interiors, the architectural historian Harry Mallgrave has concluded that Loos "was, at heart, an ornamentalist."[112] This might be rephrased slightly: he was, in the hearth, an excrementalist; anal-retentive, he saved excremental ornament for the inside. Yet in the end the solution to the Loos-Tzara riddle might lie in the persistent oddness of the couple. "To encompass both Breton and Le Corbusier," Benjamin writes in *The Arcades Project,* "that would mean drawing the spirit of contemporary France like a bow, with which knowledge shoots the moment in the heart."[113] This is also true of Loos and Tzara, the prior pair in this particular dialectic of modernism. Perhaps, as Loosian architecture pitches its tent in place of excrement, so too the proper subject of Loos is mirrored by its improper double represented by Tzara.[114]

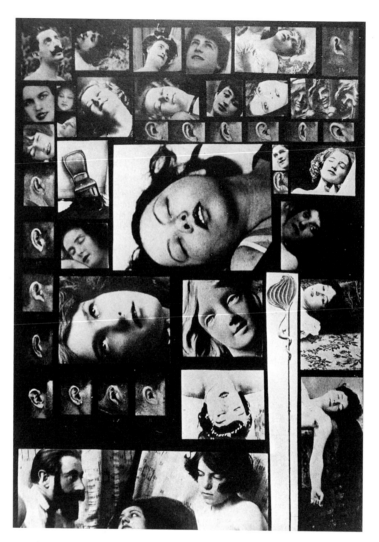

2.8. Salvador Dalí, *The Phenomenon of Ecstasy*, 1933. Photocollage, 11 × 7¼ in.
© 2003 Salvador Dalí, Gala-Salvador Dalí Foundation/Artists Rights Society
(ARS), New York.

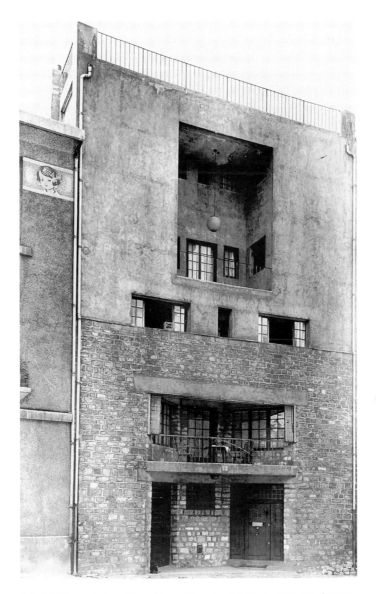

2.9. Adolf Loos, Tristan Tzara House (front facade), Paris, 1926–27. © 2003
Artists Rights Society (ARS), New York/VBK, Vienna. Photo: Albertina,
Vienna (ALA 2623).

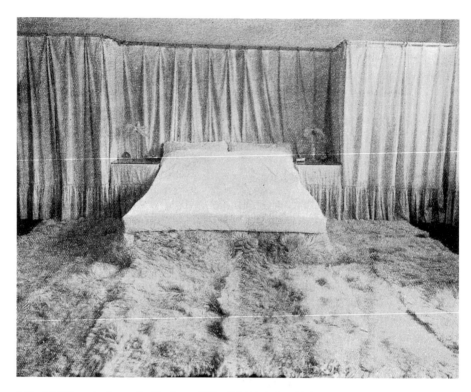

2.10. Adolf Loos, bedroom for Lina Loos, 1903. © 2003 Artists Rights Society (ARS), New York/
VBK, Vienna. Photo: Albertina, Vienna.

NO SUCH STRAGGLERS AND MARAUDERS

I want to conclude with two aspects of the proper subject advanced by Loos. I have mentioned the first, the demand for objective limits, which he finds in two traditions above all others: folk craft and (neo)classical architecture. This is most explicit in "Architecture" (1910), which begins as a folk story, with a positive origin myth of architecture that counters the negative one in "Ornament and Crime." Here the imaginary setting is a mountain lake, not a "Papuan" village or a degenerate prison cell (or bathroom), and it is respected by farmers and engineers alike, who work with what the land offers them, like an animal "guided by its instincts" (again, for Loos the engineer is also a natural creator of proper form). It is only the architect who "desecrates" the setting, because, "like almost every urban dweller, [he] has no culture [in this natural sense]. He lacks the certainty of the farmer, who possesses culture" (*AL* 104). At work here is another fundamental topos of Germanic thought of the time, the opposition of *Kultur* and *Zivilisation:* the farmer is grounded in culture, while the "urban dweller" is "uprooted" by civilization.[115] In fact the architect is its unfortunate epitome: "he who had the ability to build in any past style, he who had lost contact with his time, the one who was uprooted and remolded, he became the dominant man, he was the architect" (*AL* 105).

For those not rooted in folk culture, another type of grounding can be found in (neo)classical architecture. Beyond "his classical predilection for cubic form,"[116] Loos views the classical tradition as a "common thought," a transhistorical legacy, resistant to regression, that offers an ideal for individual and society alike: "The level of culture that mankind attained in classical antiquity can no longer simply be eradicated from man's mind. Classical antiquity was and is the mother of all subsequent periods of culture." Here Loos elaborates the classical as the *neo*classical, as the Roman reception of the Greek; in "Architecture" he explicitly states his preference for Rome: "We have inherited our social conscience and the discipline of our souls from the Romans" (*AL* 108). Loos admires the Romans because they "adapted" and "administered" more than "invented"—that is, because they were dedicated to tradition understood (almost etymologically) as

a rigorous passing down. "One common thought has unified all great architects. They think: the way I build is the same as the way the Romans would have built" (*AL* 108). This "common thought" was dispersed by the historical pastiche of the nineteenth century. "I, therefore, had to begin again at that point where the chain of development had been broken" (*AL* 107); and Loos specifies the bourgeois neoclassicism of Karl Schinkel as the point of departure to renew. Above all, Loos seeks a combination of these two traditions of folk craft and (neo) classical architecture, and he finds the commonality in the fact that both are objective in technique and collective in reception.[117] Again, he imagines this combination in his own person(a), his ego ideal as "a stonemason who has learned Latin," but he also proposes it in his architecture, which often combines classical clarity with rustic comfort. For Loos, this modern recovery of a craft classicism ("the English and the engineers are our Greeks" [*SV* 35]) is the way out of the historicist eclecticism of the nineteenth century.

But into what exactly? The subtitle of his 1903 journal *The Other,* "A Paper for the Introduction of Western Culture into Austria," is a caustic clue, for Loos regards the project of this culture as incomplete, especially in his homeland. This leads to my second point about his proper subject. Formed philosophically by the century that he disdains stylistically, Loos views history on the model of the individual: history is a subject writ large. In this way his grand narrative not only foreshadows the Freudian formula of sublimation and renunciation, but also assumes the Hegelian march of *Geist* through time: early and late, Loos writes of "The Spirit of the world" (*AL* 108), "the march of civilization" (*SV* 102), "the modern Spirit" (*SV* 94), and so forth. On this view, the *Kunstwollen* of each period is a stage in the life of the historical spirit or subject, and it must emerge and develop clearly and cleanly, so that it might assume its proper position in world history. For Loos the purpose of the modern *Kunstwollen* is the formation of a proper subject rooted in folk culture, guided by (neo)classical tradition, driven by an ethos of practicality. In order for this *Kunstwollen* to be coherent as such, its subjects must be proper to it, ideally aligned with its style and spirit. (Incidentally, this is the gravest charge against ornament: that it is superfluous not only materially but spiritually—superfluous to the modern *Kunstwollen*.)[118] In this

way, the notion of *Kunstwollen* is a form of decorum on a world-historical scale ("is the tasseled robe not appropriate to the Gothic style and the wig to the Baroque?"): it demands a "correspondence" in all things—style, culture, class, period. For Loos this propriety, lost in the nineteenth century, must be restored in the twentieth, for, finally, the danger of historical pastiche lies in its schizophrenic effects: it threatens the very coherence of the subject of history—and of each (architectural) period as a mini-subject.

Strange to say, there might be a historical propriety in the very concept of modernism too: the rallying cry of Rimbaud—*Il faut être absolument moderne*—can also be heard as a marching order to get in line with the time.[119] Loos is most stringent in this regard, perhaps because of his either-or sense of temporality (Architecture or Devolution), perhaps too because of the bad dream of historical eclecticism that his Vienna seemed to slumber in. In any case, his proper subject—his proper architecture, style, culture—is ideally singular in time and place. It denies the nonsynchronous in style and, far worse, in people: "The stragglers slow down the cultural evolution of the nations and of mankind," he writes in "Ornament and Crime." This is also to say that it denies the multicultural: the classical folk presumed to be unitary are to hold out against "the marauders." "Happy the land that has no such stragglers and marauders. Happy America!" (*OC* 21). (This is an odd vision of America, but it is projected from an Austria perceived to be "an ungovernable mélange.")[120]

A final comment: In "Architecture" Loos makes a connection between art and architecture that is only slightly less famous than his association of ornament and crime. Although most of the text works to separate art and architecture, Loos marks two points where they converge, two exceptions that prove the rule of distinction: "Only a very small part of architecture belongs to art: the tomb [*Grabmal*] and the monument [*Denkmal*]. Everything else that fulfils a function is to be excluded from the domain of art" (*AL* 108). As for the monument, Loos wants architecture to partake of the mnemonic dimension of traditional art (as in commemorative sculpture), but obviously by means of classical form rather than historical ornament. As for the tomb, it seems more proper to architecture in any case; indeed, in the literal origin myth suggested in this parable, the grave is

2.11. Adolf Loos, mausoleum for Max Dvořák (model), 1921. © 2003 Artists Rights Society (ARS), New York/VBK, Vienna. Photo: Albertina, Vienna (ALA 2784).

architecture at its most primordial: "When we come across a mound in the wood, six feet long and three feet wide, raised to a pyramidal form by means of a spade, we become serious and something in us says: somebody lies buried here. *This is architecture*" (AL 108; original emphasis). At the same time, according to his own definition of the tomb, it is also art. In fact the tomb seems to override the distinction between urn and chamberpot, art value and use value; in a sense, it is a chamberpot turned into an urn, a mound of earth sublimated into classical form; it is excremental matter redeemed by architectural art (fig. 2.11).[121]

However, at least nominally, Loos chooses to reserve the primary drawing of this ultimate limit of death, this final line of distinction, for architecture. In any case, no art or architecture—no civilization—exists without this marking, without the recognition of death in burial, burning, or some other ritual of passing. It is a primary marker of civilization, understood as such from prehistory through antiquity to the present. That mound marks civilization from wilderness; without it there is only a no-man's-land of indistinction.[122] Together the monument and the tomb, memory and memorialization, comprise tradition as authority, which architecture, for Loos, is to convey. Without this limit of the tomb-monument, of life defined by death, there is only living with one's corpse, death-in-life. *Et in architectura ego:* this (neo)classical ego is the ultimate proper subject in Loos.

3.1. "The 'image of God' with a gas mask," from Ernst Friedrich, *War against War!* (1924; Seattle: Real Comet Press, 1987).

3

PROSTHETIC GODS

In the first decades of the twentieth century, the human body and the industrial
machine were still seen as alien to one another, despite the gradual spread of
Taylorist and Fordist techniques of labor that integrated the two as never be-
fore.[1] Thus opposed, the two could only conjoin ecstatically or torturously, and
the machine could only be a "magnificent" extension of the body or a "troubled"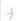
constriction of it, as Freud suggested in a famous passage in *Civilization and Its
Discontents* (1930) (fig. 3.1).[2] Even with the new machines of transportation and
representation of the Second Industrial Revolution, such as automobiles, air-
planes, radio, and film, technology was still often regarded as a demonic sup-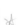
plement, an addition to the body that threatened a subtraction from it.[3] After
Marshall McLuhan, I will call this paradoxical view of technology as both ex-
tension and constriction of the body the double logic of the prosthesis.[4] To-
day, this view might strike us as almost quaint, and certainly the body and the
machine are no longer seen as so discrete. Yet this double logic governed the
machinic imaginary of high modernism in the first decades of the twentieth
century—underwrote its utopias of the body extended, even subsumed in new
technologies, as well as its dystopias of the body reduced, even dismembered by
them. In this way, this logic also circumscribed the cultural politics of the ma-
chine: for the most part, modernists of this time could only hope to resist new

technologies in the name of some given natural body, or to accelerate them in the search for some imagined postnatural body. More complementary than opposite, this restrictive advocacy of resistance or acceleration was as pronounced in modernist art as it was in critical theory, and it marks a structural limitation of both formations.[5]

After the mass deaths of World War I, a truly industrial war, the first position of resistance in the name of a natural body became difficult to hold. Even before the war this difficulty is evident in expressionism, which, even as it insisted on a natural body, also seemed to register the strain of this ideal in its very distortions of that body. Immediately after the war, affirmations of a natural body were mostly therapeutic or compensatory, and they did not last long, as instanced by the brief attempt of the early Bauhaus to restore an integrated body through craft practice. Thereafter the period was dominated by two tendencies above all. On the one hand, there were various returns to the figure, some neoclassical in spirit, that can be read in part as reactions against the mutilated bodies of World War I as well as the fragmented figures of high-modernist art (cubist above all).[6] On the other hand, there were various machinic modernisms, most constructivist in spirit, that can be seen in part as attempts to make over this body-ego image damaged in reality and representation alike. If the first, neoclassical reaction proffered the nostalgic fiction of an intact body, a "Return to Order," especially in Western Europe (fig. 3.2), the second, machinic reaction looked to the very mechanization of the modern body for a new principle of physical being, a "New Man," especially in revolutionary Russia (fig. 3.3). Perhaps in the end the first reaction was no more humanist than the second, for *both* tended to treat the body as if it were already dead: a kind of statue in the first instance, a kind of mechanism in the second.[7]

Many machinic modernisms made a fetish of technology: they treated it apart from the mode of production and turned it into a subject of art, and in this way it became a force in its own right, an agent of *l'esprit moderne* (as Le Corbusier and others termed it). This fetishistic occlusion of the socioeconomic bases of technology occurred wherever a machinic style was held out as the lure of a technological future to which people were asked (or compelled) to consent. In other

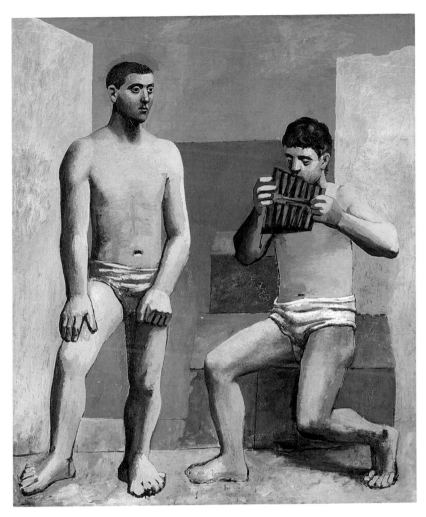

3.2. Pablo Picasso, *The Pipes of Pan,* 1923. Oil on canvas, 80¾ × 68½ in. Musée Picasso, Paris.
© 2003 Estate of Pablo Picasso/Artists Rights Society (ARS), New York. Photo: Réunion
des Musées Nationaux/Art Resource, New York; photo by J. G. Berizzi.

3.3. El Lissitzky, *The New,* 1920–21. Color lithograph, 15 × 10½ in. Philadelphia Museum of Art: Gift of Dr. George J. Roth. Accession: 1953-23-10. © 2003 Artists Rights Society (ARS), New York/VG Bild-Kunst, Bonn. Photo: Philadelphia Museum of Art; photo by Lynn Rosenthal.

words, it occurred in different ways in futurism in Italy, vorticism in England, purism in France, precisionism in the United States, Neue Sachlichkeit in Germany, and constructivism in Russia and elsewhere.[8] In the capitalist West the beautiful image of the machine might distract people from the grim reality of industrialization, while in the communist East the heroic representation of production might compensate them for the even grimmer lack of productivity (the early Soviet Union was more advanced in the representation of industry than in its implementation).

Of course there were also critiques of technology in high modernism, especially in Dada and surrealism, but these critiques tended to complement the celebrations. In this way the primary modernist positions on technology can be mapped schematically according to the double logic of the prosthesis. Thus constructivism, for example, mostly projected technology, in a communist system of relations, as an *extension* of the body, and it did so in at least two ways: as a transformation of physical sense (László Moholy-Nagy called constructivism a "socialism of vision") and as a transcendence of bourgeois individualism (he also termed it "the common property of all men"), all under the aegis of the artist-as-engineer, the new machinic man par excellence.[9] The critical counterpart of this position was Dada, especially the Cologne version of Max Ernst, which mostly mocked technology, set in a capitalist system of relations, as a *constriction* of the body. With caustic irony, this version of Dada figured the new technological subject in terms of physical breakdown and psychic regression: in lieu of the paragon of the communist engineer, it offered the parody of the capitalist man-machine as autistic (as in the early collages of Ernst discussed in chapter 4).

Other complements on the question of technology include the Bauhaus and surrealism (I mean the Bauhaus after its partial turn to constructivist principles following the appointment of Moholy-Nagy in 1923). Like constructivism, the Bauhaus presented technology as an extension of the body, but in the context of an attempted rapprochement with capitalist industry. Thus, even as it, too, worked to transform the physical senses and to subsume bourgeois individualism, it did so in a context that mostly abetted the capitalist rationalization of bodies and psyches alike. In this regard, surrealism not only countered the

Bauhaus with a presentation of technology as a constriction of the body, but also exposed this capitalist rationalization as often irrational in its effects.[10] However, rather than image this irrationality as a regressive breakdown of the body à la Dada, surrealism figured it, with broken automatons and fragmented mannequins, in terms of a castrative dismemberment (as in the dolls of Hans Bellmer discussed in chapter 6). In doing so, it disclosed the psychic underpinnings of the double logic of the technological prosthesis that governed the machinic imaginary of high modernism: the machine as a castrative trauma *and* as a phallic shield against such trauma. It is this fetishistic logic that I want to trace in the early writings of the futurist F. T. Marinetti and the vorticist Wyndham Lewis, two competitors in the European avant-garde, two complements in machinic fantasies in the period of World War I.

Marinetti was an early collaborator of Mussolini, and Lewis a sometime admirer of Hitler. Yet the desire to embrace technology, to accelerate its transformation of bodies and psyches, is hardly bound to reactionary modernists or to the cultural politics of the right.[11] At different times such figures as Antonio Gramsci, Siegfried Kracauer, and Walter Benjamin also advocated this embrace, in a "left-Fordist" position that can hardly be confused with the political posture of Marinetti or Lewis. The fundamental difference here is between a primarily Marxist project to *overcome* technological self-alienation dialectically and a potentially fascist desire to *elevate* this self-alienation into an absolute value of its own. The latter is a form of ego ecstasy (this is how Benjamin understood the technological sublime in Marinetti: self-destruction imagined as "an aesthetic pleasure of the first order") and/or a form of ego armoring (this is the gist of "the new egos" proposed by Lewis before the war).[12] Nevertheless, both positions, left and right, have one thing in common: they all appear to be haunted by the specter of the damaged body of the worker-soldier. The same is true of the interwar critique of technology in the dysfunctional male figures of Dada and the dismembered female figures of surrealism (the former sometimes evokes this damaged body almost directly).[13]

Here I will focus on the wartime models of the new technological subject in Marinetti and Lewis. Marinetti works on the first part of the preparation of

this subject—to explode the old bourgeois idea of a nontechnological subject (fig. 3.4)—while Lewis plies the second part—to imagine a new ego that can withstand the shocks of the military-industrial, the modern-urban, and the mass-political, indeed, that can forge these stimuli into a new protective shield, convert them into a new hardened subject able to *thrive* on such shocks (fig. 3.5).[14] In the same period, Freud used the terms "binding" *(Bindung)* and "unbinding" *(Entbindung)* to describe the different states of instinctual energy in the human subject: bound, submitted to control, or unbound, open to discharge. In his account of the individual, the first object of binding is the ego, which in turn becomes the primary agent of further binding. If the ego is breached in situations of shock, the process of integration is threatened: hence the imperative to shield the ego before its breaching, or to shore it up afterwards. It is largely in relation to such shock, real and fantasmatic, experienced and imagined, that Marinetti and Lewis develop their early models of art and subjectivity. But binding and unbinding not only concern the ego understood as an energistic entity under pressure from within and without; they also bear on the ego understood as a bodily image whose inside and outside are always in doubt. For Freud the ego is "first and foremost a bodily ego . . . a projection of a surface"; the subject is founded in this projection, in an identification with this body image.[15] Lacan pushes this account further: as this bodily image is external, it is seen as somehow other, and an identification with it is also an alienation from it. This alienation prompts a kind of aggressivity, which is the "the correlative tendency" of the narcissistic founding of the ego. On the one hand, the ego is constituted in part as armoring (Lacan uses this term in "The Mirror Stage"); on the other, it is driven in part by aggressivity.[16]

Armoring and aggressivity are thus in tension vis-à-vis the bodily ego, as are binding and unbinding vis-à-vis instinctual energy, and these tensions also seem to operate in early models of art and subjectivity proposed by Marinetti and Lewis.[17] Again, Lewis tends to advocate armoring: "Deadness is the first condition of art," the eponymous protagonist of his first novel, *Tarr* (1914/18), states. "The armored hide of the hippopotamus, the shell of the tortoise, feathers and machinery. . . ."[18] For his part, Marinetti "exalts aggressive action," most famously

3.4. Filippo Tommaso Marinetti, *Parole in libertà (Irredentismo)*, c. 1915. Ink and collage on paper, 8½ × 17⅞ in. © 2003 Artists Rights Society (ARS), New York/SIAE, Rome.

3.5. Wyndham Lewis, *Self-Portrait as Tyro,* 1920–21. Oil on canvas, 29⅞ ×
10⅞ in. Ferenz Art Gallery, Hull City Museums and Art Galleries, UK.
© Wyndham Lewis and the estate of Mrs. G. A. Wyndham Lewis by kind
permission of the Wyndham Lewis Memorial Trust.

in "The Founding and Manifesto of Futurism" (1909).[19] Lewis seeks to bind energy and ego, often in paranoid terms: "I resist the process of melting," he writes in *Blasting and Bombardiering* (1937). "It's myself I want to conserve" (*BB* 15). Marinetti celebrates unbinding, usually in ecstatic terms: "Art," he states in "Technical Manifesto of Futurist Literature" (1912), "is the need to destroy and scatter oneself" (*M* 89). For both men this tension between binding and unbinding is often figured in the machine: it attracts them not for its utilitarian and productive possibilities but for its imagistic and energistic qualities—and perhaps because it can image both the dynamism of the drives and the aggressivity of the ego.[20]

SURPRISING ORGANS

Marinetti published the first manifesto of futurism in Paris in 1909, at the age of thirty-three. Like several origin myths in high modernism, this one is structured as a rebirth: it opens with a small group of young men in a claustrophobic interior in bourgeois Milan, who, once roused to the futurist call, forsake this metaphorical womb for an actual automobile. As a bursting forth, this rebirth is also a death: "I stretched out on my car," Marinetti exclaims, "like a corpse on its bier" (*M* 40). But it is a death necessary to rebirth as a technological subject: the futurists emerge in "the very first dawn" as modern "centaurs," half men, half machines (*M* 40).

This blurring of birth and death in the conjoining of man and machine is typical of Marinetti. In the first manifesto it recurs in the baptism of the car crash that concludes the joy ride:

> Oh! Maternal ditch, almost full of muddy water! Fair factory drain!
> I gulped down your nourishing sludge; and I remembered the blessed
> black breast of my Sudanese nurse. . . . When I came up—torn, filthy, and stinking—from under the capsized car, I felt the white-hot
> iron of joy deliciously pass through my heart! (*M* 40–41)

This baptism evokes the conventional moment in legends of heroes and artists when a new identity is bestowed.[21] Here the baptism is industrial, the new identity technological, but the metaphor of rebirth remains. In a sense this is a fantasy of cloacal rebirth (maternal ditch, muddy water), a fantasy that Freud associates with the anal stage, and it serves Marinetti in several ways.[22] At the level of the unconscious it allows his man-machine conjunction to appear as a return to a pre-Oedipal state—that is, as a release from all (sexual) difference, from any division or lack; and this vision is further supported by his memory of "the blessed black breast of [his] Sudanese nurse." Here his technological fantasy of origin is doubled by a primitivist fantasy, a combination frequent enough in high modernism (as we saw in chapter 1). And this double release from lack permits the result of this conjunction, his new technological self, to be imagined as purely phallic, "a white-hot iron of joy."[23] It is a self, moreover, that Marinetti both creates and embodies (again, per the Freudian principle of cloacal birth: "if babies are born through the anus then a man can give birth just as well as a woman").[24] Torn and filthy when plunged into the maternal ditch, he emerges from it whole and clean, a technological phallus free of human castration. This is the psychic reward of this technological rite of passage, and the theme recurs often in his writings.[25]

We know that the futurists celebrated speed above all else. But in Marinetti here speed means more than new machines of movement, more even than a new sensorium effected by the Second Industrial Revolution: it is also a psychic figure, a trope of time travel, of the clock turned back in order to re-create the self. Hence his plunge into the ditch is also a plunge into the past; more, it is a primal scene that allows Marinetti to reimagine his own conception, which he does through a family romance in which he is his own progenitor. This autogenetic fantasy is thus "an end-run around Oedipus," for it positions Marinetti as father, mother, and sacrificial son in one.[26] This desire is finally not so much incestuous as it is phallic: to become as perfect and dynamic as he imagines the phallus to be. Only the machine can produce this phallus for him, can produce it *as* him—or so Marinetti believes. And in his texts, mere humans do tend to drop out in favor of glorious machines: the intercourse he desires is with cars, planes,

ships, trains—any machine of transport in which he can imagine his body-psyche reforged phallicly.[27]

Marinetti thinks this "redoubling" in two related ways. I noted his fantasy of self-birth, of autogenesis, but he is also obsessed with the related fantasy of "a mechanical son, the fruit of pure will" (*M* 75).[28] This fantasy of technological procreation is active in other machinic modernisms too (Fernand Léger, for one, is prone to it), and, as we will see in chapter 4, it is mocked as such in the "bachelor machines" of Dada (e.g. *Self-Constructed Little Machine* by Ernst [c. 1920; fig. 4.2]). Yet the fantasy is most extreme in movements like futurism that aspire to technologize nature and to naturalize technology.[29] In this crossing, the human and the natural only appear to be reconciled; in fact they are forced together in a technological hybrid that confuses the creative and the destructive. Witness this vision of a landscape, typical of Marinetti, as a body that is at once exalted and violated technologically: "Multicolored billboards on the green of the fields, iron bridges that chain the hills together, surgical trains that pierce the blue belly of the mountains, enormous turbine pipes, new muscles of the earth, may you be praised by the Futurist poets" (*M* 67–68).

Even more than creative or destructive, technology is phallic for Marinetti, and desire for phallic power governs not only his machinic fantasies but his misogynous outbursts as well. This misogyny is more fundamental than either the absence of women in futurism or its attacks on feminism and femininity alike. Perhaps at the psychic level Marinetti resents woman because of his desire to be not only self-born but self-born as the phallus—for, at least according to Lacan, the phallus is represented not by man but by woman.[30] In "The Meaning of the Phallus" (1958), Lacan defines sexual difference in terms of "having" or "being" the phallus, though he notes that as a signifier it cannot be possessed or embodied as such. Hence for Lacan the heterosexual "comedy" wherein men perform "an 'appearing' which gets substituted for the 'having,'" and women attempt to mask their "lack."[31] In this charade of sexual difference, masculinity is a display just as much as femininity is a masquerade, but men are more fraudulent than women because men pretend to have the phallus while women are under no such pretense (though they are asked—that is, compelled—to support men in their

performance). So it is, according to Lacan, that most men compensate for the lack of the phallus with a show of virility. Yet here, too, there is a catch, for display is conventionally regarded as feminine as well, and so the very show of virility might feminize men further: that is, it might make them appear theatrical in a way that is conventionally associated with women. Such a conundrum seems to be in play in early writings by Marinetti. First, he desires to be self-born, but this desire threatens to feminize him as a creator, as does his desire to become the phallus. Then his very show of virility, precisely as a show, feminizes him all the more, and indeed Marinetti was often seen as histrionic, if not hysterical, in his performances around Europe—again in a manner conventionally deemed feminine. Might this conundrum have compounded his anxiety, heightened his desire to change his body—to transform it altogether in a machinic conjunction?[32] In any case, his very attempt to override sexual difference is often played out, hyperbolically, according to its traditional terms.

These related fantasies—to be self-born and to become a machine-phallus—also influence his thinking on avant-garde art and literature, which Marinetti understands, in modernist fashion, as a transformation of both signification and subjectivity. In order to prepare for the new ego, the old bourgeois subject must first be destroyed: hence his persistent attacks, both polemical and poetic, on subjectivity understood as interiority (as we will see, Lewis launches similar attacks). "Destroy the I in literature," Marinetti exclaims in "Technical Manifesto of Futurist Literature" (1912), "that is, all psychology" (*M* 87). Again and again he calls on futurist art and writing to remake bodies and psyches in keeping with new technologies: in "Technical Manifesto" he enlists the flight of an airplane to attack "the old shackles of logic" (*M* 84); in "Geometric and Mechanical Splendor and the Numerical Sensibility" (1914) the pitching of a ship bridge is said to rebuff traditional "human psychology" (*M* 97); and in "Tactilism" (1924) an artillery battery is taken as the inspiration of his "tactile art" (*M* 109). In all these ways, Marinetti poses technological shock against "the old syntax" of the bourgeois subject—its culture, experience, and sense.[33]

This attack is the crux of his poetic texts as well, especially his *parole in libertà* or words-in-freedom (fig. 3.4). Often, in these works, word and image fly

apart: the text is released into the tactility of nonsensical sounds and energistic gestures, and the syntax of the old subject is scattered. Frequently Marinetti resorts to onomatopoeia as a way almost to reforge language physically, as so much matter or force; this is to remotivate language fundamentally, to make it almost primordially mimetic. (In this respect, these experiments differ radically from superficially similar ones in Russian futurism and German Dada that foreground the arbitrary nature of language.) Such physicalizing is also a strong clue to the new futurist subject to be constructed. In a text on declamation (1916), Marinetti calls on futurists to "dehumanize" the voice and to "metallize" the face, to render the body as anonymous as "semaphores" and as geometric as "pistons" (*M* 144). And in "Multiplied Man and the Reign of the Machine," a section of *War, the World's Only Hygiene* (1911–15), he images this "bodily development" as a metamorphosis of an aviator into an airplane, with the breastbone extruded "in the form of a prow" (*M* 91). At times Marinetti thinks this technological transformation in terms of "pure will," at other times in terms of the "transformational hypothesis" of the French biologist Jean-Baptiste Lamarck (1744–1829), according to which one generation inherits the evolutionary alternatives of the body developed by the generations before it (*M* 75, 91). For Marinetti the futurist subject must accelerate this process, speed this evolution, for only then might man "be endowed with surprising organs: organs adapted to the needs of a world of ceaseless shocks" (*M* 91).

Here Marinetti almost anticipates the Freudian hypothesis, also influenced by Lamarck, that each organism evolves a "protective shield" (*Reizschutz*) out of stimuli from the world.[34] In this hypothesis (which is also pertinent to Lewis), the shield develops as the surface of the organism hardens into inorganicity under the force of these stimuli, and it does so in order that the central nervous system at its core might survive. "*Protection against* stimuli," Freud writes in *Beyond the Pleasure Principle* (1920), "is an almost more important function for the living organism than *reception of* stimuli" (*BPP* 21; original emphasis). For the human organism in the military-industrial epoch of capitalism, Marinetti implies, this process has hypertrophied: the extruded shield has become a technological organ that (*pace* Freud) has indeed "grown on to him," and the stimuli of the world are

so many shocks pure and simple.[35] In effect, modern technology has transformed the dialectic of shield and stimulus-shock, collapsed it in such a way that the human organism now requires technology as *both* shield and stimulus-shock—and needs ever more of the shield because it needs ever more of the stimulus-shock. As with the double logic of technology as both extension and constriction of the body, this dialectic thus becomes a kind of deadlock. Yet the power of this techno-biological addiction is also clear, and Marinetti celebrates it. The futurists "lust for danger"; "our nerves demand war" (*M* 67, 46). And then, almost as an afterthought regarding the figure that represents the *un*shielded for this subject, he adds: "Our nerves demand war and despise women."[36]

In this intimation of a dialectic of shield and stimulus-shock, Marinetti almost anticipates the greater hypothesis of *Beyond the Pleasure Principle* that the fundamental drive of the organism is to return to its prior state of inanimation, to the inorganicity of death. As we have seen, Marinetti was fascinated by the breaching of the body ego. Again, for Freud the response to this breaching is a binding of the body ego, a binding that develops through repetition; but this repetition cannot be easily controlled: it might conduce to a becoming-inorganic not only of the protective shield but of the entire being—at least to the degree that it is gripped by the death drive. In his double move to reify the body and to vitalize things, "to substitute for human psychology, now exhausted, the lyric obsession with matter" (*M* 87), Marinetti seems to intimate this same process. More radically, he seems to embrace it, *to transvalue the death drive as the very principle of self-preservation, indeed of self-exaltation.* Apparently, for Marinetti the way not only to survive but to thrive in the military-industrial epoch of capitalism is to exacerbate its fetishistic process of reification: on the one hand, in a Lamarckian evolution, to extrapolate the human toward the inorganic-technological; on the other, to define the inorganic-technological as the epitome of the human. On the one hand, this is to accept a kind of death; on the other, it is to stake a new future for "life" in a technology (in or beyond mere death).[37] Marinetti suggests not only that the best protection against modern mass death is to be deader than dead, but that this reification must be turned into a libidinal process: that we must *desire* our self-alienation, perhaps our destruction, as the most sublime of modern experiences.[38]

THE WORLD'S ONLY HYGIENE

Before I return to this transvaluation of the death drive, I want to pursue the Lamarckian transformation of man into machine a little further. In *Capital* (1867) Marx argued that capitalism subjects the industrial worker to the machine: like the commodity, the machine comes to be seen as more vital than the worker, and the worker more automatic than the machine. Fifty-six years later, in *History and Class Consciousness* (1923), Georg Lukács argued that, with the advent of Taylorist-Fordist practices on the assembly line, capitalism fragments this worker as well: the effects of mechanization penetrate body and psyche alike. Implictly, Marinetti reverses both these Marxist accounts: rather than master the machine, he admonishes the worker to be "educated" by it (*M* 92), as if its mastery were the only one that now matters; and rather than resist the machine as a force of fragmentation and reification, he urges that it be embraced as a figure of totality and vitality—indeed, as the modern paragon of these states.

In this way Marinetti conceives technology not as a violation of body and nature but as a means to reconfigure both as better than new, more than whole. Again, this is a fetishistic operation—to turn an agent of a trauma into a shield against this same trauma—but as such it presents Marinetti with a problem. For Freud, the fetish is not only a "protection" against castration; it is also a "memorial" to it: the fetish might occlude recognition of castration, but it cannot erase it entirely; the trauma is never undone, its threat is never exorcized.[39] And so it is with the machine: it might figure a new totality, a dynamic phallic body, but it cannot rectify the old fragmentation, nor make good the primordial sense of lack, the originary castration of the subject. In this way the double logic of the prosthesis replicates that of the fetish: the prosthesis cannot undo its reason for being; it might even underscore that the subject requires this crutch, that he is defined in lack. Marinetti seems caught in this bind between recognition of psychic castration and faith in the technological phallus, and it pushes him toward an extreme "solution": the way to pass beyond this bind is to lose this lacking body in an ecstatic embrace of the machine, an embrace that will either subsume the body, or blow it to smithereens, or both. In a way, this "solution" is parallel to the paradoxical logic that, according to the psychoanalyst Catherine Millot,

incites the male transsexual to undergo actual castration: in order to become the phallus, he must lose the penis.[40] So too, in order to become the technological phallus, Marinetti must lose the penile body. In a sense, he is an imaginary transsexual who seeks the phallus through the machine—to become one with it and/or, according to the unconscious equation of baby and phallus, to bear "a mechanical son" through it. Here, in effect, the totalistic logic of the phallus overrides the fetishistic logic of the prosthesis.[41]

This imaginary self-castration is thus no great sacrifice; as Millot describes it, it is an "absolute, unlimited *jouissance,* outside the law, but also outside sex."[42] Yet there is a rub here too, for this *jouissance* demands an inordinate discharge of energies. Perhaps this is why Marinetti seeks discharge not only in art but also in speed and war, all of which he conceives in terms of ecstasy, even "autotomy." This last term was developed by Sándor Ferenczi, the Hungarian associate of Freud, to describe the extreme condition when, "on behalf of the entire organism," the genitals are not only discharged but *ejected* in the release of sexual tension.[43] Marinetti calls this sort of discharge "hygiene," which again he associates with art, speed, and war—indeed, with modernity in general. Like Lewis, who substitutes the figure of the vortex for the trope of speed, Marinetti looks to art and war to suspend the tensions that plague him, especially the tension between binding and unbinding, and it is on this basis that he associates them. Thus, in "Let's Murder the Moonshine" (1909), Marinetti writes of war: "It's our only hope, our reason for living, our only desire!" (*M* 45) And in *War, the World's Only Hygiene* (1911–15), he turns the old condemnation of war as murderous whore into a celebration of war as a "furious coitus": "See the furious coitus of war, gigantic vulva stirred by the friction of courage, shapeless vulva that spreads to offer itself to the terrific spasm of final victory!" (*M* 53–54). Yet what is his real object of desire here? It might be less the "shapeless vulva" than the soldier-subject as phallus that "stirs" it—the body-psyche as aggressive weapon, as autotomic projectile, a "body in flames, like a fireship, against the enemy" (*M* 46).[44] This seems to be the primary object of investment for Marinetti: an image of the body ego that is both armored and aggressive, defended and discharged, that finds its "only hope [and] only desire" in war.

Here the rhetoric of violence in Marinetti must be addressed. Sadistic on the surface, it might be masochistic underneath—after all, it is he who explodes in his autotomic fantasies. In several texts Leo Bersani has defined the essence of sexuality in terms of this sublime sort of self-shattering. "We desire what nearly shatters us," Bersani writes. "The mystery of sexuality is that we seek not only to get rid of this shattering tension but also to repeat it, even to increase it."[45] This approximates the dynamic of violence in Marinetti: he desires such shattering, such "scattering" (*M* 89)—desires to repeat it, but also to be rid of its tension. According to Bersani, actual violence arises when this desire is arrested, when its "psychic dislocations" are denied.[46] At some level, the rhetorical violence of futurism, the bombastic glorification of aggressive art, speed, and war in Marinetti, might serve as a form of release, as a way to embrace the disruption created by desire in defense against the destruction provoked by its arrest. This is the more benign view of his rhetorical violence—to see it as a protection against actual violence rather than a preparation for it.[47]

However, it is difficult to take a more benign view when Marinetti becomes involved with Mussolini, whose fascism he also seems to conceive along the lines of phallic fantasy. In "Beyond Communism" (1920), written not long after Mussolini formed his *Fasci di combattimento* (combat squads), Marinetti argues that "Futurist Fascism" supersedes not only liberalism but also Bolshevism as the historical force of progress. More, it purifies and protects an Italy corrupted by bourgeois parliamentarianism and threatened by communist bureaucracy. Here the futurist discourse of "hygiene" is overtly political, but its paradoxical logic remains corporal and sexual. In order to make whole, one must amputate: "We Italian Futurists have amputated all the ideologies and everywhere imposed our new conception of life, our formulas for spiritual health" (*M* 148).[48] For Marinetti, it is not enough to unify Italy politically; it must be totalized ideologically, all heterogeneity effaced. And this totality is figured in the phallic body purged of all weak, impure, merely penile elements.

Subject and nation mirror one another in this image of the body politic. Marinetti imagines his fellow nationals as fellow nerves in one great electrical system: the fatherland is not only "the greatest extension" of each, but also the

"single configuration" that "ties [them all] together" (*M* 149).[49] Technological apparatuses that bind the masses to both the party and the leader replace political institutions that once mediated subject and nation—"all that in the great affectionate solidarity of our race on our peninsula within the firm circle of boundaries conquered and deserved by our great victory" (*M* 153). Not only racial and ideological, this binding is libidinal and imagistic: in the fascist peninsula, the subject will find "boundaries," "solidarity," "victory." And this totality, Marinetti warns, cannot be achieved otherwise: "To deny the fatherland is the same as to isolate, castrate, shrink, denigrate, or kill yourself" (*M* 149).

In this way, the aesthetic of the phallus also becomes a politics of the fatherland in which the Italian peninsula is invoked as a libidinal image for a new collective ego. But here, too, the image might be flawed, as the etymology of the term *peninsula* suggests: *paene insula,* nearly an island, nearly severed. This peninsula dangles dangerously below the body of Europe, and Marinetti feels compelled to project it, in effect to phallicize it, as he advocates that Italy be extended to its linguistic limits, to recapture its whole native body. In one word-in-freedom titled *Irredentismo* (c. 1915; fig. 3.4), Marinetti shows the peninsula thrust north and east into Switzerland, Austria, and the Balkans, replete with futurist lines, battle cries, and patron names (such as Mazzini, the great leader of the Risorgimento). More than an irredentist Italy (with Italophonic regions absorbed into the nation), this is an Italy in aggressive advance (*avanzata* is typed across the arrows), even in ecstatic dissemination. Yet a tension remains between the demand for "the firm circle of boundaries," individual and national, and the desire to exceed them. This tension is another instance of the double logic of discipline and transgression, defense and discharge, armoring and exploding, pronounced in Marinetti in particular and in fascism in general.[50] Here, too, war is the primary "resolution," psychic and political, that occurs to him: "war, the world's only hygiene."

But who is to mold the "flaccid human masses" into this "higher spiritual elegance" of the fascist fatherland (*M* 154)? For Marinetti, the answer is obvious: "We will have a race almost entirely composed of artists" (*M* 156). The race is the fatherland, "the fatherland is nothing but a vast party," and the party "will

———

solve the social problem artistically" (*M* 149, 156). This crossing of aesthetics and politics, of artistic purity and social "hygiene," is ominous, especially where the language of spirituality is crossed with the technology of spectacle. Yet the party alone is not adequate as a libidinal object to mold the flaccid masses, for even fascist trappings need a particular body to hang on. This role must be assumed by the leader, and this is indeed how Mussolini was represented by artists, not all of them futurist, such as Alexander Schawinsky—as a body who subsumes the body politic (fig. 3.6). This is how Marinetti celebrates him too, in "Portrait of Mussolini" (1929), where he identifies *il Duce* with Italy directly, "because physically he is built *all'italiana*" (*M* 158): "carved out of the mighty rocks of our peninsula," his "great gesture-fist-image-conviction" embodies "the cubic will of the state" (*M* 159). Of course, Mussolini collaborated on this portrait with his self-conscious repertoire of phallic poses and dynamic expressions.[51] Turgid torso, shaved head, a body like a "projectile": if Italy is a militaristic peninsula, Mussolini is its warrior head, and he was imaged as such by R. A. Bertelli, E. M. Thayaht, and others (fig. 3.7). It is through this fetish of the body of the leader that the binding of the masses to the party and the fatherland is clinched. "A marvelous Futurist temperament," Mussolini is here made a marvelous art work as well (*M* 159).[52]

NEW EGOS

Like Marinetti, Wyndham Lewis sketches a "new ego" in his first manifestoes. The inaugural issue of *Blast* (1914) opens with a series of "blastings" and "blessings," the first of which is typical: "BLAST First (from politeness) ENGLAND / Curse its climate for its sins and infections / Dismal symbol, set round our bodies, of effeminate lout within . . ." (*B* 11). Several pages later, Lewis opposes to this blasted England the blessed image of an "industrial island machine, pyramidal workshop" (*B* 23–24). Like the Italian peninsula for Marinetti, this bounded British island, efficient like a machine, hierarchical like a workshop, is a figure for Lewis of a new collective ego. Like Marinetti, Lewis has nation and subject mirror one another in a bodily image, but he seeks a hardening of the "effeminate

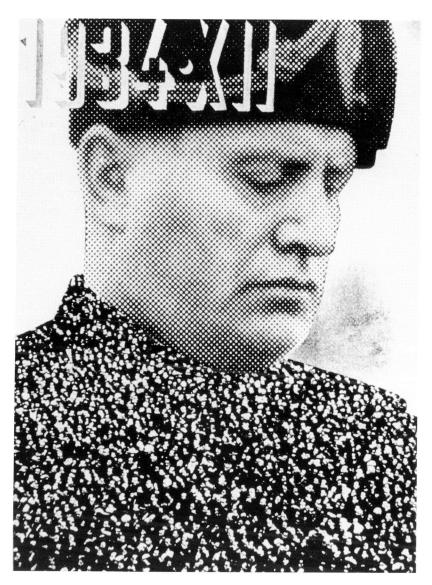

3.6. Alexander Schawinsky, *1934-XII*, 1934. Photomontage. Courtesy Gisela Schawinsky.

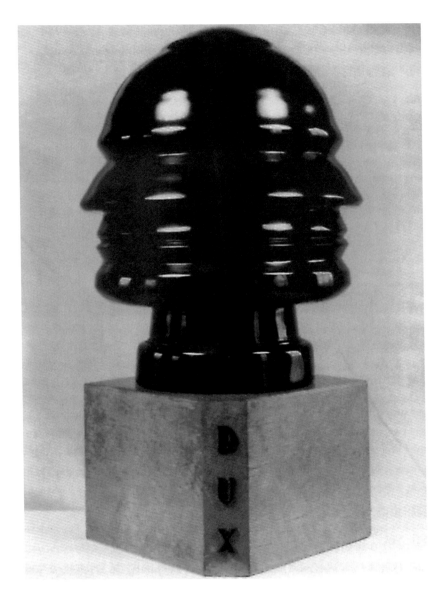

3.7. R. A. Bertelli, *Continuous Profile of Mussolini,* 1933. Ceramic, 19¼ in. high. Imperial War Museum, London.

lout within" each. In the nation, this "lout" seems to be the masses; in the subject, it seems to be the unconscious, the drives, sexuality; and each is scorned as "feminine," a force of flux, a threat to the masculinist stability of country and ego alike—a threat that stems from the implicit commutability of the two "louts." But whether the lout is the masses introjected or the unconscious projected, it must be "hardened" in nation and subject alike. "Bless this hysterical wall built round the ego" (*B* 26).[53]

Also like Marinetti, Lewis calls on artists to mold this flaccid feminine modernity into an armored masculine modernism. For these cultural leaders (he calls them "Caliphs"), "a course of egotistic hardening . . . is required" (*B* 134). Yet this hardening is only one part of the project; another is the blasting that Lewis performs with satiric relish. Aesthetic and political, these processes of discharge and defense are also psychological: if Marinetti stresses the unbinding of energy and the blasting of the subject, Lewis stresses the binding and the hardening. And this opposition might inform a basic difference between the two movements as a whole: in images and forms, futurist art favors the explosive, while vorticist art focuses on the fixed (figs. 3.8, 3.9). Thus futurist motifs of the burst of energy and the gesture forced free of the body, and futurist lines as vectors of force and traces of speed, tend to disintegrate form and to interpenetrate objects. Vorticist motifs and lines, on the other hand, tend to the opposite—even when the figure is most imbricated in space (fig. 3.10). "I hate the movement that blurs lines," Lewis often remarked—once directly to Marinetti (*BB* 35). In fact Lewis opposes all such blurrings, whether associated with crowds or women, the Freudian unconscious or the Bergsonian *durée*. (His *Time and Western Man* [1927] is a long diatribe against the temporal obsessions of modernist culture, especially in literature and philosophy.) An aversion to interpenetration seems fundamental to this aspect of his aesthetics, philosophy, and politics, just as a desire for the same appears basic to Marinetti and company. For both men the stake of these forms and phenomena is the subject: while Marinetti strives for an ecstatic release of the body ego, Lewis struggles to keep it intact and hard.

Faced with the tension between discharge and defense, the early Marinetti seeks a momentary resolution in speed, while the early Lewis pursues it in a

———

131

3.8. Giacomo Balla, *Boccioni's Fist—Lines of Force II*, 1916–17, reconstructed 1956–58 (cast 1968), painted brass, 31½ × 30 × 10 in. Hirshhorn Museum and Sculpture Garden, Smithsonian Institution: Gift of Joseph H. Hirshhorn, 1972. © 2003 Artists Rights Society (ARS), New York/SIAE, Rome. Photo: Lee Stalsworth.

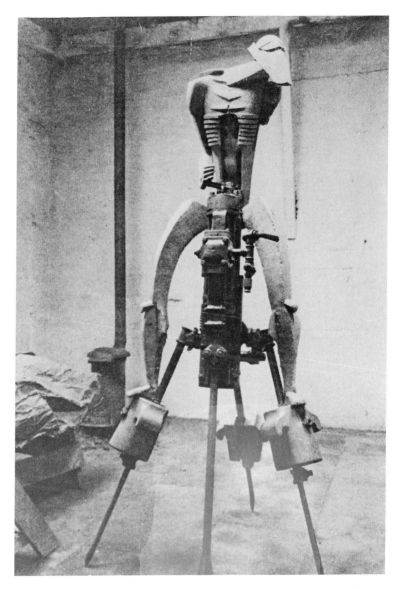

3.9. Jacob Epstein, *Rock Drill,* 1915. Plaster and readymade drill. The National Gallery of Canada, Ottawa.

related ideal, the vortex: "At the heart of the whirlpool is a great silent place where all energy is concentrated. And there, at the point of concentration, is the Vorticist."[54] This vortex is not just a symbol; at its "maximum point of energy when stillest," it is an imaginary apparatus that elicits and channels libidinal energies (*B* 148).[55] For Lewis it seems to figure not only the tension between discharge and defense, blasting and hardening, but also the binding of stimulus-shock into protective shield, the conversion of energy into ego. In a sense it is a metaphor-machine of this conversion, as Ezra Pound suggests in *Blast:* "The vortex is the point of maximum energy. It represents, in mechanics, the greatest efficiency" (*B* 153).

Lewis seems to invest in such figures of hardening in defense against its opposite—"nondifferentiation." This is the gist of his antihumanism: he insists on a separation of the human not only from the divine and the natural but also from its own intrinsic frailties; more, Lewis celebrates this separation, militates for culture to reinforce it. Here again, self-alienation is recouped as self-preservation—indeed, as the supreme value of the self. In *The Art of Being Ruled* (1926), Lewis attacks all forces of nondifferentiation, especially the "sex transformation" in postwar society that, in his view, has feminized men and masculinized women (the dreaded epitome of this nondifferentiation is "male inversion"); he also condemns modernist art as "a thirst to sexually invade everything—to violate any intimity."[56] In *Time and Western Man* this attack on nondifferentiation turns philosophical; here the great enemy of the armored ego is the Bergsonian flux, the obsession with the temporal and the psychological. For Lewis this modernist engulfment in time erodes the subject, but so does the modernist diffusion of space; and the new ego and the fierce abstraction of vorticism are arrayed against both invasions.

As Lewis rejects the flux thought by Bergson, he embraces the stasis proposed by the German art historian Wilhelm Worringer in *Abstraction and Empathy* (1908). This "psychology of style" was introduced into vorticist circles by the poet-critic T. E. Hulme, but it became a primary text for Lewis as well. Worringer combines two notions—empathy *(Einfühlung),* derived from the German

psychologist Theodor Lipps, and artistic will *(Kunstwollen),* derived from the Austrian art historian Alois Riegl—in order to relate artistic styles to "psychic states."[57] Across history and culture, Worringer argues, there are two stylistic poles in art, naturalism and abstraction, and they express two opposite relations to the world, an empathic engagement and a shocked withdrawal. "Whereas the precondition for the urge to empathy is a happy pantheistic relationship of confidence between man and the phenomena of the external world, the urge to abstraction is the outcome of a great inner unrest inspired in man by the phenomena of the outside world. . . . We might describe this state as an immense spiritual dread of space" (*AE* 15).[58] The primitive turned to abstraction, according to Worringer, because he was "dominated by an immense need for tranquility," and Worringer sees a similar turn, also driven by "inner unrest" and "spatial dread," in the modern: "slipped down from the pride of knowledge, man is now just as lost and helpless [as the primitive]" (*AE* 18). As a consequence, the modern artist also struggles to arrest and to separate, to abstract and to preserve—an account very different from the usual celebrations of modernist abstraction as an expression of spiritual confidence, technical prowess, historical progress, and so on. Worringer undercuts the humanism of all such readings of abstraction. Like Marinetti and Lewis, he is pushed toward the paradox that the very "impulse to self-preservation" (*AE* 35) has driven the modern toward the abstract and the inorganic.

Again, Lewis came to Worringer through Hulme. In January 1914, six months before the first issue of *Blast,* Hulme delivered a lecture in London titled "Modern Art and its Philosophy" that adapts *Abstraction and Empathy* toward an advocacy of vorticist art.[59] He, too, divides modern styles into two categories, geometric and organic, which are said to answer to opposite "necessities of the mind" and "attitudes towards the world" (*S* 77–78). According to Hulme, organic styles are naturalist and empathic, and express the humanist attitude dominant in art from the Renaissance through romanticism, a "flat and insipid optimism" (*S* 80) that places man at the center of nature. Thus for Hulme the return of geometric styles in modern art signals the return of the opposite attitude,

"a feeling of separation in the face of outside nature" (*S* 85). Like Lewis, Hulme celebrates this antinatural separation; he, too, embraces such "original sin" as an ultimate value.

Yet a problem arises in the vorticist adaptation of Worringer: the proximity of the modern and the primitive. Like Worringer and Riegl, Hulme subscribes to a cultural evolutionism that is racialist at base, with the geometric style, the characteristic mode of primitive art, in "the lowest position" (*S* 17).[60] Under this bias, Hulme must somehow qualify the return of this style in modern art as other than primitive. First he argues that "the necessary presupposition" of abstraction is not "a condition of fear" but a "separation between man and nature" (*S* 87); and then he insists that vorticist abstraction is modeled not on primitive art but on machinic "organization"—the involvement in primitivism simply prepared the interest in the machine (*S* 98). "It is obvious that [his] only interest in the human body," Hulme wrote of Lewis, "was in a few abstract mechanical relations perceived in it, the arm as lever and so on" (*S* 106).

"What he said should be done, I *did*" (*BB* 100), Lewis once remarked of Hulme. But, again, it is Worringer who set the aesthetic terms for both men, and both often echoed his enthusiasm for abstraction—Assyrian, Egyptian, Byzantine, and so on.[61] Already in an early text in *Blast* Lewis reveals his ambition to adapt Worringer to a modern conception of art and subjectivity. Titled "The New Egos," it reads as a Worringerian parable of two complementary figures, "a civilized savage" and a "modern town-dweller" (*B* 141).[62] Neither is "secure": the first lives in a "vagueness of space," the second amid crowds that "overlap, intersect, and are Siamese to any extent." Yet the savage has developed an art to quell his insecurity, an art of the figure abstracted to a "simple black human bullet," whereas the modern only senses that "the old form of egotism is no longer fit for such conditions as now prevail, [that] the isolated human figure of most ancient art is an anachronism, [that] the actual human body becomes of less importance every day" (*B* 141). There follows this Worringerian credo: "All clean, clear-cut emotions depend on the element of strangeness, and surprise and primitive detachment. Dehumanization is the chief diagnostic of the Modern World" (*B* 141). The chief diagnostic, it is also the chief remedy for Lewis: if the mod-

ern is to survive its own dehumanization, it must dehumanize further; it must take "strangeness, surprise, and primitive detachment" to the limit.

Lewis does not forgo the human figure. Even in his nonobjective works he often abstracts from its gestures, as if to convert the figure into its own force field. Sometimes his abstraction appears to be little more than this conversion of a figure into a protective shield, a "human bullet." Yet usually he is not content to show the mere result of this armoring; rather, he evokes its struggle and its stake. Especially in the "designs" of the early 1910s, a great tension exists between figure and surround, as if the body ego, never secure, were caught between definition, about to break free as an autonomous subject, and dispersal, about to be invaded schizophrenically by space.[63] (In effect, Lewis adapts cubism not as a technique to fracture the figure in space but as a means to dramatize its struggle for distinction.) In a typical series based on *Timon of Athens* (1912; fig. 3.10), the Shakespearian misanthrope is suspended between definition and dispersal in this way: as he strives toward autonomy, he becomes imbricated in space. Even as the cubist forms seem to derive from his body, they also subsume it in its surround.[64]

This tension is difficult to maintain, and especially in the early designs Lewis stresses the binding of the body image. At times this hardening seems to come from without, outside in, as in *The Vorticist* (1912; fig. 3.11), in which the body, pressed by external geometries, is abstracted as if under the stimulus–shock of the external world that defines it. At other times this hardening seems to come from within, inside out, as in *Vorticist Design* (c. 1914; fig. 3.12), in which the body is abstracted even further as if by its own internal drives. In one concentrated figure, *The Enemy of the Stars* (1913; fig. 3.13), these two hardenings seem to converge: on the one hand, with a head like a receiver, the figure appears reified from without, its skin turned into a shield; on the other hand, stripped of organs and arms, it appears reified from within, its ossature turned into "a few abstract mechanical relations"; in either case it looks the part of an "enemy of the stars."[65] After the war this hardening becomes more extreme: in a near-literal return to the inorganic, some figures of the 1920s appear petrified (this is true of many portraits as well), while others appear excoriated (in one drawing Lewis imagines the crucifixion as a literal excoriation, with Christ flayed as if by space).

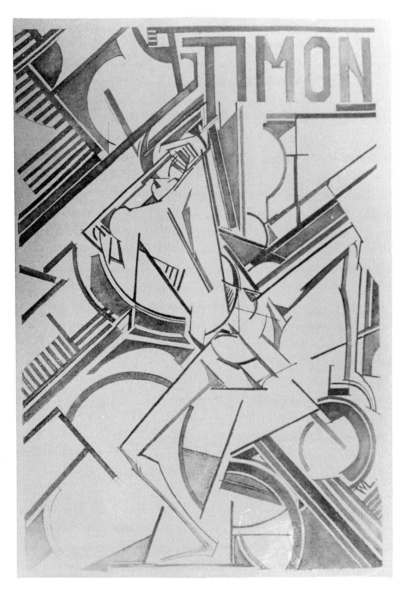

3.10. Wyndham Lewis, *Timon of Athens,* 1915. The Tate Gallery, London.
© Wyndham Lewis and the estate of Mrs. G. A. Wyndham Lewis by kind permission of the Wyndham Lewis Memorial Trust.

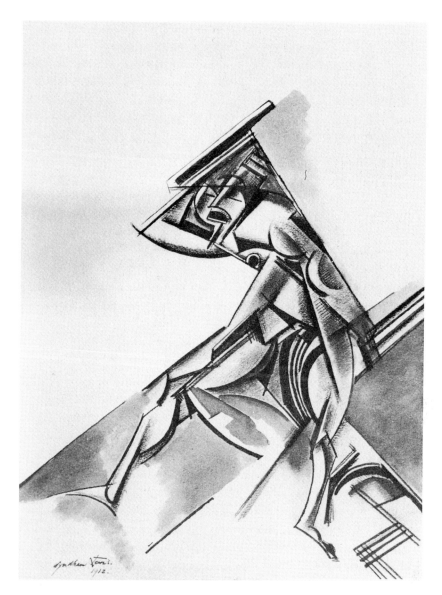

3.11. Wyndham Lewis, *The Vorticist,* 1912. Pen and ink and watercolor, 16½ × 12 in. Southampton Art Gallery, UK. © Wyndham Lewis and the estate of Mrs. G. A. Wyndham Lewis by kind permission of the Wyndham Lewis Memorial Trust.

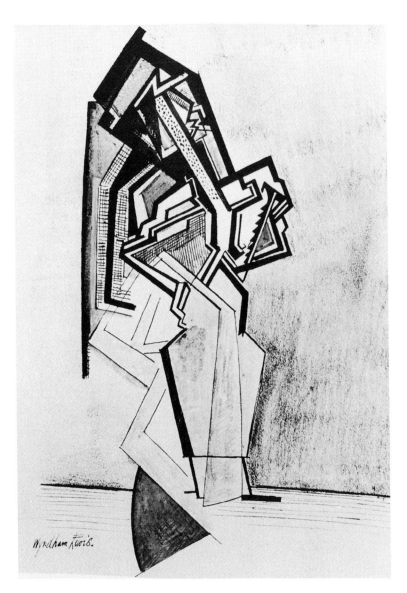

3.12. Wyndham Lewis, *Vorticist Design,* c. 1914. Pen and ink, pencil, and watercolor, 9¼ × 7⅓ in. Private collection. © Wyndham Lewis and the estate of Mrs. G. A. Wyndham Lewis by kind permission of the Wyndham Lewis Memorial Trust.

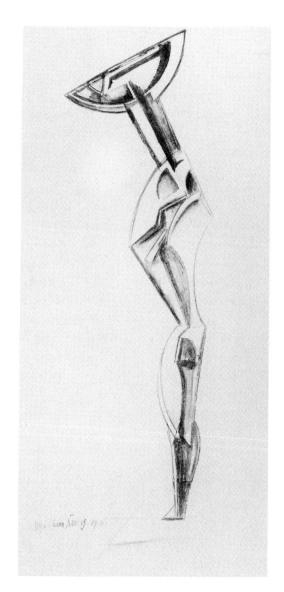

3.13. Wyndham Lewis, *The Enemy of the Stars,* 1913.
Pen and ink wash, 17¼ × 7⅞ in. Private collection.
© Wyndham Lewis and the estate of Mrs. G. A.
Wyndham Lewis by kind permission of the Wyndham
Lewis Memorial Trust.

Finally, in a few works of this period excoriation and petrification appear combined, as if the body were suddenly stripped to its ultimate state as a fossil.[66]

DEADNESS IS THE FIRST CONDITION

In some early figures, then, Lewis registers dread or shock, but often only to turn dread into aggression, shock into protection—as if to convert any breaching into an armoring that both shields and aggresses. In this way he seems to elaborate on Worringer regarding abstraction in a manner consistent with Freud regarding the protective shield and the death drive; yet his most relevant works predate *Beyond the Pleasure Principle* (published in 1920, translated into English in 1922), and his remarks on Freud thereafter are scant and negative. Might Lewis have intimated this becoming-inorganic through *Abstraction and Empathy*—the becoming-inorganic both of the protective shield, which binds the body ego against stimulus-shock, and of the death drive, which releases the organism from all such tension? There is no explicit evidence, but Worringer does suggest such a drive in his account of abstraction.[67]

In *Beyond the Pleasure Principle* Freud formulates the death drive in a famous passage: "If we are to take it as a truth that knows no exception that everything living dies for *internal* reasons—becomes inorganic once again—then we shall be compelled to say that 'the aim of all life is death' and, looking backwards, that 'inanimate things existed before living ones'" (*BPP* 32). Twelve years prior to this statement, Worringer referred the will to abstraction to a similar "morphological law" that "still echoes like a dim memory in our human organism." And here he conceives abstraction as a mimesis of this primal state of inorganicity:

A convinced evolutionist might . . . seek [geometric form] in the ultimate affinity between the morphological laws of organic and inorganic nature. He would then erect the ideal postulate that the morphological law of inorganic nature still echoes like a dim memory in our human organism. He would then perhaps also assert

further that every differentiation of organised matter, every development of its most primitive form, is accompanied by a tension, by a longing to revert to this most primitive form. . . . Thus, in the contemplation of abstract regularity man would be, as it were, delivered from this tension and at rest from his differentiation in the enjoyment of his simplest formula, of his ultimate morphological law. (*AE* 35–36)

If Lewis approaches this formulation in his own terms, he does so in a paradoxical way that inverts it, for he seeks to find, in this *pre*history of a radical nondifferentiation, a *post*history that promises an absolute differentiation. In other words, Lewis seeks to turn this "ultimate morphological law" into a principle of transcendental self-affirmation.[68]

In his writings, Lewis approaches the notions of the protective shield and the death drive in several ways. In one respect he espouses a "primordialism" more radical than any primitivism: "The artist goes back to the fish," Lewis writes in *The Caliph's Design,* "to strike the fundamental slime of creation" (*CD* 65).[69] In "The Physiognomy of Our Time," also in this first collection of art essays, Lewis describes this condition as "futuristic," as if the primordial were not only in our deepest past but in our modernist future as well. This intuition of a death drive as a process, even a goal, within modernity has two ramifications. First, for Lewis as for Marinetti, the old opposition of animate and inanimate is long since overcome. On the one hand, Lewis writes in "The Physiognomy of Our Time," "every living form is a miraculous mechanism"; on the other, in a world become "inorganic," the machine has become an "organism" of its own (*CD* 77–78). Latent in the order of things ("the seagull is not far removed from the hydroplane" [*CD* 73]), this mechanicity must now be articulated by the artist; in Worringerian fashion, he must wrest this order out of chaos ("all our efforts indicate a desire . . . to order, regulate, disinfect and stabilise our life" [*CD* 73–74]). Second, with the organic and the inorganic thus forced into an identity that is at once primordial and futuristic, Lewis can present his model of art in terms of a necessary evolution, even a biogenetic law: "The creation of a work of art is an act of the same description as the evolution of wings on the sides of a fish, the

feathering of its fins; or the invention of a weapon within the body of a hy-menopter [e.g. an ant, wasp, or bee] to enable it to meet the terrible needs of life" (*CD* 65). This formulation, which some sculptures by Henri Gaudier-Brzeska seem to anticipate (fig. 3.14), suggests two further transvaluations. On the one hand, there is a troping of Worringer on abstraction in which primitive dread before nature becomes modern empathy with a second nature, the machinic world ("we want to enjoy our consciousness, but to enjoy it in all forms of life" [*CD* 77]). On the other hand, there is a troping of Freud on the protective shield, the development of which art is not only to recapitulate but, in an embrace of the machine, to accelerate—in order "to meet the terrible needs of life."

Lewis also approaches the Freud of *Beyond the Pleasure Principle* in his concern with ectogenesis, the process by which an organism extrudes structures from its own surface. "The central nervous system originates from the ectoderm," Freud writes of the protective shield. "The grey matter of the cortex remains a derivative of the primitive superficial layer of the organism." Under "the ceaseless impact of external stimuli," this ectoderm is "baked" into an inorganic "crust," which screens stimuli for the layers beneath (*BPP* 20–21). Compare Lewis in *The Art of Being Ruled:* "We are *surface creatures. . . .* There is no meaning except on the surface. It is physiologically the latest, the ectodermic, and the most *exterior* material of our body that is responsible for our intellectual life: it is on the faculty for exteriorization that our life depends" (*WLA* 210). In effect, the young Lewis adopts the Freudian metaphor of "baking" as a model for art and subjectivity alike, but with two revisions: he reverses the process (both must be baked inside out); and he insists that the baking be total, the crust complete. For Lewis, the internal layers that Freud wants to protect are so much "jellyfish."

Even in his early writings—such as the novel *Tarr* (1914/18), the essays in *The Caliph's Design* (1919), or the short stories in *The Wild Body* (1927)—Lewis takes this sheer exteriority as one ideal. Again, its most radical formulation is presented by the protagonist of *Tarr:*

> Deadness is the first condition of art. The armoured hide of the hippopotamus, the shell of the tortoise, feathers and machinery, you may put in one camp; naked pulsing and moving of the soft inside

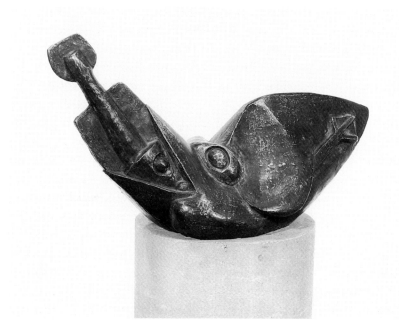

3.14. Henri Gaudier-Brzeska, *Bird Swallowing a Fish,* 1914. Bronze, 12½ in. Musée National d'Art Moderne, Centre Georges Pompidou, Paris. © CNAC/MNAM/Dist. Réunion des Musées Nationaux/Art Resource, New York.

of life—along with elasticity of movement and consciousness—that goes in the opposite camp. Deadness is the first condition of art: the second is absence of soul, in the human and sentimental sense. With the statue its lines and masses are its soul, no restless inflammable ego is imagined for its interior: it has *no inside:* good art must have no in-side: that is capital.

Already in play here in 1914 are leitmotivs key to Lewis: the attack on psycho-logical interiority as "naked pulsing"; the celebration of the uncanny deadness of the armored, the machinic, even the neoclassical (the statue); above all, the trans-formation of stimulus-shock into shield (hide, shell, feathers, machinery).

Of course, this celebration of deadness is expressed by a fictional char-acter, and it is not often borne out by the work at large: Lewis might be repelled by the naked pulsing of life, but his figures are not baked through. As I have suggested, his early designs in particular capture the tense ambiguity between inside and outside, animate and inanimate, breaching and shielding that trau-matic shock puts into play. Aggression also enlivens the deadness otherwise prized by Lewis. Consider his depiction of eyes: in Freud these organs are "feel-ers . . . left behind on the surface" (*BPP* 21); in Lewis they are opaque ob-jects, blank windows to no soul. Yet they are far from dead: like the grins of his Tyros, the "elementals" conjured up in the 1920s, the eyes for Lewis are en-livened by aggression (fig. 3.5).[70] Even in his more realistic portraits they appear as shields-cum-weapons, the point at which the body ego is most hardened, most cruel (fig. 3.15).[71]

This aggression is also apparent in his commitment to satire, which follows from his "externalist" approach. "There is a stiffening of Satire in everything good, of 'the grotesque,' which is the same thing," Lewis writes in his "Theory of the External, the Classical, Approach in Art" (1934). "The non-human outlook must be there . . . to correct our soft conceit."[72] Here the becoming-machinic of the body is not only a model of armoring but also a means to expose the inhu-man within the human. Lewis uses this trope, common in satire, to reduce the human to the physical in two related ways. First, the human is often seen as a

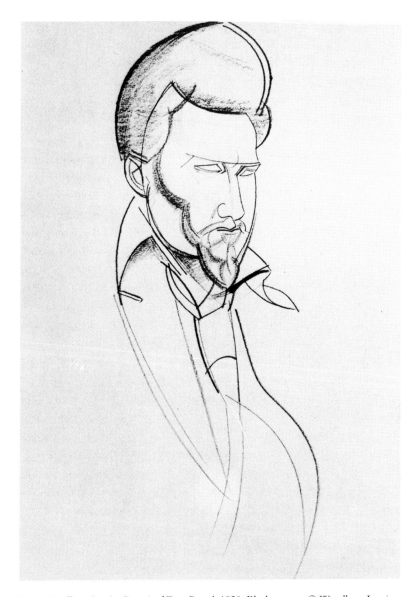

3.15. Wyndham Lewis, *Portrait of Ezra Pound,* 1920. Black crayon. © Wyndham Lewis and the estate of Mrs. G. A. Wyndham Lewis by kind permission of the Wyndham Lewis Memorial Trust.

mechanism: "Men are sometimes so palpably machines, their machination is so transparent, that they are *comic,* as we say" (*MWA* 95). Then, against our soft conceit, the human is often seen as a thing: "All men are necessarily comic: for they are all *things,* or physical bodies, behaving as *persons*" (*WB* 158). Despite his anti-Bergsonism, Lewis is influenced here by the Bergson of *Le Rire* (1900), who defines the comic in terms of the sudden exposure of a person as a mere mechanism: it is this unexpected degradation that is comic for Bergson. Yet for Lewis our status quo is largely mechanistic, and often we are ridiculous when we pretend otherwise.

Just as important to Lewis is the psychic economy of this comic effect, and here he approaches Freud on humor as well (Freud was also influenced by Bergson as well as by Lipps). For Lewis the sudden exposure of the human as mere mechanism is *satirical* because it mocks the humanist pretense of free action: it reveals us as the "puppets" we often are. But this sudden exposure is *comic,* at least according to Freud, because the mechanism that is thus revealed is the automatism of the instincts, and this revelation eases instinctual tension; indeed, the comic *is* this release whereby the unpleasure of tension is turned to the pleasure of release.[73] In similar terms Lewis writes of the comic object: "We are astonished and shocked, and we bark at him—we *laugh*—in order to relieve our emotion" (*MWA* 95). Note the atavism of this laughter: not only is the comic object instinctually automatic, but so is the comic effect. It, too, renders us a "wild body," that "supreme survival that is us, the stark apparatus with its set of mysterious spasms: the most profound of which is laughter" (*WB* 157).[74] It is this laughter that shakes his Tyros: "These immense novices brandish their appetites in their faces" (*WB* 354).

For Lewis, then, we are comic when we appear both automatic and reified, puppets of blind instinct further reduced within modernity to the status of mechanistic things. Such is the inhuman that he bids us to see as comic. But to see it in this way is also to be screened from it: on the one hand, the comedy "relieves emotion"; on the other, the satire "stiffens" us. If Marinetti asks us to desire reification, Lewis invites us to laugh at it, and this comedy of reification is yet another troping of the destructive impulse in his work—despite the fact that his satire

often remains aggressive, and his reduction of the human to the mechanistic often seems sadistic.[75] This kind of troping or turning is also at work in his "stoical embrace" of "the brutality of mechanical life," or his conflicted sense of war as "romance."[76] Often enough Lewis works to turn these shocks, the "most dramatic of ailments" (*BB* 115), into a new sort of sublime, and here, too, he presents the transformation in terms of psychic economy: "For all life must in some way be pleasure—even . . . the horror of destruction or the 'narrow escape' from it—namely, the pleasures of the battlefield, or of any 'moving accidents'" (*WLA* 212).[77] Sometimes, however, Lewis fails these transvaluations, and sometimes he does not attempt them at all—as if the destructive impulse might then be revealed as such. "Killing somebody must be the greatest pleasure in existence," he wrote as early as the first *Blast*. "Either like killing yourself without being interfered with by the instinct of self-preservation—or exterminating the instinct of self-preservation itself!" (*B* 133)

Of course this is part swagger, and its very preposterousness might serve to free Lewis from his own "poetic mania."[78] But this is also part wager, and at one point he grasps its stake: "The game consists in seeing how near you can get without the sudden extinction and neutralization that awaits you as matter, or as the machine," he writes in 1922. "In our bodies we have got already so near to extinction."[79] Could it be that this game is not the grim sideshow that it seems, that the moves of a Lewis or a Marinetti are not as aberrant as they might appear? Could it be that the very stake of high modernism at this time involves wagers with reification and death? Such figures of reification and death are approached and/or averted often in such European art—not only in the dysfunctional automatons of Dada and the dismembered mannequins of surrealism (what Lewis called "Hoffmann puppets"), but also in the machinic men of socialist constructivists and the scarecrow-statues of fascistic neoclassicisms (what Lewis called "robot-men" and "living statues").[80] This is not to suggest some grand zeitgeist whereby this period marches in lockstep to the death drive. But it is to hear, below the noisy appeals of the time—all the various quests for the New Man as well as the various returns to the Old Humanism—the insistent call of the inhuman.

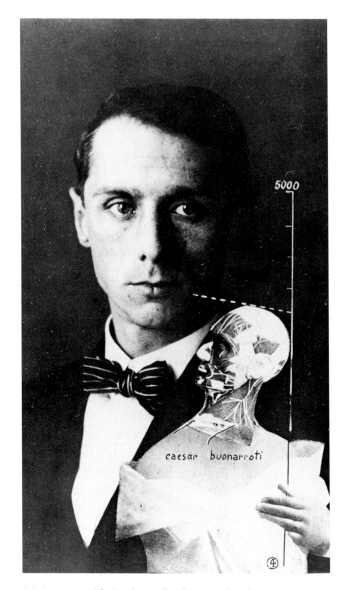

4.1. Max Ernst, *The Punching Ball or the Immortality of Buonarroti,* 1920. Cut printed reproductions, gouache, and ink on photograph, 6 15/16 × 4½ in. Arnold H. Crane Collection, Chicago. © 2003 Artists Rights Society (ARS), New York/ADAGP, Paris.

4

A BASHED EGO

Chapter 3 sketched different figures of the machine in various modernisms of the interwar period; in particular the dysfunctional mechanomorphs of Dada and the dismembered mannequins of surrealism were seen as critical complements of the new machinic man advanced by Russian constructivism, the Bauhaus, and related movements (fig. 4.1). These Dadaist and surrealist figures, I suggested, might also oppose another type, long neglected by modernist studies: the fascistic ideal, forged in the crucible of World War I, of the male body-become-weapon, of the armored soldier-worker, as celebrated by Marinetti in Italy and Ernst Jünger in Germany, among others. This tenuous connection was first presented to me by the early Dadaist collages of Max Ernst, collages that often treat the male body as a ridiculous weapon and/or an impossible tool (fig. 4.2). Created in Cologne in 1919–20 amid the political turmoil and mercenary terror after the Great War, these "bachelor machines" seem to parody the Nazi model of a military-industrial masculinity even before it emerged (the Nazi Party was founded in Munich in February 1920).[1] In any case, the critical relation of Dada to this fascistic type became encrypted for me in these pathetic figures of Ernst: I wanted to see these collages both as evocations of the narcissistic damage incurred during the war and as cautions against the reactionary obsession with the body as armor to come.

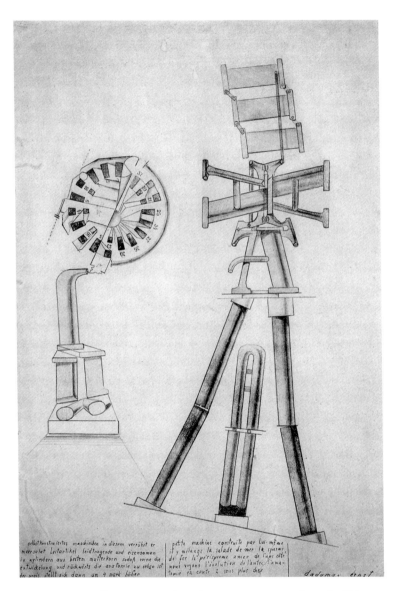

4.2. Max Ernst, *Self-Constructed Little Machine,* c. 1920. Stamp and pencil rubbings of printer's block with ink on paper, 18⅛ × 12 in. Lindy and Edwin Bergman Collection. © 2003 Artists Rights Society (ARS), New York/ADAGP, Paris.

Freud returned to the study of trauma soon after World War I, in part prompted by the shock of soldiers subject to new military-industrial technologies. To understand trauma as he does in *Beyond the Pleasure Principle* (1920)— as a wounding of the body ego, as a piercing of its "protective shield"—Freud had to posit how this body ego was formed, this protective shield armored, in the first place. Already in "On Narcissism" (1914) he had posited a stage in which the ego emerges, tentatively, out of an image of its own body or, more precisely, out of a libidinal investment in this image. For Freud this "narcissistic" stage, in which the body is the first love object of the nascent subject, precedes any attachment to things in the world, but it also succeeds a more primordial phase of autoerotic interest in different parts of the body (in contradistinction to the body as a whole). If this corporeal investment is somehow inadequate, or this body image is somehow violated, the subject will not bind as a whole image or an intact ego, and its relations to external objects will be disrupted. This kind of disturbance, I want to claim, is evoked in the damaged figures of the early Ernst collages, which are roughly contemporaneous with the relevant writings of Freud.

As is well known, Lacan developed the Freudian conception of narcissism in his paper "The Mirror Stage" (1936/49), according to which the infant comes to identify with an anticipatory image of bodily unity in a way that founds its ego precisely as imaginary. Important here is that Lacan regards the anarchic phase of autoerotic interest, which he relates to a fantasy of "the body in pieces" (*le corps morcelé*), as a retroactive effect of this imaginary unity of the fledgling ego in the mirror stage.[2] Accordingly, if there is a breakdown in imaginary unity, a crisis in narcissistic identification, the subject feels threatened by a return of this bodily "chaos." For Lacan, this threat of chaos renders the ego not only paranoid but aggressive, which only compounds the aggressivity already immanent to the ego in its fraught emergence into a world governed by others: "Aggressivity is the correlative tendency of a mode of identification that we call narcissistic," he writes in "Aggressivity in Psychoanalysis" (1948), the companion piece to "The Mirror Stage" in *Écrits*.[3] In this light, it is suggestive that, just as Freud developed his account of narcissism at the advent of the World War I, Lacan developed his notion of the mirror stage in a period of dominant fascism.[4]

This possible relation between psychoanalytic reflections on the ego and military-industrial disciplinings of the body was not developed until recently. In *Male Fantasies* (1977/78), an extraordinary account of the German mercenaries known as the Freikorps after World War I, Klaus Theweleit discusses fascist subjectivity in terms of narcissistic disturbance.[5] Other analysts before Theweleit had written of "armoring" as fundamental to the subject; Lacan does so in "The Mirror Stage," as does Wilhelm Reich in *Character Analysis* (1933). Yet for Theweleit such armoring exists almost *in lieu of* the ego of the fascist, as a kind of ego substitute or stopgap, and he does not hesitate to model the fascist after the psychotic child, as a being with a "basic fault"—that is, one for whom individuation is never completed and object relations are never resolved.[6] According to Theweleit, the fascist is unable to cathect his body fully, and so to bind it as an image properly; he is not formed, as it were, from the inside out. Hence, when confronted with stimuli that he cannot discharge, this subject feels threatened with dissolution, and other forms of binding become urgent. "[His] body did acquire boundaries," Theweleit writes, "but they were drawn *from the outside,* by the disciplinary agencies of imperialist society," such as the hierarchical academy, the military drill, and the front experience.[7] These agencies bind this subject through a special sense of the body as "delibidinized" through pain, the body as armor. Yet, rather than secure the fascist, this armor prompts him to further aggressivity, which now appears necessary not only for his self-definition but for his self-defense as well. It is for this reason, Theweleit argues, that the fascist is prone to attack any figure deemed a threat to his masculine being—in this case Jews primarily, but also communists, homosexuals, proletarian women, and "the masses." In doing so, Theweleit concludes, the fascist also aims at his own "desiring production," for it is his own unconscious and sexuality, his own desires and drives, that he fears most of all.

In this account, the fascist not only requires ego armoring; periodically he needs to be relieved of it as well: thus his great ambivalence about comminglings of all sorts, sexual, ethnic, and social; thus, too, his contradictory demand for simultaneous defense and discharge, a demand that is met most effectively in war.[8] As we saw in chapter 3, this logic of war as "the world's only hygiene" is also

pronounced in Marinetti, and it underlies the pervasive mystique of war in fascist ideology as an "inner experience" that reforges the self as a weapon.[9] For Theweleit, this reconfiguration of self as weapon is fundamental to fascism, for it allows "desiring production" to be both suppressed and expressed as "murdering production." "Was I now perhaps one with the weapon?" Ernst von Salomon, World War I veteran and infamous Freikorps officer, wrote. "Was I not machine—cold metal?"[10] Or as Jünger, the most important writer of the interwar right in Germany, declared, "technology is our uniform": it must be "intertwined with our nerves," with the "pain" of military-industrial experience transformed into a "second, colder consciousness."[11]

SELF-CONSTRUCTED LITTLE MACHINES

Ernst also experienced the front, and he formed Cologne Dada amid the Freikorps terror of 1919. Drafted into an artillery regiment of the German army in 1914, at the age of twenty-three, he was wounded twice—once by a gun recoil and once by a mule kick—which earned him the nickname "Iron Head." "We young people came back from the war in a state of stupefaction," Ernst later recalled; and in his autobiographical sketch "Some Data on the Youth of M.E. as Told by Himself" (1942), he presents the entire war as a loss of consciousness—indeed, of life: "Max Ernst died the 1st of August 1914. He resuscitated the 11th of November 1918."[12] This account of the war as a kind of blackout is equal and opposite to the fascist celebration of the war as a form of ecstasy. The emphasis on shock is also suggestive, as is the alienation of the first-person voice by the third person (Ernst uses this device frequently in his Dada period). His early work often deploys such tell-tale signs of narcissistic disturbance.

This is to propose not that Ernst was so disturbed, but that he deploys signs of disturbance to critical ends. Thus when he "resuscitates" from the war, he does so in quasi-autistic guise as "Dadamax," machinic maker of machinic figures. In this way Ernst not only figures the body in mechanistic terms in his early collages, but also assumes the machine as a persona throughout his Dada years. Meanwhile, his co-conspirator in Cologne Dada, Alfred Grünwald, the radical son of

a rich banker, takes as his alias "Baargeld," which translates as "ready money" or "cash," and Ernst is no less interested in the commodity as an object of critical mimicry. As we will see, this mimetic parody of the corrosive effects of machine and commodity—that is, of capitalist modernity—is fundamental to Dada at large, especially in Cologne and Zurich. Suffice it to say here that Ernst evokes the trauma of the military-industrial disciplining of the self in order to reflect on its psychophysical effects, and, more, to turn these effects back on the social order that produced them.

Before the war, at the University of Bonn, Ernst studied such subjects as the psychology of disturbed children and "Origins and Implications of Mental Illness." He also began to read Emil Kraepelin, the renowned German psychiatrist who provided an early typology of mental disorders in his *Textbook of Psychiatry* (1896), as well as Freud, at least such early texts as his *Interpretation of Dreams* (1900) and *Jokes and Their Relation to the Unconscious* (1905).[13] At some point Ernst also discovered such case studies as *Leonardo da Vinci and a Memory of His Childhood* (1910) and *Psychoanalytic Notes on an Autobiographical Account of a Case of Paranoia* (1911), for he echoes the Leonardo case in *Beyond Painting* (1948), his surrealist art-treatise-*cum*-auto-analysis, and his interest in paranoia must have led him to the famous account of the paranoid Judge Schreber as well. Certainly Ernst encountered the art of the mentally ill early on, even before the influential publication of *Artistry of the Mentally Ill* (1922) by Hans Prinzhorn (more on which in chapter 5). In his "Biographical Notes," for example, Ernst reports that as a student he visited an asylum near Bonn to see such work, and that he once planned a book on the subject.[14] His early collages do resemble schizophrenic representations in several respects: they share an obsession with repetition, a mixing of drawing and script, a contradictory treatment of boundaries, sometimes ignored and sometimes reiterated, and an imaging of bodies as both mechanistic and disjunctive (fig. 4.3).[15] Ernst adapts these signs in a way that exceeds considerations of style; perhaps, aided by his reading in schizophrenia, he intuits that this disturbed image-making might articulate a disturbed ego construction, and that, if reworked in his fascist milieu, such image-making might in turn be politically incisive precisely because it is psychologically incisive—again, both as an

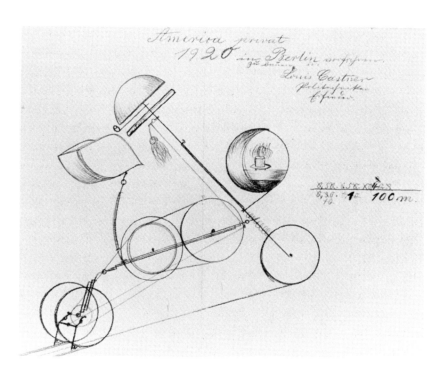

4.3. Louis Castner, *America Privat,* n.d. Pencil on paper, 13 × 8¼ in. Sammlung Prinzhorn der Psychiatrischen Universitätsklinik Heidelberg. Inv. 3115. Photo: Manfred Zentsch.

evocation of narcissistic disturbance incurred during the war and as a caution against fascist armoring of the ego thereafter.[16]

These connections will remain tenuous unless they are grounded in his artistic context. On his return from the war, Ernst is still an expressionist with a style marked by fantastic elements akin to Marc Chagall as well as social-critical aspects akin to Georg Grosz.[17] Back in Cologne, he becomes affiliated with the Expressionist Society for Artists directed by Karl Nierendorf, who also publishes the expressionist journal *Der Strom* (The Stream). However, like many of his generation, Ernst soon strays from expressionism, especially in the face of the radical events of winter 1918–19 (on November 9, the Kaiser flees; on January 15, the Spartacist leaders Karl Liebknecht and Rosa Luxemburg are murdered by mercenaries; on February 21, Kurt Eisner, socialist prime minister of Bavaria, is also assassinated). At this time Ernst begins to collaborate with Baargeld—first on a magazine, *Der Ventilator,* which is suspended by the British army of occupation in Cologne after six issues for its anarchistic rhetoric—and together they gravitate toward Dada.[18] Ernst had met Hans Arp before the war, and no doubt Arp reported on the exploits of Hugo Ball and Tristan Tzara thereafter; by mid-1918 Ernst also encounters Zurich Dada through publications. The critical literature stresses an epiphany that occurs a year later: together with Arp in Munich, in late summer 1919, Ernst sees reproductions of the "metaphysical" painting of Giorgio de Chirico and Carlo Carrà in a special issue of *Valori Plastici*—a discovery that Ernst later describes in uncanny terms ("as when an event already seen opens up an entire region of our personal world of dreams").[19] By this time, too, he had discovered the "mechanomorphic" work of Francis Picabia (whose celebrated drawing made of inked parts of a smashed alarm clock stamped on paper is reproduced in *Anthologie Dada* 4–5 in May 1919), and by fall 1919 Ernst shows this influence as well.[20]

Like his early combination of Chagall and Grosz, his new joining of de Chirico and Picabia is odd, even singular, yet it is also crucial to his cast of inhuman figures set in deranged spaces—work that will be seminal in turn to the visual vocabulary of surrealist art. At the time, however, these influences are not resolved, as is clear from the signal productions of Cologne Dada. Two shows

accompanied two publications titled *Bulletin D* and *Die Schammade,* both of which arise when Ernst and Baargeld run afoul of other exhibitions. In the first instance they are expelled, due to their new Dadaist sympathies, from a room devoted to the Society for Artists at a Kunstverein exhibition in November 1919; the Kunstverein director, Walter Klug, offers them a separate room (Room D, thus "Bulletin D," the D of which also signals Dada), and in good Dadaist fashion, Ernst and Baargeld exploit the controversy with a show that assembles a miscellany of African sculpture, drawings by children, art of the mentally ill, pictures by Sunday painters, and found objects of his own work. Ernst exhibits Chiricoesque paintings (*Aquis submersus* [1919], which depicts a strange homunculus before a cenotaphic pool, is the best known) and derivative assemblages that partake stylistically of Picasso, Arp, and Kurt Schwitters, but no collages as yet (at least, none are listed in the catalogue). However, perhaps his first collage of the sort at issue here is produced for the cover of *Bulletin D* at the time of this first exhibition (fig. 4.4). It shows, at lower right, two pneumatic line figures dancing (coupling?) upside down above an illustration of an engine cut from a magazine, and, at middle left, a drawing of a man in a flying machine. Already aspects of his Dadaist idiom are scattered across the page.

Not long afterwards, in February 1920, Arp is again in Cologne, where he assists Ernst and Baargeld on *Die Schammade,* which is published for their next Dada show in April. Again prompted by an exclusion, in this case from an exhibition at the Museum of Decorative Arts, the "Dada—Early Spring" show is the one Cologne event that has entered all Dada lore, in part because it is staged at a beer hall, in a courtyard accessed only through a public toilet. On the first day a girl in a white communion dress greets visitors with obscene poems, and Ernst displays an object with an ax attached, along with a note inviting visitors to destroy it (which they do several times over). He shows some twenty of his own works here: more Chiricoesque paintings and Dadaist assemblages, but also new bric-a-brac constructions that one reviewer calls "flower-pot sculptures," as well as such diagrammatic collages as *Hypertrophic Trophy, Erectio sine qua non,* and *Don't Smile.* The show is shut down for a day on charges of fraud and indecency: the setting provokes talk of homosexual activity, but the principal target turns

4.4. Max Ernst, cover of *Bulletin D,* 1919. 12¼ × 9⅜ in. The Menil Collection, Houston.
© 2003 Artists Rights Society (ARS), New York/ADAGP, Paris.

out to be a "flower-pot sculpture" whose full title runs *Old Lecher with Rifle Protects the Museum's Spring Apparel from Dadaist Interventions [l'état c'est MOI!] [Monumental Sculpture]* (fig. 4.5). Related to the well-known collage *The Hat Makes the Man* (1920), this long-lost figure was stuck together with wood rods and other odds and ends, given a stick-gun, and topped with a helmet-hat. At its crotch Ernst hung a tray splashed with red paint on which he also set a medallion with the Dürer engraving of *Adam and Eve*. Ironically, it was this use of a canonical image that brought in the police; no doubt, however, the crazy juxtaposition of things overall provoked the good citizens of Cologne—including his father, Philipp Ernst, a teacher of the deaf and the mute (a devout Catholic who painted religious pictures, he once depicted young Max as Christ). "I curse you," Philipp writes of the show in a letter that Max later cites, with Oedipal relish, on several occasions. "You have dishonored our name."[21]

This is the immediate context of the diagrammatic collages that concern me here. Begun in fall of 1919, they are not as materially heterogeneous as most collages by Schwitters: they are plate prints, pencil rubbings, or a combination of the two, with additional lines and inscriptions, all produced as if anonymously, almost automatically, from stereotypes, letter blocks, and other stock elements of the printing trade.[22] Occasionally these collages include line etchings taken from technical publications (usually renderings of engines or engine parts), and often they are tinted with watercolor and/or gouache. The collages make up an extended sequence (I will discuss only five or six); most of the extant ones involve schematic figures constructed from the aforementioned elements, which Ernst finds at a Cologne printer where *Der Ventilator, Bulletin D,* and *Die Schammade* are printed. My reading of these bizarre images is guided by the inscribed texts, which are garbled just enough to derange any conventional relation between work and title—just enough, that is, to render these images all the more bizarre. Of course, to find any meaning in these works is tendentious, and usually they are read as so much Dada nonsense. Yet this nonsense is purposeful not only in its disruption of conventional signification, but also in its imaging of both mechanistic bodies and quasi-schizophrenic subjectivities. For through this imaging,

4.5. Max Ernst, *Old Lecher with Rifle Protects the Museum's Spring Apparel from Dadaist Interventions [L'état c'est MOI!][Monumental Sculpture]*, 1920 (lost). © 2003 Artists Rights Society (ARS), New York/ADAGP, Paris.

the collages seem to pose a modern subject that is, on the one hand, diagrammatic, so many given elements to be designed and redesigned, and, on the other, dysfunctional, a bachelor machine which, as defined by Deleuze and Guattari, "interferes with the reproductive function of technical machines," and works "to short-circuit social production."[23]

The titles of two collages, *Le Mugissement des féroces soldats* (The Roaring of Ferocious Soldiers) and *Trophée hypertrophique* (Hypertrophic Trophy), point to a military-industrial subject, perhaps to an ego armoring of the fascist sort discussed above (figs. 4.6, 4.7). "The roaring of the ferocious soldiers" (provocatively enough, the phrase derives from the national anthem of France) suggests a loss of speech or reason, a becoming-animal or other—a trope that the surrealists will soon develop for a becoming-unconscious. Yet immediately after the war, such "roaring" indicates a becoming-machine or weapon (a caption—"Druck in kg. pro.gm" [pressure in kg. per gram]—also suggests an engine of some sort). However, there is nothing "ferocious" about the fragile contraption diagrammed here: its three parts are connected only by ink lines that evoke wispy belts, and the title is written around the thinnest of pulleys. One element, made up of two solid cylinders attached to two spindly wheels, appears twice—once in the lower half of the image, and again rotated 140 degrees in the upper right. The "soldiers" are completed by a third form, a small schematic of an internal combustion engine set in the upper left (this found illustration appears in other collages as well). Meshed as they are, the three soldiers suggest a Rube Goldberg contraption that has lost even the slight functionality of such devices. Stranded like stalled railway cars or suspended like a broken assembly line, these ferocious soldiers mock the military-industrial fantasies of a Marinetti or a Jünger. They also jab at the delusional claims rampant in postwar Germany of a nation "undefeated in war."[24]

Made up of calibrational devices as well as mechanical designs, *Hypertrophic Trophy* appears even more fragile than *Ferocious Soldiers*. Here, the becoming-machine or weapon is keyed by the title which, written at the bottom left like a legend in French, German, and English, seems to commemorate three of the national combatants of the Great War. From a reluctant soldier like Ernst, this commemoration can only be ironic—war dead as *trophies?*—yet such is the first

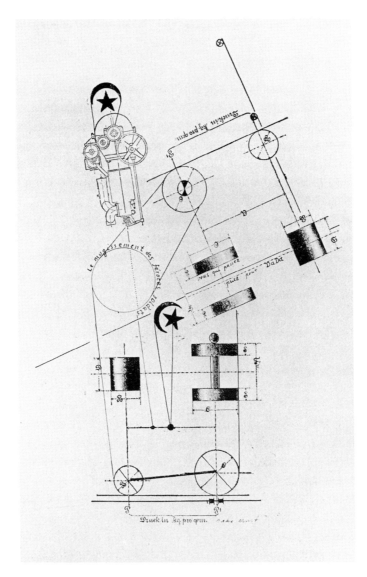

4.6. Max Ernst, *The Roaring of Ferocious Soldiers*, 1919–20. Proof of assembled printer's blocks with ink on paper, 14¹⁵⁄₁₆ × 10⅝ in. Collection Arturo Schwarz. © 2003 Artists Rights Society (ARS), New York/ADAGP, Paris.

4.7. Max Ernst, *Hypertrophic Trophy*, 1919–20. Lineblock with pen and ink, 13⅞ × 7⅛ in. The Museum of Modern Art, New York: Gift of Tristan Tzara. © 2003 Artists Rights Society (ARS), New York/ADAGP, Paris. Digital image © The Museum of Modern Art/Licensed by SCALA/Art Resource, New York.

definition of "trophy": "Arms etc. of vanquished enemy set up on field of battle or elsewhere to commemorate victory" (*OED*). In this definition, arms first vanquish the body, then represent it, and finally displace it; in effect, the trophy *is* the body transformed into armor. This play on the figure "trophy" is deepened by the term "hypertrophic." Of a different Greek root than "trophy" (*trophia* rather than *tropaion*), "hypertrophy" concerns the "enlargement (of organ etc.) due to excessive nutrition." "Hypertrophic trophy," then, suggests not only that the war has swelled the number of soldier-trophies, and so nourished death excessively (nothing could be more alien to the mysticism of the front indulged by the right), but also that it has armored the male body, and so turned it into a hypertrophic trophy. In play here, both formally and thematically, is the Dadaist strategy of mimetic adaptation, according to which one assumes a given condition—here the fascist armoring of the body—and inflates it through hyperbole (or "hypertrophy") in order to explode it bombastically or at least to deflate it parodically. "What we call dada is a farce of nothingness," Hugo Ball writes in *Flight Out of Time,* his extraordinary diary of Zurich Dada, "a gladiator's gesture, a play with shabby leftovers."[25] Yet, more than a form of adaptation, a technique of survival through camouflage in a hostile environment, this mimetic strategy is a kind of *exacerbation,* whereby an excessive identification renders the given condition absurd, or at least insecure. In effect, Ernst offers us not the hypostasis of the hardened ego as presented by a Jünger, but the buffoonery of "the bashed ego."[26]

This parodic presentation of the military-industrial subject is not only a riposte to fascist visions of war and masculinity. More generally, in keeping with Germanic Dada at large (including Zurich), it is an insult to the humanist ideals of art and individuality cherished by the classes that forced the war in the first place. "Our rage had to find some expression somehow or other," Ernst commented in retrospect. "This we did quite naturally through attacks on the foundations of the civilization responsible for the war." The intent is not quite to shock this civilization. "Contrary to general belief, Dada did not want to shock the bourgeoisie," Ernst continues. "The bourgeoisie was already shocked enough."[27] Rather, the intent is to work over this trauma—to work it over caustically rather than to work it through therapeutically.[28] This difference is intimated

in *The Roaring of Ferocious Soldiers,* where Ernst inscribes "vous qui passez priez pour DaDa" along one belt. This note casts "the roaring" in infernal terms ("you who pass pray for Dada"), yet it also suggests that Dada hopes to treat this trauma, to survive this hell, however futile, even farcical, this hope might be. In this guise, Dada both exploits the shock of the military-industrial for purposes of critical negation, and seeks to work over this shock—perhaps to "prepare" (as Freud wrote grimly of the symptomatic nightmares of World War I shock victims in *Beyond the Pleasure Principle*) for a trauma that has already come.[29] "The artist as the organ of the outlandish threatens and soothes at the same time," Ball writes in *Flight Out of Time.* "The threat produces a defense."[30]

In *The Roaring of Ferocious Soldiers* and *Hypertrophic Trophy,* then, a historical mechanizing of the male body is pushed to the point of parodic excess. In *Petite machine construite par lui-même* (Self-Constructed Little Machine), this mechanizing is seen to penetrate the very biology of the body (fig. 4.2). Here the "self" is literally schizo, split into two small "machines," "constructed" from print plates and pencil rubbings over blocks (letter and other), again all found at the Cologne printer.[31] On the left is a figure with a roulette wheel for a head (only the red numbers appear); on the right is a tripod whose head resembles the bellows of a camera or the mount of a gun. Below runs a nonsensical text in German and in French. The garbled French reads: "Petite machine construite par lui-même/ il y mélange la salade de mer la sperme / de fer le périsperme amer de l'une côté / nous voyons l'évolution de l'autre l'ana- / tomie ça coute 2 sous plus cher." This might be translated literally as: "Self-constructed little machine: it mixes sea salad, iron sperm, a bitter perisperm on the one side; on the other we see the evolution of the anatomy, that costs 2 sous more." One is reminded of the dysfunctional machines and semi-anagrammatic puns of Picabia and Duchamp as well as of Raymond Roussel, the idiosyncratic French writer whom Ernst also admired; yet there might be another association here more particular to Dadamax. In his account of "dementia praecox," Kraepelin (whom, again, Ernst had read before the war) disparaged schizophrenic representation as "word or picture salad," and manifestly this work is both: "il y mélange la salade" verbal and visual.[32] Allusively schizophrenic in this way, the collage struggles to describe a "self-constructed

little machine," perhaps to evoke what it feels like *to be* such a schizo machine. "On the one side" (perhaps the left) is an "anatomy" that mixes "sperm" and "salad" in a "perisperm" (a tegument that covers seeds like a protective shell or shield). In this light, the work reads as an imaging of a particular kind of conception, an autogenesis, in which the self is constructed like a machine, even as a machine, through a technological conjunction that substitutes for a biological origin. As we saw in chapter 3, such fantasies of machinic creation outside the maternal body are a staple of modernists across the political spectrum, but they are pronounced in figures like Marinetti.[33] Here, as in other Dadaist machines, these fantasies are mocked: the "self-construction" is an abortion, the figure is divided and dysfunctional, even its gender is ambiguous (a similar figure is announced as feminine in *Femme Belle et Femme Debout* [Beautiful Woman and Upright Woman]). In this regard, the phrase *la salade de mer* also evokes, through *mère,* a "mother salad" and, through *merde,* a "shitty mess," and, as in childhood theories of conception, this "self-construction" conflates the sexual and the scatological as well. This play with regression is as characteristic of Dada as the strategy of mimetic adaptation; here the two are bound up with each other.

On the one hand, then, the sexual-scatological mocks the mechanical; on the other, the mechanical is seen to penetrate the sexual-scatological—not only in the mechanical construction of the figure, but in its very species-substance as a machine whose "sperm" is "iron." In this way, *Self-Constructed Little Machine* points to a historical armoring of the body, an "evolution" of "anatomy," which has become almost genetic. In chapter 3 we saw that the hypothesis of a "protective shield," the exterior layer that an organism extrudes as protection against excessive stimuli, was a modernist fiction that operates in thinkers as diverse as Freud, Benjamin, Marinetti, and Lewis.[34] It can be glimpsed in Ernst, too, but again, in Dadaist fashion, he presents it excessively, parodically, as a "bitter perisperm" or a "hypertrophic trophy." *Self-Constructed Little Machine* suggests that, under the shocks of industrial war and capitalist exchange (as at a freak show we are invited to take in this anatomy "on the other side," perhaps the right, for "2 sous more"), the male body has become an instrumental camera or gun. Paradoxically, however, this very instrumentality renders it dysfunctional as a body

image, and this dysfunctionality points to the psychic resonance here. For the collage intimates an autistic system: this "self-constructed little machine" evokes a protective shield or an armored body of a schizophrenic sort—a machinic substitute for a damaged ego that only debilitates this ego all the more.[35]

Two further collages also nuance the historical armoring of the male body in psychic terms. *Ça me fait pisser* (That Makes Me Piss) diagrams another fantastic engine or pump (it is topped by the same schematic of a combustion engine that appears in *The Roaring of Ferocious Soldiers*), and together title and image posit the male body as little more than a mechanical or hydraulic penis (fig. 4.8). At the same time, the diagram also resembles an elevation of a tower with four levels crowned by a star, a skyscraper or *gratte-ciel,* with the words LE GRATTE-POPO inscribed atop its second stage. Like other neologisms in Ernst, this one appears both nonsensical and multivalent. On the one hand, it grounds the meanings of the image in its production (*gratter papier,* to scratch paper), which Ernst liked to sexualize. (In *Beyond Painting* he relates his signature techniques—collage; "frottage," an image produced through rubbing; and "grattage," an image produced through scratching—to a hallucinatory erotics of image-making.)[36] On the other hand, "le gratte-popo" twists the phallic aspect of this skyscraper toward both "skin" scratcher (*peau* is "skin" in French) and "ass" scratcher ("popo" is German slang for "ass"). An ass-scratcher that makes me piss: this is yet another Dadaist figure of a derangement of bodily functions and/or a regression in psychosexual stages. *Gratter* also means "to cross out," and *popo* recalls "papa" too: in this light, the phallic tower is not only mocked in scatological terms, but also challenged in pre-Oedipal terms. In short, this "father-scraper" might imply a crossing out of the paternal image, a defiling of the symbolic order.

The pendant to *That Makes Me Piss* is *Adieu mon beau pays de Marie Laurencin* (Farewell My Beautiful Land of Marie Laurencin; fig. 4.9). Another tower in elevation, it is topped by the same schematic of the combustion engine, here tilted like an artillery gun in a way that makes the whole resemble less a mock skyscraper than a schematic weapon, a missile-tank. Moreover, its inscriptions— the allusion to the French artist Marie Laurencin as well as the phrase MAMAN

4.8. Max Ernst, *That Makes Me Piss,* 1919.
Stereotype print with pen and ink on paper,
19¾ × 8 in. Collection Arturo Schwarz.
© 2003 Artists Rights Society (ARS), New
York/ADAGP, Paris.

4.9. Max Ernst, *Farewell My Beautiful Land of Marie Laurencin,* 1919.
Rough proof from assembled printer's plates, pen and ink on paper,
15¾ × 11 in. The Museum of Modern Art, New York. © 2003 Artists
Rights Society (ARS), New York/ADAGP, Paris. Digital image © The
Museum of Modern Art/Licensed by SCALA/Art Resource, NY.

TOUJOURS FJC-TICK atop its second stage—seem to gender it female.[37] Private associations are certainly possible, but the psychology of the work is not only personal, for just as *That Makes Me Piss* suggests a parodic version of the paternal image, *Farewell My Beautiful Land* suggests an ambivalent representation of the maternal body—the maternal body as a fantasmatic object of infantile aggression. It evokes a nightmarish fantasy of the sort detected in disturbed children by Melanie Klein—the maternal body as a destructive weapon made up of stone organs and machine parts exposed to view—a fantasy that, as in Klein, seems to threaten the little subject who projects it ("Help!" is scribbled in German and French around the image). Despite the "beautiful land" of the title, the work seems to express fear, even hostility (the inscription "Mama Always Fjc-Tick" sounds obscene as well).

However obliquely, Ernst refers the historical armoring of the body evoked in *The Roaring of the Ferocious Soldiers* and *Hypertrophic Trophy* to a psychic deforming of the subject in *Self-Constructed Little Machine, That Makes Me Piss,* and *Farewell My Beautiful Land.* In each collage he associates a dysfunctional machine with a narcissistic disturbance, as if the machine were an attempt to image the disturbance and/or to rectify it—an attempt that, again, only debilitates the damaged subject further. In effect, Ernst juxtaposes historical *reification,* in the military-industrial development of the subject, with psychic *regression,* in a pre-Oedipal disordering of the drives; more, he associates the two processes, puts them into play together, allusively but critically. Of course, these two notions are in great tension—reification (as thought by Georg Lukács) involving broad historical agencies, regression (as thought by Freud) concerning particular psychic states—but it is this kind of tense connection between the social and the subjective that Ernst invites us to think. In doing so, he offers a bitter riposte to reactionary modernists like Jünger, Marinetti, and Wyndham Lewis, who (as we saw in chapter 3) worked to transvalue reification and regression alike, to turn them into the ecstatic condition of a "new ego" or a "cold consciousness." At the same time, these collages mock a more general faith in the "evolution" of a modern "anatomy," in the "construction" of a new "self."

THE HAT MAKES THE MAN

Four of the five collages discussed thus far include stock symbols found at the Cologne printer—a little star and, in one instance, a little sun. Usually set atop the vertical figures, they suggest symbols of the military, party, or state—placeholders for different regimes of the time. But they might also stand in for different subjects of the time, interpellated as soldiers, party members, or bureaucrats, as so many cogs in the machine of a given regime (the trope of the nation as machine is soon common enough). The sheer blankness of the symbols suggests the violent arbitrariness of this interpellation: in these collages, figures are literally imprinted and/or constructed out of letter blocks (out of language, no less), but again in a dysfunctional way—bachelor machines that do not mesh with either the meanings or the mechanisms of the state.

Ernst once cited this account of his work with apparent approval: "His art is neither realistic nor abstract but emblematic."[38] This emblematic quality pertains not only to the stock symbols but also to the diagrammatic elements of the early collages. The operation of a diagram is to abstract a reality in order to communicate it conceptually or to reconceive it programmatically; often, then, a utopian projection is implicit in this kind of representation. At the same time, a diagram works to control this reconceived reality, so it could be said to carry a dystopian potential as well. Perhaps this doubleness is irreducible in diagrams; certainly both principles seem immanent to some radical diagrams within modernist art (e.g. some of the late "Architekton" models of the suprematist Kazimir Malevich, or some of the "New Babylon" drawings of the situationist Constant). In this light, the Ernst collages might not only mock the fascist visions of a Marinetti or a Jünger, but also question the utopian proposals of a Tatlin or a Lissitzky: *That Makes Me Piss* and *Self-Constructed Little Machine* might then be read as parodies of such near contemporaries as *Monument to the Third International* of Tatlin and *The New* of Lissitzky (fig. 3.3). As we saw in chapter 3, all these modernists are prompted by the new forces of the Second Industrial Revolution, especially in means of transportation and representation, and most view these new techniques as triumphant prostheses, as the making of modern types of machinic

movement and vision. In his Dadaist collages, however, Ernst seems to present this "machine vision" as a regressive reification, regardless of the political inflection—capitalist or socialist, fascist or communist. "On the one hand, a tottering world in flight, betrothed to the glockenspiel of hell," Tzara writes in his "Dada Manifesto" (1918); "on the other, new men."[39]

The Ernst figures totter toward failure more than flight; indeed, his roaring soldiers, hypertrophic trophies, and self-constructed little machines point to phallic regimes in distress. Such figures recur in all his work of the time; *Die Schammade,* the publication that accompanies the "Dada—Early Spring" show, is especially telling in this regard. On its title page, over the simple legend "Dada," appears another self-constructed disaster, a fragile tower made up of stereotype prints; and under the title *die schammade* runs the phrase *dilettanten erhebt euch* (dilettantes rise up; fig. 4.10). This pathetic call seems to mock dilettante artists who pretend to revolutionary insurrection, ambivalent avant-gardists who remain dandyish. But then Dada is not free of dandyism either; Ball once defined it as "a synthesis of the romantic, dandyistic and daemonistic theories of the nineteenth century," with Baudelaire and Nietzsche in mind.[40] In this light, Ernst might be implicated in his own mockery of the dilettante. Perhaps, after the failed revolts of November 1918, there seemed to be little alternative, at least in Cologne, to a dandyish kind of ambivalent critique. In any case, his tower figures suggest a political impotence that implies a sexual impotence as well, as if these dilettantes fail to "rise up" in that sense too. The title of the tower-pump, *That Makes Me Piss,* evokes penile dysfunction, and the title of another collage with two meshed figures is more explicit: *Erectio sine qua non* (1920), literally "erection without which nothing," or indispensable erection (a play on the Latin formula *conditio sine qua non,* or indispensable condition). One of these figures has a little spigot for a penis with a blood-red drip, a detail that is repeated in the collage *minimax dadamax selbst konstruiertes maschinchen* (minimax dadamax self-constructed little machine) in a way that associates this condition, in which penile dysfunction bleeds into outright castration, with his own alter ego, Dadamax.[41] As we have seen, this bloody mark is also present in the assemblage *Old Lecher with Rifle* (where it is associated with *Adam and Eve,* that is, with the Fall), and this

4.10. Max Ernst, title page of *Die Schammade,* 1920. Spencer Collection, The New York Public Library, New York. © 2003 Artists Rights Society (ARS), New York/ADAGP, Paris. Photo: The New York Public Library/Art Resource, New York.

condition casts other figures like *The Roaring of Ferocious Soldiers* and *Hyper-trophic Trophy* in a new light as well: they all present different scenarios of "phal-lic divestiture."

In her formulation of the male masochist, Kaja Silverman defines phallic divestiture in these terms:

> He acts out in an insistent and exaggerated way the basic conditions of social subjectivity, conditions that are normally disavowed; he loudly proclaims that his meaning comes to him from the Other; prostrates himself before the Gaze even as he solicits it, exhibits his castration for all to see, and revels in the sacrificial basis of the so-cial contract. The male masochist magnifies the losses and divisions upon which cultural identity is based, refusing to be sutured or rec-ompensed. In short, he radiates a negativity inimical to the social order.[42]

Such divestiture is fundamental to much Dada; in a sense, it is the sexual compo-nent of its strategy of mimetic adaptation to military-industrial reification and psychosocial regression. The term *Die Schammade* seems to name this divestiture and to clinch this strategy for Ernst in particular. The word is one of the slip-periest of his neologisms. Hans Richter, a veteran of Zurich Dada, heard both *Schamane* (shaman) and *Scharade* (charade) in the term, a reading perhaps closer to the world of Ball than to that of Ernst (though here they are close enough); again, Ball performs Dada precisely as the shaman of a charade, of "a play with shabby leftovers," a kind of sham or scam.[43] Werner Spies reports that Ernst in-tended the term to be "purposely defeatist in tone": a *Schammade* is a bucolic mel-ody, and "the phrase *Schammade schlagen* . . . means to sound the drum or trumpet signal for retreat."[44] This melancholic surrender suits our picture of phallic dives-titure, but a further combination is possible as well—of *Scham,* which means both "shame" and "genitals" (a tell-tale association that must have pleased Freud), with *Made,* which means "maggot." This reading of the neologism gives us a nasty im-age of maggoty pubes, of wormy penises and rotten vaginas, perhaps with a hint

of "maggoty shame" as well (along the lines of the "agenbite of inwit" coined by James Joyce in *Ulysses* [1922]).[45]

There is other support for this reading. Baargeld included a junk assemblage with the apposite title *Anthropophiliac Tapeworm* in *Die Schammade*, on the cover of which Ernst listed his collaborators along a "Dadameter" made up of the term *die Schammade*—as if to associate Dadaists with a maggoty mess directly and/or to measure phallic failure, mock-scientifically, with a meter. A similar Dadameter appears in his self-portrait *dadamax maximus* (1920), the photocollage also known as *The Punching Ball or the Immortality of Buonarroti* (fig. 4.1). Here a handsome young Ernst (his photograph is inscribed "dadamax") gazes out at us from behind the head of a repellent old man flayed for anatomical study (this smaller photo is inscribed "caesar buonarroti," as in Michelangelo Buonarroti) set in turn on the bust of woman in a strapless white gown (an alien hand attached to her body holds the Dadameter). Often juxtaposed with a photomontaged self-portrait of Baargeld with his head atop the Venus de Milo, *The Punching Ball* has as much in common with *L.H.O.O.Q.* (1919), the goateed Mona Lisa of Duchamp. Here, rather than a mocked Leonardo ("L.H.O.O.Q." sounds like "she has a hot ass" in French), Ernst gives us a Michelangelo stripped bare; but, as with the goateed Mona Lisa, there is gender trouble: "buonarroti" appears in drag. This trouble might extend to the paternal function as well, for "buonarroti" is also identified as "caesar," an ultra-patriarch. As with *L.H.O.O.Q.*, then, a revered icon of Western art is turned into a pilloried image, even a circus freak: art history as *cadavre exquis,* the classical tradition as "punching ball."[46]

Ernst also foregrounds phallic divestiture in his "flower-pot sculptures" of the period, perhaps inspired by "the bread-crumb sculptures" of the mentally ill that he may have seen in Bonn before the war. Ernst makes several figures of various sizes along the lines of *Old Lecher with Rifle,* figures that we know today mostly through grainy photographs in Dada publications. Stuck together out of wood rods and metal curlicues, *Objet dad'art* (1920; fig. 4.11), which appears in *Die Schammade,* is another hapless personage. So too is *The Little Virile Tree,* and the title of *Bone Windmill of Powerless Hairdressers* (which is all that remains) suggests that it is one as well. Like others in this loose group, these rickety figures mock any pretense of phallic autonomy, let alone any fantasy of autogenetic

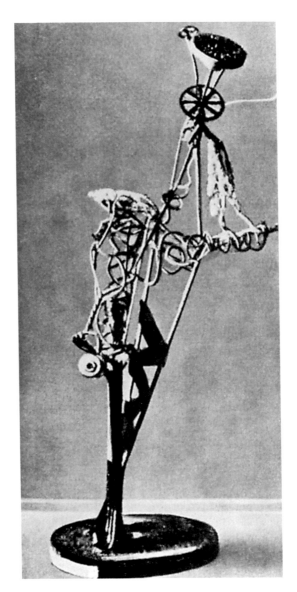

4.11. Max Ernst, *Objet dad'art,* c. 1920 (lost). Assemblage
reproduced in *Die Schammade* (Cologne, 1920). 12³⁄₁₆ × 9⅞
in. Collection Timothy Baum, New York. © 2003 Artists
Rights Society (ARS), New York/ADAGP, Paris.

creation.[47] This is also true of another lost construction; exhibited along with *Bone Windmill of Powerless Hairdressers* in the "Dada—Early Spring" show, *Phallustrade* was made up mostly of doll parts, apparently along the lines of the four unsteady stacks of semi-animate hats and hat-blocks tinted in different colors in *The Hat Makes the Man* (1920; fig. 4.12, pl. 6).[48] Another provocative neologism, "phallustrade" is a contraction of "phallus" and "balustrade"; indeed, in *Beyond Painting* Ernst uses the word to model his conception of collage as "the unexpected meeting of two or more heterogeneous elements."[49] Might this also be how he remembers his early sequence of collages and assemblages—as a parade of penile stick-figures, of phallic imposters?

Like *die Schammade,* "phallustrade" conjures up a pathetic charade, a play with shabby leftovers. Once more the term points to phallic divestiture, perhaps effected here through a parodic excess of penile forms, a "hypertrophy" that only exposes deficiency and dysfunction. As we have seen, Ernst often evokes castration in these works: thematically, in the blood-red drips of his penis-spigots; formally, in the failed postures of his pathetic figures; and procedurally, in the castrative cuts and fetishistic accumulations of the making of the collages and assemblages. Paradoxically, the excess of penile forms in *The Hat Makes the Man* and *Phallustrade* is another way to evoke castration. In "Medusa's Head" (1922), Freud argues that any fetishistic "multiplication of penis symbols" might only declare what it seeks to deny, namely, the lack of the penis, castration. Such is the double import, he continues, of the snaky hair of the Gorgon Medusa: castration is revealed in the very fetishistic attempt to conceal it.[50] So it is too, perhaps, with the phallustrade figures of Ernst. If the hat makes the man, then it follows that without the hat the man is little; that is, without his phallic embellishments, his hypotrophic trophies, the man is deficient. (As the Lacanian psychoanalyst Eugénie Lemoine-Luccioni writes, "if the penis were the phallus, it would have no need of feathers or ties or medals."[51]) Such virile display is most pronounced in fascist subjects, and here the phallic politics of Marinetti and others is also mocked by the pathetic phallustrades of Ernst.

If Picabia gives us "daughters born without a mother," then Ernst offers us sons born without a father—or, more precisely, sons born against the father.

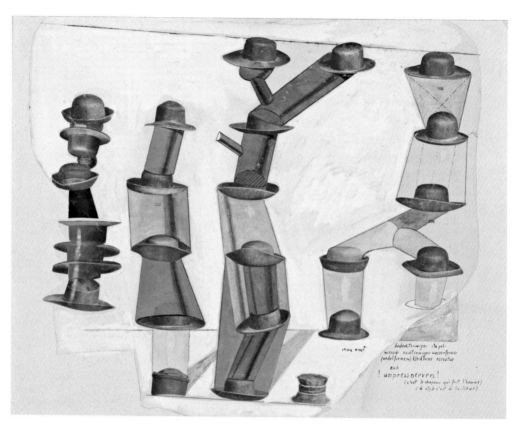

4.12. Max Ernst, *The Hat Makes the Man,* 1920. Cut-and-pasted paper, pencil, ink, and watercolor on paper, 14 × 18 in. The Museum of Modern Art, New York. © 2003 Artists Rights Society (ARS), New York/ADAGP, Paris. Digital image © The Museum of Modern Art/Licensed by SCALA/Art Resource, New York.

More than once Ernst titles his figures "ambiguous," as if to indicate an uncertainty of form that also bespeaks a confusion in identity. But often in this confusion his figures are more than "ambiguous"; they are perverse—perverse in the sense (developed in chapter 2) of *père-verse,* turned against the father. Again, like the bachelor machine defined by Deleuze and Guattari, they work against normative reproduction. "Childhood knows Dada," Ernst remarks in *Beyond Painting,* but by the same token Dada knows daddy, and kidnaps him to the nursery.[52]

Ernst also intimates "male trouble" in *Fiat modes, pereat ars* (1919; fig. 4.13). This sequence of eight lithographs traces the strange metamorphoses of two featureless figures, a male tailor and a female model that are the most direct progeny of his joining of the mannequins of de Chirico and the mechanomorphs of Picabia in fall 1919. Announced by another diagrammatic tower on its cover, the sequence is not a coherent narrative, but the title ("FIAT MODES" in capital letters, "pereat ars" in tiny script) keys our reading. Another Dadaist inversion of a familiar saying, it transforms "let there be art, life is fleeting" (*fiat ars, pereat vita*) into "let there be fashion, art is fleeting." Here, then, fashion has replaced art as the human approximation of immortality: in a way that parallels German critics of his extended generation (Lukács, Benjamin, and Adorno), Ernst implies that fashion has become eternal in its very transience (the ever-new as the ever-same), a "second nature" to whose laws the (bourgeois) individual is subject.[53] *Fiat modes* is thus more than a general attack on humanist ideals of art; it is a particular tale about the "fashioning" of the self, or, as the inscription has it, "the hat makes the man, style is the tailor." As with *The Hat Makes the Man,* the male tailor is also caught up in this fashioning, manipulated no less than the female model as so many parts. This set of transformations looks ahead to the perverse variations that Hans Bellmer wrought on his dolls (see chapter 6); at the same time, the deranged space in *Fiat modes* looks back to de Chirico.[54] By the penultimate lithograph, the two figures seem to be combined in one bulbous creature with a little penis (fig. 4.14). This large ridiculous figure in the foreground is diagrammed by an irrational perspective that seems to be controlled by a small sinister figure housed in a schematic cone with cavities and shadows in the background. This image is another Chiricoesque derangement of Renaissance space with a smutty Dadaist

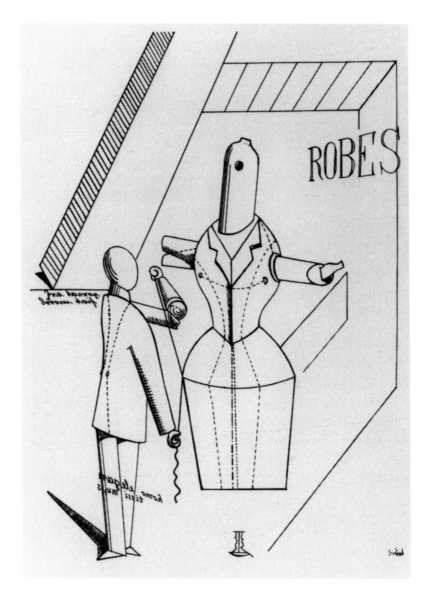

4.13. Max Ernst, *Fiat modes, pereat ars,* 1919–20. #1 in a portfolio of eight lithographs, 7³⁄₁₆ × 12⅝ in. Collection Timothy Baum, New York. © 2003 Artists Rights Society (ARS), New York/ADAGP, Paris.

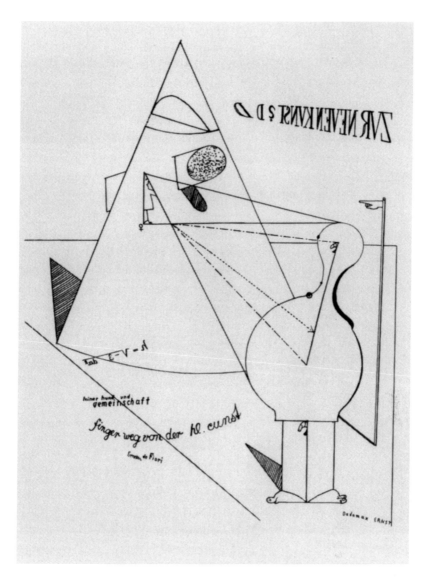

4.14. Max Ernst, *Fiat modes, pereat ars,* 1919–20. #7 in a portfolio of eight lithographs, 7³⁄₁₆ × 12⅝ in. Collection Timothy Baum, New York. © 2003 Artists Rights Society (ARS), New York/ADAGP, Paris.

jibe at high art thrown in, for inscribed by the large figure is the phrase *finger weg von der hl. Cunst,* or "hands off holy art" (perhaps with an undertone of "hands off holy cunt"), an ironic plea to halt the degradation of art by the likes of Ernst. Another inscription inflects the image further: "ZUR NEUEN KUNST?" (Towards a New Art?) follows, in reverse script, the space of the image as it plunges into the distance. This is an ambiguous gesture: it might suggest an additional target—not only Renaissance perspective but its modernist transcendence in abstract space as proposed, say, by Lissitzky ("Towards the New Art" was the motto, UNOVIS the acronym, of a group of Russian artists formed around Malevich at the very moment that *Fiat modes* was made).[55] Here the reification of the subject appears to be total, without redress even (or especially) in radical art.

In *Fiat modes,* reification appears as a reciprocal process of subject and object, as indeed Lukács would argue three years later in *History and Class Consciousness* (1923). In his account of reification, which fuses Marx on commodity fetishism with Max Weber on rationalization, Lukács considers the effects of industrial production as transformed by Taylorist regimes of work, which were introduced into Germany just before World War I.[56] On the assembly line, he argues, the bodily integrity of the worker is broken up as much as the organic unity of the product, and the worker becomes "a mechanical part incorporated into a mechanical system."[57] In *Fiat modes,* Ernst (who once worked briefly in a hat factory owned by his father-in-law, Jacob Straus) implies that this kind of reified fragmentation occurs in consumption as well as in production. Again, *The Hat Makes the Man* is the complementary work here, for its "men" are also both mechanical (they resemble four pistons) and commodified (they are nothing but hats). In fact, Ernst gives *The Hat Makes the Man* an inscription that reads like a crazy litany of many of his concerns at this time. It appears first in German, and translates roughly as: "seed-covered stacked-up man seedless water-former well-fitting nervous system also tightly-fitted nerves!" And then in parenthetical French: "the hat makes the man, style is the tailor."[58] Once more, in the schizophrenic language of a subject damaged by the process, the inscription points to the evolution of a new kind of man, with a new sort of nervous system—armored, mechanical, mass, sterile, constructed out of standard parts and commodity images, a "mass ornament" of one.[59]

This irrational rationalization is a recurrent theme in the early collages. It is also a formal operation, for Ernst puts his own kind of mad mechanization to work here: as noted above, his images are often made up of standard parts (stereotype prints and letter blocks) repeated from figure to figure and/or from work to work. In a sense, the collages perform a mechanization not only of bodily form but of artistic procedure, with different marks that are semi-automatic—printed and stenciled, rubbed and stamped. Almost always his pen and pencil additions also conceal his hand (Ernst often photographed his collages to this same end), and, however absurd, his texts sound semi-automatic, too, in the manner of the anagrammatic readymades of Roussel and Duchamp. As Benjamin would argue famously, the modern work of art is not only subject to mechanical reproduction; it also adjusts to this modality, becomes predesigned, as it were, for it. Ernst suggests this process with images that are (de)constructed almost serially, as if on an assembly line; and again this mimetic adaptation to industrial production and/or mechanical reproduction is pushed to a parodic point: both procedure and appearance become Frankensteinian, and the subject that they project is schizo.[60]

Perhaps the apparent oppositions here between the rational and the irrational are mediated by *chance*. Several collages, for example, contain images of roulette wheels (fig. 4.2). Yet if these wheels are images of chance, they are not opposed, say, to machines as images of order, for sometimes the two are combined, as in *Self-Constructed Little Machine, vademecum mobile be all warned,* and *Canalization of Refrigerated Gas* (c. 1919–20), where roulette wheels merge with bicycle wheels (an early allusion to Duchamp?). Sometimes, too, images of bodily organs are also included, as if to imply that chance and order cannot be opposed at the level of the body either, or that the body is equally implicated in both. Despite common opinion, chance and order are not opposed in Dada (not to mention in surrealism); rather, they are revealed to be bound up with each another, to determine one another. This imbrication of the two is demonstrated in numerous works from Duchamp to André Breton and beyond, and the demonstration is not only philosophical, for it also reflects on an important aspect of this capitalist epoch. "Where would one find a more evident contrast than the one between work and gambling?," Benjamin asks in "On Some Motifs in Baudelaire"

———

(1939), written at a time when Dada was much on his mind. Yet, as Benjamin suggests, this contrast between regimes of order and chance is only apparent: the automatic dimension of capitalist production and consumption "reconciles" them in a way that Baudelaire already glimpsed in his tableaux of modern Parisians. "The jolt in the movement of a machine is like the so-called coup in a game of chance," Benjamin continues. Both the worker and the gambler "live their lives as automatons"—that is, they confront repetitions that, though expected, surprise them nonetheless—and "the work of both is equally devoid of substance."[61]

Some of the early collages of Ernst point to a similar condition. Look once more at the figures in *Self-Constructed Little Machine* (fig. 4.2): they resemble strangely animate cameras or guns—or perhaps both, as if the body were retooled as a photographic rifle. In the late 1870s, the French physiologist Étienne-Jules Marey devised the *fusil photographique* to capture the mechanical dynamics of the body in motion, and like many other modernists (Duchamp, certain futurists), Ernst was interested in the "chronophotography" that resulted (in his later collage-novels he uses related illustrations drawn from the scientific magazine *La Nature,* where Marey published his images). Such time-motion studies of the body in the last decades of the nineteenth century prepared "the scientific management of labor" in the first decades of the twentieth. Perhaps Ernst alludes to this development of the body as examined by devices like the camera-gun and reconfigured according to its specifications. In any case, he implies that the body might also be transformed into such a device, that its vision might become a machine vision. In this light, the ultimate target of his dysfunctional figures might be not the futurist fantasies of a "new ego," much less the constructivist diagrams of a "new man," but the Taylorist-Fordist (dis)assembly of the worker that, adopted by many regimes of this time, subtends all these modernisms.

KILLING BY TEMPERATURE

In 1920 Ernst adds more procedures to his Dadaist repertoire: he collaborates with Arp and Baargeld on collages called "Fatagagas"; he combines collages with photographs and illustrations; he makes photographic enlargements of some

works; and, most importantly, he develops his "overpaintings." These small pieces are made up of found images, usually illustrations of scientific devices cut whole or in part from instructional catalogues, which Ernst then variously draws over, obscures, and deranges with paint (a few are discussed in chapter 5).

Along with this shift in technique comes a shift in theme: rather than the diagrammatic figures of the print collages, deathly organisms often appear in these works, and they are often set in spaces that resemble geological sections and subterranean realms (fig. 4.15).[62] In short, the dysfunctional men and stalled engines of the print collages cede to industrial fossils and entropic landscapes in the overpaintings, as if the regression and reification of the individual had become the devolution and heat-death of the world, as if the "colder consciousness" of the armored subject had permeated nature to its core. As with prior work, this theme is also worked through the procedures and in the inscriptions: if the print collages suggest an "imprinting" of diagrammatic figures, the overpaintings suggest an "embedding" of deathly beings—as so many remains that have resurfaced almost uncannily, as though unburied in a general wearing away of the world.[63]

Images of flayed bodies, human and animal, appear in works like *Young Man Charged by a Flourishing Fagot* and *Song of the Flesh—the Shitting Dog* (both c. 1920), and sometimes these bodies harden into outright dissections and skeletons, as in *Stratified Rocks, Nature's Gift of Gneiss Lava Icelandic Moss . . .* (1920; fig. 4.15), in which sectional images of horse organs make up the grotesque figures of a barren world. Occasionally Ernst intimates a deathly chiasmus whereby organic forms appear mechanical and vice versa (*Slightly Ill Horse—the Beautiful Season* [1920], for instance, is assembled in part out of machinic elements), and he underscores this organic-mechanical convergence with various inscriptions (such as "antediluvian machinelets" and "vulcanized iron bride") that imply that this industrial world has devolved to a primordial state. Sometimes, too, "ambiguous figures" preside over his Dadaist wastelands like so many fisher kings beyond redemption, as in *1 Sheet of Copper 1 Sheet of Zinc 1 Sheet of Rubber . . . Two Ambiguous Figures* (c. 1920). Although he was not immune to the mythological temptations of his artistic generation, Ernst invokes myth here mostly to mock its transcendental motives. In one inscription that frames a grim picture of

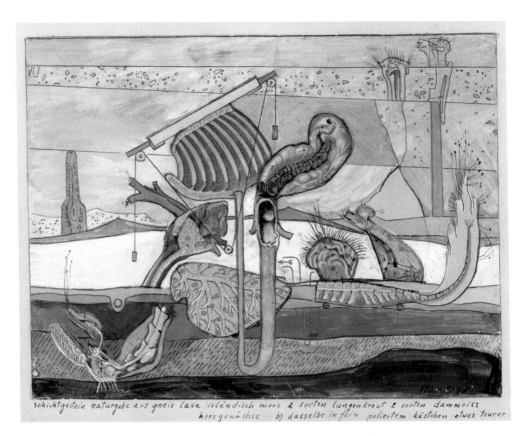

4.15. Max Ernst, *Stratified Rocks, Nature's Gift of Gneiss Lava Icelandic Moss . . .* , 1920. Gouache and ink on printed reproduction mounted on paperboard, 6 × 8⅛ in. The Museum of Modern Art, New York. © 2003 Artists Rights Society (ARS), New York/ADAGP, Paris.

broken gears in an underground world, he appeals to "the Landlady on the River Lahn" as the "guardian angel of the germans": "yours is industry anatomy pale-ontology, grant us little jubiliations." Here the old myth of the Rhine, as revived by Richard Wagner in *The Ring,* with its great Teutonic heroes, becomes a new myth of the Lahn, with its very different sort of "industry anatomy paleontol-ogy." In his own version of romantic anticapitalism, Ernst presents his world as wasted by a military-industrial Ice Age.

Some overpaintings do draw on one modern mythic narrative—that of entropic heat-death. In *Winter Landscape: Carburation of the Vulcanized Iron Bride for the Purpose of Producing the Necessary Warmth in Bed* (1921), Ernst takes a dia-gram for the production of nitrogen and nitric acid, turns it upside down, and paints it over to create a desiccated landscape above and below level. Whatever "carburation" occurs in the tubing underground does not generate "the neces-sary warmth" above ground: its trees are dead, its chimneys cold, and everything appears "vulcanized."[64] *Hydrometric Demonstration of Killing by Temperature* (1920; fig. 4.16, pl. 7) is also based on a page of diagrammatic instruments—in this case, devices used to measure the pressure of fluids—which is inverted and painted over to produce colored cones and cylinders that appear as so many mad scien-tists or "hydrometric" murderers of the world. In such works Ernst plays with the vision of entropy, the dark side of the thermodynamic model of the world as mo-tor, which obsessed his entire generation of war-worn Europeans.[65] In the middle of the nineteenth century, as the historian Anson Rabinbach has demon-strated, this thermodynamic model produced enormous excitement about the energistic potential of the world, at a time of great industrial expansion and bour-geois confidence. However, amid new fears of cultural degeneration at the end of the century, this same paradigm produced enormous anxiety about its en-tropic consequences. Exacerbated by World War I, this cultural anxiety turned to historical pessimism, a "decline of the West" argued most famously by Oswald Spengler in his tome of that title (the first volume was published in summer 1918, the second in 1922: it thus straddles the Ernst work at issue here).[66] In "this meta-physics of a collective soul which develops and dies like a plant," cultural decay is as necessary as biological decay, and "history becomes transformed into a second

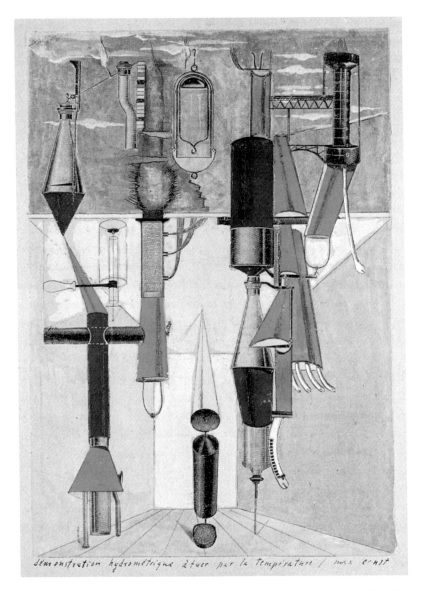

4.16. Max Ernst, *Hydrometric Demonstration of Killing by Temperature,* 1920. Gouache, ink, and pencil on printed reproduction, 9⁷⁄₁₆ × 6¹¹⁄₁₆ in. Private collection. © 2003 Artists Rights Society (ARS), New York/ADAGP, Paris.

nature, as blind, closed, and fateful as any vegetal life."[67] In his overpaintings Ernst depicts "natural history" in similar terms (which might almost qualify them as "history paintings"). But is he not then implicated in this cultural pessimism, in which romantic anticapitalism verges on reactionary modernism? He is so implicated, but once again Ernst turns his implication to critical ends, for he pushes this Spenglerian world-view to a parodic extreme: his overpaintings literalize—indeed, magnify—the entropic "Contours of a Morphology of World History" (the subtitle of *Decline of the West*), make it hyperbolic or "hypertrophic." Once more the Dadaist strategy of mimetic exacerbation is in play. In 1920, the year when the overpaintings were initiated, Freud also extrapolated the second law of thermodynamics into his own theory of the death drive, defined in *Beyond the Pleasure Principle* as "the expression of the inertia inherent in organic life."[68] In chapter 3 I suggested that reactionary modernists like Marinetti and Lewis worked to recoup this death drive as a new vital principle of a military-industrial epoch. Here Ernst suggests a riposte to this vision: rather than the prosthetic gods of a technological utopia, he gives us the bashed egos of an entropic world.[69] As Marx once urged in another context, he teaches the "petrified social conditions . . . to dance by singing them their own song."[70]

In all these ways the early collages, assemblages, and overpaintings of Ernst suggest an elliptical but caustic critique. On the score of "negativity inimical to the social order," he is rivaled only by Ball at this time. For Ball, the Dadaist "suffers from dissonances to the point of self-disintegration," and this formula captures the strategy of mimetic exacerbation *in extremis:* more desperate than the cynical reason of a Duchamp or a Picabia, this strategy resists in the "form of unresisting accommodation."[71] Of course, for many critics this is the limitation of Dada—that it advances a critique that flaunts its own futility, a defense that knows the damage is already done—and its "schammade" is less inimical negativity than middle-class amusement.[72] Paradoxically, however, it is this buffoonish attitude that also gives the bashed ego of Dada its critical edge, this radical hopelessness that also makes for its unaccommodated negativity. In any case, it is on this tightrope between critique and cynicism that Dada dances in its macabre way, and the young Ernst is central to the performance.

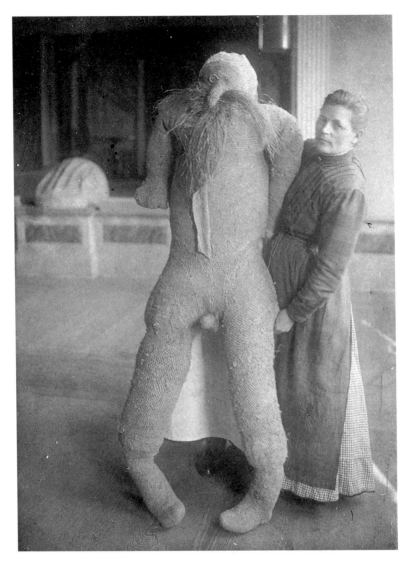

5.1. Katharina Detzel with a stuffed dummy of her own making. Sammlung Prinzhorn der Psychiatrischen Universitätsklinik Heidelberg. Inv. 2713a. Photo: Manfred Zentsch.

Blinded Insights

✗ Read at some point!

The revaluation of the art of the mentally ill followed the reassessment of the arts of "primitives" and children in both time and logic. Long viewed as meaningless or symptomatic, the art of the mentally ill was due for rethinking by the late 1910s and early 1920s. Yet, as with these other arts, interested modernists saw this art only according to their own ends—as expressive of an essence of art, a purity of vision, or a defiance of convention—and for the most part it was none of these things. Rather, these three readings—I will call them "expressionist," "visionary," and "transgressive" respectively—bespeak modernist fantasies either of a simple origin of art or of an absolute alterity to culture, and they tend to obscure rather than to illuminate the art of the mentally ill.

The romantics had also viewed the art of the mentally ill as an epitome of creative genius, but they focused on verbal rather than visual productions. Thereafter the value of this art was downgraded dramatically, to a point in the late nineteenth century when it had become little more than a symptom of psychological "degeneration." As noted in chapter 2, the key figure in this discourse of degeneration was the Italian psychiatrist Cesare Lombroso, who, along with his Hungarian follower, Max Nordau, spread this ideological notion from psychiatric practice to cultural interpretation. Lombroso understood madness as a return to a primitive stage of development, and this account prepared the phobic

association of the mentally ill, the primitive, and the child that continued into the twentieth century, where it vied with the idyllic association of the three as innocent visionaries that was a legacy of the romantics.[1] Already in *Genius and Madness* (1864), a study of 107 patients, half of whom drew or painted, Lombroso detected such degeneration in representations that he deemed "atavistic" and/or "absurd."[2]

The discourse of degeneration is not strong in psychoanalysis, but it did survive in residual form in the notion of "regression"; the diagnostic approach to the art of the mentally ill also persisted. Like his French teacher Jean Martin Charcot, Freud continued the diagnostic approach through reversal, as it were, as he searched for signs of psychic disturbance in the art of sane masters like Leonardo and Michelangelo (his analyses of these artists date from 1910 and 1914 respectively). Only gradually was the diagnostic approach to the art of the mentally ill countered with accounts attuned to the intrinsic qualities of the work. Here the two landmarks are *L'art chez les fous* (1907) by Marcel Réja, the pseudonym of the French psychiatrist Paul Meunier, who examined the art of the mentally ill for insight into the nature of artistic activity as such, and *Bildnerei der Geisteskranken* (Artistry of the Mentally Ill, 1922) by the German art historian Hans Prinzhorn, who extended this inquiry into the fundaments of "configuration" (*Gestaltung*) in ways that influenced several modernists directly.

This last revaluation of the art of the mentally ill came in the midst of great debate about the definition of the psychoses. By 1898 the German psychiatrist Emil Kraepelin had presented his typology of "dementia praecox" that included paranoid, catatonic, and hebephrenic forms. By 1911 the Swiss psychoanalyst Eugen Bleuler had introduced his category of "schizophrenia," which he defined as a broken relation to self and world as manifest in a dissociation of thought, action, or affect—that is, as a disruption of subjectivity often marked by a disruption in representation (the Greek root of "schizophrenia" means "split mind"). Bleuler offered a compromise position between Kraepelin and Freud: like Kraepelin, he connected paranoia and schizophrenia, and, like Freud, he stressed a splitting (*Spaltung*) of the mind as key. Nevertheless, Freud offered his own term, "paraphrenia," as an alternative to "schizophrenia" and as a complement to

"paranoia" (obviously "schizophrenia" prevailed). Although he sometimes found schizophrenia and paranoia combined, as in his celebrated case study of Judge Schreber (1911), Freud treated them as symptomatically distinct: in his view, the schizophrenic is overwhelmed by hallucinations that only deepen his sense of catastrophe within and without, while the paranoid constructs delusions of personal grandeur to counter the internal crisis, and projections of world order to counter the external crisis.[3] This distinction between schizophrenia and paranoia is important to my own reading of the art of the mentally ill here, the modernist reception of which centers on the work of Prinzhorn.

CONFIGURATION ACCORDING TO HANS PRINZHORN

Prinzhorn had studied art history at the University of Vienna before he turned first to psychiatry and then to psychoanalysis. It was this unique training that led Karl Wilmanns, the director of the Heidelberg Psychiatric Clinic from 1916 to 1933, to appoint him in February 1919 to oversee its collection of the art of the mentally ill. Begun when Kraepelin had directed this clinic from 1890 to 1903, the collection was developed under Wilmanns and extended under Prinzhorn to some 4,500 works by some 435 patients from various institutions, mostly in Germany; seventy-five percent of the represented artists were diagnosed as schizophrenic in one way or another. (Although women outnumbered men in these institutions, they hardly did so in the collection; only sixteen percent of the works were made by women [fig. 5.1].) Prinzhorn left the clinic abruptly in July 1921, even before the publication of the *Artistry.* Clearly he had great ambitions for the book, for he lectured widely thereafter, including a seminar at the Vienna Psychoanalytical Society presided over by Freud, as well as several talks in Germany attended by various modernists.

The *Artistry* includes a "theoretical part," ten case studies of "schizophrenic masters," and a summary of "results and problems"; with 187 reproductions, it is very selective of the overall collection.[4] Although several works show affinities with symbolism and expressionism, few of the patients were interested in art, though they were sometimes encouraged to draw for diagnostic or therapeutic

reasons, which might render the results less spontaneous than Prinzhorn claims. In any case, the selection offered in the *Artistry* is too disparate in material, technique, and style to fit any one theory, and the theory that Prinzhorn does present is somewhat contradictory.

On the one hand, Prinzhorn does not want to be only diagnostic in his interpretation ("a purely psychiatric approach is insufficient" [*AMI* 240]), and he does not see the works as direct expressions of illness. Although he proposes six "drives" as dominant in psychotic representation, he regards them as active in all other art as well. Indeed, he argues that "the components of the configurative process" appear "unadulterated" in such work [*AMI* 269]).[5] On the other hand, Prinzhorn also does not seek to be only aesthetic in his interpretation, and he cautions against any simple equation of the "pictures" with art. Although he calls his ten favorites "masters," he uses the archaic term *Bildnerei* or "artistry" ("image-making" is more exact) rather than the usual *Kunst* or "art." At the same time, Prinzhorn does refer to Van Gogh, Rousseau, Ensor, Kokoschka, Nolde (whom he knew personally), Max Pechstein, Erich Heckel, and Alfred Kubin (the only significant artist of the period to see the collection in person), and he does stress "the particularly close relationship of a large number of our pictures to contemporary art," primarily expressionism (*AMI* 270). Of course, interested modernists also made connections of this sort, as did equally interested enemies of modernism. The 1937 Nazi exhibition "Degenerate 'Art'" attacked modernists such as Paul Klee and Max Ernst precisely through this association with the mentally ill, and it drew on images from the Prinzhorn collection to do so (ironically, this show also offered the greatest exposure of such art, modernist and mentally ill, in Germany to date).[6] In this way, a reversibility haunts the modernist revaluation of the art of the mentally ill, for if this art could be revealed as somehow modernist in affinity, the art of the modernists could also be branded as somehow pathological in tendency.[7]

Prinzhorn had studied with the art historian August Schmarsow, who was known for his ontological approach to art (for instance, he liked to define each discipline according to its essential vector: the horizontality of painting, the verticality of sculpture, the depth of architecture, and so on). Prinzhorn then wrote

his dissertation under the psychologist Theodor Lipps, whose idea of "empathy" informed this entire generation of Germanic art historians (see chapter 3). In the *Artistry,* Prinzhorn was also guided by the formalist aesthetics of the art historian Conrad Fiedler, as well as the psychology of expression of the philosopher Ludwig Klages. In effect, he attempted to reconcile the autonomy of visual form stressed by Fiedler with the expressivity of the psyche stressed by Klages.[8] As his artistic allusions also suggest, Prinzhorn was intrigued by expressionism; despite his own caveats, he claimed for the art of the mentally ill a profound affinity with the "emotional attitude" of such art, with its "renunciation of the outside world" and its "turn inward upon the self" (*AMI* 271).[9]

Taken together, these influences led Prinzhorn to his theory of six drives that he held to govern the art of the mentally ill, but also to inform all other art—drives toward expression, play, ornamental elaboration, patterned order, obsessive copying, and symbolic systems. Here too, however, he courted contradiction, for his drives toward expression and play imply a subject open to the world in a way that the other drives do not. On the contrary, compulsive ornamenting, ordering, copying, and system-building imply a subject in rigid, even paranoid defense against the world. Perhaps Prinzhorn sensed this contradiction, for he was led to propose that the drives of expressive play were correctives to the drives of obsessive ordering (as we will see, his initial blindness here might point to an eventual insight into the opposed imperatives often at work in this art).[10] Moreover, in the end he admitted this fundamental difference between the artist and the schizophrenic:

> The loneliest artist still remains in contact with humanity, even if only through desire and longing, and the desire for this contact speaks to us out of all pictures by "normal" people. The schizophrenic, on the other hand, is detached from humanity, and by definition is neither willing nor able to reestablish contact with it. If he would he would be healed. We sense in our pictures the complete autistic isolation and the gruesome solipsism that far exceeds the

limits of psychopathic alienation, and believe that in it we have found the essence of schizophrenic configuration. (*AMI* 266)

Even as Prinzhorn cautioned against an equation between image and psyche, he often assumed it (as he does in the above passage), and it is this lack of mediation that allowed him to claim, in the art of the mentally ill, the "essential features" of artistic configuration as such (*AMI* 11).[11] His inculcation of formalist aesthetics, empathy theory, and expressive psychology (including the notions of expressive urges, intrinsic drives, and eidetic images) predisposed him to this sort of aesthetic essentialism. A similar equation between image and psyche also allowed modernists influenced by Prinzhorn—in particular Klee, Ernst, and Jean Dubuffet—to see "essential features" of art in the art of the mentally ill. All three knew the *Artistry* well, though not the Prinzhorn collection as such. Aware of the art of the mentally ill early in his career, Klee heard Prinzhorn lecture before his book appeared. As noted in chapter 4, Ernst also discovered this art independently, perhaps during his prewar studies at the University of Bonn. Younger than the others, Dubuffet encountered the *Artistry* in 1923, only a year after its publication, when he was not yet active as an artist. Although the art of the mentally ill is only one influence on these modernists, it affected their distinctive elaboration of stylistic devices and aesthetic models alike.

VISION ACCORDING TO PAUL KLEE

Klee begins his "Creative Credo" (1920) with these well-known words: "Art does not reproduce the visible; rather, it makes visible."[12] This text comes at the height of his engagement with the art of the mentally ill, and in this making-visible he credits "the child, the madman and the savage" with special power, for they "can still, or again, look into" the "in-between world" that "exists between the worlds our senses perceive."[13] Clearly this power is visionary for Klee—it concerns "the realm of the unborn and the dead"—and as early as 1912, in a review of the Blaue Reiter expressionists (with whom he would soon be associated), he deems it necessary to any modernist "reformation" of art.[14]

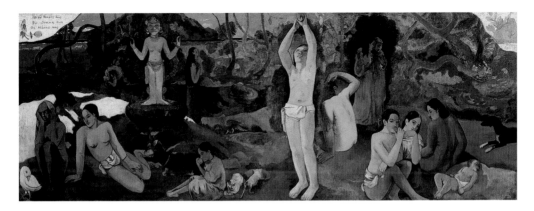

Plate 1. Paul Gauguin, *Where Do We Come From? What Are We? Where Are We Going?*, 1897–98. Oil on canvas, 54¾ x 147½ in. Museum of Fine Arts, Boston, Tompkins Collection. Photograph © 2003 Museum of Fine Arts, Boston.

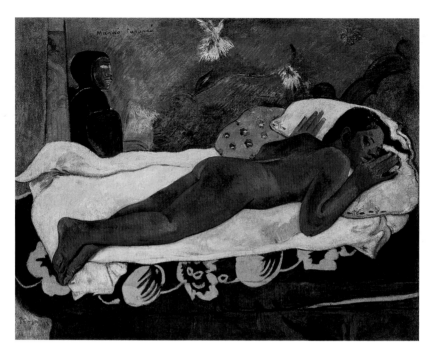

Plate 2. Paul Gauguin, *Spirit of the Dead Watching,* 1892. Oil on canvas, 28½ x 36⅛ in.
Albright–Knox Art Gallery, Buffalo, N.Y., A. Conger Goodyear Collection, 1965 (1965:1).
Photo: Albright–Knox Art Gallery, Buffalo, N.Y.

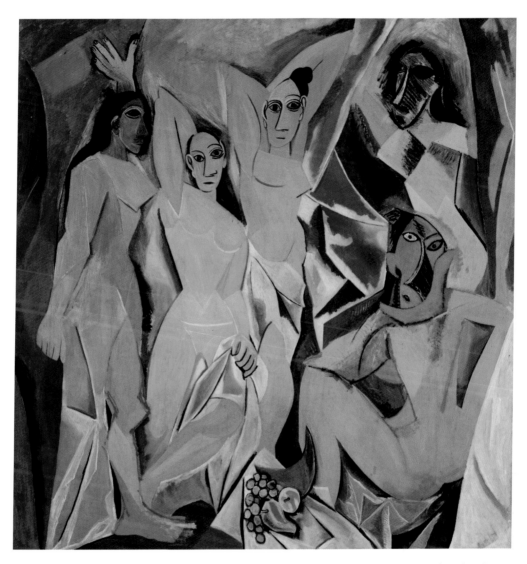

Plate 3. Pablo Picasso, *Les Demoiselles d'Avignon,* 1907. Oil on canvas, 96 x 92 in. The Museum of Modern Art, New York, Acquired through the Lillie P. Bliss Bequest (333.1939). © 2003 Estate of Pablo Picasso/Artists Rights Society (ARS), New York. Digital image © The Museum of Modern Art/Licensed by SCALA/Art Resource, New York.

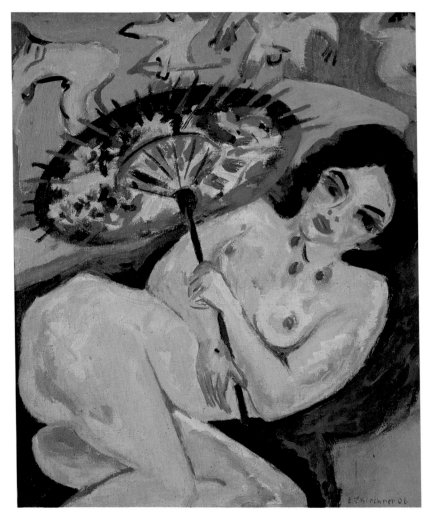

Plate 4. Ernst Ludwig Kirchner, *Girl under a Japanese Umbrella,* c. 1909. Oil on canvas,
36¼ x 31½ in. Kunstsammlung Nordrhein-Westfalen, Düsseldorf. © Ingeborg & Dr. Wolfgan
Henze-Ketterer, Wichtrach/Bern. Photo: Erich Lessing/Art Resource, New York.

Plate 5. Paul Gauguin, *The Day of the God (Mahana no atua),* 1894. Oil on canvas, 26⅞ x 36 in. The Art Institute of Chicago: Helen Birch Bartlett Memorial Collection (1926.198). Photograph © 1997 The Art Institute of Chicago.

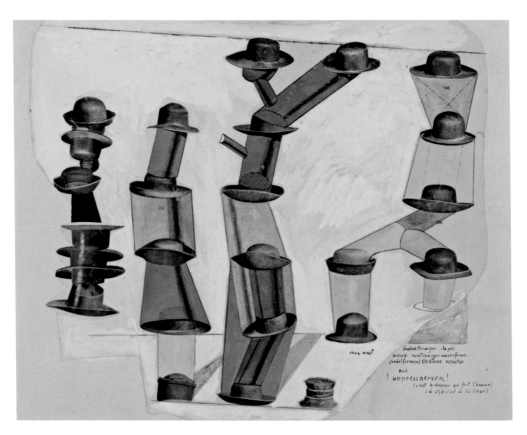

Plate 6. Max Ernst, *The Hat Makes the Man,* 1920. Cut-and-pasted paper, pencil, ink, and watercolor on paper, 14 x 18 in. The Museum of Modern Art, New York. © 2003 Artists Rights Society (ARS), New York/ADAGP, Paris. Digital image © The Museum of Modern Art/Licensed by SCALA/Art Resource, New York.

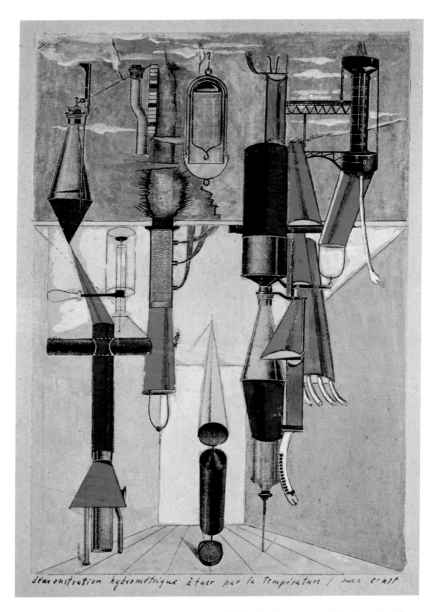

Plate 7. Max Ernst, *Hydrometric Demonstration of Killing by Temperature,* 1920. Gouache, ink, and pencil on printed reproduction, 9⁷⁄₁₆ x 6¹¹⁄₁₆ in. Private collection. © 2003 Artists Rights Society (ARS), New York/ADAGP, Paris.

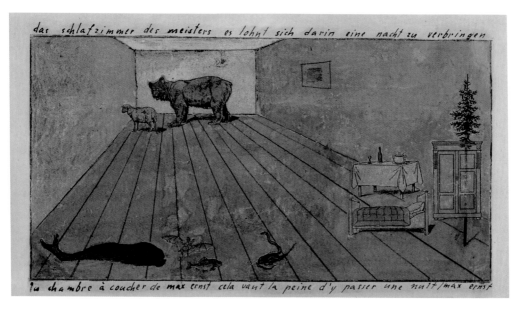

Plate 8. Max Ernst, *The Master's Bedroom,* 1920. Gouache, pencil, and ink on printed reproduction mounted on paperboard, 6⁷⁄₁₆ x 8⅜ in. Private collection. © 2003 Artists Rights Society (ARS), New York/ADAGP, Paris.

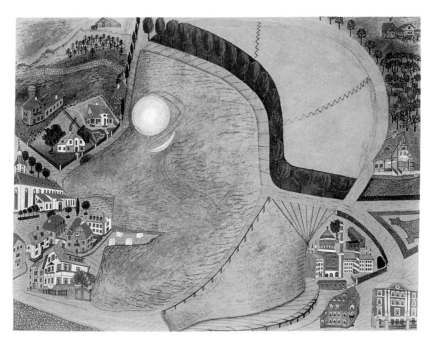

Plate 9. August Natterer, *Witch's Head,* n.d. Pencil, watercolor, and pen on varnished card, recto and verso, 10¼ x 13½ in. Sammlung Prinzhorn der Psychiatrischen Universitätsklinik Heidelberg. Inv. 184. Photo: Manfred Zentsch.

Plate 10. Jackson Pollock, *Cut-out,* c. 1948–50. Oil on cut-out paper mounted on canvas, 30½ x 23½ in. Ohara Museum of Art, Kurashiki, Japan. © 2003 The Pollock-Krasner Foundation/Artists Rights Society (ARS), New York. Photo: Ohara Museum of Art.

Plate 11. Jackson Pollock, *Out of the Web: Number 7, 1949,* 1949. Oil and enamel on masonite, 48 x 96 in. Staatsgalerie, Stuttgart. © 2003 The Pollock-Krasner Foundation/Artists Rights Society (ARS), New York. Photo: SIPA Press/Art Resource, New York.

Plate 12. Morris Louis, *Alpha-Phi,* 1961. Acrylic on fabric, 102 x 195 in. Tate Gallery, London. Photo: Tate Gallery, London/Art Resource, New York.

Plate 13. Robert Morris, *Threadwaste,* 1968. Threadwaste, copper, mirrors, asphalt, felt; dimensions variable.
© 2003 Robert Morris/Artists Rights Society (ARS), New York. Photo courtesy of the artist.

Plate 14. Robert Gober, *Untitled,* installation at Los Angeles Museum of Contemporary Art, 1997. Photo: Joshua White.

Plate 15. Robert Gober, *Untitled,* installation detail at Los Angeles Museum of Contemporary Art, 1997. Photo: Russell Kaye.

Some Klee experts see the influence of the art of the mentally ill on his work as early as 1904–05. Others speculate that he came across the now-celebrated art of Adolf Wölffli, a patient in a institution near Bern, while Klee still lived there; but the Wölffli images were not published until 1921, and Klee makes no mention of such an encounter at the time. We do know from Oskar Schlemmer, his colleague at the Bauhaus, that Klee knew of the Prinzhorn collection before Prinzhorn lectured near Stuttgart in July 1920.[15] Certainly his work shows the strongest effects of the art of the mentally ill in this period, with the heteroglossic markings and obsessive orderings that Prinzhorn ascribed to such representation. We also know from another Bauhaus colleague, Lothar Schreyer, that Klee identified deeply with the *Artistry* on its publication in 1922 (he kept a copy of the book in his studio), and did so in the context of an institution, the Bauhaus, soon to be renowned for its rationalism. "You know this excellent piece of work by Prinzhorn, don't you?," Schreyer has Klee remark as he flips through the *Artistry*. "This picture is a fine Klee. So is this, and this one, too. Look at these religious paintings. There's a depth and power of expression that I never achieve in religious subjects. Really sublime art. Direct spiritual vision."[16]

There is much to unpack in this rhetoric of celebration that moves between hubris ("a fine Klee") and humility ("I never achieve . . ."), a rhetoric that is also characteristic of the modernist rapport with primitive art. Most important is the casting of the art of the mentally ill almost in the register of the sublime, as a matter of "direct spiritual vision." Yet Klee is accurate here in his self-appraisal: when he simply illustrates "religious subjects," as in his various "angels" and "demons," "ghosts" and "seers," he does not achieve the "power of expression" often found in the *Artistry;* but when he evokes "direct spiritual vision," he does sometimes approach this power, as in his celebrated watercolor known as *Angelus Novus* (1920; fig. 5.2). With its quasi-schizophrenic patterning, its strange elaboration of wreaths as hair and scrolls as fingers, its immense head with averted gaze and ambiguous mouth, this figure who presses toward us does seem to "make visible," as if it did have the power to make us behold. At least the figure appeared so to its onetime owner Walter Benjamin, for whom it was an allegorical angel of history-as-catastrophe that "preferred to free men by taking

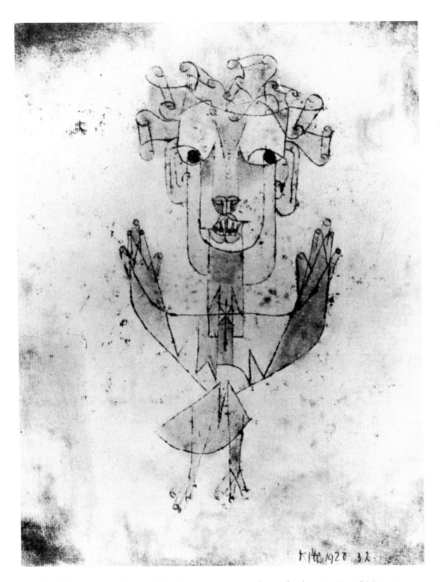

5.2. Paul Klee, *Angelus Novus,* 1920. Watercolor over oil transfer drawing. Israel Museum, Jerusalem. © 2003 Artists Rights Society (ARS), New York/VG Bild–Kunst, Bonn.

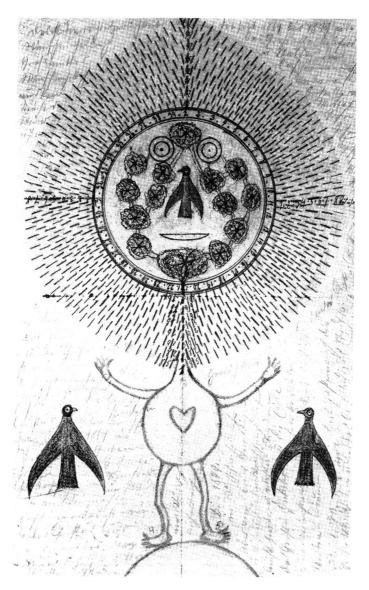

5.3. Johann Knopf (Knüpfer), *Monstrance Figure*, n.d. 13 × 10⅝ in. Sammlung
Prinzhorn der Psychiatrischen Universitätsklinik Heidelberg. Inv. 1491.
Photo: Manfred Zentsch

from them."[17] But what exactly is this "direct spiritual vision" that Klee invokes? Might it run the risk of a mental state that, far from innocent, is hallucinatory, even horrific—a vision that comes to possess its subject with a sudden annunciation, as glimpsed in this angel by both Klee and Benjamin? This state—too direct, too sublime—is evoked in some representations in the *Artistry* that are akin to *Angelus Novus,* such as *Monstrance Figure* by Johann Knopf (fig. 5.3), one of the ten schizophrenic masters whose work Klee would have known (Prinzhorn gives him the pseudonym "Knüpfer," and his diagnosis is listed as "paranoid form of dementia praecox").[18] A "monstrance" is indeed a "making visible": in the Roman Catholic Church, it is an open or transparent vessel in which the Host is displayed for veneration. But this "monstrance figure" is also monstrous—an image that, however obscure it may seem to us, appears too open, too transparent, to the "religious vision" of its paranoid maker, which shines through with some of the untamed intensity of the Lacanian real (see chapter 7).

Klee catches a glimmer of this intensity in several of his works of the time, such as *Man Is the Mouth of the Lord* (1918), the title of which alone suggests a paranoid vision, and *The Saint of the Inner Light* (1920), a figure whose "inner light" is evoked through a blinded visage. The ironic play with pictographic systems, which is active in other Klees but foreign to the art of the mentally ill, is also absent here. ("Irony is by its very nature totally excluded," Prinzhorn writes, "because it always refers to commonly accepted conventions, the very thing that the schizophrenic has excluded from his thought" [*AMI* 245].) More importantly, the innocent idea of the art of the mentally ill cherished by Klee is burned away in these works. Just as Prinzhorn wanted to see this art as expressive, only to discover that it is often radically *in*expressive, that is, expressive only of schizophrenic withdrawal, so Klee wanted to see an innocence of vision in this art, only to discover an intensity that sometimes borders on paranoid terror—an Angelus Novus of catastrophe. Here, as with Prinzhorn, the initial blindness of his model of the art of the mentally ill produces an eventual insight for us, whereby the artistic vision projected onto these patients is revealed as the psychological terror that it often is.

TRANSGRESSION ACCORDING TO JEAN DUBUFFET

The horrific dimension of this hallucinatory vision does not make it less immediate for Klee; on the contrary, it makes it more so, and it is this heightened immediacy that allows him to seek the modernist grail of pure vision in the art of the mentally ill. Another kind of immediacy is projected by Dubuffet, who develops a transgressive model of modernist art based in part on this art. Again, he encountered the *Artistry* early in his formation; it was given to him in 1923, at which time he studied other publications of visionary art as well. Yet his own work in this vein did not develop until the early 1940s, and then his first inspiration was the drawing of children: his figures of this time recall the stick-people of such art, presented frontally or in profile, or (paradoxically) both at once. In the interim, however, Dubuffet corresponded with patients and doctors in various asylums, and this contact culminated in 1945 in a three-week tour of psychiatric hospitals in Switzerland (where he encountered the work of Wölfli, among others). This experience prompted him to two signal acts: to destroy most of his art prior to 1942, and to begin a collection of "irregular" art (including primitive, naïve or folk, and mentally ill productions) under the rubric of *art brut*—*brut* as in "raw," "crude," "uncivilized." In 1948, along with André Breton, Jean Paulhan, Charles Ratton, Henri-Pierre Roché, and Michel Tapié, Dubuffet formed the Compagnie de l'Art Brut, and in 1949 he presented the first exhibition of its holdings (which totaled roughly 2000 works by sixty-three artists) at the Galerie René Drouin in Paris. The show was accompanied by his important text on the subject, "L'Art Brut préféré aux arts culturels," in which Dubuffet first presents the *brut* artist as a radical version of the romantic genius free of all convention:

> We understand by this term works produced by persons unscathed by artistic culture, where mimicry plays little or no part (contrary to the activities of intellectuals). These artists derive everything—subjects, choice of materials, means of transposition, rhythms, styles of writing, etc.—from their own depths, and not from the conceptions

of classical or fashionable art. We are witness here to a completely pure artistic operation, raw, brute, and entirely reinvented in all of its phases solely by means of the artist's own impulses.[19]

In a subsequent essay Dubuffet transforms this category of *brut* into a criterion of all modernist art: "a work of art is of no interest to me unless it is an absolutely immediate and direct projection of the depths of the individual."[20]

This idealization of the art of the mentally ill is similar to those of Prinzhorn and Klee: it, too, assumes the notions of an essential "expression" and a direct "vision." Yet for Dubuffet, the nature of this art is less formal (as it is for Prinzhorn) or spiritual (as it is for Klee) than transgressive: "I believe very much in the values of savagery; I mean: instinct, passion, mood, violence, madness."[21] So too, as with the others, his idealization is a kind of primitivism: Dubuffet also believes in a return to "depths." Yet, unlike the others, he defines these depths not as an *origin* of art, which one can reclaim redemptively, so much as an *outside* to art, which breaks into its cultural spaces disruptively. Nevertheless, like other primitivists before him, Dubuffet targets academic art first and last; in this regard his outsider logic is also an insider move, one that, intentionally or not, works to win him a place within avant-gardist lineages.[22] Moreover, even as he seeks to undo the opposition between normal and abnormal ("this distinction between normal and abnormal seems quite untenable: who, after all, is normal?"), Dubuffet affirms an opposition between *brut* and *culturel,* between civilized and noncivilized.[23] In this way his transgression might come to support the very law that it purports to contest. Indeed, as Michel Foucault remarked of Georges Bataille, such transgression might serve to reimagine the "sacred" basis of this law that modern secularization has eroded. "Profanation in a world which no longer recognizes any positive meaning in the sacred," Foucault writes. "Is this not more or less what we may call transgression . . . a way of recomposing its empty form, its absence, through which it becomes all the more scintillating?"[24]

Yet right here, like Prinzhorn and Klee before him, Dubuffet might point to an insight into the art of the mentally ill in the very blindness of his anticultural conception of it—two insights, in fact. The first one involves the

subjective order: far from "unscathed," the psychotic is scarred by trauma, and this psychic disturbance might be registered in the bodily distortions that pervade the art of the mentally ill. For in this art, significant parts of the body, especially eyes and mouths, are often grossly enlarged, and sometimes disruptively plunged into other parts of the body, so that eyes become breasts, say, or mouths double as vaginas (fig. 5.4).[25] Klee also experimented with such derangements of the body image, but Dubuffet did so more extremely, and occasionally in ways that correspond to works in the *Artistry* (fig. 5.5). His affinity with Hermann Beehle, known as Beil, is uncannily (or is it consciously?) close: they share a frontal presentation of schematic nudes sometimes rearranged, often splayed, and always embedded in the support (which for Beil tended to be toilet paper). Through such devices in his own work Dubuffet evokes a schizophrenic sense of literal self-dislocation, which is far from the "completely pure artistic operation" that he otherwise wished to project onto the art of the mentally ill.

If his first insight concerns subjectivity, his second involves the status of the symbolic order as imagined in the art of the mentally ill. The bodily derangements in this art imply a world that is more desperate, even debilitated, than empowered, and despite his assertions to the contrary, this is sometimes true in Dubuffet as well. In this way both bodies of work might point to a different kind of transgression, one conceived along the lines less of the avant-gardist logic of Dubuffet than of the immanent logic of Foucault on Bataille. In other words, rather than attack artistic convention and symbolic order, the art of the mentally ill seems concerned to *find* such aesthetic laws again—perhaps to *found* a symbolic order again; at the very least (as Foucault remarks), to "recompose its empty form, its absence." For, to their horror, this is what these artists often seem to see: not a symbolic order that is *too* stable, that they wish to contest as such (again as posited by avant-gardist logic), but, rather, a symbolic order that is *not* stable at all, that is in crisis or corruption. Far from anticivilizational heroes, as Dubuffet wanted to imagine them ("insanity represents a refusal to adopt a view of reality that is imposed by custom"), these artists are desperate to construct a surrogate civilization of their own, a stopgap symbolic order in default of the official one that, like the Angelus Novus of Klee and Benjamin, they perceive to be in ruins.[26]

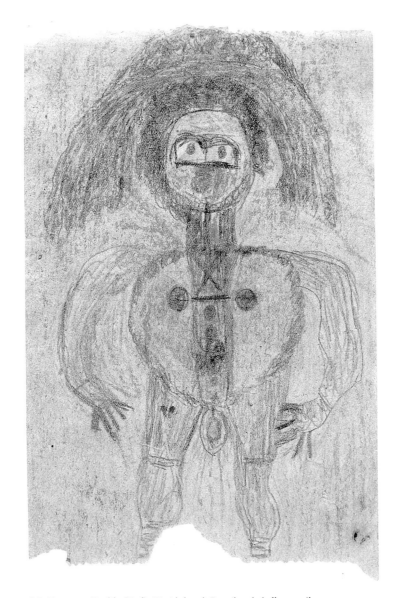

5.4. Hermann Beehle (Beil), *Untitled,* n.d. Pencil and chalk on toilet paper, 6⅞ × 4¾ in. Sammlung Prinzhorn der Psychiatrischen Universitätsklinik Heidelberg. Inv. 76/4. Photo: Manfred Zentsch.

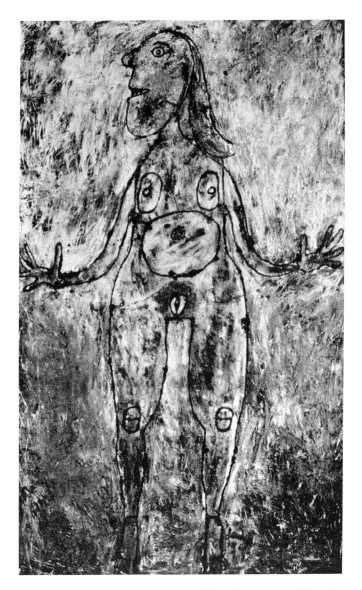

5.5. Jean Dubuffet, *Grand nu charbonneux,* 1944. Oil on canvas, 38¾ × 13¾ in. Collection Carlo Frua de Angeli, Milan. © 2003 Artists Rights Society (ARS), New York/ADAGP, Paris.

This hypothesis suggests a further speculation: that the schizophrenic and paranoid visions recorded in the Prinzhorn collection might be symptomatic of a crisis in the symbolic order specific to the capitalist modernity of the time; more, that this crisis prepared the explosion of psychosis in this period (of which the Prinzhorn collection is but one archive); and, finally, that some modernists found in the art of the mentally ill a perspective on this crisis.[27]

Thus far I have sketched three creative misreadings of the art of the mentally ill: the Prinzhorn model of expression, the Klee model of vision, and the Dubuffet model of transgression. All three are modernist projections that use the art of the mentally ill to propose a metaphysical essence of art. Although each model locates the artist differently, they all presuppose an ego that is intact enough—indeed, self-present enough—to be expressive, visionary, or transgressive in the first place. Even more oddly, they imagine this ego in radical discontent with artistic convention and symbolic order alike, rather than in "autistic isolation" from both.[28] In this way they project a symbolic order against which this radical discontent is posed—one that is stable, solid, set. And none of this projection seems true of the art of the mentally ill; instead, this projection conforms to avant-gardist ideologies of rupture, immediacy, purity, and so on. Far from self-present, the psychotic artist is profoundly dislocated, often literally lost in space. And far from avant-gardist in its revolt against artistic convention and symbolic order, psychotic representation attests to a frantic desire to reinstate convention, to reinvent order, which the psychotic feels to be broken, and so in desperate need of repair or replacement. In short, the obsessive elaborations of this art are not made to *break* the symbolic order; on the contrary, they are made in its apparent *breach*. And here, perhaps, is a further lesson for us all: the seeming intractability of the symbolic order might lie less in any grounded fixity that it possesses (it is we semi-paranoics who project this fixity, at least in part) than in the fragile arbitrariness that it works to conceal at all costs—and which the mentally ill glimpse at *their* cost. This has significant implications for a rethinking of transgression as a primary objective of avant-garde art.

HALLUCINATION ACCORDING TO MAX ERNST

Ernst had few illusions about the innocence of the art of the mentally ill—expressive, visionary, transgressive, or otherwise. On the contrary, he sought to exploit its disturbances in order "to escape the principle of identity."[29] Again, Ernst encountered this art almost as early as Klee, perhaps during his prewar studies in psychology at the University of Bonn, where he read Kraepelin as well as Freud (at some point, too, he must have seen the Schreber case study, for he uses Freudian tropes of paranoia in *Beyond Painting,* his extraordinary art-treatise-*cum*-self-analysis). As noted in chapter 4, Ernst claims that he visited a collection of art of the mentally ill at an asylum near Bonn while a student, and that he once planned a book on the subject. "They profoundly moved the young man," he writes of such art works in his "Biographical Notes." "Only later, however, was he to discover certain 'procedures' that helped him penetrate into this 'no-man's-land.'"[30] As much as Ernst discovered these procedures "beyond painting"—his own versions of collage called frottage and grattage—he also extrapolated them from the art of the mentally ill.

As we saw in chapter 4, his first Dadaist collages of mechanistic figures, made in Cologne before the publication of the *Artistry,* allude to the psychological damage produced by World War I. Such images as *Self-Constructed Little Machine* (1919; fig. 4.2) resemble a particular kind of schizophrenic representation, a genre of machinic structures that seem intended as ego-supports but only serve to debilitate the ego all the more (there are several dysfunctional machines in the Prinzhorn collection; see fig. 4.3). In such alienated portraits, Ernst evokes a regression to disordered drives and deathly functions, a regression that resonates with the reactionary events of the time; in this way he seems to adapt the art of the mentally ill into an indirect critique of the symbolic order of his age.

His Dadaist work impressed young surrealists-to-be when it was first shown in Paris in May 1921, but André Breton and Louis Aragon were struck less by his collages of disjunctive figures than by his "overpaintings" of found illustrations (figs. 5.6, 4.15, 4.16, pls. 7, 8). These weird palimpsests of painted

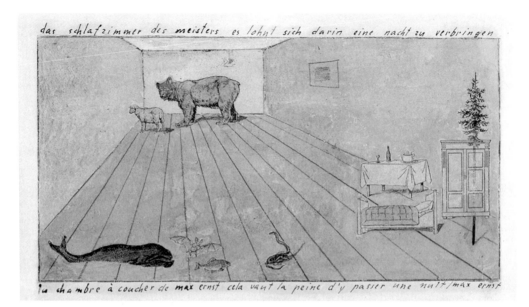

5.6. Max Ernst, *The Master's Bedroom,* 1920. Gouache, pencil, and ink on printed reproduction mounted on paperboard, 6⁷⁄₁₆ × 8⅝ in. Private collection. © 2003 Artists Rights Society (ARS), New York/ADAGP, Paris.

pages from teaching-aid catalogues "introduced an entirely original scheme of visual structure," Breton later remarked; "at the same time [they] corresponded exactly to the intentions of Lautréamont and Rimbaud in poetry," the designated precedents of surrealism.[31] In effect, the overpaintings demonstrated how *visual* art could advance the surrealist poetics of "the coupling of two realities, irreconcilable in appearance, upon a plane which apparently does not suit them," as Ernst defines collage in *Beyond Painting,* essentially in a paraphrase of Lautréamont, Pierre Reverdy, and others (*BP* 13). Crucial here is the connection that Ernst draws between disruptions in image and in subjectivity, a connection supported by the example of the art of the mentally ill. This art emerges, then, as a necessary point of mediation between Dadaist and surrealist aesthetics, one that often disappears in accounts of this passage. When Ernst moved to Paris in 1922, he brought the *Artistry* as a gift for Paul Eluard, who in the same year collaborated with Breton on *Immaculate Conception,* a poetic simulation of madness that is an inaugural text of surrealist writing.

Ernst connects disruptions in image and in subjectivity explicitly in *Beyond Painting.* In "Some Data on the Youth of M.E.," he recounts his earliest memories in a way that correlates symbolic crises with psychic disturbances. In one memory his little sister dies on the same night as his pet bird, a coincidence to which he ascribes his later "confounding of the images of human beings with birds and other creatures" (*BP* 26). More important, however, is his "vision of half-sleep" (dated "from 5 to 7 years") that opens *Beyond Painting:* here, little Max watches his roguish father, a Sunday painter, make "joyously obscene" marks on a panel (*BP* 3). This is a first encounter with painting cast in terms of a primal scene, which Freud defines as a traumatic fantasy of parental intercourse through which a child teases out the riddle of origins (see chapter 1).[32] Ernst evokes the trope of the primal scene in the origin stories of all his procedures "beyond painting"—a repetition that again underscores his desire to open up aesthetic order to psychic disruption. Just as Freud describes his psychologically foundational scenes in visual terms, so Ernst seems to describe his pictorially originary scenes in psychoanalytic terms.

More is involved here than a desublimatory device, however, for Ernst develops this notion of traumatic fantasy into a theory of aesthetic practice. "It is as a spectator that the author assists . . . at the birth of his work," he argues in *Beyond Painting*. "The role of the painter is to . . . *project that which sees itself in him*" (*BP* 8; original emphasis).[33] Apparently with the primal scene again in mind, Ernst positions the artist as both inside and outside the scene of his art, as both active creator of his fantasy and passive voyeur of its images. The visual fascinations and sexual confusions of the primal scene inform not only his definition of collage ("the coupling of two realities irreconcilable in appearance") but also his sense of its purpose (to disturb "the principle of identity"). And he puts this model into practice as early as *The Master's Bedroom* (1920; fig. 5.6, pl. 8), a celebrated overpainting of a catalogue chart of fifty objects used for elementary instruction in perception, speech, and writing (note the brilliance of this particular subversion of rationalist training). All but ten of the original items are painted over (table, bed, cabinet, tree, whale, bat, fish, snake, sheep, bear); wildly out of scale, they are set in a bizarre bedroom that Ernst sketches in with only enough lines and tints to evoke a schizophrenic *theater mundi*. Strange occupants and skewed space alike seem to gaze back at the artist-viewer, as if a traumatic fantasy, long repressed, had suddenly returned to threaten its master, a hallucination that might "unmaster" him altogether. Although the title alone suggests a primal scene, it is in the formal dis/connections of the image—its play with mad juxtaposition, contradictory scale, and anxious perspective—that traumatic fantasy is evoked and paranoid affect produced. These are the "procedures" that helped Ernst penetrate the "no-man's-land" of psychotic representation, and thereby to pass from the more social residues evident in Dadaist collage to the more psychic traces at work in surrealist images.

As one model of the surrealist image, the surrealists liked to cite the exemplum used by Leonardo to describe how artistic genius can discern, in a mere stain on a wall, an entire landscape, battle scene, or other such invention.[34] Often, however, this canonical allusion seems like a bid for artistic respectability; the more insistent model of the surrealist image, as Ernst states in *Beyond Painting,* is

"the simple hallucination" (*BP* 12). "I was surprised," he writes in one version of his primal scene of art, "by the sudden intensification of my visionary capacities and by the hallucinatory succession of contradictory images superimposed, one upon the other, with the persistence and rapidity characteristic of amorous memories" (*BP* 14). Although the "mechanism" of his procedures remains the "chance meeting" of images, the "technique" is not as materially blatant as in most Dadaist collages (*BP* 13). As we saw in chapter 4, Ernst tended to obscure his means of production: "ce n'est pas la colle qui fait le collage," he remarks in *Beyond Painting* (*BP* 13). That is, he tended to burn away the material support so that the resultant image might appear as immaculate—indeed, as hallucinatory— as a psychic vision. "The drawings thus obtained," Ernst writes of his frottages, "lost more and more . . . the character of the material interrogated . . . and took on the aspect of . . . the first cause of the obsession, or produced a simulacrum of that cause" (*BP* 8). This burning away of the material support replicates the oneiric intensity of the psychic vision—of the dream, the screen memory, or the primal scene (as noted in chapter 1, the dream of the Wolf Man—another Freud case study that Ernst must have known—is all three at once). As in these psychic visions, so in the Ernst collages: singular intensity is produced through a multiple layering of visual scenes that appear as "psychic readymades."[35] With images in superimposition that sometimes seep through one another, the medium of over-painting is well suited to evoke this field of psychic readymades. Indeed, the over-painting suggests a visual correlative of the very "scenography" of the psyche: the juxtaposition of incongruous images as in a dream, the return of the familiar es-tranged through repression as in the uncanny, the conflation of two events distant in time as in trauma. And, again, this model of art as hallucinatory vision appears to be underwritten by the art of the mentally ill.[36]

In his early Dadaist collages, then, Ernst evokes a damaged subject in the manner of some schizophrenic representations, in particular those of machinic structures devised as ego-supports. Soon thereafter he develops a surrealist aesthetic in the manner of some paranoid representations, in particular those governed by a "hallucinatory succession of contradictory images." In this way Ernst not only elaborates the art of the mentally ill stylistically; he seems to understand

it almost diagnostically, and to turn the symptomatology of its representations to critical purposes.[37] This understanding makes his use of the art of the mentally ill different from the avant-gardist uses represented by Klee and Dubuffet. Unlike them, Ernst does not position such images as a redemptive origin of art or as a radical outside to civilization; again, that is to project a symbolic order that is intact, even solid. Rather, he points to the more radical insight that the symbolic order is somehow already cracked, and that this crack might not only precipitate a crisis in the subject but also prepare a new kind of critical art, one that rethinks both the site and the stake of transgression.

A PATIENT IS GOD BUT SWEEPS THE FLOOR WILLINGLY

As we have seen, both Klee and Dubuffet often derange the image of the body, as if in keeping with a schizophrenic apprehension of ego-damage or self-dislocation, and, like Ernst, they sometimes figure the body as a dysfunctional mechanism as well.[38] These distortions of the body image are also pronounced in the Prinzhorn collection, and they point to a common characteristic of its art—a paradoxical treatment of boundary lines and figure-ground relationships. Sometimes borders are effaced, as if in schizophrenic dissolution; sometimes, on the contrary, they are exaggerated, as if in paranoid defense. And sometimes, too, boundaries are exaggerated to the point where they are effaced again—as if, in the very attempt to underscore the distinction between self and world necessary to an image of autonomy, this very distinction were undone. The failure of the boundary in this art takes as many forms as the drives posited by Prinzhorn: figure-ground relationships are confused in ornamental ordering, obsessive copying, systematic fantasies, and so on. In all these modes, the will to order is often so insistent that it overbears the device designed to deliver it, and the image is plunged back into chaos.

A recurrent instance of this paradoxical dis/ordering of figure and ground is the compulsive inscription of the pictorial field with repeated numbers and/or letters, words and/or phrases. Here a longing for *any* difference seems to be pronounced not only in the primordial marking of a figure against a ground, but

also in the fundamental nature of the signs that are used. Yet, again, these marks are often elaborated to the point where the desired difference is overwhelmed ("the tendency to fill in each area," Prinzhorn writes, "contradicts completely the essence of representation which aims at individualization" [*AMI* 233]). A poignant example in the Prinzhorn collection is the letter-writing of Emma Hauck, diagnosed with dementia praecox, who darkened her pages into near illegibility with a repeated plea for her husband "to come" to her, even though this "her" seems far from secure or stable (fig. 5.7). Here the very desire for human connection becomes another expression of "autistic isolation."

This tipping of order into disorder also occurs when order is the explicit subject of the work, as in paranoid projections of grandiose fantasies. Often in the Prinzhorn collection, depictions of miraculous events and hostile machinations, mappings of institutional spaces and cosmic systems—in which the "metaphysical urge" (*AMI* 241) of the art of the mentally ill is most apparent—are so obsessively articulated that the order that they construct for the world deconstructs on its own, a casualty of its own overelaborate systematicity. A good example is the compendious work of Josef Heinrich Grebing, a commercial clerk also diagnosed with dementia praecox. Grebing reassembled a symbolic order out of the perceived debris of the official one: he issued financial certificates, painted religious icons, drew "world maps," and, most extraordinarily, developed an entire calendar of the twentieth century—"a chronology for Catholic youths and maidens"—replete with astrological tables (fig. 5.8). What Freud remarks of the paranoid system of Judge Schreber seems true here as well: "The delusion-formation, which we take to be a pathological product, is in reality an attempt at recovery, a process of reconstruction."[39]

The collapsing of figure and ground is also pervasive in the related work of our three modernists, where it is closer to such psychotic representations than to the formal deconstructions of this relationship in other modernists (one can compare the grids of Klee with the grids of Mondrian as a test of this point). In the small watercolor *Room Perspective with Inhabitants* (1921; fig. 5.9), Klee collapses figure and ground in a way that effectively merges subject and space. In this image orthogonals lead to a conundrum of rooms, an arrow points nowhere, and

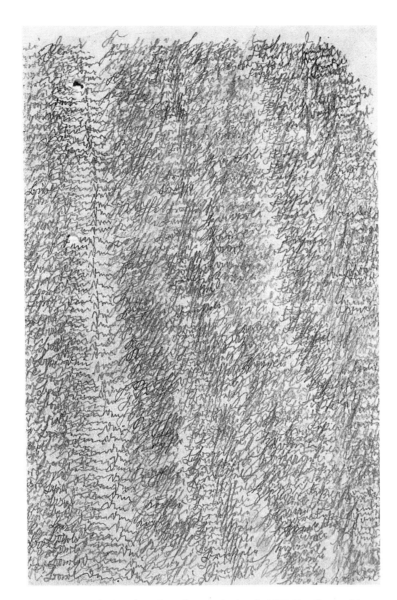

5.7. Emma Hauck, *Sweetheart Come* (letter to husband), 1909. Pencil on writing paper, 8¼ × 6½ in. Sammlung Prinzhorn der Psychiatrischen Universitätsklinik Heidelberg. Inv. 3622/4. Photo: Manfred Zentsch.

5.8. Josef Heinrich Grebing, *Calendar of My 20th Century—Chronology for Catholic Youths and Maidens,* n.d. Collage with pencil, pen, Indian ink, inks, and watercolor in an exercise book, 12⅞ × 8¼ in. Sammlung Prinzhorn der Psychiatrischen Universitätsklinik Heidelberg. Inv. 613. Photo: Manfred Zentsch.

5.9. Paul Klee, *Room Perspective with Inhabitants,* 1921. Watercolor over oil transfer drawing, 19 × 12½ in. Bern, Kunstmuseum, Fondation Paul Klee. © 2003 Artists Rights Society (ARS), New York/VG Bild-Kunst, Bonn.

a ghostly grail offers little hope of salvation. The few objects in the room are vec-
tored into transparency by the perspective, and the same fate befalls the figures
that are flattened in the floor and along the wall like schematic spectres. They less
inhabit the room than are inhabited by it—by a perspective that seems to trace
an "in-between world" (to use his own term). In this way, Klee pushes the old
project of perspective—which Erwin Panofsky once defined, in its Renaissance
epitome, as the humanist reconciliation of subject and object—to the point of
an inhuman reversal, for here subject and object are not reconciled as equal terms
so much as dissolved as distinct entities.[40] The best gloss on the horrific spatial-
ity of *Room Perspective with Inhabitants* is this singular account of schizophrenic an-
guish, of a literal losing of self in space, by the surrealist associate Roger Caillois
in 1937:

> To these dispossessed souls, space seems to be a devouring force.
> Space pursues them, encircles them, digests them in a gigantic pha-
> gocytosis [consumption of bacteria]. It ends by replacing them. Then
> the body separates itself from thought, the individual breaks the
> boundary of his skin and occupies the other side of his senses. He
> tries to look at himself from any point whatever in space. He feels
> himself becoming space, *dark space where things cannot be put.* He is
> similar, not similar to something, but just *similar.* And he invents
> spaces of which he is "the convulsive possession."[41]

This awful condition of mere similarity and convulsive possession captures
the schizophrenic terror of collapsed boundaries and invasive spatiality that is of-
ten evoked in the art of the mentally ill. Of special interest here is that sometimes
this horror seems to call out for a paranoid counter—a defensive projection of a
space that now becomes *too* distinct and distant, of a world that is suddenly es-
tranged and hostile. Ernst evokes this paranoid alienation in a work like *The
Master's Bedroom,* where the viewer becomes the viewed, and the storybook an-
imals and bedtime things turn into alien beings (fig. 5.6, pl. 8). If we can juxta-
pose the two rooms of Klee and Ernst for a moment, *Room Perspective with*

Inhabitants seems to perform a schizophrenic dissolution of the subject into space, while *The Master's Bedroom* seems to project a paranoid alienation of the subject by space—as if the schizophrenic subject imagined in the first room sought to be recentered, made master again, by the paranoid projection of space in the second room, in its hallucinated opposition of self and other.[42] In this way paranoia might be understood as the last refuge, the final asylum, of a subject threatened by schizophrenic self-loss: "I" am still an "I" as long as there is an other in space, perhaps an other *as* space, out there to threaten me; this other keeps me centered by its very alterity, in its very threat.[43] Yet this paranoid projection of space is no more guarantee of the subject than the schizophrenic construction of machinic prostheses mentioned above in relation to Ernst. Both are attempts at self-rescue that only underscore self-loss. Such is the understanding of the art of the mentally ill that a reading after Ernst allows.[44]

Rather than a simple opposition between schizophrenia and paranoia, then, there is a contradictory connection between the pictorial traits that might be associated with each. In the Prinzhorn collection one sees a persistent oscillation between images of schizophrenic "catastrophe" and images of paranoid "reconstruction" (to use the Freudian terms): every cancellation of boundary seems countervailed by an insistence on boundary, every opening to chaos by a groping at order, and so on.[45] This tension exists not only between schizophrenia and paranoia but also within each condition, that is, within each patient torn between visions of self-loss and visions of self-rescue. Prinzhorn detected such ambivalence in most of his masters, whether they were diagnosed as schizophrenic or paranoid. This ambivalence extends to external objects ("a child's head . . . reminds the drawer of death, a radish pulled from the earth reminds him of Christ with chalice and host" [*AMI* 236]) as well as to other beings ("the physician may be greeted as if he were the mailman" [*AMI* 39]), but it is finally rooted in the subject ("a patient is God but sweeps the floor willingly" [*AMI* 266]). This ambivalence in the subject is most extreme in the recurrent identification among the Prinzhorn masters with Christ. The force of this identification is that it allows for simultaneous delusions of grandeur and persecution, for a status that is at once "supernatural" and "sacrificial," exalted and abject (*AMI* 117). However,

rather than a position of a double authority, this is a position of a double bind, in which the subject is indeed caught in an "in-between world," caught in a crisis between symbolic orders, caught (perhaps like Christ) as the crux between such orders—between a ruined old dispensation and an emergent new dispensation that no one else yet perceives, let alone believes in.[46] The Prinzhorn collection is full of images that seem to recount a blasphemous transgression of religion, or a carnivalesque overturning of society. But rather than heroic acts of refusal or revolution, what these images might register are panicked attempts to restore or to replace such social systems—panicked attempts, that is, both to record the breaking of an old order and to project the founding of a new one.

THE SYMBOLIC ORDER AS "OLD LECHER WITH RIFLE"

I want to conclude with a work by Ernst, mentioned in chapter 4, that turns an evocation of a failed subject into a critique of a failed symbolic order. It is a work now known through a photograph that shows Max and Luise Ernst, and Paul and Gala Eluard, in the Cologne studio of the former in 1920; the infant Jimmy Ernst is barely visible between them (fig. 5.10). It is a simple snapshot that commemorates a new friendship—a friendship that would soon become a difficult Max-Paul-Gala *menage à trois*. They appear under a strange assemblage that resembles a three-dimensional version of the "self-constructed machines" of Ernst; it is one of the junk sculptures made at the same time as his Dadaist collages, apparently inspired by the "bread sculptures" seen on his prewar visit to the asylum near Bonn. As I argued in chapter 4, most of these sculptures evoke hapless personages of phallic authority in trouble. Akin to the collage *The Hat Makes the Man* (1920; fig. 4.12), the strange figure here is indeed an "old lecher," stuck together with wood rods, a helmet hat, and a stick-gun (a later collage with the same title is de/constructed out of similar items of fashion and war).

Again, Ernst presented *Old Lecher with Rifle* in the "Dada—Early Spring" show in April 1920, and it was this sculpture that provoked the good citizens of Cologne to call out the police to close the exhibition. (In this regard, *Old Lecher with Rifle* is partner to the plaster pig head, stuck on a military uniform and hung

5.10. Luise Straus-Ernst, Max Ernst, and son Jimmy with Gala and Paul Eluard in Ernst's studio, Cologne, November 1921, in front of *Old Lecher with Rifle Protects the Museum's Spring Apparel from Dadaist Interventions [L'état c'est MOI!] [Monumental Sculpture]*. © 2003 Artists Rights Society (ARS), New York/ADAGP, Paris.

from a ceiling, that caused a similar furor at the "First International Dada Fair" in Berlin a few months later.) His own father broke with Ernst over the event. Clearly this work pressured a time that was already out of joint.

Ernst gives the sculpture a caption in the quasi-schizophrenic "word salad" common in his contemporaneous collages: "Old Lecher with Rifle Protects the Museum's Spring Apparel from Dadaist Interventions [L'état c'est MOI!] [Monumental Sculpture]." This is near nonsense, to be sure, but it is pointed nonsense, for in this moment of military defeat and social chaos the state is figured as an "old lecher" whose only authority is sheer force, "the rifle." And yet this pathetic state still attempts to protect the cultural patrimony, "the museums," from the attack of "Dadaist interventions." However, the performative magic of this state power ("l'état c'est MOI!") no longer functions; it is ridiculous, and here the Ernst-Eluard quintet, at once promiscuous and provocative, lies casually, almost insolently, indifferent to this emblem of police force. Moreover, the cultural patrimony that the state wishes to protect is already degraded: it is little more than fashion, "spring apparel," an array of new commodities for each new season, and Ernst does not seem to exempt the avant-garde in general, or Dada in particular, from this status. If *Old Lecher* is indeed a "monumental sculpture," it is thus a monument to the failure of symbolic monumentality, a monument to the collapse of social authority. It is this blinded insight—that the art of the mentally ill might point less to pure expression, originary vision, or vanguard transgression than to a given crisis in the symbolic order—that Ernst discovers in "the no-man's-land" of its representations.

6.1. Jacques-André Boiffard, *Untitled,* 1929. Gelatin silver print. Musée National d'Art Moderne, Centre Georges Pompidou, Paris. © Mme. Boiffard.

A Little Anatomy

Although the surrealists preached the liberation of sexual desire for all, most surrealists were men, and men came first in this liberation. Surrealism included women, of course, and in many ways its liberation focused on women, but they were asked to represent desire more than to experience it. This much is suggested by surrealist photography, which is dominated by images of women made by men. Many of these images present versions of femininity that, however risqué in the 1920s and 1930s, appear restrictive now, such as woman as erotic muse (also common in surrealist painting, poetry, and prose), or, conversely, woman as fearsome Medusa, as evoked in a 1929 close-up by Jacques-André Boiffard of a wild-eyed woman caged by her own snaky hair (fig. 6.1). Manipulated in various ways, surrealist photographs of women may appear strange formally, but most are familiar psychically, for they tend to position women as "objects of the male gaze" (this old feminist formula holds true here).[1] Yet sometimes these photographs display an ambiguity, or otherwise disclose an ambivalence, that cannot be so neatly understood, as when this gaze of the implied viewer is returned by the woman, as if it were refused. In the Boiffard portrait, for example, "the male gaze" is suffered, but it also seems to be thrown back, as if her subjection might be turned into a challenge.

This doubling of the gaze might only increase the anxiety that many of the images appear to treat. According to Freud, this anxiety in men derives from a

threat associated with women—with the castration that the female body is said
to signify to the male subject. Since the woman lacks a penis, this hypothetical
male imagines that he may lose his too, perhaps somehow at her hand.[2] Some-
times, according to Freud, this fear of loss is registered as an anxiety about blind-
ness, and numerous portraits of women with distorted eyes (enlarged, split, and
so on) suggest that some surrealists made this metaphorical association as well.
In 1922, Man Ray approached this fantasy-image of woman as castrative Me-
dusa in a portrait of the Marquise Casati, a surrealist patron whose eyes, through
double exposure, are made to appear both severed and severing (fig. 6.2).

There is, then, a castrative aspect in many surrealist *portraits*. The relevant
photographs provide evidence enough, but this hypothesis is further supported
by a complementary tendency that is even more pronounced: the fetishistic as-
pect of many surrealist *nudes*. Often these nudes are cropped or otherwise manip-
ulated in a way that turns the female body into a near fetish-image, as Brassaï does
in a nude of 1931–32 in which the head and legs of the woman are concealed,
the back and buttocks face out, and the body is illuminated, so that it seems to
rest in space as a penile apparition (fig. 6.3). There are many examples of such
photographic transformation in the work of Man Ray, André Kertész, and oth-
ers; and women like Lee Miller played with this fetishistic form as well, just as
they did with the semi-sexist stereotypes of woman mentioned above—an indi-
cation that these types were not restricted by the gender of the artist (one can cast
a "male gaze" and not be male).[3]

According to Freud, the fetish is one response to the traumatic sighting of
castration in which the male subject concentrates on a substitute object in order
not to acknowledge the lack of the penis in the female body, as if to say "*it* is not
really gone as long as I have *this*." The great trick of some surrealist photographs
that evoke this traumatic sighting is that they reshape the very body said to sig-
nal the threat of castration into a fetishistic form that might defend against this
same threat. But the transformation is rarely complete. In the manner of some fet-
ishes described by Freud, many images seem to register castration even as they ap-
pear to conceal it, and sometimes they do so in the same act, as when the cropping
that reshapes the body into fetish-form simultaneously marks it with a castrative

cut (this occurs in the 1931–32 nude by Brassaï). In such cases, as Freud comments, the fetish as "protection" against castration is also the fetish as "memorial" to it. In some instances this ambiguity of form might disclose an ambivalence of intent in the artist, and/or produce an ambivalence of affect in the viewer. Or at least in *some* viewers: wittingly or not, surrealist photography underscores sexual difference in spectatorship.

At this point a troublesome question arises concerning surrealist awareness of Freudian psychoanalysis, and it cannot be answered definitively.[4] Often surrealism appears to be illustrative of Freudian notions, but it can also anticipate or parallel them, elaborate or contradict them. Few surrealists read German (Max Ernst is an obvious exception, but he was not central to surrealist photography), and French translations of Freud often came late. Although Freud mentions fetishism early on, in *Three Essays on the Theory of Sexuality* (1905), his short text devoted to the subject dates to 1927, and it probably did not influence the surrealist photographs at issue here directly. In any case, the most effective of these images are not merely illustrative of psychoanalytic notions, and the same goes for the photographic devices that they develop: the most effective of these devices— close cropping, extreme angles, raked lighting, mirror distortions, double exposures, montage and solarization—are not contrived to stage Freudian ideas given beforehand. In the development of surrealist photography, these devices seem to appear almost by accident, as if they were actual instances of "objective chance" (to use the surrealist term); at the same time, this "marvelous" accident makes these devices all the more pointed as expressive mediums of psychic conflict.

A Dictionary of Analogues-Antagonisms

The tension between surrealist images of woman-as-castrative and woman-as-fetish can be finessed, as when the castrative body is reshaped into a fetishistic form, but it cannot be resolved, for these types are as contradictory as they are complementary. And so we often see in such surrealist photography an oscillation between images in which the anxiety provoked by woman is somehow expressed or flaunted, and others in which it is somehow deflected or contained.

6.2. Man Ray, *Marquise Casati,* 1922. Silver positive on glass plate. Musée National d'Art Moderne, Centre Georges Pompidou, Paris. © 2003 Man Ray Trust/Artists Rights Society (ARS), NY/ADAGP, Paris. Photo: CNAC/MNAM/Dist. Réunion des Musées Nationaux/ Art Resource, New York; photo by Adam Rzepka.

6.3. Brassaï, *Untitled*, 1931–32. Gelatin silver print, 11⅛ × 16 3/16 in. Collection Rosabianca Skira, Geneva. © Mme. Brassaï.

This oscillation between castrative and fetishistic visions of women is most intense in the doll photographs of Hans Bellmer, and when he attempts to arrest this tension through a near-impossible conflation of the two types, it becomes all the more volatile.

Made of wood, metal, plaster pieces, and ball joints, the two principal sets of *poupées* were often manipulated in drastic ways and photographed in extreme positions. Ten images of the first doll were published in *Die Puppe* (1934), and a series of eighteen photographs followed in *Minotaure* 6 (Winter 1934–35) under the title "Variations sur le montage d'une mineure articulée" (fig. 6.4). For Bellmer these "variations" on the first *poupée* produced a volatile mixture of "joy, exaltation, and fear," an ambivalence that sounds fetishistic in nature.[5] Bellmer did not discourage this reading: in "Memories of the Doll Theme," the introductory text of *Die Puppe,* he describes the first doll as a talisman with which he hoped to recover "the enchanted garden" of childhood, a familiar trope for a pre-Oedipal moment before any impression of castrative loss or sexual difference. Apparently, however, his ambivalence of "joy, exaltation, and fear" was too intense to be contained by this trope, too intense *not* to be acted out on the doll, for the *poupée* hardly exists in "the enchanted garden" of childhood—unless we understand this childhood as one riven by an outlandish sexuality beyond the conjectures of Freud.

The second *poupée* makes this fetishistic manipulation even more manifest, for this doll consists of tumescent body parts that are obsessively repeated, aggressively conjoined, perversely transformed (fig. 6.5). What Freud writes of "Medusa's Head" (1922) seems true of the second *poupée* as well: its various decapitations seem to express a castration anxiety, while its fetishistic "multiplication of penis symbols"—in the snaky hair of the Medusa there, in the tumescent body parts of the doll here—works to counter this anxiety. Yet, as Freud further suggests, this fetishistic multiplication might also underscore the very castration that it means to deny.[6] Paradoxically, the construction of this doll is also a kind of dismemberment, and its effect is at once castrative (in the disconnection of its parts) and fetishistic (in the often penile appearance of these parts).[7] This formal conjunction cannot suffice as a psychic resolution, and in fact Bellmer is led to

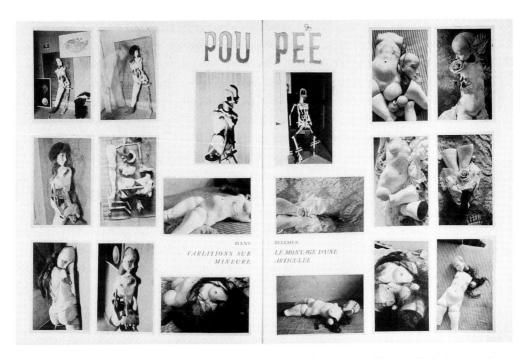

6.4. Hans Bellmer, "Variations sur le montage d'une mineure articulée." Photographic ensemble in *Minotaure* 6 (Winter 1934–35). © 2003 Artists Rights Society (ARS), New York/ADAGP, Paris.

pose the second *poupée* in sadistic tableaux—in scenes, often luridly colored by hand, that sometimes evoke the aftermath of child abuse, rape, or murder (fig. 6.6).

Bellmer investigates the first doll with apparent cruelty too. In "Variations sur le montage d'une mineure articulée," there is no clear narrative of construction, let alone resolution of desire; rather, we witness the *poupée* in various states not only of *déshabillée* but of disassembly (fig. 6.4). Like the little Hans analyzed by Freud in "Analysis of a Phobia in a Five-Year-Old Boy" (1909), this big Hans seems to violate the doll so as to expose the signs of gender and/or the mechanics of birth.[8] Here, rather than denied fetishistically, the avatars of castration seem staged openly, even prosecuted aggressively, as though the *poupée* were punished for the damaged condition that she is also made to represent. (In one photograph in "Variations sur le montage," the doll appears punished to the point of utter disarticulation: its parts are laid out almost forensically.) As with the fetishist according to Freud, so here with Bellmer (or at least, the subject that he projects): erotic delight seems mixed with "horror at the mutilated creature or triumphant contempt for her."[9]

Yet we should not be too quick to pathologize Bellmer. First, these scenes are representations, not realities—a fact that some viewers still tend to overlook. Second, similar scenes occur in the work of other surrealists, female as well as male. And, third, the subject implicated in these scenes, as elsewhere in surrealism, is not necessarily identical with the artist, whose fantasies are not transparent in the work in any case. That said, sadism is evoked through the dolls as much as fetishism. Apart from his photographic records of imaginary misdeeds, Bellmer writes openly of his drive to master his "victims," and to this end he poses his *poupées* very voyeuristically. (With the first doll he goes so far as to design an internal mechanism filled with miniature panoramas to "pluck away the secret thoughts of the little girls.")[10] Obviously, then, a fantasy of control is in play—of control not only over creation but over desire as such. Although Bellmer might claim that other desires are figured here ("the secret thoughts of the little girls"), it is clear who the masterful is, and what the mastered object.

Or is it? What is this desire exactly, and if it is so masterful, why does it require such a show of mastering? As we saw with primitivist scenes in chapter 1,

this display is so extreme that it suggests that the artist is not totally in control af-
ter all. If the dolls involved only fetishism, one would expect a fixing of desire in
particular details, but this is not strictly the case in the *poupées:* they enact a shift-
ing of desire too, one that points to possible reversals of positions and vicissitudes
of drives. In his essay on "Instincts and Their Vicissitudes" (1915), Freud argues
that the voyeur might be an exhibitionist in disguise, and that the sadist might
conceal a masochist within. Could this be true of the Bellmer that the dolls pro-
ject here? The scenarios do stage a sadistic attack that seems to go beyond the
female object to redound on the male subject. Might this shared shattering be
the "erotic liberation" that Bellmer seeks, and the "final triumph" of the *poupées*
that he claims?[11] Paradoxically, in "Memories of the Doll Theme" he locates this
triumph at the very moment when the dolls are "captured" by his gaze. How are
we to understand this entanglement?

One way to begin is to posit a masochistic subtext in the sadistic staging of
the *poupées.* "I wanted to help people come to terms with their instincts," Bellmer
remarked in retrospect.[12] Here, I think, we should take him at his word, for the
dolls do appear to stage a struggle between instinctual fusion and defusion—
or, in his own words, between "the innumerable integrating and disintegrating
possibilities according to which desire fashions the image of the desired."[13] Ac-
cording to Freud, within each of us is a nonsexual drive to master the object
that, when turned inward, becomes sexual, and, when turned outward again, be-
comes sadistic. But within each of us, too, there remains an element of aggressiv-
ity that Freud calls an "original erotogenic masochism."[14] It is this difficult relay
between sadism and masochism, between the erotogenic and the destructive, that
the *poupées* evoke. In his sadistic scenes Bellmer leaves behind masochistic traces;
in his erotic manipulation of the dolls he explores a destructive impulse that also
appears self-destructive. In this way the dolls might probe sadistic mastery to the
point where the subject is exposed to its own greatest fear—its own fragmen-
tation and disintegration. And yet, paradoxically, this might also be its greatest
desire: "All dreams return again to the only remaining instinct," Bellmer writes,
"to escape from the outline of the self."[15] Is this why he seems not only to desire
the dolls but also, in some sense, to *identify* with them, not only to manipulate

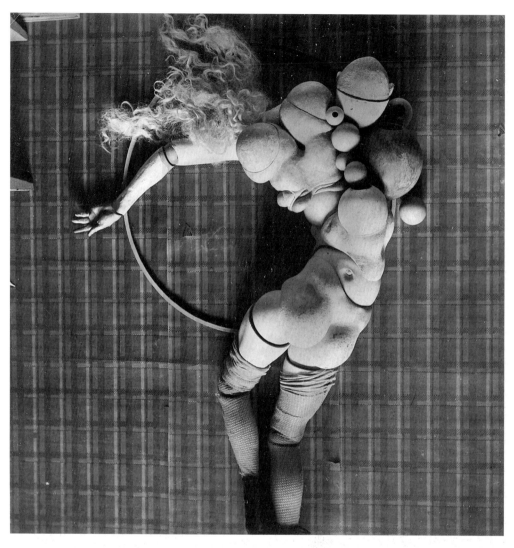

6.5. Hans Bellmer, *The Doll,* 1935. Silver salt print, 26 × 26 in. Musée National d'Art Moderne, Centre Georges Pompidou, Paris. © 2003 Artists Rights Society (ARS), New York/ADAGP, Paris. Photo: CNAC/MNAM/Dist. Réunion des Musées Nationaux/Art Resource, New York; photo by Jean–Claude Planch.

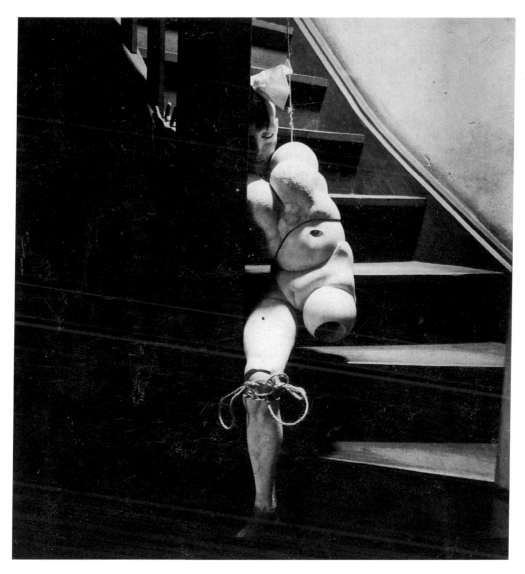

6.6. Hans Bellmer, *The Doll,* 1936. Gelatin silver print, 29 × 26 in. Musée National d'Art Moderne, Centre Georges Pompidou, Paris. © 2003 Artists Rights Society (ARS), New York/ADAGP, Paris. Photo: Réunion des Musées Nationaux/Art Resource, New York; photo by Philippe Migeat.

235

them sadistically but also, in some sense, to *become* them masochistically? In one double-exposed photograph in "Variations sur le montage d'une mineure articulée," Bellmer appears opposite the first doll less as its separate creator than as its spectral double (fig. 6.7). Moreover, the very notion of a "montage" implies a kind of splicing of subject and object, a kind of suturing of Bellmer into the scenes of his *poupées.* And in his subsequent drawings of such "minors," he often commingles male and female parts, his own image with theirs. "Should not this be the solution?"[16]

Again, the dominant model of the surrealist photograph is the fetish, as is most manifest in the aforementioned nudes where a phantom of the penis returns uncannily through the female body, even *as* the female body, that was imagined to lack it. Yet this formal manoeuvre does not provide a psychic resolution (even though it seems to displace female subjecthood altogether), and sometimes the fetishistic defense breaks down—an event that can release the sort of aggressivity performed in the Bellmer dolls. In effect, these *poupées* elaborate the logic of the fetish to the point of its collapse, that is, to the point where this logic is both exposed and undone; and in this collapse of the fetish, another logic of the object begins to emerge.

In psychoanalysis, fetishism is first and last a disavowal of sexual difference; in this way it suggests a faltering at the threshold of the genital order in which sexual difference is established. Psychically, if it is not arrested with a fetish, this faltering might precipitate a fall from the genital order, in particular a fall back to the anal order. As we saw in chapters 1 and 2, psychoanalysis has long understood the world of anality as one of sexual indifference, of strange substitutions and odd equivalencies, in which the body never appears quite whole. According to Freud, the tokens that are "ill-distinguished" in this world include feces, babies, and penises.[17] With the second doll Bellmer seems to add buttocks, breasts, and heads to this list, for they, too, are "ill-distinguished" here (fig. 6.5). Perhaps Bellmer performs this imagined regression to anality as an act of defiance against his Nazi father, as a gesture of assault on all phallic authority, paternal and political.[18] In this respect, the perversion of the dolls is also a *père-version,* a turning away from the father, a disavowal of his genital monopoly and a challenge to his preemptive

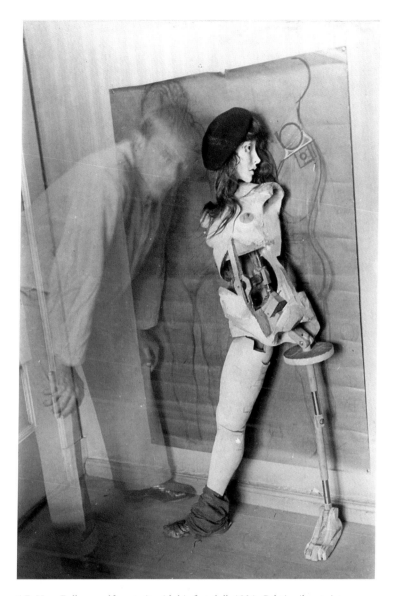

6.7. Hans Bellmer, self-portrait with his first doll, 1934. Gelatin silver print, 11¾ × 7¾ in. Ubu Gallery, New York and Galerie Berinson, Berlin. © 2003 Artists Rights Society (ARS), New York/ADAGP, Paris. Photo: Ubu Gallery and Galerie Berinson.

law through "an erosion of the double difference between the sexes and the generations."[19] This erosion of difference is so scandalous because it exposes an archaic order of the drives, "the undifferentiated anal-sadistic dimension."[20] And it is this order of the drives, with its logic of part-objects, that Bellmer indicates "underneath" the broken surface of the surrealist fetish.[21] In this way, if the first doll suggests a breakdown of the fetish with its fixed desire, the second doll suggests a release of the part-object with all its wild associations—again, legs that are breasts, buttocks, heads. . . .

In a later text titled *Petite anatomie de l'inconscient physique, ou l'Anatomie de l'image* (1957), Bellmer refers to the dolls as a "dictionary of analogues-antagonisms."[22] This description also intimates less a fixing of desire in a fetish than a roaming of drives across part-objects. Perhaps he came to this notion of a bodily dictionary through the writings of Georges Bataille, in particular his *Histoire de l'oeil* (1928), which Bellmer illustrated in 1947. In a sense, *Histoire de l'oeil* is what its title announces: the story of an object (an eye) that calls up first a set of solid analogues (testicles, breasts, eggs . . .) and then a set of liquid correlatives (urine, milk, yolks . . .). According to Roland Barthes, the transgression associated with Bataille is effected when these two metaphorical lines are made to cross metonymically—that is, when strange encounters between part-objects replace conventional associations (e.g. "an eye sucked like breast"). "The result is a kind of general contagion of qualities and actions," Barthes writes. "The world becomes *blurred*."[23] This blurring is fundamental to Bataillean eroticism: it is a somatic transgression, a crossing of the limits of the subject, doubled by a semantic transgression, a crossing of the lines of sense. More than the fetishistic beauty touted by André Breton and others, it is this Bataillean eroticism that Bellmer explores: out of a difficult dictionary of analogues-antagonisms he devises a transgressive anatomy of desires-drives.[24] In this way Bellmer illuminates the tension between "integrating and disintegrating possibilities" more starkly than any other surrealist; he illuminates it more because he sublimates it less. And the sadomasochistic nature of sexuality is revealed as a difficult crux not only of the *poupées* but of surrealism at large.

A VEILED ROLE

Bellmer came to surrealism late, and his vision of surrealism was extreme. As we have seen, the common response to the surrealist tension between the castrative and the fetishistic was not to compound it, as Bellmer did, but to resolve it or to suspend it somehow. Yet there are other images in the surrealist repertoire that suggest a different strategy: to block out this tension, and so to remain committed to the phallic order, disguised as it then is. Such is the operation of a beautiful set of surrealist nudes, whose very beauty might depend on this blockage. Many of these images are by Man Ray, who often used his fellow photographer and onetime lover Lee Miller as his model, but he is not alone: Brassaï, Miller, and others worked in this undeclared genre as well. As usual, these nudes reshape the female body in fetishistic form, but there is little reminder of castration (or its analogues) in the transformation here. The subject is clearly a woman, but she is more phallic than fetishistic; in a sense, she is woman *as* phallus.[25]

There are two basic versions of these nudes. In the first version, the nude is cropped of legs and head (which suggests that the woman is cropped of subjecthood), and the torso is reshaped as a phallus. In a 1931 nude by Brassaï, a headless body, lighted from above and shot from the side, seems to float, foreshortened, as such a white phallus, while in a circa 1931 nude by Miller, another headless body, seen from behind and below, rises up as an anamorphic apparition of a similar sort (fig. 6.8). The second version of this nude reverses the strategy of the first, but to the same end: here the body is nothing but head and neck, which are elongated by pose and angle in order to form another kind of phallic figure. The best example is *Anatomies* by Man Ray (1929; fig. 6.9), who photographs his model with her neck stretched out and head pulled back. (The model is probably Miller; a 1930 Man Ray portrait of Miller in profile also attenuates her neck in extreme fashion.) Soon enough these headless bodies and bodyless heads were subsumed under the rubric of the Minotaur, the man-bull of Greek mythology that the surrealists adapted as a totemic figure of the surrealist subject lost in the labyrinth of his own desire (the journal *Minotaure* appeared from

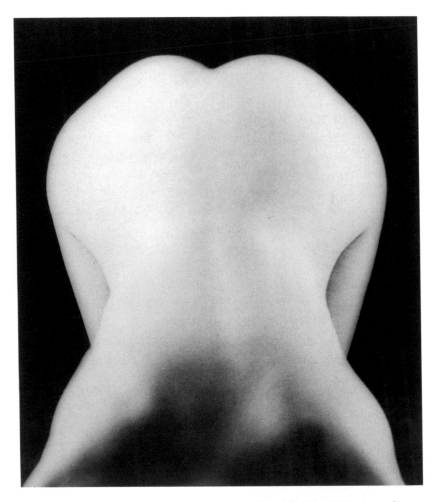

6.8. Lee Miller, *Untitled*, c. 1931. Gelatin silver print, 7⅞ × 6⅞ in. The Art Institute of Chicago: the Julien Levy Collection, 1988.157.54. © Lee Miller Archives, Chiddingly, England, courtesy of The Art Institute of Chicago. Photo © The Art Institute of Chicago.

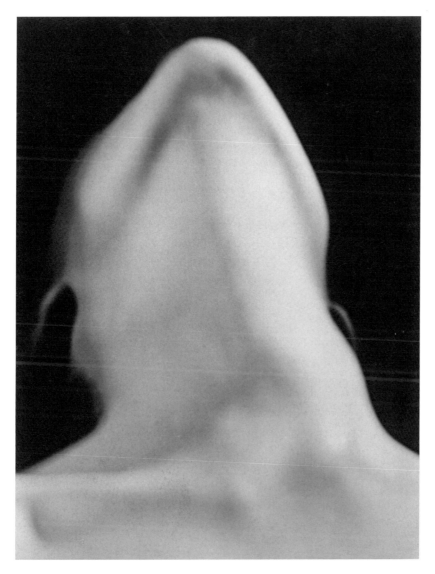

6.9. Man Ray, *Anatomies,* 1929. Gelatin silver print, 8⅞ × 6¾ in. The Museum of Modern Art, New York: Gift of James Thrall Soby. © 2003 Man Ray Trust/Artists Rights Society (ARS), NY/ADAGP, Paris. Digital image © 2001 The Museum of Modern Art, New York.

1933 to 1939). But often this man-as-animal is evoked through the woman-as-phallus; in the most famous incarnation of the surrealist Minotaur, a 1934 photograph by Man Ray, the head of the bull is figured by the torso of a woman (fig. 6.10).[26]

Perhaps the richest instance of the surrealist woman-as-phallus is the earliest, the wryly titled *Return to Reason* (1923) by Man Ray (fig. 6.11). This nude is cropped at neck and navel, and posed in the near dark by a window hung with lace; she is also turned in such a way that a veil of refracted light and shadow striates her body almost to the point of its dissolution into the liquescent space of the room (which is also the liquescent surface of the print: this slippage is a recurrent effect of surrealist photography). This type of image must have fascinated Man Ray, even arrested him, for he returned to it often enough. In a related photomontage of 1924, two pairs of breasts, more frontal here, are stacked one above the other to form a phallic figure. To transgender this female body part in this way is a bold move, but the cut of the montage makes the image appear less perfectly phallic than the others in question.

Five years later, in a series of photographs of Miller, Man Ray returns to the type. Again posed by the window, the nude is more explicitly veiled—in the first image by a lace curtain, in the others by various patterns of refracted light and shadow (as in *Return to Reason*). Significantly, in this series Miller is not headless: she retains this sign of subjectivity, and her various expressions and postures seem to convey different moods—distracted, contemplative, intense. Closely related to these images is another photograph (circa 1930) of Miller. Headless once again, with her body more frontal and her breasts and arms less obscured, she is reconfigured vertically, phallically, by a similar arabesque of refracted light and shadow (fig. 6.12). Krauss describes these veiled nudes as an "inscription of the body by space . . . in which boundaries are indeed broken and distinctions truly blurred"; that is, she associates them with "formless" and "psychasthenic" states as discussed by Bataille and Roger Caillois respectively.[27] But we can also see them in the terms offered here, in this case as neither the fetish nor the part-object so much as the "beautiful" phallus in which distinctions—between male and female above all—are indeed blurred.

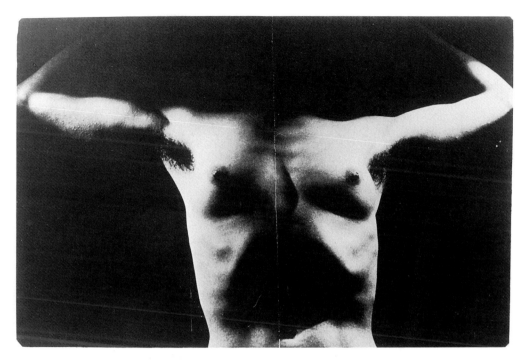

6.10. Man Ray, *Minotaur,* 1934. Gelatin silver print, 5⅞ × 9 in. Collection of Michael Senft, East Hampton, New York. © 2003 Man Ray Trust/Artists Rights Society (ARS), NY/ADAGP, Paris.

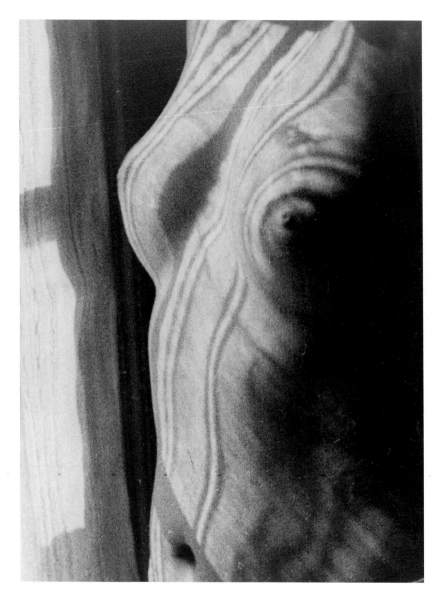

6.11. Man Ray, *Return to Reason*, 1923. Gelatin silver print from a motion picture negative, 7⅜ × 5½ in. The Art Institute of Chicago: the Julien Levy Collection, 1979.96. © 2003 Man Ray Trust/Artists Rights Society (ARS), NY/ADAGP, Paris. Photo © The Art Institute of Chicago.

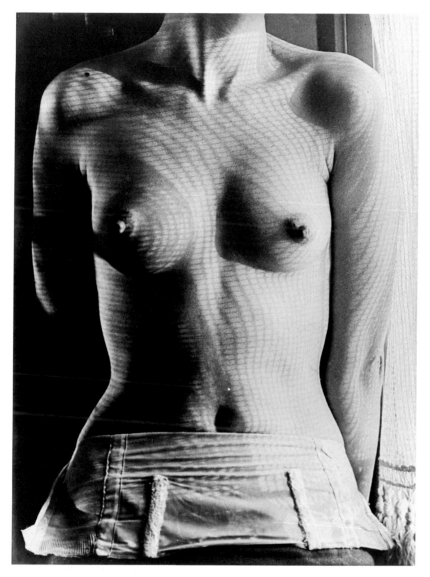

6.12. Man Ray, *Untitled,* c. 1930. Gelatin silver print, 11¼ × 8⅞ in. © 2003 Man Ray
Trust/Artists Rights Society (ARS), NY/ADAGP, Paris. Photo courtesy of Lee Miller
Archives, Chiddingly, England.

To elaborate these terms, we need to turn to Jacques Lacan, who was a young associate of the surrealists in the early 1930s. As is well known, in his revision of psychoanalysis elaborated in the 1950s and 1960s, Lacan reread Freud through the structural linguistics of Ferdinand de Saussure, a contemporary of Freud whose work Freud did not know, but whose epistemological field he shared in part. Through this association of Freud and Saussure, Lacan arrived at formulas such as the famous one presented in "The Meaning of the Phallus" (1958): that the unconscious is structured like a language, or, more precisely, that the psychic mechanisms of condensation and displacement in dreams can be understood in terms of the linguistic operations of metaphorical substitution and metonymic connection. Perhaps today, in a similar way, we can reread Lacan through surrealism; certainly surrealism resurfaces in his work with deferred effectivity in the late 1950s and early 1960s (this is especially evident in his seminars on trauma, repetition, and the gaze held in 1964, seminars known to us as *The Four Fundamental Concepts of Psycho-Analysis*).

At first glance, this hypothesis seems contradicted by a text like "The Meaning of the Phallus." Here Lacan revisits psychoanalytic debates of the 1920s and 1930s involving Karl Abraham, Ernest Jones, and Melanie Klein, debates regarding the phallus that implicate surrealism as well. Against the positions articulated by these early analysts, Lacan argues that the phallus is neither a fetish-fantasy nor a part-object, models that, as we have seen, are also at work in surrealism. "It is even less the organ," Lacan states. "For the phallus is a signifier."[28] It is not just any signifier for Lacan; it is *the* signifier, the primary signifier of all desire. It has this status for him because it represents the desire of the other, in the first instance the desire of the mother, a desire that is born of lack (or castration). In this account the phallus is also the primary signifier of lack, the lack of the phallus that the child soon detects in the mother. It is this lack, moreover, that initiates the child into the play of difference that is language—into the symbolic order supervised by the father. "The phallus is our term for the signifier of his alienation in signification," Lacan writes a year later, in 1959.[29]

Of course, no one can possess this signifier. Nevertheless, Lacan claims, "the relations between the sexes" turn on the fantasy that men have the phallus

and women embody it, with "the effect that the ideal or typical manifestations of behavior in both sexes, up to and including the act of copulation, are entirely propelled into comedy."[30] As we saw in chapter 3, these manifestations are comic because men pretend to *possess* the phallus in order "to protect it," and women appear to *be* it in order "to mask its lack." To these ends men are led to a "virile display" of masculinity (with the added irony that such display is culturally coded as feminine), and women to a "masquerade" of femininity (for "it is for what she is not that she expects to be desired as well as loved").[31]

Not a fetish, not a part-object, "even less the organ": this conception of the phallus as signifier depends on its distinction from the penis. This difference is very important, theoretically and politically, for in principle it renders men and women equal, that is, equally at the mercy of lack and desire. But, as feminists like Kaja Silverman and Jane Gallop have charged, the separation is not complete in Lacan; the phallus remains propped on the penis in his writings.[32] This propping is most evident in "The Meaning of the Phallus" when Lacan alludes to "the famous painting in the Villa of Pompeii" of the Dionysiac rites of betrothal and marriage. One scene in this Great Frieze of the Villa of the Mysteries shows a phallic object covered by a purple veil attended by a kneeling woman who appears about to unveil it (fig. 6.13). Lacan remarks of this scene that "the phallus can only play its role as veiled."[33] Contrary to the account that he then develops, this statement implies that the phallus can maintain its dominant position in our symbolic order only if it remains a signifier—that is, only if it remains not simply veiled and hidden as a thing, but also inflated and elevated as a signifier. Only then can the phallus retain its status as the symbol of sovereign potency: if it were not raised to this transcendental level (Lacan uses the Hegelian term *aufgehoben*), it might be unveiled as a mere penis in disguise.

This veiled sublation is evoked in the last surrealist nudes in question here. Not only is the castrated/castrative woman transformed fetishistically into a penile form, but this form is also disguised, raised to the power of a signifier. And the result is that the male subject is invited not only to contemplate this body-turned-signifier with peace of mind, all castration anxiety allayed, but also to admire this phallus *as if it were the beauty of woman to which he pays homage, and not the*

6.13. Detail of the fresco cycle at the Villa of the Mysteries, Pompeii, depicting initiation into the cult of Dionysus. © Archivo Iconografico, S.A./CORBIS.

inflated prowess of his little thing. Of course, this peace of mind, this "return to reason," comes at the cost of a total confusion of female and male, a complete collapse of difference, which surrealists of both Bretonian and Bataillean stripes were more than willing to indulge.[34]

My reading of this kind of nude as a specular idealization of the feminine-as-phallic is tendentious, but we should remember that the Paris art world had recently experienced a public controversy involving a related confusion of the feminine and the phallic.[35] In 1920 Constantin Brancusi exhibited his *Princess X* (1916; fig. 6.14) at the Salon des Indépendants. Brancusi designated this oblong curve of polished marble (another was executed in bronze) "the Eternal Feminine," after Goethe, but everyone else—from Picasso to the police who came to remove the sculpture—seemed to see it for what it was: a phallus.[36] Neither party was wrong; or rather, both were right: *Princess X* is a woman, but it is also a phallus; it is woman-as-phallus, and perhaps it was this overt identification that was so scandalous. In the surrealist nudes this identification is precisely veiled, which is to say that these photographs allow a misrecognition of feminine beauty as phallic plenitude.[37]

LETTERS OF DESIRE

My cross-referencing of surrealism and Lacan involves more than the veiled nudes of surrealist photography, and I want to conclude with one more possible connection. A central concept of surrealism is "convulsive beauty," which Breton introduces in *Nadja* (1928) and elaborates in *L'Amour fou* (1937). In the latter novel, Breton associates this beauty with three kinds of uncanny experience that he never quite defines: "fixed-explosive," "veiled-erotic," and "magical-circumstantial." Krauss has in turn related these three categories of beauty to three operations of photography—its arresting, framing, and otherwise interrupting of the space of the world. In her account, surrealist photography discovers convulsive beauty in "the experience of reality transformed into representation . . . [of] nature convulsed into a kind of writing."[38] Krauss describes this photographic transformation as a "fetishization of reality," but again, "phallicization"

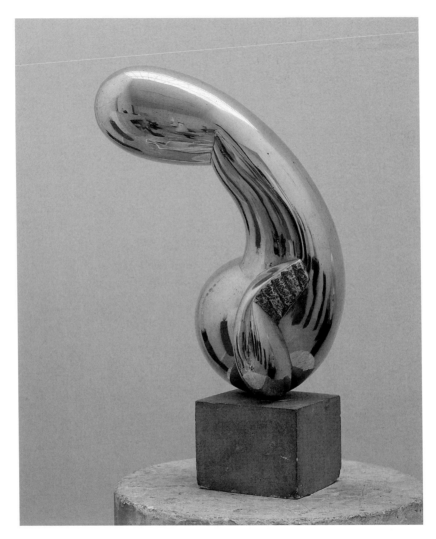

6.14. Constantin Brancusi, *Princess X,* 1916. Bronze, 22⅝ × 9 × 16¼ in. Musée National d'Art Moderne, Centre Georges Pompidou, Paris. © 2003 Artists Rights Society (ARS), New York/ADAGP, Paris. Photo: CNAC/MNAM/Dist. Réunion des Musées Nationaux/ Art Resource, New York; photo by Christian Bahier.

may be more exact. "The phallus can only play its role as veiled," Lacan writes, "that is, as in itself the sign of the latency with which everything signifiable is struck as soon as it is raised (*aufgehoben*) to the function of signifier." Lacan intends *aufgehoben* here as Hegel used the term, to mean "dialectically sublated"— that is, cancelled on one, referential level (the level of the penis), only to be preserved, even elevated, on another, semiotic level (the level of the phallus).[39] This formulation is difficult, but "the latency with which everything signifiable is struck" might be understood in terms of the surrealist experience of a reality pregnant with uncanny meaning, of a reality that awaits revelation as representation by the inspired surrealist (detective, flâneur, lover, reader . . .). What else is surreality but this "striking" of a reality with semiotic potential, a striking that is precisely explosive but fixed, erotic but veiled, magical but circumstantial? And what else is this semiotic potential but a power that is culturally coded as phallic?

In *L'Amour fou,* Breton defines this surreality as a "screen" on which "everything humans might want to know is written . . . in phosphorescent letters, in letters of *desire*."[40] I understand this "screen" as the phallic prism of lack through which the world is "struck" with the "latency" of the "signifiable," with signifiers that appear as "letters of desire" to the subject presumed to be male; this screen may take the form of dreams, screen memories, any "grid of desire."[41] Both time and place of these "letters" are obscure: the surrealist subject regards them as omens of the future, even though they "retrace" the past; and he reads them passively, as if it were they that construct him rather than he who contrives them. ("It is as a spectator that the author assists . . . at the birth of his work," Ernst writes in *Beyond Painting*. "The role of the painter is to . . . *project that which sees itself in him*.")[42] This confusion is at the heart of the surrealist aesthetic: the signs of past trauma are (mis)taken as portents of future desire; and they appear as if by chance, even though they are already there as so many readymades in the unconscious—for how else could they be experienced as uncanny, as familiar-yet-strange? Brassaï might be the great photographer of such surreality. Consider *The Statue of Marshal Ney in the Fog* (1932; fig. 6.15), with the uncanny sign "Hotel" in the distance that glows dimly through the fog-shrouded Paris

6.15. Brassaï, *The Statue of Marshal Ney in the Fog,* 1932. Silver salt print, 11½ ×
8½ in. © Mme. Brassaï.

night, guarded (or menaced?) by the sabre-drawn ghost of Marshal Ney in the foreground. Think, too, of all the other phallic guardians of Paris in his photographs—the Gothic gargoyles, Métro ornaments, and so on.[43]

After Ernst, Salvador Dalí transformed this confusion of signs into an aesthetic program, which he called "the paranoid-critical method."[44] In *L'Amour fou* Breton termed this confusion "interpretive delirium," and it "begins only when man, ill-prepared, is taken by a sudden fear in the *forest of symbols.*"[45] But why is this experience felt as "sudden fear"? Perhaps because the "ill-prepared" man has occluded the fact that he prepared this "forest of symbols" in the first place; perhaps, too, because the surrealist phallicization of the world as so many "letters of desire" depends on a prior recognition of castration that cannot be entirely blocked (an anxious note of castration cuts through the otherwise murky atmosphere in *The Statue of Marshal Ney in the Fog*). In any case, such uncanny fear is a small price to pay for the command of a reality in which the "marvelous precipitates of desire" are found almost anywhere by the surrealist subject. For finally, as Freud suggests in his essay on "The Uncanny" (1919), this fearful uncanniness is another way of being-at-home; or, as Breton states in *L'Amour fou,* "You only have to know how to get along in the labyrinth."[46] This might be less difficult than it seems for the surrealist subject who is not only the Minotaur of his maze but its Daedalus as well.

One final reference might clarify this speculation that the "interpretive delirium" of surrealism relies on a phallic ordering of the world as representation. In *The Four Fundamental Concepts of Psycho-Analysis,* Lacan distinguishes among different sorts of psychic repetition. After Freud, he identifies as *Wiederholung* the uncanny return of repressed material as so many symptoms—symptoms that, in an allusion to Aristotle, he terms the *automaton,* precisely because as symptoms they seem to return automatically, of their own accord, to "haul" up the subject again and again.[47] Lacan identifies as *Wiederkehr* a different kind of repetition, the return of "the encounter with the real": unlike the first repetition, this one resists all symbolization, even all symptomatization; it is a traumatic eruption that Lacan terms the *tuché,* again in an allusion to Aristotle (here concerning accidental causality). This *tuché* is located "beyond the *automaton*"; it involves a real

that exists behind "the insistence of the signs," behind the "coming-back" of symptoms that are "governed by the pleasure principle."[48] This suggests that, even as the "automatic" repetition of symptoms "haul" up the subject against his will, even as these symptoms recur disruptively "as if by chance," they can also serve to screen, or otherwise to protect, the subject from the more traumatic return of this "tuchic" real. Might "the insistence of the signs" in surrealism, governed as they too are by the pleasure principle, function in a similar way—to protect the subject from the traumatic return of the real? In chapter 7, I turn to moments in art and literature when this protection either fails or is given up, even attacked.

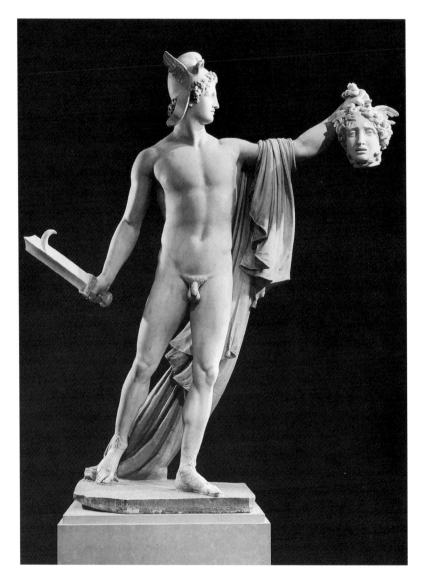

7.1. Antonio Canova, *Perseus with the Head of Medusa,* 1804–06. Marble, 86⅜ in. high.
The Metropolitan Museum of Art, New York: Fletcher Fund, 1967 (67.110.1 & .2).
Photo: The Metropolitan Museum of Art, New York.

7

TORN SCREENS

In the center of the balcony above the great hall of the Metropolitan Museum of Art stands the marble *Perseus with the Head of Medusa* carved by Antonio Canova in 1804–06 (fig. 7.1). In his left hand the Greek hero holds up the severed head of the Gorgon by her snaky hair and, in his right, the sword that decapitated her. Posed almost frontally, with only a slight contrapposto, nude except for his emblematic Hades helmet, magic sandals, and slung cape, Perseus appears calm, even though the decapitation is fresh. Is it by chance that *Perseus with the Head of Medusa* is the first work that one sees at the Met, the guardian spirit that presides over this vast museum? At any rate, that was the case until 2003, when the work was moved to the sculpture galleries, in a dubious triumph of chronological order over allegorical thought.

Canova carved the sculpture for Pope Pius VII, who had commissioned the Perseus to replace the Apollo Belvedere expropriated by Napoleon on his Italian campaign (the Met version is a copy made for a Polish countess). Canova modeled his Perseus on the Apollo, so here Perseus evokes Apollo formally, just as Medusa evokes Dionysus thematically: in this opposition of Perseus and Medusa, then, is ghosted the opposition of Apollo and Dionysus. Again, Canova presents the hero as perfectly composed, and the sculpture was often considered the last word in the Apollonian aesthetics of neoclassicism. His Perseus dares to

look at the head of Medusa (most incarnations of the hero do not) as if there were nothing more to fear from her gaze, and she does appear more sorrowful than frightful: clearly Perseus-Apollo has vanquished Medusa-Dionysus. Yet two considerations disturb this peace slightly. Neither figure escapes petrification: the paradox of any representation of Medusa, given her powers of reification, are already in play here. And like Benvenuto Cellini, whose *Perseus* (1545–54) also served as a model, Canova twins the heads of Perseus and Medusa—as if to suggest that a commonality exists between them.

The old positioning of *Perseus with the Head of Medusa* is also telling. Placed high above the entrance hall, it marked the primary axes of the museum: to the right lies Egyptian and Asian art, to the left Greek and Roman, Near Eastern and Islamic art, and beyond, in line with the entrance, is the grand stairway of the museum (with the names of its benefactors cut into the walls) that leads to the galleries devoted to European painting. This dramaturgy is ceremonial, almost ritualistic: we might not have noticed the sculpture, positioned high above us, yet as we passed under Perseus-Apollo triumphant—which is also to say, under Medusa-Dionysus subdued—its authority was somehow in the air, somehow assumed: it was the *genius loci*. A canny photograph by Louise Lawler brings this stagecraft into view (fig. 7.2): it shows a truncated Perseus (significantly he is the one who is cropped here, and from this angle his phallic sword seems to compensate for his little penis), the grand stairway, the Corinthian colonnade, the luminous vault and, in the distance, a history painting by Giovanni Battista Tiepolo, *The Triumph of Marius* (1729), which inaugurates the painting galleries. This massive canvas depicts the triumphal procession of the Roman general Marius on January 1, 104 BCE, following his capture of the African king Jugurtha, who, though still mighty (he looks down on us from the lofty space of the painting), is bound in chains.

The museum made its introduction, then, by way of a passage not only in aesthetic types, from a neoclassical sculpture of a Greek hero to a late baroque painting of a Roman general, but also in moral exempla, from the mythical subjugation of a supernatural kind of otherness in Medusa to the historical subjugation of a cultural kind in Jugurtha. This subjugation of the monstrous and the

7.2. Louise Lawler, *Statue before Painting, Perseus with the Head of Medusa, Canova*, 1983. Black and white photograph. Courtesy the artist and Metro Pictures.

barbarous is celebrated explicitly as a heroic event and implicitly as an artistic task—as the touchstone of this museum in particular, and perhaps of Western civilization in general. The legendary price of this civilization—the sacrificial cost of any symbolic order, the surrender of the instinctual to the rational—is also figured in the decapitated Medusa and the manacled Jugurtha. Yet the uncivilized is not eradicated here—neither in the Greek myth, nor in the Roman story, nor in the art works that depict them—because the symbolic order also requires the power of the uncivilized, or the power that is projected there. What is celebrated is the strategic taming of these uncivilized forces to civilizational ends, the "apotropaic" transformation of a deadly enemy into a prized trophy, of the evil eye of Medusa into the wise vision of Athena (*apo-tropaios* is to turn or to trope away). This transformation is thematic in both *Perseus with the Head of Medusa* and *The Triumph of Marius:* soon Perseus will hand over the monstrous Medusa to his goddess, just as Marius will deliver the barbarous Jugurtha to the city of Rome. The implication (might we speak here of an "unconscious" of the museum?) is that this apotropaic transformation of weapon into shield is fundamental to art, perhaps its originary purpose.

One leitmotiv of this book is the modernist equivalent of this apotropaic transformation. Picasso struggled to tame the unruly power that he projected onto both prostitutes and tribal objects in *Les Demoiselles d'Avignon,* and Adolf Loos worked to repress the degenerate eroticism that he imagined at work in the ornamental impulse. F. T. Marinetti and Wyndham Lewis sought to recoup the shock of industrial technologies in the making of hardened "new egos," and in his Dadaist work Max Ernst adapted some of the defensive strategies of the art of the mentally ill. Finally, several surrealists brandished figures of the fetish and the phallus almost explicitly as apotropaic devices. Here I want to think further about this apotropaic dimension of art in its ancient origins as well as in its modernist echoes. Why is that which is deemed other to art—nature, instincts, the mob, the real—so often projected as unruly or horrific, Dionysian or Medusan? And why is art so often regarded as a taming or a sublimating of this wild other term? What happens when art is not redemptive in this way—is it not art?[1]

THE POWER OF RADIATION

The myth of Medusa appears in various versions, from Hesiod and Apollodorus through Ovid and Lucan, but the basic story is clear enough. Medusa is one of the three Gorgons, the winged monsters who, born of the night, reside in a subterranean region near the world of the dead; she is the only Gorgon who is not immortal. Perseus, the son of Danäe and Zeus, is induced by an unsavory suitor of his mother to take on the task of beheading Medusa. The act is heroic because her horrific visage petrifies all mortals who behold it; her would-be assassins are turned to stone. In order to confront Medusa, Perseus must first acquire three talismans that only the Nymphs can bestow; and in order to find the Nymphs, he must first compel the three Graiai, the gray sisters of the Gorgons, to confess their whereabouts.

The Graiai, who combine youth and age in a hideous mix, have only one eye among them, which Perseus intercepts as it passes from one weird sister to another; already in play here, then, is the topos of the power of the gaze, or, more precisely, of this power intercepted. In order to regain the eye, the Graiai surrender the location of the Nymphs, who are no match for Perseus, and they grant the talismans that he needs: the magic winged sandals that transport him to Medusa, the Hades helmet that renders him invisible to her, and the special pouch in which to stash her severed head. Once more the power of the gaze is registered, here in the instruments required to suspend it. The Nymphs also arm Perseus with a curved blade to behead Medusa (significantly, given the Freudian reading of her decapitation as a figure of castration, it is the kind of sickle that the Titan Kronos used to castrate his father Ouranos, the first lord of the universe). Perseus waits for Medusa to fall asleep, and then, further protected from her gaze by a bronze shield given him by Athena, he decapitates her. In some versions of the myth he looks at the Gorgon only through her reflection in the shield, and in other versions Athena offers her aid only in exchange for the severed head.

Medusa is killed, but she remains vital. Previously raped by Poseidon, she bears the horse Pegasus and the giant Chrysaor from her neck as she dies (perhaps in a demonic permutation of the birth of Athena from the forehead of

Zeus), and, more important, her gaze retains its deadly power. It is this power that Athena transforms when Perseus presents the head to her: its image is arrested on her shield, its gaze fixed on her aegis, which is thereafter known as the Gorgoneion (it is a common emblem on military shields from Greek vases through Renaissance armor). Again, this apotropaic transformation from gaze-weapon to reflection-shield is the crux of the myth, and it points to a twinning-in-opposition of Athena and Medusa similar to that of Apollo and Dionysus. For just as Apollo needs Dionysus as his foil, Perseus must overcome Medusa in order to establish his heroic identity, and Athena must transform Medusa to establish her civilizational function.[2]

Claude Lévi-Strauss has long taught us to see a myth as a set of variations on a significant theme, often a fundamental contradiction in a culture that the myth serves to ease through its spinning into narrative. His prime example is the myth of Oedipus, which he decodes as a debate about the uncertainty of human origin—autochthonous, from the earth, or familial, from blood relations.[3] On this analogy, the uncertainty treated by the myth of Medusa centers on the power of the gaze and the capacity of representation to control it: "Medusa" is to these riddles as "Oedipus" is to the enigmas of identity and destiny, with a persistence in the culture almost as strong. On the one hand, the Gorgon is the anti-artist par excellence; the opposite of Pygmalion, she turns animate bodies into inanimate statues. On the other hand, this very power makes Medusa the master artist, for she produces sculptural images by her gaze alone.[4] And yet the crux of the myth vis-à-vis representation remains elsewhere—in the apotropaic transformation of the Gorgon into the Gorgoneion, of the Medusan gaze into the Athenan shield. There are two key moments in this transformation. The first is the capturing of the image of Medusa in the mirror of the shield; this initial act of mimesis, of reflection as representation, mediates and so moderates the force of her gaze. The second is the fixing of her severed head on the aegis of Athena, who thereby gains some of her power. In the first instance representation arrests the gaze; in the second instance, however, representation also requires the force of the gaze to arrest the viewer in turn. This double movement is fundamental to subsequent reflections on art that draw on the myth.

According to the classicist Jean-Pierre Vernant, Medusa appears as both figure and mask in Greece from the seventh century BCE onward, but "one constant feature dominates all her representations: the frontal view of her face."[5] Here, too, she is similar to Dionysus, the only Olympian god represented in full face, and this frontality seems to signify both the proximity to mortals and the fascination over them that the two figures share. With Medusa this force is also represented by a monstrous "blurring of all categories": often she is depicted as both young and old, beautiful and ugly, mortal and immortal, celestial and infernal; and sometimes, with her snaky hair, leonine head, bovine ears, and boarish tusks, she appears both bestial and human as well.[6] Moreover, Medusa embodies "a fusion of genders": sometimes bearded, with her tongue pendant like a penis, her face is often rendered as the genitals, both male and female, made into a mask; her hair is also both penile and pubic.[7] In short, in Medusa "a disquieting mixture takes place, analogous to the one Dionysus achieves through joy and liberation toward a communion with a golden age. But with Gorgo the disorder is produced through horror and fear in the confusion of primordial Night."[8]

If Perseus must suspend this horror, Athena must deflect this fear; hence the transformation that they perform together: "the threat becomes a kind of protection; the danger, now directed against the enemy, becomes a means of defense."[9] Yet what precisely is transformed? What exactly is the power of Medusa? It seems absolutely other, but it also involves a "crossing of gazes," and so it must stem from us somehow. "It is your gaze that is captured in the mask," Vernant insists; "what the mask of Gorgo lets you see, when you are bewitched by it, is yourself, yourself in the world beyond, the head clothed in night, the masked face of the invisible that, in the eye of Gorgo, is revealed as the truth about your own face."[10] In other words, we project the power of our gaze onto her gaze, *as* her gaze, where it becomes other—intense, confused, wild—and subjugates our gaze in turn. Athena intervenes first to suspend this wild gaze through her proxy Perseus, then to return it to us, transformed, as a vision of rational civilization: stately art finds its initial source in this archaic power. Thus the apotropaic transformation is indeed a crossing of gazes, and its crux is again the fixed reflection

of the Medusan gaze on the Athenan shield. "Through the intervention of the mirror or the use of some other mode of represented image," Vernant writes, "this *power of radiation* is controlled, used for certain ends, and directed according to the disparate religious, military, and aesthetic strategies required. In the 'sympathy' they share, there is no absolute break between the image and the real, but rather affinities and means of passing from one to the other."[11]

Note that Vernant associates the gaze with the real, which he understands as dangerous, even horrific. (Was he influenced by Jacques Lacan, who also imagines the real in this manner, or was Lacan influenced by the Medusan associations that Vernant unpacks? Or is it both?) Note, too, that Vernant sees the image not as an "absolute break" with the real but as a "means of passing" from it. This positions the mirror-shield, the Gorgoneion, as a kind of ur-painting, an originary model of art, which the Gorgoneion informs with its own apotropaic purpose, a controlling of the "radiation" of the real—radiation in the sense of maleficent rays of light. Before the fourth century BCE, Vernant tells us, "the motif of reflection" was absent from the myth; it was "introduced on vases and in texts to explain the victory of the hero over Medusa," for without this protection from her gaze, the deed seemed impossible (in some versions Perseus also beheads her with this shield).[12] Importantly, this reflection is also fundamental to the controlling of "radiation" in other ways, in "religious, military, and aesthetic strategies." Vernant again: "The motif [of reflection] seems connected to the efforts of contemporary painters to give the illusion of perspective, to philosophers' reflections about mimesis (imitation), and also to the beginning of experiments that, from Euclid to Ptolemy, will lead to a science of optics."[13] The implication here is that some ancient approximations of perspective, theories of mimesis, and studies in optics were driven in part by the need to control the primordial power of the real-as-radiation; more, that they projected, as a foil that motivates them, the real as a Medusan realm that resists all order, whether pictorial (as in perspective), philosophical (as in mimesis), or scientific (as in optics). In this hypothesis, then, the real is an effect of the symbolic that is taken to precede it, even as the symbolic is steeped in the real that it is supposed to screen. (Perhaps the correlative of this notion in the myth is that, in some versions, it is Athena who produces the

beautiful Medusa as a monster in the first place—as a punishment for her rape by Poseidon in a temple dedicated to the goddess.)

For Vernant, the horror of Medusa is a horror of a "blurring of all categories," of a "return to the formless and indistinct," and her powers are "the powers of the beyond in their most radically alien form, that of death, night, nothingness."[14] For Lacan, too, Medusa is a figure of "the object of anxiety par excellence," and her chaotic visage is "the revelation of that which is least penetrable in the real, of the real lacking any mediation, of the ultimate real, of the essential object which isn't an object any longer."[15] In this light, might the terror of Medusa be more primordial than "the terror of castration" that Freud famously saw in her image? That is: more than a terror of castration, of lack or difference, might the Gorgon figure a terror of a *lack* of difference, of a primal state in which all differences (sexual, semiotic, symbolic) are confounded or not yet established? But if this is the case—that is, if Medusa figures the horrific real as radical other to the symbolic order—then this very figuring is also a first move in the mitigation of this real, a primordial act of civilization.[16]

TEMPESTUOUS LOVELINESS

Medusa fascinated the West long after antiquity. From the medieval period through the Renaissance, the story of Perseus and Medusa is often reworked as a Christian allegory of the triumph of heavenly virtue over earthly vice, and from the Renaissance through the romantic period, it sometimes serves as an occasion for the grotesque, a genre of representation that aims "to invoke and subdue the demonic aspect of the world."[17] Medusa returns with renewed force in baroque art, as in the celebrated paintings of her fearsome head by Caravaggio (1596–98) and Rubens (1617–18) (figs. 7.3, 7.4). Rubens depicts an early moment in her transformation, with her snaky head strewn amid devilish creatures, while Caravaggio captures a later moment, with her outraged visage fixed on the mirrorshield (whether that of Perseus or Athena is not quite clear—perhaps they are made one here). Although Medusa is newly decapitated in the Rubens, everything is in order: her head is laid out as if on a banquet table, and even her snakes

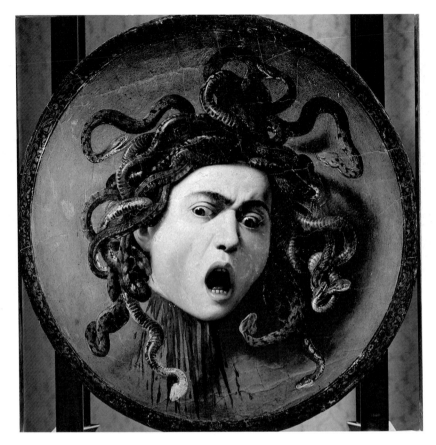

7.3. Michelangelo Merisi da Caravaggio, *Medusa,* 1596–98. Oil on canvas on wood shield, 21¾ in. diameter. Galleria degli Uffizi, Florence. Photo: Scala/Art Resource, New York.

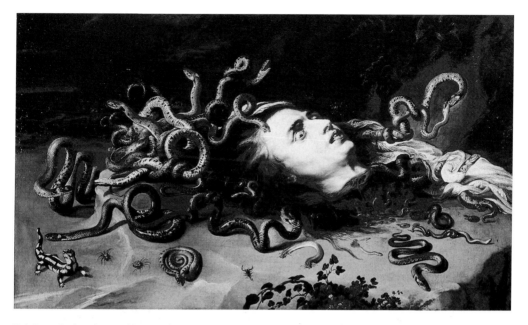

7.4. Peter Paul Rubens, *The Head of Medusa,* 1617–18. Oil on canvas, 27 × 46½ in. Kunsthistorisches Museum, Vienna. Photo: Erich Lessing/Art Resource, New York.

follow the sinuous lines of baroque convention. Clearly the art of painting triumphs over the force of chaos. Of course, there is also order in the Caravaggio, where a close relation between mirror, Gorgoneion, and painting, between reflection, protection, and representation, is posed (as a support, Caravaggio uses an actual wood shield, an old tournament prop). Yet, as Louis Marin suggests in his brilliant reading of the work, this redoubling makes for an *excess* of mimesis that threatens to undo its own illusion, or at least to disturb any delectation of the painting along contemplative lines; perhaps it was this kind of excess that led Poussin to declare that Caravaggio "had come into the world in order to destroy painting."[18] On the one hand, mirror, shield, and canvas are not seamlessly one; on the other, the painting remains so illusionistic as to appear hyperreal ("mimesis," Marin writes, "is turned inside out like a glove"); and the combined effect is indeed almost Medusan.[19] Here painting does not quite contain the intensity of the Medusan gaze, the horror of the Medusan real, but conveys them as well.

The Rubens is similar to the Flemish painting of Medusa in the Uffizi Gallery (c. 1620–30; fig. 7.5) that was long attributed to Leonardo (Leonardo did begin such a work, Vasari tells us, but he never finished it). This painting shows her head cast among other creatures à la Rubens, but it is turned away from us, foreshortened in a way that renders it almost formless, and cast into a murkier world (what light there is shines on the snakes, not on her face). In 1819 the painting inspired Shelley to write a poem, "On the Medusa of Leonardo in the Florentine Gallery," which exemplifies the romantic ideal of beauty, that is, of the beautiful enlivened by the horrific, crossed with the sublime.[20] "Its horror and its beauty are divine," Shelley writes in the first stanza. "Loveliness like a shadow, from which shine / Fiery and lurid, struggling underneath / The agonies of anguish and of death." It is this oxymoronic "grace," not sheer "horror," which arrests the "gazer"; for beauty to compel us, Shelley suggests, it must possess "the tempestuous loveliness of terror." In effect, this is the romantic version of the apotropaic transformation of Medusa, and this mixture of beauty and terror, of pleasure and pain, not only underwrites the visual allure of the work of art, but also prepares its redemptive power: "'Tis the melodious hue of beauty thrown / Athwart the darkness and the glare of pain / Which humanize and harmonize

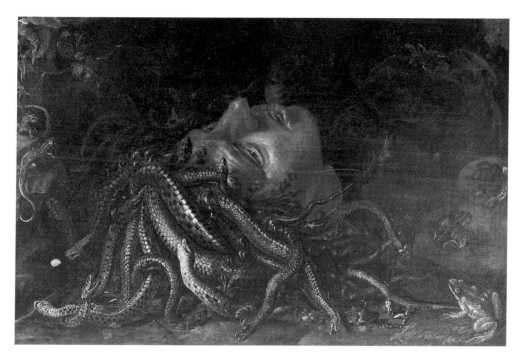

7.5. Flemish School, *Head of Medusa,* c. 1620–30. Oil on canvas. Galleria degli Uffizi, Florence. Photo: Alinari/Art Resource, New York.

the strain." This redemptive reconciliation is not complete, however: the painting retains its "mailed radiance" and "brazen glare," and the poem is left unfinished.

Medusa persists in modern reflections in a related register of the beautiful crossed with the sublime; and in some of these texts her apotropaic transformation is figured, implicitly, as fundamental to art. The first text is the most famous. In *The Birth of Tragedy* (1871), Nietzsche presents not Athena and Medusa but Apollo and Dionysus as the opposed representatives of "two radically dissimilar realms of art," the first associated with visual art, the second with music, poetry, and tragedy: "Apollo embodies the transcendent genius of the *principium individuationis;* through him alone is it possible to achieve redemption in illusion. The mystical jubilation of Dionysus, on the other hand, breaks the spell of individuation and opens a path to the maternal womb of being."[21] Here again, the two figures are twinned in opposition: the "deliverance from the self" represented by the Apollonian principle requires the "primordial pain" represented by the Dionysian principle as its ground (*BT* 37). Moreover, when the Apollonian principle degenerates into "aesthetic Socratism" and "logical schematism," it also requires the "un-selving" of the Dionysian principle for its renewal. "In the Dionysiac dithyramb man is incited to strain his symbolic faculties to the utmost," Nietzsche writes; "something quite unheard of is now clamoring to be heard: the desire to tear asunder the veil of Maya, to sink back into the original oneness of nature; the desire to express the very essence of nature symbolically. Thus an entirely new set of symbols springs into being" (*BT* 88, 27).[22] There are many echoes in *The Birth of Tragedy* (Socrates, Plato, Kant, Schiller, Hegel, Schopenhauer, Wagner), but here Nietzsche anticipates another voice, that of Freud, especially on the death drive as articulated in *Beyond the Pleasure Principle* (1920).

"The Apollonian need for beauty had to develop the Olympian hierarchy of joy by slow degrees from the original titanic hierarchy of terror," Nietzsche also writes (*BT* 30), and this "redemptive vision" also anticipates Freud, here on the necessity of renunciation and sublimation as sketched in *Civilization and Its Discontents* (1930). Freud was a close reader of Nietzsche, so this foreshadowing might not be accidental; yet Nietzsche wishes to retain the "titanic terror" of Dionysus as much as to advance the redemptive vision of Apollo (like Milton, he

seems to sympathize with the devil). More than the Freudian vision of civiliza-
tion, then, the Nietzschean theory of art remains within the ancient frame of the
apotropaic transformation of Medusan power. In fact, the Apollo of *The Birth of
Tragedy* performs the acts and embodies the principles of *both* Perseus and Athena:

> What kept Greece safe was the proud, imposing image of Apollo,
> who in holding up the head of the Gorgon to those brutal and gro-
> tesque Dionysiac forces subdued them. . . . That act of reconciliation
> [*Versöhnung*] represents the most important event in the history of
> Greek ritual; every department of life now shows symptoms of a rev-
> olutionary change. The two great antagonists have been reconciled.
> (*BT* 26)[23]

Note that Nietzsche stresses "reconciliation," not eradication: in his account,
Dionysian sublimity is as crucial to art as Apollonian beauty. As in the Medusa
myth, the crux lies in the transformation of the one by the other.

Freud discusses Medusa by name only in a short text titled "Medusa's
Head" (1922), and not in relation to art. Although he is alert to the fusion of gen-
ders in her image, Freud regards Medusa as the primordial woman: her head, with
its snaky hair, is an ambiguous figuration of the female genitals, of the "terror
of castration" that they are said to hold for all men.[24] In his view these genitals
petrify man with the terror of castration, but they also arouse him—make him
"stiff" with delight as well. Freud sees this "transformation of affect" in expressly
apotropaic terms: "For becoming stiff means an erection. Thus in the original sit-
uation it offers consolation to the spectator: he is still in possession of a penis, and
the stiffening reassures him of the fact."[25] At this point in his argument, however,
the feminist Hélène Cixous interjects an apotropaic twist of her own: "Men say
that there are two unrepresentable things: death and the feminine sex. That's be-
cause they need femininity to be associated with death; it's the jitters that gives
them a hard-on! for themselves! They need to be afraid of us."[26]

In "Medusa's Head" Freud assumes the twinning of Medusa and Athena:
her image condenses both "terror" and "consolation"—the terror of castration

and the consolation of its transformation. In this regard, her image is the originary fetish, both a "memorial" to castration and a "protection" against it.[27] But more than fetishistic displacement might be involved here; perhaps in the myth of Medusa and Athena there lies a psychoanalytic allegory in which the two opposed figures serve the same symbolic order. Cast in Lacanian terms, the moral of this story would be: submit to Medusa-Athena, undergo the penile castration necessary for access to the symbolic order, and be rewarded with the phallic shield of signification, of civilization, for doing so. Might this be the implicit message of *Perseus with the Head of Medusa,* with its raised head of Medusa and its raised sword of her decapitation: give up the penis in exchange for the phallus? Might this "phallologocentric sublation" be the introit of the museum as well? Certainly it is one that feminists such as Cixous have decried, for it leaves women on the margins, if not headless on the ground.[28]

THE IMAGE SCREEN

The role of apotropaic transformation is less explicit in the final text at issue here, the seminars on the gaze in *The Four Fundamental Concepts of Psycho-Analysis* (1972), though Lacan does allude to both Medusa and Apollo. These seminars are also well known, but not well understood, in part because their premise is so radical: that in the first instance the gaze is not human at all. To an extent like Jean-Paul Sartre in *Being and Nothingness* (1943), Lacan distinguishes between the gaze and the eye (that is, physiological vision), and to an extent like Maurice Merleau-Ponty in *Phenomenology of Perception* (1945), he locates this gaze in the world, again at least initially. For Lacan the world "sees" or, more precisely, it "shows"; it is the "iridescence" of its light that allows us to see at all, and it is this "gratuitous showing" that he calls the "essence of the gaze," perhaps in the sense of the fundament.[29] In Lacan, then, not only does language preexist the subject, but so does the gaze, and even more primordially, for we are literally born into "the spectacle of the world" (*FC* 72, 75). Yet this is no benign bathing in light: "looked at from all sides," we can feel the gaze only as a threat, indeed, as an "evil eye" (*FC* 118); this old superstition possess a profound truth for Lacan. Here,

then, behind the veil of Maya, or the world of appearances as Nietzsche sees it, stands Medusa, or the horrific real as Lacan imagines it.[30]

Even more than Sartre and Merleau-Ponty, Lacan challenges the presumed mastery of the subject in sight; more, the Lacanian gaze mortifies this subject, catches him out, as it were, unawares. This is the gist of his famous anecdote of the sardine can in *The Four Fundamental Concepts:* on a fishing boat as a young man, Lacan spies a can afloat on the sea and aglint in the sun, which seems to look at him "at the level of the point of light, the point at which everything that looks at me is situated" (*FC* 95). Lacan turns this anecdote into an epiphany about "the crossing of gazes" similar to the one disclosed by Vernant in the Medusa myth: seen as he sees, pictured as he pictures, the Lacanian subject is caught in a double position, in a cat's cradle of implicated looks.[31] To graph this double position, Lacan superimposes, on the customary cone of vision that emanates from the subject, another cone that emanates from the object, at the point of light. It is this second cone that he first terms "the gaze" (fig. 7.6).

The first cone of vision (graph 1) is familiar from Renaissance treatises on perspective: an object is focused as an image for a subject at a geometric point of viewing. (Of course the analogy is a loose one, for our vision is not monocular and fixed, as in one-point perspective.) Here the subject-as-view*er* is in a position of apparent mastery that Lacan calls "Cartesian." But, he adds immediately, "I am not simply that punctiform being located at the geometral point from which the perspective is grasped. No doubt, in the depths of my eye, the picture is painted. The picture, certainly, is in my eye. But I, I am in the picture" (*FC* 96). Hence the second cone (graph 2) that emanates from the point of light, the object in the world (e.g. the sardine can): the subject is also under its gaze, "photographed" by its light; it is in this sense that the subject is (in) a picture as well. Here the tables are turned: the subject-as-view*ed* is now in a position of potential annihilation; in fact, Lacan writes (with a trace of paranoia), the gaze might "go so far as to have me scotomized" (*FC* 84). Thus the superimposition of the two cones of vision (graph 3), which is meant to capture this double status of the subject as seer and seen in one: "the object" (in graph 1) is now in line with "the point of the light" (in graph 2), the combination of which is

7.6. Jacques Lacan, diagram of the gaze, from *The Four Fundamental Concepts of Psycho-Analysis.* © 1973 Éditions du Seuil. English translation © 1977 Alan Sheridan. By permission of W. W. Norton & Company, Inc.

termed "the gaze"; "the geometral point" (in graph 1) is now in line with "the picture" (in graph 2), the combination of which is called "the subject of representation"; and "the image" (in graph 1) is now in line with "the screen" (in graph 2), the combination of which is dubbed "the image screen."

How can "the subject of representation" be in a position of both mastery and threat? Here again, the analogy of one-point perspective might clarify this apparent paradox. In such perspective the space seems to build rationally from the vanishing point toward the viewer, who is thus placed in command of the pictorial array. In this respect, perspectival painting is a perfect screening of the gaze understood as the light of the world, of its power of radiation. At the same time, the vanishing point is also a point of absence, indeed, a point of nullity: a tiny hole that opens onto a vast void. (In Renaissance painting it is sometimes exploited as a sign of divine infinity, as in the *Last Supper,* where Leonardo places the head of Christ over the vanishing point.) Since the vanishing point is structurally opposite the viewing point, it might communicate some of this nullity to the viewer. In this way, despite the plenitude afforded by perspective, there remains a hole at its heart, a hole that signifies a kind of lack. In Lacanian terms, then, the gaze is not completely screened in perspectival painting; its status as a look with a lack, its castrative implication, is still in play, potentially there to "scotomize" the viewer. It is this troublesome connection between perspective and castration that Duchamp evokes in *Etant donnés* (1946–66; figs. 7.7, 8.17), his diorama with headless mannequin in the Philadelphia Museum of Modern Art (which was completed roughly at the time of the seminars on the gaze). Here the viewer, positioned as a Peeping Tom, looks through a perspectival construction at the splayed body of a female nude, directly at her vulva: viewing point and vanishing point coincide at the point of putative lack or castration. "*Con celui qui voit,*" Jean-François Lyotard remarked concisely of this schema. "He who sees is a cunt."[32] This is the double bind of the Lacanian viewer as well: apparent master of vision yet potential victim of the gaze.

Of all the terms in the diagram of the gaze, the meaning of "the image screen" is especially obscure.[33] I understand the term to represent the totality of what is recognized as an image in a given culture, of what counts socially as visual

7.7. Diagram of Marcel Duchamp's *Etant donnés,* 1944–66. © 2003 Artists Rights Society (ARS), New York/
ADAGP, Paris/Succession Marcel Duchamp.

representation. In this sense it is the imagistic corollary of language, the visual medium of social recognition and exchange, and as such it partakes equally of the imaginary and of the symbolic. Of course, it is hardly singular or simple: each culture has different image screens, with different sub-screens, and each cultural subject arranges them in different files. Yet enough is held in common in any one culture to allow for communication, not least because we fashion our visual identities not only *of* the world but *for* the world from images selected from this screen. We might believe that we create these self-representations freely, but the imagistic material is mostly allotted to us, often imposed on us, and a fall outside of the image screen has the same dire consequences as a fall outside of language: our status as social beings is cast in doubt; we risk the outsider condition of the psychotic. Such is the profound conservatism of this aspect of Lacanian thought: for Nietzsche, the tearing of the veil of Maya might allow for a renewal of the symbolic order, "an entirely new set of symbols"; for Lacan, any tearing of the image screen can evince only a breakdown of the symbolic order, a psychotic failure in representation.

Although we are mostly oblivious to the image screen, it is hardly natural; it has a history, a myriad histories, and art is only one index of them, as partial as it is privileged. Lacan is no historian (on the contrary), but he does allude sketchily to three orderings of the image screen in the postclassical West, which he calls "religious," "aristocratic," and "financial" respectively; they correspond roughly to the social regimes governed by the medieval church, the aristocratic court, and the modern market. The emblematic form of the first regime is the icon, which Lacan describes as "a go-between with the divinity" (*FC* 113): in effect, a pictorial mask that mediates the gaze of God for medieval subjects, that allows them to behold this omniscient gaze even as it subjects them to it (fig. 7.8). In this "sacrificial" regime, man is under the divine gaze, and what is sacrificed, for the most part, is human autonomy. "The next stage" in his potted history is the aristocratic ordering of the image screen, and here his given example is "the great hall of the Doges' Palace in Venice, in which are painted all kinds of battles, such as the Battle of Lepanto": in effect, a pictorial history of the city. The painting of this regime (significantly, Lacan thinks only of painting) is more political

7.8. Detail of katholikon of monastery of Daphni: dome with mosaic of
Pantocrator, c. 1080. © Gian Berto Vanni/CORBIS.

than religious; "in these vast compositions," Venetians are invited to imagine the collective gaze of their forebears and the governmental gaze of their Doges, who, "when the audiences are not there, deliberate in this hall. Behind the picture, it is their gaze that is there" (*FC* 113).[34] This "communal" spectatorship is absent in the modern regime of the image screen governed by the market, which positions the artist as solitary producer, and the viewer as solitary consumer, of individual visions (Lacan mentions Cézanne and Matisse in particular). Here "the gaze of the painter" appears in the historical default of those of God and aristocracy, which allows the artist to claim his gaze as "the only gaze" (fig. 7.9). Of course, this narrative is schematic in the extreme, and it is concerned only with hegemonic formations within one Western tradition; recent orderings of the image screen—which are very different, with painting greatly fallen in importance—are neglected. But at least this sketch sets the image screen in historical motion as the visual medium of different codes of subjective identification and social recognition.[35]

This screen is more than the grid of images through which a subject reads a society. It has another side, as it were, that faces another way—toward the real. Thus for Lacan the function of the image screen is not only to mediate the social; it is also to filter the real: it protects the subject from the gaze of the world, captures its light, which he describes as "pulsatile, dazzling and spread out" (*FC* 89), and tames it *in* images, *as* images. Lacan terms this primordial function of the image screen a *dompte-regard,* or "taming of the gaze," and he ascribes this purpose to all art (though, again, his paradigm is painting). The *dompte-regard* is also distinctive to the human: in his account, animals are only caught in the spectacle of the world, whereas we are not reduced to this "imaginary capture" (*FC* 103); we have access to the symbolic not only in the articulations of language but in the picturings of the image screen, with which we can moderate and manipulate the gaze. Unlike animals, then, we "know how to play with the mask as that beyond which there is the gaze. The screen is here the locus of mediation" (*FC* 107). In this way the image screen allows the subject, at the point of the picture, to behold the object, at the point of light. Otherwise it would be impossible to

7.9. Paul Cézanne, *Mont Sainte-Victoire Seen from Les Lauves,* 1902–06. Oil on canvas, 25 × 32¾ in. Kunsthaus, Zurich. Photo: Scala/Art Resource, New York.

do so, for to see without the image screen would be to be touched by the real, blinded by its radiation, petrified by its gaze. Clearly Lacan is informed by the Medusa myth; certainly it inflects his language.[36]

Even as the gaze may trap the subject, the subject may tame the gaze, and it is through the image screen that we, like so many little Athenas, negotiate its "laying down [*dépôt*]" (*FC* 101). The English phrase introduces a double meaning: a laying down of the gaze of the artist, as in laying down of paint, that promotes a laying down of the gaze of the world, as in a laying down of a weapon. This trope also presents the gaze not only as maleficent but as violent—again as a Medusan force that can arrest us, even petrify us, if it is not disarmed first—and, elliptically, Lacan does intimate different degrees of apotropaic disarming in painting. At its more expressive, he suggests, painting aims to arrest the gaze before the gaze can arrest us, as if the very gestures of such compositions might preempt the violence of the gaze. At its more "Apollonian" (*FC* 101), painting aims to pacify the gaze, as if the perfections of such compositions might ease the viewer from the grip of the gaze.[37] "In the contemplation of the picture," an auditor comments, "the eye seeks relaxation from the gaze" (*FC* 103), and Lacan concurs. Such is aesthetic contemplation for Lacan: some art attempts a *trompe-l'oeil,* a tricking of the eye, but all art aspires to a *dompte-regard,* a taming of the gaze.[38]

Again, to tame the gaze is not to block it entirely: it is to deflect it, to redirect it, as a mask does (a trope that Lacan uses more often than the image screen). In this way a picture must not only "tame" and "civilize" the gaze; it must also "fascinate" the viewer with the gaze transformed (*FC* 116).[39] Just as Dionysian terror is necessary to tragedy according to Nietzsche, Medusan fascination is necessary to the image according to Lacan. "The evil eye is the *fascinum,*" he writes, and this *fascinum* (the Latin version of *baskania,* the Greek for evil eye) "has the effect of arresting movement and, literally, of killing life." Hence, once more, the necessity of the picture as an apotropaic transformation: "it is a question of dispossessing the evil eye of the gaze, in order to ward it off"(*FC* 118).[40] But its moderated power must also be used to arrest the viewer; this is the Medusan aspect of beauty to which Shelley and others have attested. Lacan speaks of the process as one of "initial" seeing and "terminal" arrest, as one of "suture" through

"pseudo-identification" (*FC* 117): the subject must not be trapped by the image, but just as surely he must be lured by it.[41]

Traditionally in Western philosophy, tropes like "veils" and "screens" figure as blinds that obscure truth, illusions that mystify reality: we are supposed to shed them (like the scales before our eyes in the New Testament), to see beyond them (like the shadows on the wall in the cave of Plato), to tear them asunder (like the veil of Maya in Schopenhauer). In Lacan, on the contrary, the screen is a necessary protection without which we are at the mercy of the real; almost as a structural effect, then, his binary logic constructs the real as horrific—and positions the symbolic as protective, and art as redemptive. Just as elsewhere in his thought the imaginary integration of the body achieved in "the mirror stage" projects a prior stage of a fearsome "body-in-pieces" (*corps morcelé*) to be avoided at all costs (see chapters 3 and 4), so here the image screen projects the real as amorphous and awful. The Nietzschean opposition of the Apollonian and the Dionysian has a similar effect, but, as noted above, Nietzsche anticipates a symbolic renewal in the Dionysian shattering of Apollonian individuation, whereas Lacan sees no such possibility in the tearing of the image screen. Far from a phenomenological plenitude, the Lacanian real is a black hole, a negative space of nonsociality—indeed, of nonsubjectivity.

I want to conclude this section with an intimation of this terrible tearing of the image screen. Again, this screen is likely to be detected, if at all, only at moments of crisis or of transition between different orderings—and then only from an extreme perspective.[42] When it is so glimpsed, on such a radical oblique, it is likely to appear fragile (like the curtain behind which the hapless Wizard of Oz operates his fearsome image of authority) and/or seamy (like the corrupted symbolic orders that Kafka often evokes in his stories). One example of this extreme perspective might clarify what is at stake here; I draw it from *Artistry of the Mentally Ill* by Hans Prinzhorn (discussed in chapter 5), and it does seem to emerge (as Paul Klee once remarked of such art) from an "in-between world."[43]

August Natterer was a German electrician born in 1868; he succumbed to paranoid schizophrenia in his fortieth year, and drew his visions obsessively after 1911; some of his drawings are featured in the *Artistry*. "He had one great primary

hallucination," Prinzhorn tells us there, "the imminent last judgment." In 1919 Natterer described it to his doctors in these terms:

> At first I saw a white spot in the cloud, very near by—the clouds all stood still—then the white spot withdrew and remained in the sky the whole time, like a board. On this board or screen or stage pictures followed one another like lightning, maybe 10,000 in half an hour, so that I could absorb the most important only with the greatest attention. The Lord himself appeared, the witch who created the world—in between there were worldly scenes: war pictures, parts of the earth, monuments, battle scenes from the Wars of Liberation, palaces, marvelous palaces, in short the beauties of the whole world—but all of these in supra-earthly pictures. They were at least twenty meters high, could be seen clearly, and were almost colorless, like photographs; some were slightly colored. They were living figures that moved . . . it was like a movie. The meaning became immediately clear, even if one became conscious of the details only later while drawing them. The whole thing was very exciting and eerie. The pictures were manifestations of the last judgment. Christ could not complete the redemption because the Jews crucified him too soon. Christ said at the Mount of Olives that he had shivered under the pictures that appeared there. These are pictures, in other words, like those of which Christ spoke. They are revealed to me by God for the completion of the redemption.[44]

There is much to say about the historical content of this vision (especially the anti-Semitic prejudice), but I want to focus on its structure. Characteristic of paranoia, according to Freud, is an oscillation between delusions of grandeur and persecution. As for grandeur, Natterer identifies not only with Christ but elsewhere with Napoleon; and as for persecution, he also reports elsewhere that his body is controlled by electrical mechanisms (along the lines discussed by Victor Tausk in his classic paper on paranoid delusions, "The Influencing

Machine," also of 1919).[45] For Freud both kinds of delusion are projections of order in a world that otherwise appears catastrophically bereft of the same. This is literally the case here, for Natterer discovers a hole in the sky, "a white spot" in the screen, and he comes to associate this void with the eye of "the witch who created the world," that is, in terms suggestive of Medusa. This hole is intolerable to him (at one point he describes it as "the invisible enemy of God in the clouds"); it is as if it threatened to dissolve the screen, to let the real through. So, in a move both desperate and brilliant, Natterer transforms the negative into a positive: he turns the white hole into an image "board," a substitute "screen or stage" on which his own vision of a surrogate order is projected. In short, he performs his own apotropaic trick: a hole in the world becomes a support for "worldly scenes," a world history *cum* last judgment projected "like a movie." This is not only to salvage the image screen; it is to redeem the symbolic order, to complete "the redemption" begun by Christ (Natterer is also a latter-day Perseus). Allusions to cinema dominate his account: with its theatrical setting and historical tableaux, giant screen and projected images (at 10,000 in half an hour, they appear at over twice the "normal" speed), his vision suggests a private version of an early spectacle like D. W. Griffith's *Intolerance* (1916). Here the connection between the filmic and the unconscious, especially via the analogy of projection, is almost explicit.[46]

In the institution Natterer makes many drawings of this world history, mostly "a vast number of faces" that follow the transformational il/logic of his vision (in a sense he produces "the hallucinatory succession of images" that Ernst only imagines in chapter 5). These drawings circle around a single figure, his Medusan witch, whose "face appeared to me as a skull, but had life just the same." One extraordinary rendering of the witch is a double portrait of her mask-head on both sides of a large card that recalls the naïve composition of some folk art (fig. 7.10, pl. 9). Each side presents her profile in such a way that it outlines a landscape (we encountered this conflicted relation to boundaries in the art of the mentally ill in chapter 5). Recto and verso share one profile; they are especially linked by her eye, which again evokes the hole in the sky, the void in the screen, of his vision. On the recto everything is order: the witch outlines tended fields

7.10. August Natterer, *Witch's Head,* n.d. Pencil, watercolor, and pen on varnished card, recto and verso, 10¼ × 13½ in. Sammlung Prinzhorn der Psychiatrischen Universitätsklinik Heidelberg. Inv. 184. Photo: Manfred Zentsch.

marked by trees and roads and surrounded by neat towns with impressive build-
ings and stately homes. On the verso this world is racked: trees are bare, build-
ings blown apart, fields flooded with aquatic life, and her white eye is cut by a
black arc. In a sense, this double portrait is an economic presentation of his para-
noid oscillation between an Athenan principle of order and a Medusan principle
of catastrophe; here the two are literally twinned. Yet this apotropaic transforma-
tion does not take, and so Natterer attempts it again and again: even as he turns
his hole in the sky into a substitute screen, it requires a frantic repetition of im-
ages. In the sanitarium he draws the witch obsessively.

OBSTREPEROUS SIGHT

Lacan could not imagine an art that transgresses the image screen in order to
transform it radically; perhaps the vicissitudes of figures such as Natterer cau-
tioned against such a possibility. And yet his binary logic—the image screen on
the one side, the real on the other—makes the tearing of the image screen, the
probing for the real, appear transgressive, and a version of this project has proved
almost irresistible to many avant-gardists. Contra Lacan, not all art is pledged to
the *dompte-regard;* in fact some strives to undo this taming, perhaps to rend the
image screen as such, at least to "destroy painting" (sometimes in the mistaken
belief that the two—painting and image screen—are one).[47] As we have seen in
other chapters, sometimes this attack is undertaken in the hope of symbolic re-
newal (as with Gauguin); it might also occur in the spirit of ritualistic reanima-
tion (as with Picasso). Sometimes, too, it assumes an anarchistic force: "The
Gorgon's head of a boundless terror smiles out of the fantastic destruction," Hugo
Ball wrote of Zurich Dada, with the drum poems of Richard Huelsenbeck and
the shamanistic masks of Marcel Janco in mind (fig. 7.11). In each instance the
aggression against the image screen is keyed to a crisis, aesthetic or political or
both—the exhaustion of academic art, for example, or the horror of World War
I. (The same is true of the most recent instance, "abject" art of the late 1980s
and early 1990s, which emerged at the height of the AIDS epidemic; often this
art presented wounded bodies and traumatic subjects as if without mediation, as

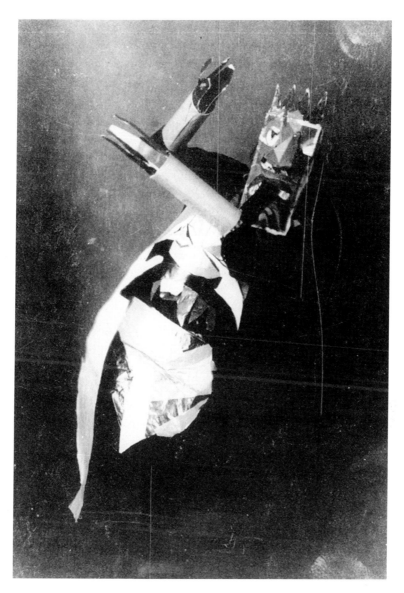

7.11. Sophie Taeuber dancing in a mask by Marcel Janco, 1916. © 2003 Artists Rights
Society (ARS), New York/ADAGP, Paris.

though in direct evidence of the work of the real, which was sometimes evoked in Medusan guise.)[48] Here, however, I want to concentrate on a different crisis— "the crisis of the easel picture" exacerbated by the drip paintings of Jackson Pollock produced in 1947–50.[49]

As is well known, there was a profound split in the critical reception of these works. On one side was a formalist reading advanced by critics like Clement Greenberg and Michael Fried, and artists like Morris Louis and Kenneth Noland, for whom Pollock had resolved the fundamental oppositions in painting between depicted figure and given ground, illusionistic space and flat surface. In so doing he had produced a new spatiality that was "strictly optical," traversed by the eye alone, in which the imaginative projection of the embodied viewer into pictorial space, offered by painting since the Renaissance, was both canceled and preserved—in effect sublated.[50] Far from an avant-gardist transgression of painting, then, Pollock had refined its forms in keeping with its dedicated sense of sight alone; hence the drip paintings marked an epitome of great painting, not a rupture with its past. Of course, this reading was disputed by other critics and artists, Harold Rosenberg and Allan Kaprow prominent among them, for whom Pollock had transformed painting into an "arena" of bodily performance, not a space of optical purity. According to Rosenberg, Pollock had surpassed representation less in the service of abstraction than for the sake of action, and his new "act-painting" had effaced "every distinction between art and life." Rather than a refinement of past art, then, his move effected a "liberation from value," and all that remained was "the anguish of the aesthetic."[51] Kaprow agreed: for this creator of environments and happenings, Pollock represented "absolute liberation," and in "The Legacy of Jackson Pollock" (1958) he saw "two alternatives": artists could persist with "near-paintings" à la Pollock—which Kaprow viewed as an end-game—or "give up the making of paintings entirely" for activities involving "the space and objects of our everyday life, either our bodies, clothes, rooms, or, if need be, the vastness of Forty-Second Street"—which was in line with his own practice.[52]

This opposition between the "optical space" of painting after Pollock and the "everyday life" of performance after Kaprow was far too simple. Other lines

———

were pursued by different artists in the Americas, Europe, and Japan (Robert Rauschenberg and Jasper Johns are only the most famous); indeed, the simultaneous negotiation of formalist and avant-gardist legacies made for a very complicated field of artistic practice in the late 1950s and early 1960s. However, one line of work favored neither option, or rather, it partook equally of formalist painting and avant-gardist performance. Neither a refinement of painting to "optical space" nor a transgression of its frame into "everyday life," this third way is relevant here, for it seems to probe, in the slow demise of the easel picture, a tearing of painting as a kind of opening onto the gaze.

To trace this other line (which is far from consistent, let alone continuous), one text in the Pollock reception is especially instructive. In "Three American Painters: Kenneth Noland, Jules Olitski, Frank Stella" (1965), Michael Fried argues that the drip paintings loosened drawing "from the task of figuration" in a way that undid the distinctions not only of figure and ground but of "positive and negative": there was "no inside or outside to [the] line or to the space through which it moves," and the result was both a new kind of line, one which "bounds and delimits nothing—except, in a sense, eyesight," and a new kind of space, "if it still makes sense to call it space, in which conditions of seeing prevail rather than one in which objects exist, flat shapes are juxtaposed, or physical events transpire."[53] Again, this was not the radical rupture seen in the drip paintings by Rosenberg and Kaprow, but it was still too radical for Pollock, according to Fried, who argues that Pollock could not bear this complete loss of the figural capacity of line, and so returned to figuration after 1950. Yet already in a few of the drip paintings Pollock had recovered a hint of figuration, usually by one of two means. The first was to affix a foreign object to the canvas, as in *The Wooden Horse: Number 10A, 1948* (1948), a horizontal painting in which the abraded head of a literal hobbyhorse appears to the left on the brown-cotton ground. The second was to cut away pieces of the canvas, as in *Cut-out* (c. 1948–50; fig. 7.12, pl. 10), a vertical painting in which the large excised form at the center is semi-figurative (white except for patches of black, gray, and ochre, it looks like a ghost or alien with cropped head and amorphous limbs). In these cut-out paintings Pollock

evokes a virtual figuration through a literal negation—indeed, an actual obliteration. Fried again:

> The figure is something we *don't* see—it is, literally, *where* we don't see—rather than something, a shape or object in the world, we do see. More often than anything, it is like a kind of blind spot, or defect in our visual apparatus; it is like part of our retina that is destroyed or for some reason is not registering the visual field over a certain area.[54]

For Fried, the contrast between cut-out shapes and all-over drips is too extreme in paintings like *Cut-out,* but Pollock achieved a "new synthesis of figuration and opticality" in works like *Out of the Web: Number 7, 1949* (1949; fig. 7.13, pl. 11), which is eight feet wide. Figures are still described here (the fiberboard support is cut and scraped, then sketched in with brown), but in an abstract way that meshes with the "strictly optical" space of the metallic drips; the rhythmic quality of the excised parts also works to weave them into the ground like so many abstracted dancers.[55] Importantly for Fried, this "new synthesis" is then developed by painters such as Louis, Noland, Jules Olitski, and Frank Stella.

However, there remains the question of how the putative opticality of a painting like *Out of the Web* might produce "a kind of blind spot" in a viewer—that is, how the visual plenitude of an *object* might effect a partial scotoma in a *subject* (note how Fried jumps from painting to retina in the above passage). The implication is that the sheer luminosity of the all-over drips (some in aluminum paint) threatens to burn away bits and pieces not only of the picture plane but of our visual field as well.[56] Recast in Lacanian terms, this is to suggest that the paintings force an opening to the gaze that not only disturbs their surface but deranges our vision. "Pulsatile, dazzling, and spread out" is how Lacan describes the gaze, and these words apply to works like *Out of the Web* as well. (This effect is also evoked in the titles—usually attributed by others—of such works as *Shimmering Substance* and *Eyes in the Heat* [both 1946], or *Galaxy* and *Phosphorescence*

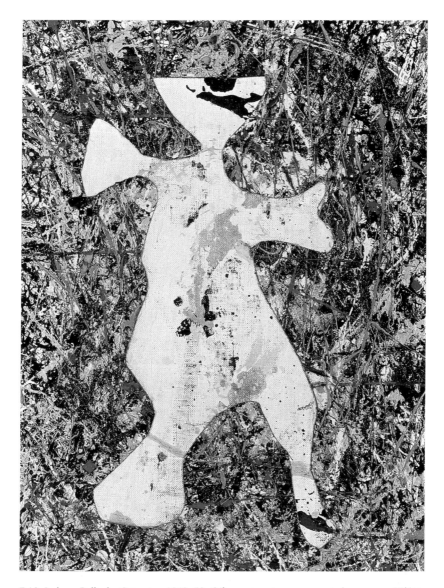

7.12. Jackson Pollock, *Cut-out,* c. 1948–50. Oil on cut-out paper mounted on canvas, 30½ × 23½ in. Ohara Museum of Art, Kurashiki, Japan. © 2003 The Pollock-Krasner Foundation / Artists Rights Society (ARS), New York. Photo: Ohara Museum of Art.

291

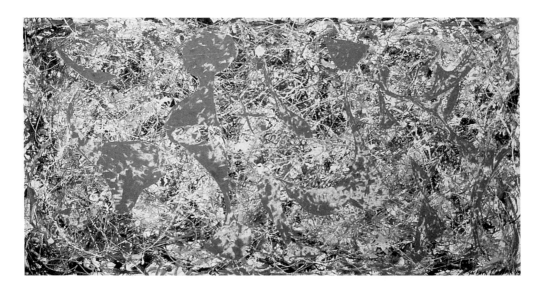

7.13. Jackson Pollock, *Out of the Web: Number 7, 1949,* 1949. Oil and enamel on masonite, 48 × 96 in. Staatsgalerie, Stuttgart. © 2003 The Pollock-Krasner Foundation/Artists Rights Society (ARS), New York. Photo: SIPA Press/Art Resource, New York.

[both 1947].) "The gaze wants me scotomized," Lacan adds, and sometimes it is as if Pollock painted in the service of this scotomatization. According to Freud, scotoma is a state in which "the ego has lost control of the organ" of sight, and a drip painting like *Out of the Web* all but induces this sort of optical vertigo.[57]

Fried is right about "a kind of blind spot" sometimes produced by the cut-out paintings, and right too that Pollock veered away from it. Certainly this sensation is alien not only to the *dompte-regard* that Lacan assigns to all painting, but also to the subject-effect that Fried otherwise advocates in modernist painting—a state that he describes as one of moral "alertness" and transcendental "presentness."[58] Fried finds this state supported by the paintings of Louis, Noland, and others, who, again, "developed the new synthesis of figuration and opticality" first proposed by Pollock.[59] Yet here too—in some of the poured canvases of Louis, for example—Fried senses a risk of scotomatization, of a burning-through of the gaze in a blind-spotting of our vision. "The dazzling blankness of the untouched canvas," he writes of an "unfurled" painting such as the sixteen-foot-wide *Alpha-Phi* (1961; fig. 7.14, pl. 12), "at once repulses and engulfs the eye, like an infinite abyss, the abyss that opens up behind the least mark that we make on a flat surface." Yet, in an apotropaic turn that wards away this "dazzling blankness" even as it is glimpsed, Fried adds, "or *would* open up if innumerable conventions both of art and of practical life did not restrict the consequences of our act within narrow bounds."[60] The sudden summoning of "innumerable conventions" bolsters painting at the threshold of its undoing, as if the image screen were also at stake in this undoing. Painting would not be so protected from the gaze by other artists outside the "narrow bounds" of the medium, in particular by Robert Morris in his process art and Robert Smithson in his earthworks.

As a minimalist in the early to middle 1960s, Morris had questioned the illusionistic space still residual in abstract painting and sculpture, and soon thereafter, as a process artist, he questioned the figure-ground relationship still active in minimalist installations as well. "So-called Minimal art fulfilled the project of reconstituting art as objects," Morris wrote in "Beyond Objects" (April 1969), "while at the same time sharing the same perceptual conditions as figurative

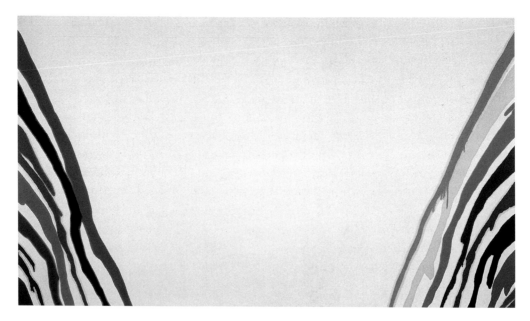

7.14. Morris Louis, *Alpha-Phi,* 1961. Acrylic on fabric, 102 × 195 in. Tate Gallery, London. Photo: Tate Gallery, London/Art Resource, New York.

sculpture. Both objects and figures in real space maintain a figure-ground rela-
tion."[61]Already in "Anti-Form" (April 1968) he had noted another problem: that
the serial ordering of most minimalist schemes had "no inherent relation to the
physicality of the units."[62] In effect, Morris wanted to reassert what he took to
be the obscured lesson of the drip paintings: the overcoming of traditional op-
positions not only of figure and ground, of a vertical image read against a hori-
zontal field (whether virtual, as in painting, or actual, as in sculpture), but also of
content and form, of means and ends. More, he wanted to radicalize this lesson—
to reveal the process of the work *in* the product, indeed *as* the product, and noth-
ing more. Once again, then, Pollock returned as the great precedent, but now as
the artist who retained his process "as part of the end form" of his art through a
"profound rethinking" of his materials and tools in the drip paintings—in par-
ticular the use of sticks to disclose the fluidity of paint, and the placement of the
canvas on the ground to underscore the condition of gravity.[63] This account of
Pollock differs not only from the optical painter seen by Greenberg and Fried,
but also from the existentialist actor seen by Rosenberg and Kaprow, yet it draws
on both models, too, precisely in order to trump them, to move beyond them.[64]

Ironically, this demand for procedural unity often led to a practice of anti-
formal dispersal. Artists as diverse as Morris, Smithson, Richard Serra, Eva
Hesse, Alan Saret, and Barry Le Va began to scatter various materials, not here-
tofore associated with art (strips of felt, rocks and crystals, rubber and lead, latex
and fiberglass, chicken wire, and shattered glass, respectively), in ways that
worked to resolve figure and ground and means and ends; obviously this was a
"synthesis" very different from the one desired by formalist artists and critics.
Moreover, these dispersive gestures worked to reveal the material nature of the
art rather than the subjective condition of the artist; this, too, was an exposure
very different from the one desired by existentialist artists and critics. To these
ends, Morris wrote in "Anti-Form," "chance is accepted and indeterminacy is
implied" as "random piling, loose stacking, hanging, give passing form to the
material."[65] Morris was programmatic in his demonstrations of such (de)compo-
sition, as in *Continuous Project Altered Daily* (1969), where he manipulated such
materials as earth, clay, asbestos, cotton, water, grease, felt, and threadwaste

daily for three weeks with no final form; in *Dirt* (1968), where he refused to aestheticize his materials at all; and in *Steam Piece* (1967), where he used a "material" that could not be formed in any sense.

In such work Morris sought to move "beyond objects" altogether. However, this "beyond" was not a reduction of art either to pure idea (as in much conceptual art) or to sheer substance (as in much other process art); more important to Morris was the creation of a "field effect." In her show "Eccentric Abstraction" (1966), Lucy Lippard pointed to related departures from minimalist protocols of the time. One direction was a new nonfigurative intimation of the body through materials shaped so as to register its drives, even its fantasies, as explored most profoundly by Hesse.[66] Another direction was "an alogical visual compound" in which the object was often fractured, if not dissolved, and the vision of the viewer often disturbed, if not deranged; Lippard termed this effect "obstreperous Sight," and it preoccupied Morris above all others.[67] In his own words, Morris wanted "to take the conditions of the visual field" as the "structural basis" of his work, not merely its physical limit.[68] In so doing, he sought to shift the viewer from a focal gaze (as one looks at a painting, a sculpture, or indeed a minimalist object) to a "vacant stare" on a visual array; and it was to this end that he arranged his materials in a way that could hardly be grasped, in profile or in plan, as an image or object at all. Here the minimalist undoing of pictorial illusion became a postminimalist scattering of spectatorial vision, and process art was revealed to concern visuality as much as materiality and spatiality, or, more precisely, to concern a visuality that was at once materialized in stuff and scattered in space. In a work like *Threadwaste* (1968; fig. 7.15, pl. 13) it is as if vision were decentered from the subject, thrown into the world, precisely not reclaimed "for eyesight alone"—as if vision were registered as already there, primordially, in the world.

My recalling of Lacan here is not incidental. His seminars on the gaze date to 1964, and so are nearly contemporaneous with process art; he also shares a source with some of its practitioners in Merleau-Ponty, whose *Phenomenology of Perception* was published in English in 1962. However, artists like Morris, Serra, and Smithson were not influenced by Lacan; for support, they looked to critics

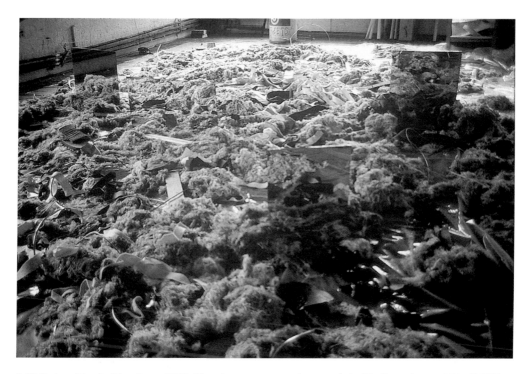

7.15. Robert Morris, *Threadwaste,* 1968. Threadwaste, copper, mirrors, asphalt, felt; dimensions variable. © 2003 Robert Morris/Artists Rights Society (ARS), New York. Photo courtesy of the artist.

of Gestalt psychology closer to hand, such as Anton Ehrenzweig, author of *The Hidden Order of Art,* and Morse Peckham, author of *Man's Rage for Chaos* (both 1967). "Only in our conscious experience has [perception] the firm and stable structure which the gestalt psychologists postulated," Ehrenzweig wrote in *The Hidden Order of Art,* and nothing is more pronounced in process art than the rejection of "gestalt forms" and "holistic readings." Morris in particular sought to elicit a mode of vision that Ehrenzweig called "syncretistic" or "dedifferentiated" (he defined "dedifferentiation," a crucial term for art of the time, as "the dynamic process by which the ego scatters and represses surface imagery").[69] Morris wanted to "acknowledge" this way of seeing—indeed, to "hypostatize" it—in his work.[70] However, the mode of vision projected in an installation like *Threadwaste* seems less "syncretistic" than "saccadic," prone to inadvertent jumps, and even "scomatic," riven by blind spots, with both effects produced by the indeterminate depths of the piled threadwaste of the work, the discontinuous lines of its copper tubing, and (above all) the scattered reflections of its various mirrors. In a sense, *Threadwaste* is a piece that (to recall Fried on Pollock) "we don't see" as much as we do; it suggests how "loss of control" over sight (again, the Freudian definition of scotoma) might be considered almost a "structural feature" of a work of art; and, in so doing, it intimates an opening of vision to the gaze of the world.

Smithson pushed the critique of "all notions of gestalt unity" even further than Morris; "separate 'things,' 'forms,' 'objects,' 'shapes,' etc. with beginnings and endings," he wrote in 1968, "are mere convenient fictions."[71] However, Smithson did not oppose formal gestalts with anti-formal gestures (perhaps he deemed the opposition too static) so much as he performed a dialectical testing of institutional frames through incursions into distant spaces and deployments of entropic time. This undoing of limits was not transgression for its own sake: "If art is art it must have limits," Smithson once remarked, and even as he opened up art to new sites, he also rearticulated these sites through various samplings and mappings that he termed "non-sites": "There's a sort of rhythm between containment and scattering."[72]

This dialectic is concentrated in *Spiral Jetty* (1970), his celebrated earth-
work in the Great Salt Lake, and even more so in the film of its construction; this
film opens onto a Medusan real more directly than any postwar work I know (fig.
7.16). From its initial sequence of sunbursts to its meditation on dinosaurs in a
natural history museum and on legends of a whirlpool that once connected the
Salt Lake to the Pacific, from the actual siting, staking, and making of the jetty at
Rozel Point to its final traversing by Smithson, the film spirals vertiginously, both
visually and thematically (there is also Medusan imagery, more or less incidental,
of eyes, snakes, and "stony matrices" along the way). This optical vertigo is ex-
treme in the final frames, filmed from a helicopter. These shots begin slow and
steady on the site, then seem to speed up as the helicopter swoops in. As it does
so, Smithson drones, "North—Mud, salt crystals, rocks, water. North by East—
Mud, salt crystals, rocks, water . . . ," in a voiceover repeated for all points of the
compass. As the jetty spirals more tightly, the camera turns more rapidly, and we
lose our orientation—a vertigo deepened by the banking of the helicopter.
Gradually the camera pulls back, and we see the work as a distinct image once
more, but only long enough so that this "gestalt form" might then be withdrawn,
as the helicopter flies in low again to circle the site tightly. At this point the cam-
era zooms in on the end of the jetty (which is also, in a sense, its center, its eye),
and the film cuts to images of salt crystals formed on its rocks (spirals exist at all
scales in this film).

Next we see Smithson from the helicopter as he walks, runs, and stumbles
toward the tip of the jetty. Sunlight glares from the water more brilliantly than
any sardine can, as Smithson speaks of a blinding gaze into the sun (he also re-
cites the symptoms of sunstroke, including "delirium"). Dazzling light burns
through the screen, and blind spots seem to be everywhere—on the surface of
the lake, in the emulsion of the film, on the retina of the viewer. The critical lit-
erature on Smithson often discusses his decentering of the art object and his
transgressing of the institutional frame. Not so remarked is that, here at least, he
also evokes a burning-through of the gaze and a tearing of the image screen
through an opening to light that is "pulsatile, dazzling and spread out." (The sheer

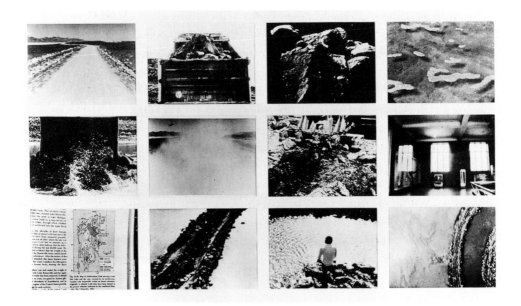

7.16. Robert Smithson, film stills from *Spiral Jetty,* 1970. Gelatin silver prints. Panel C: 25¼ × 43½ in. Collection of Museet for Samtidskunst, Oslo. © Estate of Robert Smithson/Licensed by VAGA, New York, New York. Courtesy James Cohan Gallery, New York.

difficulty of his jetty ramble is also important here, for it suggests that the break-
down of the body, as a topos of performances of the time by Vito Acconci, Bruce
Nauman, and others, is also a sign of this tearing of the screen.) At moments in
the film, "the power of radiation" of the real is glimpsed; at one point Smithson
speaks, almost like Natterer, of "a hole in the film reel."

In his 1972 text on *Spiral Jetty*, Smithson describes its landscape in Medu-
san terms, but here the gaze of the world dissolves as much as it petrifies. Amid
hills like "melting solids" and slopes like "viscous masses of perception," the lake
"resembles an impassive faint violet sheet held captive in a stony matrix, upon
which the sun poured down its crushing light."[73] The religious epigraph of the
essay, which points to the red algae in the lake as well as the red filter that tints
much of the film, also evokes a torn screen: "Red is the most joyful and dreadful
thing in the physical universe; it is the fiercest note, it is the highest light, it is the
place where the walls of this world of ours wear the thinnest and something be-
yond burns through."[74] Later in the text Smithson expands on this red:

> Chemically speaking, our blood is analogous in composition to the
> primordial seas. Following the spiral steps we return to our origins,
> back to some pulpy protoplasm, a floating eye adrift in an antedilu-
> vian ocean. On the slopes of Rozel Point I closed my eyes, and the
> sun burned crimson through the lids. I opened them and the Great
> Salt Lake was bleeding scarlet streaks. My sight was saturated by the
> color of red algae circulating in the heart of the lake, pumping into
> ruby currents; no, they were veins and arteries sucking up the ob-
> scure sediments. My eyes became combustion chambers churning
> orbs of blood blazing by the light of the sun. All was enveloped in
> a flaming chromosphere; I thought of Jackson Pollock's *Eyes in the
> Heat*. Swirling within the incandescence of solar energy were sprays
> of blood.[75]

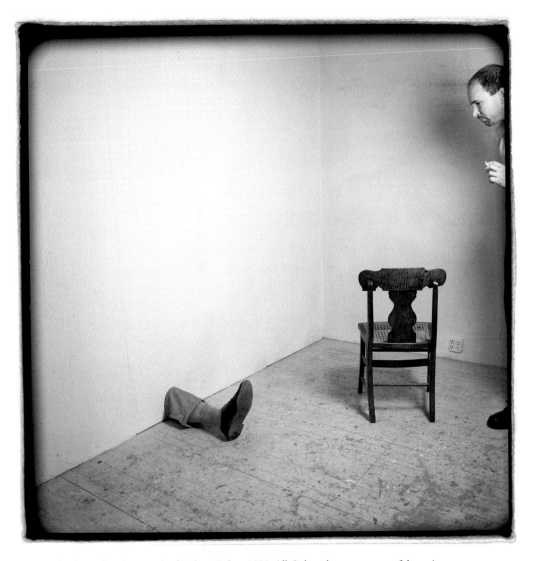

8.1. Michael Biondo, photograph of Robert Gober, 1991. All Gober photos courtesy of the artist.

8

A Missing Part

My first exhibit is a black and white photograph (fig. 8.1). A little burned at the edges, it is difficult to date, and its space is ambiguous—a spare studio, perhaps a hotel dive. A pensive man stands to the right, cut by the frame (we see only a profile of a head, a hand with a cigarette, a bit of a shoe); a wicker chair is turned to the corner; and a male leg extends from the left wall. With trouser, sock, and shoe, it is cut below the knee, inexplicably.

The man peers at the leg. Does he investigate a crime or revisit a deed of his own, ponder a work of art or hallucinate a body part? Is he the witness of the event? Its perpetrator? Its victim? Or is he somehow all three? Clearly the man is a voyeur; but, if the leg is somehow his, is he not an exhibitionist as well? To gaze so seems a little sadistic; yet, if this humiliated leg is somehow his, is he not a little masochistic too? This ambivalence of active and passive roles is performed in visual terms: both an active seeing and a passive being-seen are in play here, and they meet in a reflexive seeing oneself.[1] The man is Robert Gober in 1991, and this is the uncanny thing about his art: before it or (more exactly) within it, one has the strange sense of seeing oneself, of revisiting the crime that is oneself.

My second exhibit is drawn from an interview with Gober. Asked about his way of working, the artist replies: "It's more a nursing of an image that haunts me and letting it sit and breed in my mind, and then, if it's resonant, I'll try to

figure out formally, could this be an interesting sculpture to look at?" Questioned about his setting of scenes, he adds: "This seemed a wide open area to me—to do natural history dioramas about contemporary human beings."[2] These statements are as paradoxical as the photograph. Each object, Gober tells us, begins as an image, perhaps a memory or a fantasy. It might lie in the past, but it is also still alive, like an infant to be nursed (an odd metaphor for an image); and at this point it is not yet entirely external: it remains within its host, even haunts him a little. Both inside and outside, then, intimate and alien (a Lacanian critic might call it "extimate"), the image is figured as a brood that breeds on its own (this is odder still). Perhaps it threatens its host; in any case he wants to objectify it, to get it out into form—but only if it is "resonant" for others too. The share of the beholder, psychological as well as visual, is large in this work.

To these ends Gober sets his objects in "dioramas." Developed in the nineteenth century, the diorama was a scenographic re-creation of a historical event or a natural habitat; part painting, part theater, it brought battlescenes to civilians and exotic wilds to industrial metropoles. Closer to peepshows than to pictures, the diorama was loved by the masses but scorned by the cultivated as a vulgar device of illusion.[3] Often the tableaux included actual things, but in the service of illusion, an illusion more real than a framed image: a hyperrealism that borders on the hallucinated or the fantasmatic. Gober conjures these effects as well: to make us eyewitnesses to an event (re)constructed after the fact, to place us in an ambiguous space—again, as in a dream, we seem to be within the representation too—that is also an ambiguous time: "Most of my sculptures have been memories remade, recombined, and filtered through my current experiences."[4] Here, then, the scene of the diorama has changed: neither public history nor grand nature, the backdrop of these memories is at once private and unnatural, homey and *unheimlich*.

PRIMAL FANTASIES

What do the dioramas stage? Whether alone or in an ensemble, the objects often look forlorn: a miniature house or church split, burned, or flooded (fig. 8.2);

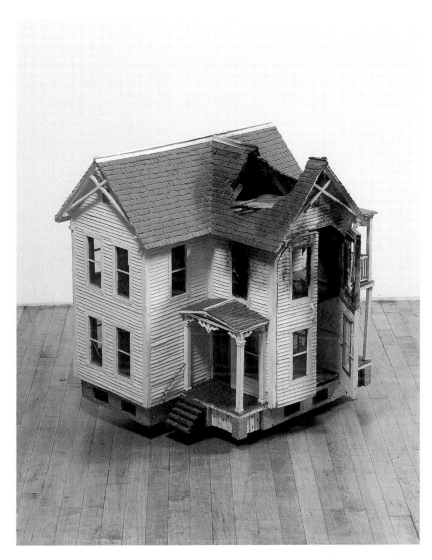

8.2. Robert Gober, *Burnt House,* 1980. Mixed media, 33 × 26 × 30 in. Photo: D. James Dee.

a wedding gown stripped bare of its bride (fig. 8.16); a cast male leg planted with candles or plumbed with drains (figs. 8.8, 8.9); cast male buttocks tattooed with music (fig. 8.18); and so on. Some suggest a fixated image of an awful accident or a traumatic fantasy; and Gober has alluded to a childhood story, told by his mother (a former nurse), of a leg amputated at a hospital. Yet it is as an enigma that the story struck him, and it is as riddles that his dioramas resonate. In a sense, this is the work of his work: *to sustain enigma*.[5]

Sometimes the dioramas intimate scenes in which the subject is somehow at stake, put into play. As we saw in chapters 1 and 2, to posit an originary scene in order to ground a self, to found a style, is a familiar trope in modernist art: many movements began with a baptismal event or a foundational story, often consecrated with a new name and/or a dramatic manifesto. Art involved in primal fantasies, however, is different from art staked in origin myths. For primal fantasies are riddles rather than proclamations of origin: they confound rather than found identity. So it is with some Gauguin paintings discussed in chapter 1; so it is with some Gober scenes as well.

Freud distinguished three primal fantasies in our psychic lives: the primal scene proper (where the child witnesses parental sex, or imagines so), the threat of castration, and the fantasy of seduction. First called scenes, they were later termed fantasies when Freud saw that they need not be historically actual in order to be psychically effective, indeed, that the analysand may construct them, in whole or in part, after the fact, often with the prodding of the analyst. Even when contrived, however, these fantasies appeared consistent, so much so that Freud deemed them phylogenetic—inherited schemas that we all might elaborate on. Today, however, it is hardly necessary to see them as hereditary in order to understand them as originary, for, again, it is through such fantasies that the child is said to tease out the riddles of origins: in the primal scene, the origin of the individual (where do I come from?); in the fantasy of castration, the origin of sexual difference (which sex am I?); in the fantasy of seduction, the origin of sexuality (what is this strange stirring within me?).[6]

As is well known, Freud first referred each case of hysteria to an actual event: for every hysterical woman in the present, he presumed a perverse seducer in the past. Although Freud abandoned this seduction theory as early as 1897, he

retained the essential idea of a trauma that initiates one into sexuality—indeed, into subjectivity. "Presexually sexual" (thus did Freud struggle to articulate the paradox), the first event comes from outside in a way that the child cannot comprehend, let alone master. It becomes traumatic only if it is revived by a second event that the now-mature subject associates with the first, which is recoded retroactively, charged as sexual after the fact. This is why the memory is the traumatic agent, and why trauma seems to come from inside as well.[7] Such confusion of inside and outside is the paradoxical structure of trauma; it might be this complication that *is* traumatic, especially when it triggers a further confusion of private and public. In any case, Gober (re)stages this complication in his dioramas, with scenes that seem both internal and external, private and public, past and present, fantasmatic and real—as though (in a natural history museum designed by David Lynch or David Cronenberg) we suddenly happened upon the most secret events of our own lives.

The primal fantasies are only scenarios, of course, and they never appear pure in life, let alone in art. However, they may help to illuminate this work of "memories remade, recombined," in particular why its subject positions and spatial constructions are often so ambiguous. The scenes of most daydreams are relatively stable because the ego of most daydreamers is relatively centered, and this is true of most pictorial spaces as well: the ego of the artist grounds them for the viewer, or, rather, the primordial conventions that set up such spaces for the mastery of the ego (e.g. the framing of a pictorial field) so grounds them.[8] This is not the case with the scenes of the primal fantasies, for the subject is implicated in these spaces: put into play *by* them, he or she is also at play *within* them, prone to identify with different elements *of* them. This is so because the fantasy is "not the object of desire, but its setting," its mise-en-scène, in a sense its diorama; and this implication of the subject in the space might distort it.[9] Such distortion is also evident in some surrealist art; and, more effectively than any other artist today, Gober elaborates its aesthetic of convulsive identity and uncanny space in contemporary terms.[10]

In "Manifesto of Surrealism" (1924), André Breton evoked this surrealist aesthetic with a Goberesque image: "a man cut in two by a window."[11] Extrapolated into an aesthetic model, this image suggests neither a descriptive mirror nor

a narrative stage, the two dominant paradigms of Western picture-making from the Renaissance to modernism, but, rather, a fantasmatic scene where the subject is split both positionally, at once inside and outside, and psychically, "cut in two." Two aspects of this model (which we also saw at work in chapters 5 and 6) are relevant to my reading of Gober. First, in this way of working the artist does not invent forms so much as (s)he retraces tableaux in which the subject is not fixed in relation to identity, difference, and sexuality; again, these are precisely the terms in question in primal fantasies.[12] Second, the location of these scenes is not certain, as is evident in the paradoxical language used to describe them. "It's more a nursing of an image that haunts me," says Gober. "Who am I?," asks Breton at the beginning of *Nadja* (1928). "If this once I were to rely on a proverb, then perhaps everything would amount to knowing whom I 'haunt.'. . . Perhaps my life is nothing but an image of this kind; perhaps I am doomed to retrace my steps under the illusion that I am exploring, doomed to try and learn what I should simply recognize, learning a mere fraction of what I have forgotten."[13]

ENIGMATIC SIGNIFIERS

In a series of texts over the last two decades, the psychoanalyst Jean Laplanche has rethought *all* the primal fantasies as seductions—not as literal assaults but as "enigmatic signifiers" received from the other (parent, sibling, caretaker), which the infant finds seductive precisely because they are enigmatic.[14] These signifiers, which need not be verbal at all, concern the subject profoundly—again, they involve the fundamental questions of our existence—yet they come from an elsewhere, from an other. So, too, the Gober objects seem to arrive from an other place, as if from a fairy tale, a dream, or some other unconscious scene. They possess an alterity, and this alterity produces a passivity in the viewer, for, again, the objects appear as if suddenly, and one feels almost helpless before them—one *suffers* them.[15]

The quintessential enigmatic signifier is the maternal breast, which the infant sees as an entity in its own right. Gober presents the breast (1990; fig. 8.3) in this way too—as a part-object on its own, a fragment in relief (it is made of

painted beeswax). It recalls *Please Touch* (1947; fig. 8.4) by Marcel Duchamp, but that breast is more frontal, more aggressive: an object for a post-Oedipal subject, it challenges one to touch, to break this taboo of art, to question aesthetic appreciation with sexual desire, to trace the sense of the beautiful to "the secondary sexual characteristics" of the body (as Freud once clinically termed the breast). The Gober breast is different: neither maternal nor sexual, it is also neither good object nor bad object (in the terms of Melanie Klein); it is exactly enigmatic.

Laplanche ventriloquizes the infant before this enigma in this way: "What does the breast want from me, apart from wanting to suckle me, and, come to that, why does it want to suckle me?"[16] Here the desire of the other prompts the desire of the subject precisely as an enigma, and this enigma recalls the riddle of seduction: What does this other want? What is this strange force that it stirs inside me? What is a sexual object? What is a sexual object for me? And who—or what—am I? For Freud, the sexual drive is "propped" on the self-preservative instinct: the infant at the breast sucks milk out of need, which can be satisfied, but it also experiences pleasure—a desire for the punctual return of this pleasure—which cannot be satisfied. The milk is the object of need; the breast is the object of desire, the first such object for everyone. But even (or especially) when the constitution of the subject is at issue, Freud tends to presuppose a heterosexual male. With his ambiguous breast, Gober seems to query this presupposition, to ask when it can no longer be held. In so doing, he implies that the riddle of sexuality cannot be separated from the riddle of sexual difference: across the spectra of masculine and feminine, heterosexual and homosexual, these two enigmas are bound together.

If the Gober breast poses the riddle of the sexual *object,* his chest (1990; fig. 8.5), bisected and bisexed, embodies the riddle of the sexual *subject:* which gender am I, and what sexuality? At first glance, this hermaphrodite torso-pillow (also made of painted beeswax) seems not so much enigmatic as repulsive—in its very refusal of enigma, perhaps, in its making-literal of bisexuality as double-sex. Nonetheless, the ambiguity of gender persists: the female breast (it is made from the same mold as the solitary one) is a little penile, the male breast a little supple, hair strays into the female side, the male side is fleshy too, and so on. In a sense,

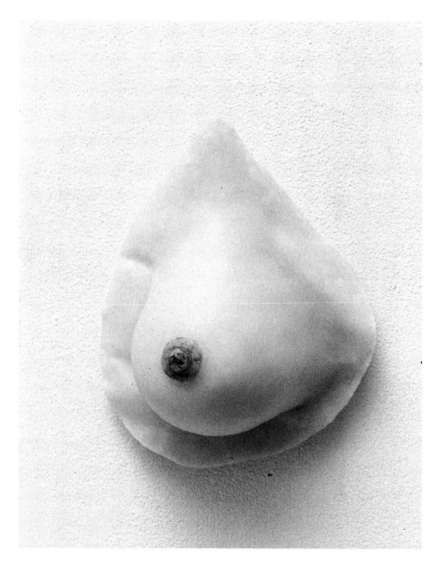

8.3. Robert Gober, *Untitled,* 1990. Beeswax and oil paint, 8½ × 7⅛ × 3¾ in. Photo: D. James Dee.

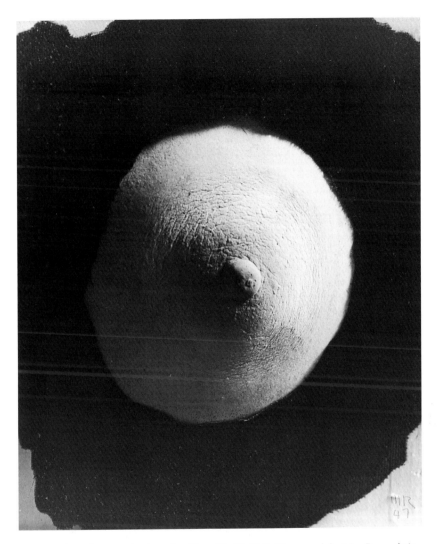

8.4. Marcel Duchamp, *Prière de toucher (Please Touch)*, 1947. Photograph by Man Ray; gelatin silver print, 9½ × 7¾ in. Philadelphia Museum of Art: Gift of Jacqueline, Paul, and Peter Matisse in memory of Alexina Duchamp. Photo: Philadelphia Museum of Art.

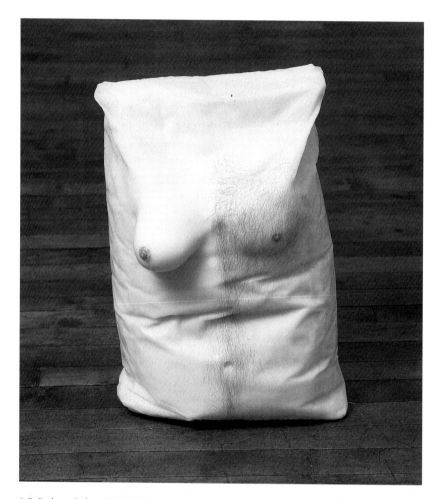

8.5. Robert Gober, *Untitled,* 1990. Beeswax and human hair, 24 × 15½ × 12 in. Photo:
D. James Dee.

this truncated torso is enigmatic because it is both literal and ambiguous: here sexual difference is presented as both physically absolute and psychically undecidable. It is irreducibly both, and it is traumatically enigmatic because it is irreducibly both.[17]

This hermaphrodite, then, is not replete: its doubleness reveals a division, its excess a loss, and here Gober allows for a special insight into psychoanalysis and aesthetics alike. For if the breast is our first sexual object, it is also our first lost object. Again, according to the psychoanalytic formula, though the need for milk can be satisfied, the desire for the breast cannot, and in this desire the breast appears lost to the infant. It can hallucinate the breast (in desire begins fantasy, and vice versa) or find a substitute (what is the thumb, or the pacifier, but the breast in displacement?). On the one hand, then, as Freud remarked, "the finding of an object is in fact a refinding of it."[18] On the other hand, this refinding is forever a seeking: the object cannot be regained because it is fantasmatic, and desire cannot be satisfied because it is defined in lack. This is also the paradoxical formula of the found object in surrealism, its great ruse: a lost object, it is never recovered but forever sought; always a substitute, it drives on its own search. Thus the surrealist object is impossible in a way that most surrealists never quite understood, for they continued to insist on its discovery—on an object *adequate* to desire.

The epitome of this misrecognition occurs in the flea-market episode of *L'Amour fou* (1937), when Breton recounts the making of *The Invisible Object* (or *Feminine Personage,* 1934; fig. 8.6) by Alberto Giacometti, a sculpture born of a romantic crisis. Breton tells us that Giacometti had trouble with the head, the hands, and, implicitly, the breasts, which he resolved only after his discovery of a particular mask at the flea market. For Breton, this is a textbook case of an object found—almost called into being—by an unconscious desire. But *The Invisible Object* might evoke the opposite, the impossibility of the lost object regained, of the void filled: with its cupped hands and blank stare, this feminine personage shapes "the invisible object" *in its very absence.*[19] One achievement of Gober is that within a surrealist line of work he reveals this impossibility of its object, this

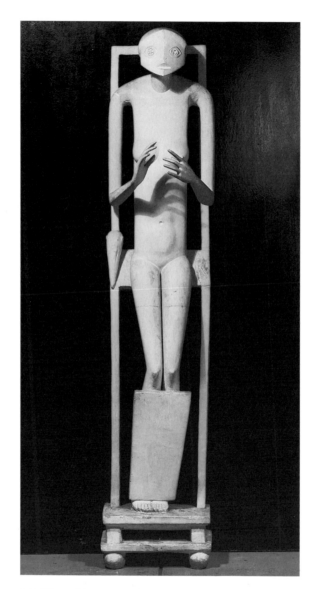

8.6. Alberto Giacometti, *The Invisible Object*, 1934. Plaster,
61½ in. high. Yale University Art Gallery. © 2003 Artists Rights
Society (ARS), New York/ADAGP, Paris.

paradox of its aesthetic. He questions the surrealist trust in desire-as-excess with the psychoanalytic truth of desire-in-lack.

Sometimes Gober registers this desire-in-lack less in objects than in settings, as in his "traumatic playpens" (1986; fig. 8.7). These crazy cribs recall the celebrated passage in *Beyond the Pleasure Principle* (1920) where Freud discusses the *fort/da* game of his young grandson. According to Freud, the little boy was devastated by the periodic disappearances of his mother, which he sought to master actively rather than to suffer passively. To this end he represented her movements with a string attached to a spool: into his crib he would throw the spool, make it disappear (*fort!* gone!), only to recover it with the string, to make it reappear, each time with delight (*da!* there!). This game suggests that the psychic basis of all representation resides in loss, which any representation works to compensate a little. However, the traumatic playpens of Gober present a less redemptive view of symbol-making. Pitched, slanted, tilted, or otherwise distorted, these cribs are cages marked with aggression—whether of the child or the other (as intuited by the child) it is difficult to say. The nastiest playpen is the most normal, as if every standard pen were potentially a Skinnerian box. This is true as well of his beds (1986), each made up of a simple stand, sheets, blanket, and pillow: the nastiest is the most generic, as if every bed were potentially an institutional straitjacket. Rather than a happy accession of the infant to representation, then, Gober evokes a socialization that is blocked or broken. Perhaps the child of these deranged cribs and pens refuses the enigmatic signifier, rejects the name of the father—only, these cages seem to suggest, to earn a designation nonetheless, that of psychotic.

From the breast through the torso to the penis, Gober asks these questions: What is a sexual object? What is a sexual subject? What is desire? What is loss? And for whom? Moreover, how do we distinguish between subject and object, desire and loss? Even as Gober reveals the found object to be a lost object, he reworks the surrealist aesthetic of desire, often tilted to the heterosexual, into a contemporary art of melancholy and mourning, here tinged gay, in which subject and object may indeed appear confused. According to Freud, this is the problem for the subject struck by loss: as the melancholic refuses to surrender the lost

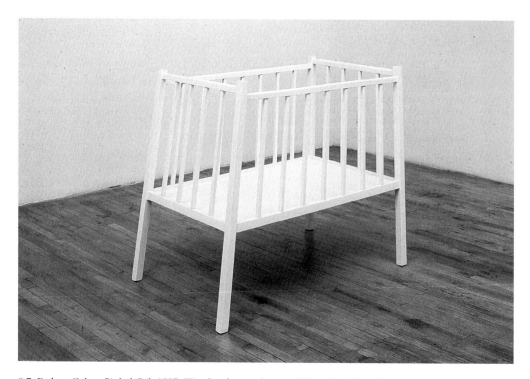

8.7. Robert Gober, *Pitched Crib,* 1987. Wood and enamel paint, 38¼ × 77 × 52 in. Photo: D. James Dee.

object, he makes it internal, and reproaches it in the guise of a self-reproach, while the mourner learns to relinquish the lost object, to disinvest in this one thing in order to reinvest in other things, to return to life. Gober captures this vacillation of the forlorn subject between reproach and reverence. On the one hand, the legs planted with candles or plumbed with drains may evoke a body consumed or wasted—the body burned at both ends, drained, spent in all senses of the word (figs. 8.8, 8.9). On the other hand, they might evoke a body radiant or cleansed—the body transformed from an abject thing, too close to the subject, into an honored symbol, distanced enough for the subject to go on with life.[20] Gober puts other associations into play too, conflicted connections (perhaps keyed to the Catholicism of his youth) between fire and water, altar and slaughter-bench, remembrance and oblivion, in a way that points to an enigma less of origins than of ends—of departures and deaths. What do you do with desire after loss? You burn for a while, carry a torch for a time, eventually light a candle to the memory of the loved one. What do you do with a body after death? You wash it in order to purify it of you and to free you of it.

In terms of precedents one thinks first of Duchamp, but Gober queers his reception in significant ways.[21] Unlike many contemporaries, Gober does not focus on the model of the readymade, which can question the relation between art work and commodity. In fact he almost opposes this model, not only because he fabricates his objects, but also because Duchamp intended "complete anaesthesia" with his readymades, while Gober explores traumatic affect with his made things.[22] Instead, Gober adapts another Duchampian model, the cast body part, which can query the relation between art work and sexual drive.[23] Like Duchamp, he sees cognition as sensual (in the notorious phrase of his predecessor: "to grasp things with the mind the way the penis is grasped by the vagina"), but this cognition is different for Gober, because the desires are different. Hence, instead of the "female fig leaf" and "wedge of chastity" of Duchamp, Gober offers casts of musical male buttocks and colossal butter sticks (figs. 8.10, 8.11). And instead of the "disagreeable objects" of Giacometti, Gober offers homoerotic relics such as his candle seeded with human hair (figs. 8.12, 8.13). Nevertheless, the affinity with Duchamp and Giacometti is clear, and it rests in a shared fascination

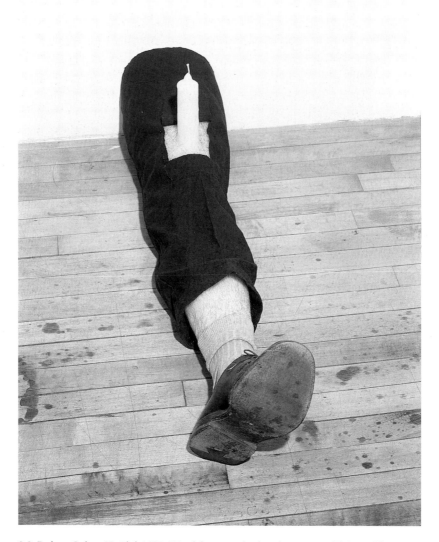

8.8. Robert Gober, *Untitled,* 1991. Wood, beeswax, leather shoe, cotton fabric, and human hair, 13½ × 7 × 38 in. Photo: Geoffrey Clements.

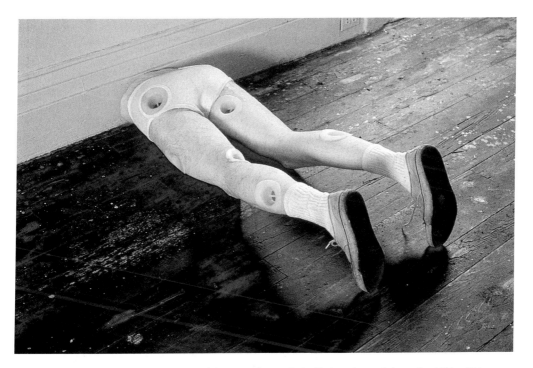

8.9. Robert Gober, *Untitled,* 1991–93. Wood, beeswax, human hair, fabric, paint, and shoes, 9 × 16½ × 45 in.
Photo: Andrew Moore.

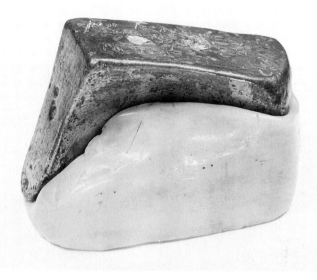

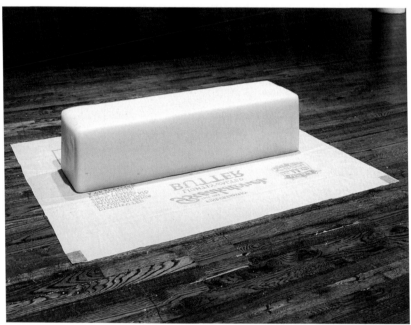

8.10. Marcel Duchamp, *Wedge of Chastity,* 1951–52. Galvanized plaster and dental plastic, 3⅞ × 2⁹⁄₁₆ × 2¾ in. Philadelphia Museum of Art: Duchamp Archive, Gift of Jacqueline, Peter, and Paul Matisse in memory of Alexina Duchamp. © 2003 Artists Rights Society (ARS), New York/ADAGP, Paris/Succession Marcel Duchamp. Photo: Philadelphia Museum of Art.

8.11. Robert Gober, *Untitled,* 1993–94. Beeswax, wood, glassine, felt-tip marker pen ink, 9½ × 36½ × 9¾ in. Photo: Russell Kaye.

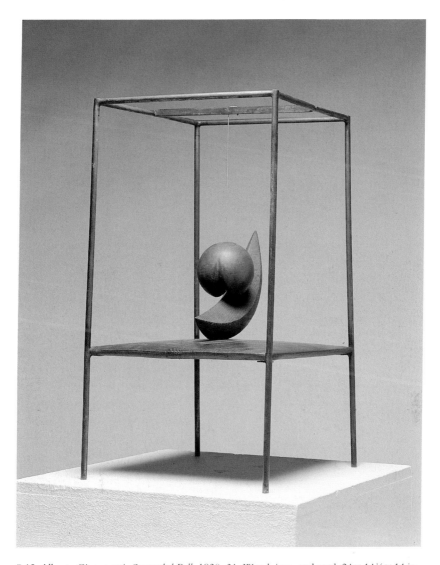

8.12. Alberto Giacometti, *Suspended Ball*, 1930–31. Wood, iron, and cord, 24 × 14¼ × 14 in. Musée National d'Art Moderne, Centre Georges Pompidou, Paris. © 2003 Artists Rights Society (ARS), New York/ADAGP, Paris. Photo: CNAC/MNAM/Dist. Réunion des Musées Nationaux/Art Resource, New York; photo by Georges Meguerditchian.

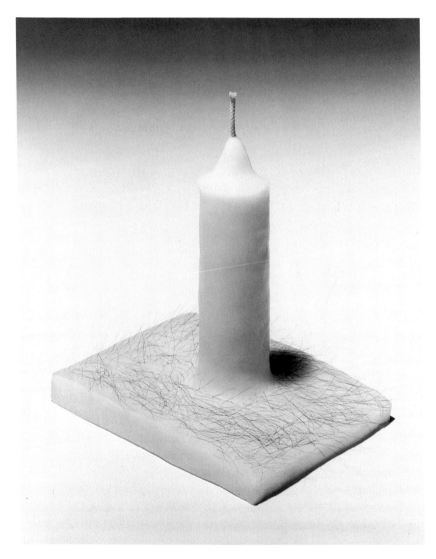

8.13. Robert Gober, *Untitled Candle,* 1991. Beeswax, string, and human hair, 8 × 4⅞ × 6½ in. Photo: Geoffrey Clements.

with enigma and desire—with the enigma *of* desire, the desire *in* enigma.[24] Seduction is also central in Duchamp and Giacometti, but it is seduction as heterosexual quest: Duchamp never lets the bachelors attain the bride in *The Bride Stripped Bare by Her Bachelors, Even* (1915–23); Giacometti never lets the banana form touch the peach shape in *Suspended Ball* (1930–31). There the operative analogy is coitus, but it is coitus not only interrupted but deferred: for Duchamp and Giacometti, "delay" and "suspension" (privileged terms for each respectively) are fundamental to desire, and this puts them somewhat to one side of the dominant Bretonian line of surrealism. In his bachelor machines, which include unconnected sinks (1983), urinals (1984), and drains (1989), Gober queers this formula of blocked desire, revises it in terms of melancholy and mourning, loss and survival—that is, in terms of the age of AIDS. "For me," he remarked in 1991, "death has temporarily overtaken life in New York City."[25]

Human Dioramas

Gober does not focus on the Duchampian readymade, but there are apparent exceptions: for example, the sinks, urinals, and drains recall the paradigmatic readymade *Fountain* (1917). Yet here, too, Gober twists Duchamp—literally so in a work like *Three Urinals* (1988; fig. 8.14). For *Fountain* was a found urinal rotated ninety degrees and positioned as art on a pedestal, while *Three Urinals* is a simulation fabricated out of wire, plaster, and enamel paint, and returned to the official place for urinals on the wall (they are hung low). In effect, Duchamp brought the bathroom to the museum, with a provocation (beyond the initial scandal) that was both epistemological (what counts as art?) and institutional (who determines it?), while Gober brings the museum to the bathroom (if one urinal signals a public toilet, three confirm it), with this additional provocation: *both* kinds of spaces, we suddenly see, mix the private and the public in uneasy ways. Although they are more prosaic than the riddles of the primal fantasies, the mysteries of the bathroom are also never solved, at least for boys. They forever wonder what is inside the girls' room (what delights and horrors), and they never get over the unease of the boys' room either. They wonder about the males next

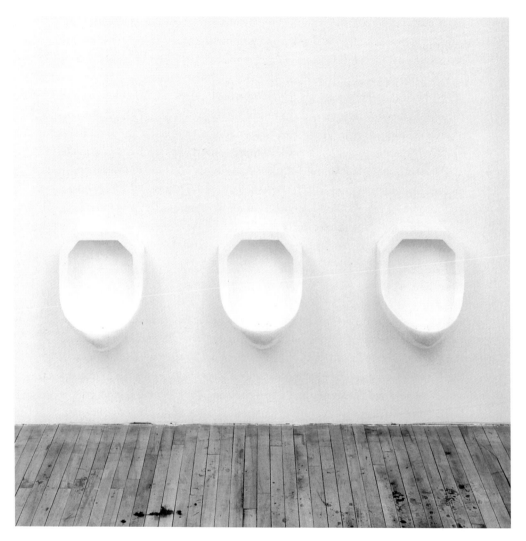

8.14. Robert Gober, *Three Urinals,* 1988. Wood, wire lath, plaster, and enamel paint, 21¾ × 73¼ × 15 in. Photo: D. James Dee.

to them. Bigger? (Freud got it wrong: penis envy—that is, penis anxiety—is mostly a male problem.) Better? Vaguely disgusted? Very interested? The Gober urinals call these secret queries to mind, at least to some viewers: the share of the beholder is not only large but specific in his art. These works put sexual difference on display in a way that again twists Duchamp.[26]

Three Urinals was followed by a series of installations, most with different Duchampian spins. The first, at the Paula Cooper Gallery in 1989, resonated with *The Bride Stripped Bare* in its concerns with sexual difference and desire. In one room Gober hung wallpaper of penises and vaginas, anuses and navels, sketched in white line on black ground and punctuated with chest-high drains, as if to suggest that sexual difference is the ambient pattern, both obvious and overlooked, of our everyday lives of eating and evacuating (fig. 8.15). In another room he hung wallpaper of schematic drawings of two men in light blue on pale yellow, the one (based on a Bloomingdale's beefcake ad) white and asleep, the other (based on a 1920s Texas cartoon) black and lynched, as if to suggest that racial antagonism is another occluded structure of our daily grinds (fig. 8.16). Like *The Bride Stripped Bare,* then, the installation was split into two registers, and each room was split in turn: in the center of the first was a bag of doughnuts on a pedestal; in the center of the second stood a wedding gown attended by bags of "Fine Fare Cat Litter" set along the wall (as usual, all were fabricated by the artist and his assistants). Thus from space to space and from images to objects, Gober put a series of oppositions in play: male and female, bachelors and bride, white and black, immaculate gown and stale food, purity and pollution, dream and reality, and, above all, sexual difference and racial difference.

Rather than map these oppositions onto one another, however, Gober intertwined the terms in an ensemble that evoked the intricacies of fear, desire, and pain at work deep in our political imaginary. In a sense, this was to elaborate Freud as well as Duchamp, for here Gober intimated that our traumas of identity and difference are social and historical too. It was also to rework the diorama as a re-creation of an actual event, for here Gober intimated that our racist past persists, nightmarishly, in the present as well. In our political imaginary, simple *oppositions* of sex (male and female) and color (white and black) reconfirm one

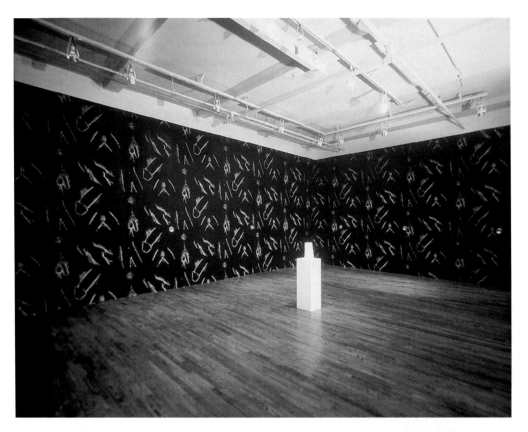

8.15. Robert Gober, installation at Paula Cooper Gallery, New York, 1989. Photo: Geoffrey Clements.

8.16. Robert Gober, installation at Paula Cooper Gallery, New York: *Wedding Gown, Cat Litter, Hanging Man/Sleeping Man,* all 1989. Photo: Andrew Moore.

PROSTHETIC GODS

another in a way that makes complex *differences* across sexual and racial positions difficult to think, let alone to negotiate. The Cooper installation prompted the viewer to tease out this old American knot in the form of a broken allegory: What is the relationship between the two men? Does the black man haunt the white man? Does the white man dream the black man? If so, does the white man conjure the black man in hatred, guilt, or desire? Is the woman implied by the wedding gown the object of their struggle? If so, is she the pretext of their violence, or the relay of their longing, or both?[27] What is the role of heterosexual fantasy in racial politics? Of racial fantasy in heterosexual politics? And how does homosexuality or homosociality come into play? Finally, how does one *dis*articulate all these terms—clarify them in order to question them? The installation posed these traumatic questions, only to remain mute. Yet the wallpaper reminded us that they remain the stuff of daily realities and nightly dreams.[28]

The installation also evoked another work by Duchamp, *Etant donnés* (1946–66; fig. 8.17). In this diorama at the Philadelphia Museum, the viewer spies, through a peephole in a door and a hole in a wall, a female mannequin spreadeagled in a wooded landscape, with a gas lamp in one hand and a waterfall behind her. (Suddenly the lamp and waterfall look like versions of the Gober candles and drains: "influence" can flow backwards too, at least in interpretation.) A more literal diorama than the Gober installations, *Etant donnés* is also a more direct re-creation of a primal scene, which, in another uneasy mixing of the public and the private, is reframed almost as a peepshow. But what traumatic origin does one revisit here? The diorama brings together two old obsessions of Duchamp: perspectival vision and sexual violation (both are also in play in *The Bride Stripped Bare*). Indeed, as we saw in chapter 7, *Etant donnés* can be read as a making-physical of perspective, one that connects our viewing point, through the holes, to the vanishing point, which coincides here with the vulva of the mannequin (fig. 7.7). Duchamp demonstrates that perspectival vision is not innocent, let alone scientific, that our gaze is marked by sexual difference, by "this central lack expressed in the phenomenon of castration," as Lacan commented in a seminar contemporaneous with the unveiling of *Etant donnés*.[29]

8.17. Marcel Duchamp, *Etant donnés: 1° la chute d'eau 2° le gaz d'éclairage,* 1946–66.
Philadelphia Museum of Art: Gift of the Cassandra Foundation, 1969. © 2003 Artists Rights
Society (ARS), New York/ADAGP, Paris/Succession Marcel Duchamp. Photo: Philadelphia
Museum of Art.

Gober assumes this Duchampian-Lacanian demonstration of the sexual inflection of the visual field precisely as a *donné*—as a given to elaborate in other ways.[30] In a 1991 installation at the Jeu de Paume he seemed to play on *Etant donnés* again. Here Gober positioned three works in relation to a late-autumnal landscape of bare trees patterned in color on the walls: cast male buttocks tattooed with bars of music and mounted against one wall (fig. 8.18), and two legs that extended from other walls, toes down, on the floor. One leg wore dark pants, dress shoes, and socks, and was planted with three candles through holes cut in the trousers; the other wore white briefs, tennis shoes, and socks, and was plumbed with several drains colored like flesh. For Gober the three works "present a trinity of possibilities—from pleasure to disaster to resuscitation";[31] and at first it seems clear which is which: pleasure is promised by the musical buttocks, disaster by the drained legs, resuscitation by the candles that await lighting. But an insistent ambivalence within each work disturbs this redemptive narrative. For the musical buttocks might evoke pain as much as pleasure (to the extreme point of the grotesque tattooing of prisoners in the Nazi death camps), and the source of the image is also ambiguous (it derives from the depiction of Hell in *The Garden of Earthly Delights* [1500] by Hieronymus Bosch).[32] Conversely, the drained legs might suggest seduction as much violation, and the candles might summon up death as much as resuscitation.[33] It is this ambivalence of near-opposites that sustains the enigma of the objects, which conduces to a complexity at once aesthetic, sexual, and moral, and which the closure of a redemptive narrative would diminish. This ambivalence might be most pointed in another object of 1991, the candle with hair at its base, which suggests both a memorial candle and an erect penis (fig. 8.13).[34] Like some other Gober objects, this mixing of mortality and sexuality projects a Catholic sense of the complementarity of the sacred and the profane, the spiritual and the base; but this complementarity is turned critically, made perverse vis-à-vis religious convention, for here the base term controls the spiritual.

What are we to make of the landscape in the Jeu de Paume installation? Once again, a comparison with *Etant donnés* is instructive. In his dioramic landscape, with its spreadeagled mannequin, Duchamp suggests a relation not only

8.18. Robert Gober, installation at Galerie Nationale du Jeu de Paume, Paris, 1991. Photo: K. Ignatiadis, courtesy of the artist and Paula Cooper Gallery, New York.

between perspective and castration but between pictorial landscape and sexual violation, perhaps through a common will to possess that the first sublimates and the second enacts. The Jeu de Paume installation also presented a perspectival landscape, the repeated avenues of bare trees drawn on the walls. Yet in this case the body-parts were male, and they were moved away from the vanishing point of the perspective toward the seams between the patterns of trees. These seams opened and closed in a way that intimated a different kind of intercourse with the natural world, one of connection rather than domination. In effect, this interaction rendered the landscape a homoerotic pastoral; yet the season evoked there was nearly winter, and this time of dying pushed this transhistorical pastoral toward a specific elegy, a lament for the lost men of the AIDS epidemic. Again, in 1991, "death has temporally overtaken life."

In a 1992–93 installation at the Dia Center for the Arts, Gober recalled *Etant donnés* once more, though by this time he had established this field of effects as his own. Again we were confronted with a wooded landscape in the form of repeated wallpaper, but the season had changed to spring, nature appeared replenished, and for the first time water flowed in the sinks that punctuated the forested walls (fig. 8.19). Moreover, there was no body or limb present; the *corpus delicti* was missing. In a sense we stood in its stead, which rendered our position all the more ambiguous. For within a room we beheld a landscape, but a landscape with squares cut like windows along one wall; and, more enigmatically, these windows (beyond which appeared the bright light of apparent sky) were barred. Gober placed bound stacks of the *New York Times* along the walls and by the columns, and boxes of "Enforcer Rat Bait" under some sinks. Both outside and inside, then, we were also somehow *below*, in a spatial experience that was equal parts bizarre Magritte tableau and everyday basement apartment. Once again, oppositions like purity and pollution (the running water, the rat poison) were in play, as were allusions to sexual and racial difference (in some newspapers, reports of abuse and discrimination were collaged next to wedding announcements). The scenic ambiguity of the diorama was also used to underscore an old divide in American ideology between transcendentalist myths of individual and nature

8.19. Robert Gober, installation at Dia Center for the Arts, New York, 1992–93. Photo: Bill Jacobson.

(the wallpaper might be called Ever Emerson or Thoroughly Thoreau) and contemporary realities of mass anonymity and urban confinement.

Much was made of the fact that, for the first time, water flowed in this installation. As his dry sinks, urinals, and drains came to be taken as "surrogate portraits of gay men," Gober began to question his own AIDS iconography of detached plumbing and drained bodies: "I felt the need to turn that around and to not have a gay artist represented as a nonfunctioning utilitarian object, but one functioning beautifully, almost in excess."[35] For some critics this turn expressed a desire not only for a recovery of health but for a model of desire based on flow and surplus rather than loss and lack.[36] Developed by Deleuze and Guattari (in part through a different reading of the bachelor machines of Duchamp), this voluntaristic model of desire opposes the psychoanalytic models elaborated by Freud, Lacan, and Laplanche that I have employed here.[37] But if Gober did make a shift, it was less a turn from an aesthetic of missing parts to a system of connective flows than a move from a realism of psychic loss to a longing for redemptive faith. And this turn was only incipient here, for, though the water ran, we were still underground, and, though spring had come, the space was still barred—not only at the windows but at a locked exit door with a red light above. In a sense, where nature was once desiccated, it was now deluged, so that if spring had indeed arrived after the winter of the Jeu de Paume installation, it remained that of a contemporary wasteland, "breeding / Lilacs out of the dead land, mixing / Memory and desire, stirring / Dull roots with spring rain. . . ."

RIDDLING, REDEEMING, WORKING OVER

In subsequent installations Gober explored this new idiom of water and flow, but its intimation of connection and renewal still vied with an imagery of division and decay.[38] However, in a 1997 installation at the Los Angeles Museum of Contemporary Art, the redemptive iconography prevailed. Here one descended into a large space dominated by a six-foot statue of the Virgin Mary set on a storm-drain grate (as always, the elements were crafted, not readymade). Behind the Virgin was an enclosed wood stairway down which water cascaded to a storm

drain below (at a rate of 180 gallons a minute), and she was flanked by two old
suitcases flung open on the floor (fig. 8.20, pl. 14). Through each suitcase one
could peer down into a tidal pool bathed in pristine light, where a man waded
with an infant in his arms; as usual one could see little more than legs (fig. 8.21,
pl. 15). These pools mixed new and old life, natural and human worlds, in an
almost baptismal way. The Virgin stood above a pool too, a wishing well strewn
with huge pennies, which Gober dated to the year of his own birth (1954). Like
her suitcases (her altarwings?), she seemed an emblem of passage, the central con-
duit in this system of flows, the main medium of faith at these different stations
of life—life everlasting (the stairway to heaven), human in its generations (man
and child in the water), and primal marine (the tidal pools).

Gober rejected the Catholicism of his youth, as it had rejected him as a
gay man. Yet it often returns in his objects—perversely, critically, as in the hairy
candle with its privileging of the profane over the sacred, the base over the spir-
itual. In the Los Angeles installation, however, the conventional hierarchy of
these opposed terms returned; more, the second term worked to redeem the first
in a way that threatened to undo the enigmatic complementarity of the two cap-
tured in prior work. This is not to say that no ambiguity or ambivalence re-
mained: the water was figured as both destructive and restorative, and the Virgin
was hardly heavenly: presented in worn concrete, a garden ornament eroded by
worldly weather, she was also run through the middle with an industrial pipe (in
bronze), as if she were only a material culvert in a material world. But did this
pipe point to a hole where the Savior should be, and did the open suitcases
underline that all was lost?[39] Or was it a conduit through which the destructive
water passed to the restorative pools?

"The stream of life goes through the Virgin," Gober remarked of the in-
stallation.[40] Here we are far from the virgins of Duchamp and his dioramas of de-
sire: rather than preside over a theater of desire-in-loss (or even desire-as-flow),
this Virgin seems to figure a wish for fulfillment—indeed, a wish-fulfillment for
a fallen world restored to maternal plenitude. "My mother had a sophisticated
reading of the show," Gober also commented. "She thought the whole piece
was about me making a sculpture of my own birth"; and he added that church

8.20. Robert Gober, *Untitled,* installation at Los Angeles Museum of Contemporary Art, 1997. Photo: Joshua White.

8.21. Robert Gober, *Untitled,* installation detail at Los Angeles Museum of Contemporary Art, 1997. Photo: Russell Kaye.

interiors (the installation was a kind of chapel) reminded him of "a miraculous human body."[41] This remark suggests another primal fantasy, an almost intra-uterine one that, in opposition to the other primal fantasies, is a dream of re-pletion.[42] And with its rushing water, tidal pools, wishing well, and enfolding mother, this diorama does seem to stage a dream of redemption, one in which the viewer is invited to participate (to project) as well. Part of the relief on offer here was no doubt due to the easing of the AIDS epidemic (at least for the more privileged) on account of the partial success of drug treatments. But part of the relief was also in keeping with the recent reaction against the difficulties of traumatic loss and critical negativity in art and theory alike, a reaction expressed in the renewed interest in Beauty and Spirituality. In any case, the relief was psychological, a solace that heretofore Gober had refused, precisely because it involved a sublimation that heretofore he had resisted—a sublimation of the enigmas of sexuality into "the mystery of faith."[43]

The problem here does not concern narrative as such. A riddle is a story too, but it is one missing in meaning, whereas the story of the Los Angeles Virgin appears allegorically intact, formally closed, structurally redemptive. For Laplanche, the most affective enigmatic signifiers are "designified," somehow broken in signification.[44] This is true of the most effective Gober dioramas as well: "Something's literally missing in the story," he remarked of the Cooper installation, "if you look at it as a story—and you kind of have to. You have to supply that: what was the crime, what really happened, what's the relationship between these two men."[45] Again, this is the work of his best work—to sustain enigma—and usually it is done in two complementary ways. The first is to evoke a narrative riddle, a story with a hole in it. The second is to trace this hole some-how, to figure the missing part, *not* to fill in this hole or to make this part com-plete. The missing part, the lost object, is not only a desired thing; sometimes it seems rejected, spited, even accursed (the missing part as *la part maudite* in the sense of Georges Bataille). It is this quality that often renders his objects para-doxical and his viewers ambivalent, for again, at these moments, it is if we beheld the thing that we have sought forever *and* dreaded to find. It is this anxious fixa-tion in us that Gober re-creates in the most effective of his dioramas.

This insistence on the missing and the *maudite* was present in much dissident art and philosophy of the twentieth century that challenged the official ideals of aesthetic completion, symbolic totality, dialectical assimilation, and the like. Subterranean in modernist art (which tended to favor Hegelian systems—think of Malevich or Mondrian—over the nasty remainders that they cannot absorb), this insistence rose to the surface again in vanguard culture of the last fifteen years. Whether conceived in terms of "the heterogeneous" (as in Bataille), "the real" (as in Lacan), "the inhuman" (as in Jean-François Lyotard), or "the abject" (as in Julia Kristeva), this motive drove many different practices in the 1990s, which faced new apparent totalities (like cyberspace and global capitalism) to resent, perhaps to resist.[46] In time, however, this motive approached the routine, and it also became restricted by its own anxious fixations. No wonder, then, that Gober wanted to escape this paranoid fascination with enigmatic signifiers, this melancholic cult of traumatic loss; so did many other artists and critics (hence, again, the recent turn to Beauty and Spirituality).[47] But between riddling and redeeming, between an aesthetic of missing parts and a dream of wish-fulfillment, there are other paths; and Gober intimates one third way: neither a fixation on trauma nor a faith that magically undoes loss, but the fabrication of scenes for a working-over of trauma and loss—a working-over, not a working-through in the sense of a having-done, a narrative closure, a redemptive meaning. Gober has revealed that the process of his work is not as laborious or painstaking as it seems to be.[48] Nonetheless, this work does suggest some ratio between physical labor and psychic labor, between the working up of fictive objects and spaces and the working-over of traumatic causes and effects. This work can be painstaking in this other sense too, in a way that neither fixes on trauma nor leaps toward redemption.

————

NOTES

PREFACE

1. My language here might evoke the notion of self-fashioning as developed in new historicism over the last two decades. This notion has done much to reorient art history away from old histories of styles and analyses of form toward new genealogies of the viewer; spectatorship has become a primary plane of discursive consistency in the discipline. The psychological subject that concerns me here, however, is not as porous as the new-historicist subject: my subject is socially constructed, of course, but in part out of unconscious residues resistant to historical make-over. At the same time, even as my readings are psychoanalytical in nature, they are not exclusively so: they seek to mediate forces in the social field as well.

2. I select these artists and not others because they focus crucial topoi of modernist art: primitivism, purity, technology, mental illness, complications of masculinity and femininity, cracks in the symbolic order. Many other figures could be discussed equally as well: origin myths are central to modernists such as Wassily Kandinsky and Fernand Léger, for example, and new subjects are proposed in movements such as constructivism and the Bauhaus. Yet my figures also permit insights into the intersections of modernism and psychoanalysis that these others do not; and some simply intrigue me in ways that I cannot fully explain.

3. Sometimes these apparent opposites are combined in techno-primitive hybrids that intrigued several modernists, in particular those (such as Le Corbusier) swept up in the craze for

jazz, which seemed to allow a potent mixing of fantasies of a primordial Africa and a futuristic America.

4. In this light, I hope my case studies might help to illuminate parallel transformations in global culture and labor regimes today—though I do not comment on them directly here.

5. However, with the possible exception of Ernst, they are not men "at the margins" in the radical sense of Kaja Silverman; see her *Male Subjectivity at the Margins* (New York: Routledge, 1992). Although the present book dates back over a decade, it has missed the recent boom in masculinity studies, but then these problems have hardly disappeared.

6. Often there is a relay here, frequently unwitting, occasionally self-aware: Freud describes the dream as a rebus-picture, Gauguin discusses his rebus-pictures as dreams; Freud sees the primal scene as a fraught visual scenario, Ernst refers his visual obsessions to the primal scene; and so on.

7. Jacqueline Rose, *Sexuality in the Field of Vision* (London: Verso, 1986), 227. "Each time the stress falls on a problem of seeing," Rose continues. "The sexuality lies less in the content of what is seen than in the subjectivity of the viewer." Psychoanalysis has the most to offer the interpretation of visual art, modernist or other, precisely here, in its account of the effects of the work on the subject—an account that places the work in the position of the analyst as much as the analysand.

8. In "The Meaning of the Phallus" (1958) Lacan writes of his methodological "wager": "to argue, as necessary to any articulation of analytic phenomena, for the notion of the signifier, in the sense in which it is opposed to that of the signified in modern linguistic analysis. The latter, born since Freud, could not be taken into account by him, but it is my contention that Freud's discovery stands out precisely for having had to anticipate its formulas, even while setting out from a domain in which one could hardly expect to recognize its sway" (*Feminine Sexuality,* ed. Juliet Mitchell and Jacqueline Rose [New York: W. W. Norton, 1985], 78). See also chapter 1 of my *The Return of the Real* (Cambridge, Mass.: MIT Press, 1996).

9. In this regard see also chapter 8 of my *Design and Crime (and Other Diatribes)* (London: Verso, 2002).

10. Leo Bersani, *The Freudian Body: Psychoanalysis and Art* (New York: Columbia University Press, 1986), 10.

11. Initial versions or partial extracts appeared in the following publications: chapter 1 in *Critical Inquiry* 20 (Autumn 1993); chapter 3 in *Modernism/Modernity* 4, no. 2 (April 1997); chapter 4 in *October* 56 (Spring 1991); chapter 5 in Catherine de Zegher, ed., *The Prinzhorn Collection: Traces upon the "Wunderblock"* (Drawing Center, 2000); chapter 6 in Jennifer Mundy, ed., *Surrealism: Desire Unbound* (Tate Gallery, 2001); chapter 7 in *Res* 44 (Fall 2003); and chapter 8 in Russell Ferguson, ed., *Robert Gober* (Los Angeles Museum of Contemporary Art, 1997).

1 Primitive Scenes

1. Frantz Fanon, *Black Skin, White Masks,* trans. Charles Lam Markmann (New York: Grove Press, 1967), 109; hereafter abbreviated *B.* The original title is "L'expérience vécue du Noir," which is less essentialist than "The Fact of Blackness."

2. See Jacques Lacan, "The Mirror Stage" (1949), in *Écrits,* trans. Alan Sheridan (New York: W. W. Norton, 1977). In Fanon, the Lacanian scenario of the imaginary development of the ego— the identification with the body image shot through with an alienation from it—is not (only) a family affair of infant and parent; it is a social event at once cultural, political, and historical, which complicates the formation of the ego greatly.

3. On this connection see Mary Ann Doane, "Dark Continents: Epistemologies of Racial and Sexual Difference in Psychoanalysis and the Cinema," in *Femmes Fatales* (New York: Routledge, 1991), 209–248. This text remains the best I know on Fanon and psychoanalysis, and it intersects with mine at several points. Apart from his critique of *Prospero and Caliban* (1950) by Octave Mannoni, a notorious psychological account of the 1948 revolt in Madagascar, Fanon was not very attentive to this primitivist inscription in psychoanalysis.

4. See William Rubin, ed., *"Primitivism" in 20th Century Art* (New York: Museum of Modern Art, 1984), 2 vols. There were many responses to this provocative show, including my own "The 'Primitive' Unconscious of Modern Art," *October* 34 (Fall 1985).

5. Sigmund Freud, *Totem and Taboo,* trans. James Strachey (New York: W. W. Norton, 1950), 1. This evolutionist notion of "the survival"—that ontogeny recapitulates phylogeny—

bedeviled psychoanalysis almost as much as anthropology, and Freud did not shy away from its primitivist implications (for example, the characterization of the oral stage as "cannibalistic"). As we will see in chapters 2 and 3, it is also operative in much modernist discourse.

6. Jews were often regarded not as too primitive but as too civilized—that is, as cosmopolitan and so deracinated, decadent, degenerate, and thus, paradoxically, as primitive once again in another sense. On this discourse of norm and deviance, see the work of Sander L. Gilman, especially *Difference and Pathology: Stereotypes of Sexuality, Race, and Madness* (Ithaca: Cornell University Press, 1985).

7. Freud states flatly that women are "little capable" of sublimation, indeed "hostile" to civilization, in *Civilization and Its Discontents* (1930, trans. James Strachey [New York: W. W. Norton, 1961], 56). The rationale for this bias is developed in such texts as "Some Psychical Consequences of the Anatomical Distinction between the Sexes" (1925), where the relative irresolution of the Oedipus complex for the girl is said to produce a weak superego.

8. On this image see Patrick Brantlinger, "Victorians and Africans: The Genealogy of the Myth of the Dark Continent," *Critical Inquiry* 12 (Autumn 1985); and on its use in Freud, see Doane, "Dark Continents." Africa was *made* "dark" or savage not only to justify Victorian imperialism but previously to excuse the slave trade. This need was not so great vis-à-vis Oceania, the other of primitive otherness, which thus could remain a place of relative light. As for the persistence of noble and ignoble types, sometimes Gauguin seems to reconcile, or at least to combine, the two, and, along with his Oceanic orientation, this softens his primitivism relative to Picasso et al. See Stephen F. Eisenman, *Gauguin's Skirt* (London: Thames & Hudson, 1997), 63.

9. On this "idyll of unrestricted consumption, oral and genital," see Hayden White, "The Noble Savage Theme as Fetish," in *Tropics of Discourse* (Baltimore: Johns Hopkins University Press, 1978), 188; and on its use in the feminine figuration of the New World, see Louis Montrose, "The Work of Gender in the Discourse of Discovery," *Representations* 33 (Winter 1991). Among other practices attributed to the primitive, White includes nakedness, lawlessness, and communal property. Against all evidence, Gauguin persists in these stereotypes when he projects Tahiti as a place innocent about money, and the Marquesas as a home of cannibals. Gauguin proceeds according to the primitivist equation of spatial and temporal distances. It is this space-time mapping that allows him to regard his voyage *out* as a voyage *back*—to the begin-

nings of the subject, civilization, even these species: "You have to return to the original source, the childhood of mankind" (Eugène Tardieu, "Interview with Paul Gauguin," *L'Écho de Paris,* May 13, 1895).

10. When does the gendering of the savage pass from male to female? Does it follow the greater shift in the genre of the Western nude in the nineteenth century? Does it reflect a deepening of the savage as a token not only of social limits but of sexual fantasies as well? Obviously much here depends on how "savage" is defined. On some of these questions, see Abigail Solomon-Godeau, *Male Trouble: A Crisis in Representation* (London: Thames & Hudson, 1997).

11. A primary concern of this book is precisely this staging of a stylistic-subjective origin; it is a familiar trope in high-modernist manifestoes and memoirs, and it often assumes the temporality of "deferred action" (more on this below). I develop the notion of primal fantasy in relation to surrealist stories of origin in *Compulsive Beauty* (Cambridge, Mass.: MIT Press, 1993), and the notion of deferred action in relation to the (neo)avant-garde in *The Return of the Real* (Cambridge, Mass.: MIT Press, 1996). Clearly the relations among fantasy, memory, visual representation, and narrative staging here are very complicated. As Hölderlin wrote: "What has a pure origin is a riddle."

12. As noted in the preface, the primitive is doubled by the machine as principal fetishes of high modernism, which at once recognizes and disavows two primary conditions through these avatars—the increased cultural alterity of the imperial epoch, and the increased technological instrumentality of the industrial world. This is why these figures are so prominent in modernist fables of identity—and why "Primitive Scenes" is doubled by "Prosthetic Gods" in this book.

13. This critique was initiated by scholars like Carol Duncan in the 1970s, and developed by others like Griselda Pollock and Abigail Solomon-Godeau in the 1980s and 1990s. See, inter alia, Carol Duncan, "Virility and Domination in Early 20th-Century Vanguard Painting," *Artforum* 12 (December 1973); Abigail Solomon-Godeau, "Going Native," *Art in America* (July 1989); and Griselda Pollock, *Avant-Garde Gambits 1888–1893: Gender and the Color of Art History* (London: Thames & Hudson, 1992). Also crucial to the debate regarding Gauguin are Peter Brooks, "Gauguin's Tahitian Body," *Yale Journal of Criticism* 3.2 (Spring 1990); and Eisenman, *Gauguin's Skirt.* The latter appeared after the original version of this chapter was published, and its concerns are more sociological and anthropological, to do with "the complexity of colonial identity" as mediated in the Tahiti paintings (20).

———

14. See Freud, "From the History of an Infantile Neurosis," in Muriel Gardner, ed., *The Wolf Man by the Wolf Man* (New York: Basic Books, 1971); hereafter abbreviated *W* (this volume contains further analyses by Ruth Mack Brunswick and Gardner). In addition, see Karin Obholzer, *The Wolf Man Sixty Years Later,* trans. Michael Shaw (London: Routledge & Kegan Paul, 1982). For an extensive analysis of the visual texts involved in the Wolf Man case history, see Whitney Davis, *Drawing the Dream of the Wolves* (Bloomington: Indiana University Press, 1995).

15. As with the notion of stages, can the concept of regression be separated from its primitivist presumption? If not, how do these assumptions affect the cultural criticism that features this concept—for instance, the critiques of modernism and mass culture by Georg Lukács and Theodor Adorno respectively? I return to these concerns in chapter 2.

16. Freudian psychoanalysis regards ambivalence as particularly active in the anal stage—in the tension between retention and expulsion of feces, in the ambiguity of excrement as loved product to conserve and hated shit to destroy, and so on.

17. This danger is not heeded in the primary psychoanalytic literature on anal eroticism: at one point or another, Freud, Sándor Ferenczi, Karl Abraham, and Ernest Jones posit art as "a sublimation of the primitive smearing impulse" (Ernest Jones, *Papers on Psychoanalysis* [London: Baillière, Tindall & Cox, 1912], 432).

18. For example, Gauguin brought a photograph of his own copy of this painting to Tahiti, where she was once mistaken for his wife.

19. See Sander L. Gilman, "Black Bodies, White Bodies: Toward an Iconography of Female Sexuality in Late-Nineteenth-Century Art, Medicine, and Literature," in *Difference and Pathology.* Saartjie Baartman was sold in 1810, and exhibited naked in circuses in England and France. After decades of demands, her remains were returned by a French museum and buried in Hankey, South Africa, on August 9, 2002.

20. Charles Baudelaire, *The Painter of Modern Life and Other Essays,* ed. Jonathan Mayne (London: Phaidon, 1964), 36. Often the African sculptures that inspired these artists do manifest a marked anality. But it was misread by them, especially the expressionists, who assumed such deformations to be psychosexually expressive, when in general African aesthetics values physical poise and spiritual grace above all else. Apparent deformations in such art tend to con-

form to cultural priorities, not expressionistic values: for example, sexual parts might be rendered large as the site of procreative power, the head as the seat of conceptual power, and so on. Clearly, primitivist modernists were not interested in the formal values of these proportions alone.

21. In one story of Western art, classical contrapposto allowed the Greek figure to step out from the frozen posture of Egyptian precedents; this dynamized the figure and opened it up to a new realism. In an analogous way in modernist art, the primitivist contrapposto dynamized the female figure and opened it up to a new eroticism. More involved in courtly art (Egyptian, Cambodian, Javanese) than in tribal art, Gauguin does not entertain this contrapposto to the same degree as the others.

22. André Salmon, "Anecdotal History of Cubism" (1913), in Edward Fry, ed., *Cubism* (London: Thames & Hudson, 1966), 82; Henri Matisse, "Notes of a Painter on His Drawing" (1939), in Jack Flam, ed., *Matisse on Art* (New York: E. P. Dutton, 1978), 82.

23. On this point, see Olivier Richon, "Representation, the Harem and the Despot," *Block* 10 (1985). On nineteenth-century Orientalist art, see especially Todd Porterfield, *The Allure of Empire: Art in the Age of French Imperialism 1798–1836* (Princeton: Princeton University Press, 1998). An excess of sexual-political power in the male other might produce an excess of anxiety in the Western viewer: identification with this power demands that its exotic representative be subjugated (as in the story of Sardanapalus), degendered (as often with Orientalist and *japoniste* figures), or absented altogether (as with the black male in modernist primitivism—more on this below).

24. Might this Orientalist homophilia that reverses into homophobia underwrite psychically the political paranoia that has long permeated Western relations to this "Orient"?

25. For example, in his letter to August Strindberg of February 1, 1895, Gauguin writes: "Civilization from which you suffer. Barbarism which for me is a rejuvenation" (*The Writings of a Savage,* ed. Daniel Guérin, trans. Eleanor Levieux [New York: Paragon House, 1990], 105; hereafter abbreviated *WS*). However reversed, this discourse retains its imperial aspect—for example, in images of an exhausted Europe in need of colonial renewal. (This is also the era of national parks, safaris, the Boy Scouts, etc.)

26. Eisenman is especially good on this topic. Politically, Gauguin was almost as dandyishly am-
biguous as Baudelaire. See his remarks in *Cahier pour Aline* (c. 1892), ed. Suzanne Damiron
(Paris: Foundation Jacques Doucet, 1963), n.p.

27. I was first tempted to relate this ambivalence to the psychic split in masculine object choice
described by Freud in his 1912 paper "On the Universal Tendency to Debasement in the
Sphere of Love." There Freud proposes a split between "affectionate and sensual currents" as in-
forming the familiar Victorian opposition of woman as Madonna and woman as whore. For
Freud this split stems from an incestuous attachment to the mother: as the "affectionate cur-
rent" remains bound up with her, the "sensual current" can be released only if distanced from
her—that is, if it flows toward an object that is degraded socially, perhaps racially too. Again,
for Freud this demand drives the sexual use by white bourgeois men of "women of lower
classes," and no doubt of "women of lower races" too. Some such split does seem active in Gau-
guin as well as in Picasso. Certainly Gauguin attempts to reunite "affectionate and sensual cur-
rents" in his art: he painted his adored mother in a darkly sensual Tahitian mode (of Peruvian
extraction, she was rather fine and fair), and used her visage for his *Exotic Eve* (1890); and then,
in a corollary move, he often presented Tahitian women as so many Virgin Marys. (In "Gau-
guin's Tahitian Body," Brooks argues that Gauguin sought to reinvent a pure savage Eve to dis-
place the corrupt Salon Venus of the time. Might this move also be related to a need to reunite
"affectionate and sensual currents"?) Yet, even as he depicted them as pure, he also used them
as prostitutes, and his bad treatment of his Danish wife Mette is well known. In any case, such
an interpretation is not sufficient alone. The ambivalence evident in Gauguin as well as in Pi-
casso is more complicated, less thematic: there is no simple split of "currents."

28. Gauguin, *Noa Noa,* in *WS,* 85–87. The publication history of *Noa Noa* is complicated.
There were three early versions: a 1893 draft by Gauguin in Paris, intentionally rough; a 1897
elaboration by the symbolist poet Charles Morice, on the melodramatic side, which Gauguin
came to question; and a 1901 edition including the contributions of both. This extract is based
on the first version; but see also the annotated translation of *Noa Noa* by Nicholas Wadley
(Oxford: Oxford University Press, 1985).

29. Wadley comments: "The notes are developed in the Louvre MS into a long comparison of
the exaggerated distinction between the sexes in Western culture (fashion, corsetry, etc.) with
the natural, egalitarian near-nakedness that was the norm in Polynesia. The passage emphasizes

the synthetic triviality that attends the moral and sexual codes of Europe. The desirability of an affinity between the sexes is a recurrent theme in Gauguin's writing" (*Noa Noa*, 74) On this topic, see Wayne Andersen, *Gauguin's Paradise Lost* (New York: Viking, 1971) and, more recently, Nancy K. Mathews, *Paul Gauguin: An Erotic Life* (New Haven: Yale University Press, 2001). Eisenman also considers sexual ambiguity in Gauguin at length. On his arrival in Tahiti, Gauguin was nicknamed *taata vahine,* or man woman, because of his long hair and odd hat. Moreover, he often signed work with the monogram PGO or "pégo," French slang for penis, while he sometimes adopted, for the polemical newspaper *Le Sourire* that he edited in Tahiti, the pseudonymn "Tit-Oil," which translates as "breast."

30. Although associated with the next anecdote in *Noa Noa, Pape Moe* (Mysterious Water, 1893) seems to treat this moment as well, though here it is a young Tahitian, "naked with a loincloth," who drinks from a "cascading stream" amid "monstrous ferns" (as in a dream, the positions are changed). In this case the "androgyny" of the figure is safe: Gauguin has rendered it nonerotic; nonetheless, the penile spout of the stream is suggestive, and if there is a fantasy in play here it is fellatio, not sodomy. The figure is female in the photograph by Charles Spitz on which the painting was based (Spitz organized the Tahiti exhibit in the 1889 Universal Exhibition that nudged Gauguin toward his trip).

31. Gauguin, *Cahier pour Aline.* This phrase from c. 1892 is repeated in his late notes, *Avant et après,* from c. 1903 (*WS* 231). As I will argue, this "dreamwork" might also be the basis of whatever consistency the Tahiti paintings do possess; or, more precisely, it might provide an analogy for how they hold their "pieces" together.

32. August Strindberg, letter to Gauguin, February 1, 1895, in Linda Nochlin, ed., *Impressionism and Post-Impressionism 1874–1904* (Englewood Cliffs, NJ: Prentice Hall, 1966), 172. In "A Philosophy of Toys" (1853), Baudelaire writes: "The overriding desire of most children is to get at and *see the soul* of their toys," a desire that he regards as a "first metaphysical tendency" (*The Painter of Modern Life,* 202). In "Analysis of a Phobia in a Five-Year-Old Boy" (1909), Freud refers such investigations to the riddling out of birth, that is, of origins; see chapter 6, note 8.

33. Gauguin cited by Wadley in his notes to *Noa Noa*, 146.

34. See Alain Corbin, *The Foul and the Fragrant: Odor and the French Social Imagination,* trans. Miriam L. Kochan, Roy Porter, and Christopher Prendergast (Cambridge, Mass.: Harvard Uni-

versity Press, 1986): "The stench of the poor became less of an obsession during the second half of the century. . . . Hereafter it was the odor of race that would constitute a threat" (157).

35. In "Gauguin's Tahitian Body," Brooks is especially good on the historical vagaries of this fantasy, English as well as French.

36. For its persistence in Lévi-Strauss, no less, see his *Tristes Tropiques: An Anthropological Study of Primitive Societies in Brazil,* trans. John Russell (1955; New York: Atheneum, 1978), especially chapter 4.

37. How different Gauguin is from Picasso here, at least in *Les Demoiselles,* where the castrative effects of the gazes are exacerbated, not obscured (for more on these effects, see chapter 7). In Gauguin, vision is sometimes promiscuous, as in his primitive scene, but often it is castrative, and so must be blunted or baffled. This can produce a complicated play between penetrative vision and opaque body (as in his account of the mystery of Teha'amana and the advent of *Spirit of the Dead Watching* in *Noa Noa,* discussed in note 62). The trope of (im)penetrability is also pronounced in other primitivist texts (think of *Heart of Darkness*), especially where a slippage between sexual and imperial "dark continents" occurs. Eisenman makes a similar suggestion regarding polymorphous sexuality in *Gauguin's Skirt.*

38. Here I follow the work of Leo Bersani on sublimation; see, for example, "Sexuality and Aesthetics," *October* 28 (Spring 1984).

39. "The converse of taboo in Polynesia is *noa,*" Freud writes in *Totem and Taboo* (19).

40. Picasso could not have seen the various masks heretofore proposed as sources for the individual faces of the prostitutes: as he remarked, the African objects were "more witnesses than models" of his work. See William Rubin, "Picasso," in *"Primitivism" in 20th Century Art,* vol. 1, 12.

41. Again, it is a layering of other scenes as well, artistic precedents above all (including, among others proposed in the literature, *Apocalyptic Vision* by El Greco, *Turkish Bath* by Ingres, different *Bathers* by Cézanne and Derain, and various sculptures by Gauguin). Clearly mine is not a proper art-historical account; that is provided in several essays by William Rubin, most fully in "The Genesis of *Les Demoiselles d'Avignon,*" in John Elderfield, ed., *Studies in Modern Art* 3

(New York: Museum of Modern Art, 1994); the original appeared in the catalogue of a 1987 exhibition detailing the composition of the painting at the Musée Picasso in Paris. (There Rubin questions the very existence of a bordello in the Calle Avignon in Barcelona.) See also Natasha Stoller, *A Sum of Destructions* (New Haven: Yale University Press, 2001).

42. Picasso in André Malraux, *Picasso's Mask,* trans. June and Jacques Guicharnaud (New York: Holt, Rinehart & Winston, 1976), 10–11.

43. For Frazer, the confusion between the sacred and the defiled was characteristic of primitive thought, as it was for Freud in the apprehension of taboo. "Dirt," Douglas writes in her classic *Purity and Danger* (London: Routledge & Kegan Paul, 1966), "is essentially disorder," and "ritual recognizes the potency of disorder" (2, 94).

44. Rubin notes that the Trocadéro displays in 1907 might have guided Picasso here: "mannequin figures in full ceremonial regalia [were] surrounded by artifacts evoking their cultures and accompanied by labels that declare that ritual function" (e.g. "cures the insane"; "protects against the sorcerer"; "cures gonorrhea") ("The Genesis of *Les Demoiselles d'Avignon,*" 104, 16). I discuss the apotropaic in chapter 7.

45. This ambivalence is in play in other forms of modernist art as well, and artists who somehow suspend this tension between regression and autonomy are often the most privileged—artists like Picasso, Jackson Pollock, Frank Stella. . . .

46. This is typical elsewhere too. In *Playing in the Dark: Whiteness and the Literary Imagination* (Cambridge, Mass.: Harvard University Press, 1992), Toni Morrison exposes this "Africanist" trope—black enslavement as necessary to white freedom—as central to the American literary imagination. In some sense this deconstruction reveals the first, black term as prior, and the second, white term as parasitical.

47. In *White Racism: A Psychohistory* (1970; New York: Columbia University Press, 1984), Joel Kovel relates racialist associations of blackness and dirt to anal ambivalence: "Dirt is at symbolic root anything that can pass *out* of the body, and that hence should not pass back *into* the body, nor even touch it" (84). This formulation is similar to the Kristevan concept of the abject, which, neither subject nor object, "lies there, quite close, [yet] it cannot be assimilated" (Julia Kristeva, *Powers of Horror,* trans. Leon S. Roudiez [New York: Columbia University Press,

1982], 1). In the Trocadéro, Picasso is indeed abject, in a "vortex of summons and repulsion [that] places the one haunted by it literally beside himself" (ibid.).

48. For this semiotic account of the modernist break, see especially Yve-Alain Bois, "Kahn-weiler's Lesson," in *Painting as Model* (Cambridge, Mass.: MIT Press, 1991); and Rosalind Krauss, "The Motivation of the Sign," in *Picasso and Braque: A Symposium,* ed. Lynn Zelevan-sky (New York: Museum of Modern Art, 1992), 261–286. In "Painting as Trauma," *Art in America* (June 1988), a review of the Musée Picasso exhibition concerning the genesis of *Les Demoiselles,* Bois suggests that the two primary primitivist episodes in Picasso—c. 1907 and c. 1912—might be structured in a relation of deferred action: "The entire Cubist adventure was an attempt to understand and to comment upon the import of this traumatic breach" (134).

49. This speculation is also subordinated—to a footnote. I return to this story, anal eroticism, and reaction formation in chapter 2. In another footnote in *Civilization and Its Discontents,* Freud stages another fantastic scene, also involving reaction formation, here against *urethral* eroticism. In this other first moment of civilization, "man" renounces his "homosexual" desire to urinate on fire in order to conserve it as a tool; here it is as if civilization begins for Freud in reaction formation against homosexuality. Although he was hostile to modernist art, Freud shared its obsession with origin myths, and his stories also tend to concern the primitive (an-other instance is the myth of the murder of the primal father in *Totem and Taboo*).

50. Freud, "On Transformation of Instincts as Exemplified in Anal Erotism" (1917), in *On Sexuality,* ed. Angela Richards (New York: Penguin, 1977), 301. See chapters 2 and 6 below, as well as chapter 5 of my *The Return of the Real.*

51. Leo Steinberg, "The Philosophical Brothel," *October* 44 (Spring 1988); this is a revised ver-sion of the text originally published in *Art News* (September/October 1972).

52. See note 22.

53. Rubin, "The Genesis of *Les Demoiselles d'Avignon,*" 105. "Abreaction" is a discharge of affect associated with a traumatic memory that might otherwise become pathogenic. See Jean Laplanche and J.-B. Pontalis, *The Language of Psychoanalysis,* trans. Donald Nicholson-Smith (New York: W. W. Norton, 1973), 1. Rubin deems *Les Demoiselles* a "self-analysis" comparable to that of Freud (34), but I see it as an acting-out more than a working-through of traumatic

"memories." Different subjects will see the painting differently, of course; indeed, difference, sexual and racial in particular, is especially important here.

54. Rubin first makes this argument in "From Narrative to 'Iconic' in Picasso: The Buried Allegory in *Bread and Fruitdish on a Table* and the Role of *Les Demoiselles d'Avignon*," *Art Bulletin* 65 (December 1983), 615–649. The sailor and the medical student are often seen as complementary attributes of Picasso: scientific and sensuous, active and passive, and so on.

55. Rubin, "The Genesis of *Les Demoiselles d'Avignon*," 67. However achieved by Picasso in the course of his own work, this iconicity was well prepared by Manet in *Olympia,* and Gauguin in *Spirit of the Dead Watching.*

56. Salmon, "Anecdotal History of Cubism," 82.

57. In "The Philosophical Brothel" Steinberg speaks of "the trauma of sexual encounter," and in "The Genesis of *Les Demoiselles d'Avignon*" Rubin sees the painting as "a sexual battleground in which both Eros and Thanatos contend" (49). In a 1970 BBC address, John Nash related the painting to the Medusa myth, with the connotations of castration and petrification developed by Freud. Although Bois alludes to the primal scene in "Painting as Trauma," he, too, reads the painting in terms of Medusa: "The Medusa (castration) metaphor is, in fact, the one that, in the evolution of the *Demoiselles,* best accounts for the suppression of allegory, on the one hand, and, on the other, the apotropaic brutality of the finished picture" (138). My suggestion is that the primal scene is more telling, and it encompasses this effect in any case (for more on Medusa, see chapter 7). In *Painting as an Art* (Princeton: Princeton University Press, 1987), Richard Wollheim also juxtaposes the Picasso painting and the Wolf Man drawing, but he does not pressure the connection as I do here.

58. An anal fixation runs through several drawings both preparatory to *Les Demoiselles* and current with its making.

59. Steinberg, "The Philosophical Brothel," 64. Steinberg offers a phenomenological reading of the painting that can be deepened by a psychoanalytical account. In a sense, the painting reverses the dreamwork of the dream: the wolves are returned to the bed. At the same time, the tree of the dream has some of the spatial ambiguity of the bed: we look both onto it vertically and through it horizontally.

60. Ibid. This intense gaze might be another lesson learned from African masks; in the previous version, all the prostitutes had the blank gaze of the Iberian visage, and they were all turned to the medical student on the left; that is, their gaze was deflected away from the (male) viewer, who thus could enjoy them in the usual protected manner of voyeuristic spectatorship.

61. Again, the painting is not only apotropaic but fetishistic in its logic. For example, the approximate center of the picture, on line with the tip of the gourd, is the sex of the central prostitute; in a sense, it is the vestige of the lost vanishing point of the painting. Yet like all the others, her sex is covered, obscured, blank.

62. However, some of this crossing or "contagion" is in play in *Spirit of the Dead Watching* as well. In his famous account of *Spirit* in *Noa Noa,* Gauguin returns to his hut one night to find Teha'amana in this state:

> She stared up at me, her eyes wide with fear, and she seemed not to know who I was. For a moment, I too felt a strange uncertainty. Her dread was contagious: it seemed to me that a phosphorescent light poured from her staring eyes. I had never seen her so lovely, so moving. . . . Perhaps she took me, with my anguished face, for one of those legendary demons or specters, the *tupapa'us* [the spirit represented in profile on the left] that filled the sleepless nights of her people. (*WS* 63).

Here, in rapid succession, Gauguin is positioned as viewer (and vice versa), with Teha'amana, and as a spirit, and he experiences a crossing of desire and identification. And in "Genesis of a Painting" (1892), included in *Cahier pour Aline,* he adds another exchange: "According to Tahitian beliefs, *Mana'o tupapa'u* has a double meaning . . . either she thinks of the ghost or the ghost thinks of her." There is also a triangulation of gazes—Teha'amana, *tupapa'u,* and Gauguin/viewer—and here the approximate center of the painting is the anal crack of the young woman, which Gauguin underlines with a lick of orange paint. As in his primitive scene, Gauguin moves to sublimate this one. "In this position . . . she is indecent," he writes his estranged wife Mette. "Still, that's how I wanted it; the lines and the movement interest me"(*WS* 63). And when this is not sufficient, he "corrects" his ambivalence (his confusion between desire and identification) with domination: he ascribes "a desire for rape" to all Tahitian women, who long "to be 'taken' brutally" (*WS* 83–84). All these terms—the trauma of difference, the

ambivalence of position, the reciprocity of a fascinated gaze, the violence of an attempted over-coming of these provocations—become all the more pressured in *Les Demoiselles.* (In "The Genesis of *Les Demoiselles d'Avignon*," Rubin argues that the prostitute on the left "may consti-tute a direct echo of the half-idol, half-human 'Tupapau,' or female ancestor spirit, in Gauguin's *Spirit of the Dead Watching,* which Picasso certainly knew in lithographic form (its elements are also present in *Noa Noa,* of which Picasso owned a copy" [95].)

63. Already in a letter of June 1901 Gauguin had written: "My Breton canvases have become rose water because of Tahiti; [those of] Tahiti will become cologne water because of the Mar-quesas" (*WS* 21). Here, acculturation is also troped as a fragrance—but a vapid one. Kirchner also retreated, though hardly as far as Gauguin: in 1909–11 he summered with friends at the Moritzburg lakes, and in 1912–14 on the Baltic island of Fehmarn. A vogue for the primitive encouraged communal retreats and studio theatrics in this period.

64. This letter is cited in Jill Lloyd, *German Expressionism: Primitivism and Modernity* (New Haven: Yale University Press, 1991), which remains the best discussion of expressionist prim-itivism (I am indebted to it here). See also her "Kirchner's Metaphysical Studio Paintings," in Jill Lloyd and Magdalena M. Moeller, eds., *Ernst Ludwig Kirchner, 1880–1938* (Washington: National Gallery of Art, 2003).

65. On the discourse of degeneration, see chapter 2. For a revisionist reading of the Berlin paintings, see Charles W. Haxthausen, "'A New Beauty': Ernst Ludwig Kirchner's Images of Berlin," in Charles W. Haxthausen and Heidrun Suhr, eds., *Berlin: Culture and Metropolis* (Min-neapolis: University of Minnesota Press, 1990).

66. This practice also follows Gauguin, who decorated his huts with erotic paintings, pho-tographs, and sculptures. For example, *Te rerioa* (The Dream, 1897) shows the frieze of his new home in Tahiti, with gods, humans, and animals in intercourse.

67. In this reading, the sighting of the genitals of the father or the brother might also be trau-matic for the little boy—perhaps more traumatic than the sighting of the maternal genitals. Norman Bryson puts the notion of a male penis envy to incisive use in a discussion of the for-lorn masculinity in the military paintings of Géricault. See Bryson, "Géricault and 'Mascu-linity,'" in *Visual Culture: Images and Interpretation,* ed. Bryson, Michael Ann Holly, and Keith

Moxey (Hanover: University Press of New England, 1993). My argument here is indebted to his there.

 This racialist ambivalence (or penis envy) might be further complicated by a patriarchal ambivalence (or phallic ruse). This, too, is only implied in Freud: in his scenario, the son projected to be heterosexual is called on to identify with the father, but not in one crucial respect: sexual privilege regarding the mother. The sign of this hierarchy of sexual privilege is the paternal penis presumed to be big, and, as feminists have long noted, patriarchy holds an enormous stake in this phallic presumption, in the sleight of hand whereby the physical penis slips into the role of the symbolic phallus. (In "Géricault and 'Masculinity,'" Bryson refers to the biblical story of the sons of Noah who cover up the drunken, naked patriarch rather than leave him exposed. In the patriarchal system, the sons are also reluctant to expose the penis as pretender to the phallus.) Moreover, patriarchy also holds a much less obvious stake in the persistence of homosexual desire within the heterosexual male. For only such a combination of identification and desire can lock this male psychically in place in the patriarchal hierarchy. As I argued in relation to the Wolf Man, there might be a similar confusion of identification and desire, a related mix of negative and positive Oedipal relations, in the primitivist relation to the racial other.

68. See note 23.

69. On this Nazi armoring, see also my "Armor Fou," *October* 56 (Spring 1991), and chapter 4 of *Compulsive Beauty*. The centerpiece of the Nazi attack on modernism, the "Degenerate 'Art'" exhibition focused on expressionist art even more than on abstract art, as if the greatest anathema had to be reserved for the art that performed the greatest distortion of the body-ego image. Ironically, this art was mostly Germanic, and the show included a one-time Die Brücke member who became a Nazi Party member—Emil Nolde.

70. From many perspectives, the primitivist crisis of white heterosexual masculinity that I have (re)constructed here might appear as an indulgence that only exploits or usurps other subject positions; its ambivalence might constitute just another privilege. So, too, it might not disrupt dominant masculinity as much as I have suggested. Again according to Freud, the heterosexual male encompasses a negative Oedipal relation, a moment of desire for the father, and this subordinated homosexuality might be structural to the heterosexual male and necessary to his patriarchal inscription. (*Artillerymen in the Shower* [1915], a painting of naked soldiers bathing under the supervision of a clothed officer, might be revisited with this notion in mind.) In

short, ambivalence might not afford the subversive mobility of position that I have sometimes proposed for it.

71. See note 31.

72. Albert Aurier, "Le Symbolisme en peinture: Paul Gauguin," *Mercure de France* 2 (March 1891), translated in Henri Dorra, ed., *Symbolist Art Theories* (Berkeley: University of California Press), 203.

73. Ibid., 196. On this sublimation of the material support as a precondition of pictorial intensity, see chapter 5, note 35. The Aurier trope is similar to the Salmon formula for *Les Demoiselles:* "picture-as-equation." Aurier also writes of "the preparation of an idealist, even mystical, reaction" (197), which is precisely what worried a leftist artist like Pissarro about symbolism in general and Gauguin in particular: "This is a step backwards," Pissarro writes his son Lucien on April 20, 1891, soon after the appearance of the Aurier article. "Gauguin is not a seer, he is a schemer who has sensed that the bourgeoisie are moving to the right, recoiling before the great idea of solidarity which sprouts among the people" (*Letters to His Son Lucien,* trans. Lionel Abel [Santa Barbara: Peregrine Smith, 1981], 204).

74. *Gauguin's Letters from the South Seas,* trans. Ruth Pielkovo (New York: Dover, 1992), 64.

75. Ibid., 70.

76. I return to the imbrication of enigma and desire in chapter 8.

77. Sigmund Freud, *The Interpretation of Dreams,* trans. James Strachey (New York: Avon Books, 1965), 312.

78. Again I adapt these definitions from Laplanche and Pontalis, *The Language of Psychoanalysis.* "Condensation" and "displacement" might help to explain why some paintings, like some dreams, seem more vivid: perhaps they, too, are more overdetermined by "associative chains." No doubt this is too direct an association, but I offer it here to counter the usual privileging of the verbal over the visual in these operations (see preface).

79. The Baudelairean term "correspondences," employed by Aurier, also became a symbolist staple. Below I argue that Gauguin locates paintings like *Day of the God* and *Where Do We Come From?* between auratic oneness and anxious difference. This is also where Baudelaire locates *Correspondances:* "Nature is a temple whose living pillars/ Sometimes give forth a babel of words;/ Man wends his way through a forest of symbols/ Which look at him through their familiar glances./ As long-resounding echoes from afar/ Are mingling in a deep, dark unity,/ Vast as the night or as the or of day,/ Perfumes, colors, and sounds commingle."

80. Sándor Ferenczi would call this universe "Thalassal." See *Thalassa: A Theory of Genitality* (1923), trans. Henry Alden Bunker (New York: Karnac Books, 1989); and chapter 3 below.

81. See Eisenman, *Gauguin's Skirt,* 145–147.

82. See Freud, *Beyond the Pleasure Principle* (1920), and Georges Bataille, *Erotism* (1957).

83. Freud, *Civilization and Its Discontents,* 11–12.

84. Eisenman suggests a genealogy "from symbolism to structuralism" (to borrow the phrase from the anthropologist James Boon), in which Gauguin should figure importantly. His reading of *Te nave nave fenua* (The Delightful Land, 1892), a portrait of Teha'amana as a Tahitian Eve with polydactyl feet (i.e. residual additional toes), draws on the celebrated reading of the Oedipus myth by Lévi-Strauss as a riddling out of the primordial question of origin—"born from one, i.e., of the earth, or born from two, of the union of man and woman?" (*Gauguin's Skirt,* 66–68). My suggestion is that Gauguin seeks, impossibly, to split the difference between natural indifference and cultural difference. A year later, in *Merahi metua no Tehamana* (Teha'amana Has Many Parents, 1893), he splits this difference in another way. Here he shows Teha'amana dressed in colonial (read "cultural") garb, surrounded by a native (read "natural") script (it is fictive). In his letter to Strindberg, Gauguin writes of his belief that "the languages of Oceania" preserve "their essential elements . . . in all their primitiveness . . . whereas in inflected languages the roots from which they sprang, as did all languages, have disappeared" (*WS* 105). On this topic, see Kirk Varnedoe, "Gauguin," in Rubin, ed., *"Primitivism" in 20th-Century Art.*

85. Gauguin to Monfried (his description is not wholly accurate):

> To the right at the lower end, a sleeping child and three crouching women. Two figures dressed in purple confide their thoughts to one another. An enormous crouching figure, out of all proportion, and intentionally so, raises its arms and stares in astonishment upon these two, who dare to think of their destiny. A figure in the center is picking fruit. Two cats near a child. A white goat. An idol, its arms mysteriously raised in a sort of rhythm, seems to indicate the beyond. Then lastly, an old woman, nearing death, appears to accept everything, to resign herself to her thoughts. She completes the story! At her feet a strange white bird, holding a lizard in its claws, represents the futility of words. It is all on the bank of a river in the woods.

86. Paul Gauguin, *The Intimate Journals of Paul Gauguin* (London: Kegan Paul, 1985), 61.

87. Again, the painting followed a suicide attempt as well as the death of a baby son, born to his new mistress Pau'Ura.

88. Gauguin in Dorra, *Symbolist Theories,* 209. These are the first questions of his title that occupied Gauguin in his writings at this time too; for example: "In what era did man begin to exist? . . . In what era did thought?" (*WS* 271).

89. In "Catholicism and the Modern Spirit," Gauguin seeks to reimagine the Bible as a mystery or an enigma, not as a doctrine or a code; see *WS.*

90. As Eisenman argues, the questions of *Where Do We Come From?* were mediated by *Sartor Resartus* (1833–34) by Thomas Carlyle, which Gauguin owned (it is represented in *Still Life: Portrait of Jacob Meyer de Haan,* 1889). In relation to an "undiscovered America," a character in *Sartor Resartus,* the philosopher Teufelsdröckh, asks: "What is this ME? . . . Whence? How? Whereto? . . . We sit as in a boundless Phantasmagoria and Dream-grotto." These questions are "the Canvass," Carlyle writes, "whereon our Dreams and Life-Visions are painted." See Eisenman, *Gauguin's Skirt,* 144.

———

2 A Proper Subject

1. Adolf Loos, "Ornament und Verbrechen," in *Sämtliche Schriften* (Vienna: Verlag Herold, 1962), 276–288. I have used the translation by Michael Bullock in Ulrich Conrads, ed., *Programs and Manifestoes on Twentieth-Century Architecture* (Cambridge, Mass.: MIT Press, 1970), 19–24; hereafter abbreviated *OC.* The essay was not published until 1910 in the Berlin journal *Der Sturm,* edited by Herwarth Walden.

2. To be sure, the architecture cannot be entirely separated from the writings. The Loos literature is vast, but a crucial resource remains Burckardt Rukschcio, *Adolf Loos: Leben und Werk* (Salzburg: Residenz, 1982). Among recent writings available in English that I have found most suggestive are Benedetto Gravagnuolo, *Adolf Loos: Theory and Works,* trans. C. H. Evans (New York: Rizzoli, 1982); Massimo Cacciari, *Architecture and Nihilism: On the Philosophy of Modern Architecture,* trans. Stephen Sartarelli (New Haven: Yale University Press, 1993); Beatriz Colomina, *Privacy and Publicity: Modern Architecture as Mass Media* (Cambridge, Mass.: MIT Press, 1994), and "On Adolf Loos and Josef Hoffmann: Art in the Age of Mechanical Reproduction," in Max Risselada, ed., *Raumplan versus Plan Libre* (Delft: Delft University Press, 1988); Kenneth Frampton, "In Spite of the Void: The Otherness of Adolf Loos," in *Labour, Work, and Architecture* (London: Phaidon Press, 2002); Hubert Damisch, "*L'Autre 'Ich,' L'Autriche*—Austria, or the Desire for the Void: Toward a Tomb for Adolf Loos," *Grey Room* 01 (2000); James Trilling, "Modernism and the Rejection of Ornament: The Revolution That Never Happened," *Common Knowledge* (Fall 1994); and Janet Stewart, *Fashioning Vienna: Adolf Loos's Cultural Criticism* (New York: Routledge, 2000). This chapter also benefited greatly from close readings by Beatriz Colomina and Mark Wigley.

3. Carl E. Schorske, *Thinking with History: Explorations in the Passage to Modernism* (Princeton: Princeton University Press, 1998), 163; and *Fin-de-Siècle Vienna: Politics and Culture* (New York: Vintage, 1981), passim. The association of Kraus, Loos, and Wittgenstein was advanced by Paul Engelmann, a student of the second and a collaborator of the third (on the house designed by Wittgenstein for his sister in Vienna), in *Letters from Ludwig Wittgenstein, with a Memoir* (Oxford: Basil Blackwell, 1967).

4. On this now-familiar commonality, see in particular Allan Janik and Stephen Toulmin, *Wittgenstein's Vienna* (New York: Simon & Schuster, 1973).

———

5. Ludwig Wittgenstein, *Tractatus Logico-Philosophicus* (1921), trans. D. F. Pear and B. F. Mc-Guinness (London: Routledge, 1974), 19, 71. Wittgenstein sees them as "one and the same" in a different sense—as equally metaphysical.

6. Robert Musil, *The Man without Qualities,* vol. 1, trans. Sophie Wilkins (New York: Vintage, 1995), 29.

7. Janik and Toulmin, *Wittgenstein's Vienna,* 40.

8. Loos was hardly the first to caution against undue ornament (even as great an ornamentalist as Louis Sullivan struck a cautionary note in "Ornament in Architecture" [1892]); he was, however, the most vehement. And he deemed his part of this project a success. In the introduction to *Trotzdem* (1930), his second collection of essays, he declares: "I have emerged from my thirty years of struggle. I have freed mankind from superfluous ornament" (*Schriften,* 213). But in "Ornament and Education" (1924), he also writes: "I did not mean what some purists have carried *ad absurdum,* namely that ornament should be systematically and consistently eliminated" (in *Ornament and Crime: Selected Essays,* trans. Michael Mitchell [Riverside, Calif.: Ariadne Press, 1998], 187).

9. Although to my knowledge Loos does not use the term "kitsch," he responds to the spread of cheap copies and ornamental applications of historical styles in both arts and crafts that would be labeled kitsch by Theodor Adorno, Clement Greenberg, Herman Broch, and others by the late 1930s.

10. As we will see, this was also his principal accusation against the Vienna Werkstätte and the German Werkbund respectively. Indeed, for his models Loos selected objects that were deemed too lowly to be redeemed by these other schools.

11. *Kunstwollen* is the Hegelian notion of the great Viennese art historian Alois Riegl (1858–1905) that Loos often echoes in his writings, according to which each culture and/or period possesses a particular "artistic will," or will to form, that it is driven to express in all things. The notion is also active in the Secession, as in the motto emblazoned on the Secession Building designed by Joseph Maria Olbrich: "To each age its art, to art its freedom."

12. Loos, "Meine Bauschule" (1913), in *Schriften,* 323.

13. To some degree, modernist formalism is but an abstracted neoclassicism (more on this below). In any case, the reclamation of this neoclassicism is more modernist than postmodernist, which complicates the accepted sense of these historical "ruptures." As for Le Corbusier, he often reprises Loosian positions, sometimes to reverse them (this is especially true in his *L'Art décoratif d'aujourd'hui* [1925]). On the relation between Loos and Le Corbusier, see in particular Stanislaus van Moos, "Le Corbusier and Loos," *Assemblage* 4 (October 1987).

14. Such masters of Art Nouveau as Victor Horta, Hector Guimard, and Henry van de Velde were most active during this time; the gallery "Art Nouveau," which gave this loose movement one of its names, was opened in Paris by the Geman art connoisseur Siegfried (Samuel) Bing in 1895. By the early 1900s Art Nouveau already showed signs of decline in Austria and Germany, and designers like Hoffmann restrained its luxuriant language geometrically—under his influence, Loos would assert, but this did not impede his attack.

15. "*Trotzdem*" derives from Nietzsche, whom Loos quotes as follows: "That which is decisive is produced in spite of everything." This outsider status did not extend to artistic and intellectual circles in Vienna, where Loos counted among his associates Kraus, Wittgenstein, Schoenberg, and Kokoschka; he also soon became well known as a critic (if not as an architect) throughout Europe.

16. Loos describes Kraus in these terms in a 1913 homage: "He stands at the threshold of a new period and shows the path to humanity which has strayed far, far away from God and Nature . . ." (Adolf Loos, "Karl Kraus," in *The Architecture of Adolf Loos,* ed. Wilfried Wang [London: Arts Council, 1985], 109; hereafter abbreviated *AL*). In his essay in this volume, Yehuda Safran notes a fascination, in the Viennese intelligentsia of the time, with the figure of Moses the lawgiver (Freud and Schoenberg are the obvious instances).

17. Kraus in *Die Wage,* 1898, as quoted in Adolf Loos, *Spoken into the Void: Collected Essays 1897–1900,* trans. Jane O. Newman and John H. Smith (Cambridge, Mass.: MIT Press, 1982), vi; hereafter abbreviated *SV.*

18. On the Paris exhibition, see in particular Debora L. Silverman, *Art Nouveau in Fin-de-Siècle France* (Berkeley: University of California Press, 1989), 284–314.

19. Loos, "Cultural Degeneration" (1908), in *AL*, 98.

20. Engelmann describes this move in *Letters from Ludwig Wittgenstein* as follows:

> Proceeding from his basic view that there is no direct path from art to craft, since between them stands the age as it is today, Loos carried out his main purpose of a clean intellectual separation between art and craft. But his insight into the nature of the crafts, in which he includes domestic architecture, also shows a way to combat all false tendencies within art, which seek time after time to establish a so-called "modern" art which must at any price differ from the old. (128–129)

21. Here one thinks, beyond Loos on "ornament," of Clement Greenberg on "kitsch" in "Avant-Garde and Kitsch" (1939), and Michael Fried on "theater" in "Art and Objecthood" (1967), more on which below. All these terms represent agents of indistinction and impurity, and all are to be banished as superfluous, corrupt, degenerate. (Note the difference here from a primitivist like Gauguin who, as we saw in chapter 1, dallies with the undoing of difference or distinction.)

22. In his essay on Kraus (1931), Benjamin quotes him on this problem as follows: "In this duality of a changed life dragging on in unchanged forms, the world's ills grow and prosper" (Walter Benjamin, "Karl Kraus," in *Reflections*, trans. Edmund Jephcott [New York: Harcourt Brace Jovanovich, 1978], 241). In "Paris, Capital of the Nineteenth Century" (1935 exposé), Benjamin returns to this problem: "The new elements of iron building, girder forms, preoccupy Art Nouveau. In ornamentation it strives to win back these forms for art" (155). For Loos this attempt is impossible, and it only aggravates the problem.

23. See Clement Greenberg, *Art and Culture* (Boston: Beacon Press, 1961).

24. This might speak to the persistent sense of Austria as a perpetual latecomer and partial outsider to Western Europe. On this score, with typical sarcasm Loos subtitled his journal *The Other* "A Paper for the Introduction of Western Culture into Austria."

25. Loos thus defines the architect in "Ornament and Education" (*Ornament and Crime*, 187).

26. Schorske, *Fin-de-Siècle Vienna,* 304. Schorske writes here of the Secession aesthetes that Loos attacks, but in this respect Loos is close to them.

27. Pierre Bourdieu remarks, in a way that is relevant here:

> The artist agrees with the "bourgeois" in one respect: he prefers naiveté to "pretentiousness". The essential merit of the "common people" is that they have none of the pretensions to art (or power) which inspire the ambitions of the "petit bourgeois". Their indifference tacitly acknowledges the monopoly. That is why, in the mythology of artists and intellectuals, whose outflanking and double-negating strategies sometimes lead them back to "popular" tastes and opinions, the "people" so often play a role not unlike that of the peasantry in the conservative ideologies of the declining aristocracy.

(Pierre Bourdieu, *Distinction: A Social Critique of the Judgement of Taste,* trans. Richard Nice [Cambridge, Mass.: Harvard University Press, 1984], 62.) Loos has both terms in play in his identifications with the aristocrat on the one side and the craftsman and the worker on the other. "In general," Schorske writes, "Loos was a kind of anti-bourgeois bourgeois, upholding the traditional moral values of his class against the practices of his class" (*Thinking with History,* 164). For "the persistence of the old regime," see Arno Mayer, *Persistence of the Old Regime: Europe to the Great War* (New York: Pantheon, 1981).

28. The battlelines between the Secession and Loos were not yet starkly drawn, as the Secession was only recently founded, and its members did not disagree substantively with Loos on the matter of historicist architecture. Indeed, it was the combined influences of Art Nouveau and English domestic architecture that broke the hold of historicism, and so prepared modernism.

29. This is an effect of his rhetoric, too, which is often one of reversals of cultural expectations and social positions (usually low for high: the coachbuilder celebrated over the artist, etc.). But these reversals are radical only rhetorically, without actual implications for social change.

30. Lionel Trilling, *Sincerity and Authenticity* (Cambridge, Mass.: Harvard University Press, 1972), 115. Trilling writes here of "the implicit belief of all English novelists of the nineteenth

century": "it is their assumption that the individual who accepts what a rubric of the Anglican catechism calls his 'station and its duties' is pretty sure to have a quality of integral selfhood." This is not to say that one cannot rise socially, only that one can do so only by dint of the bourgeois virtues of hard work, and so on; to rise in any other way is to ask for a "comeuppance." The same principle holds for race and gender as well—that is, when they are recognized at all.

31. See Karl Marx, *The Eighteenth Brumaire of Louis Bonaparte* (1852), in *Surveys from Exile,* ed. David Fernbach (New York: Vintage, 1974).

32. Greenberg, "Avant-Garde and Kitsch," in *Art and Culture,* 3. For an excellent gloss on this text, see T. J. Clark, "Clement Greenberg's Theory of Art," *Critical Inquiry* (September 1982).

33. Rather than a return to history, this might be seen as a further version of the *posthistoire,* one that, rather than subsume history in pastiche, pretends that it has ended in abstraction. These moves were still with us in postmodernism. My remarks here are influenced not only by Marx in *The Eighteenth Brumaire,* but also by Walter Benjamin in his "Addendum to 'The Paris of the Second Empire in Baudelaire,'" and Roland Barthes in his *Mythologies.* See also my *Recodings: Art, Spectacle, Cultural Politics* (Seattle: Bay Press, 1985), as well as T. J. Clark, "Postmodernism?," *New Left Review* (March/April 2000).

34. In a historicist context, abstract uniformity can also be the opposite of inconspicuousness. Loos wrote these lines in the midst of great controversy over his Goldman & Salatsch building on the Michaelerplatz opposite the Hofburg, the imperial palace (more on this below). "Due to its more than extreme lack of ornament," as one newspaper put it, "it comes to everybody's notice" (*Neuigkeits Welt-Blatt,* September 17, 1910).

35. George Mosse, *Nationalism and Sexuality: Middle-Class Morality and Sexual Norms in Modern Europe* (Madison: University of Wisconsin Press, 1985), 6. Loos was drawn to the restrained dress and furniture of the English bourgeoisie.

36. J. C. Flügel, *The Psychology of Clothes* (London: Hogarth Press, 1930), 111; hereafter abbreviated *PC.* Closer in time to Loos are the notes of Simmel on "adornment" as an expression of power and distinction; see *The Sociology of Georg Simmel,* trans. Kurt Wolff (New York: Free Press, 1950), 338–344.

37. Kaja Silverman glosses the "vicissitudes" of this "renunciation" as follows: "1) sublimation into professional 'showing off'; 2) reversal into scopophilia; and 3) male identification with woman-as-spectacle"—some of which are in play in Loos (Kaja Silverman, "Fragments of a Fashionable Discourse," in Tania Modleski, ed., *Studies in Entertainment* [Bloomington: Indiana University Press, 1986], 141).

38. See Peter Wollen, *Raiding the Icebox* (Bloomington: Indiana University Press, 1993), 14.

39. For example: "The work of civilization has become increasingly the business of men, it confronts them with ever more difficult tasks and compels them to carry out instinctual sublimations of which women are little capable" (Sigmund Freud, *Civilization and Its Discontents,* trans. James Strachey [New York: W. W. Norton, 1961], 56). See also chapters 1 and 7.

40. Freud in *Civilization and Its Discontents:* "When this happened ['when the need for genital satisfaction no longer made its appearance like a guest who drops in suddenly'], the male acquired a motive for keeping the female, or, speaking more generally, his sexual objects, near him; while the female, who did not want to be separated from her helpless young, was obliged, in their interests, to remain with the stronger male" (51). And Loos on "Ladies' Fashion": "That which is noble in a woman knows only one desire: that she hold on to her place by the side of the big, strong man" (*SV* 99). Implicit here, too, is the psychoanalytic topos of "womanliness as masquerade"; see chapter 3.

41. Here Loos echoes Nietzsche and anticipates Otto Weininger, whose notoriously misogynistic and anti-Semitic *Sex and Character* appeared in 1903 (this piece by Loos was republished in 1902). At its conclusion Loos advocates a kind of equality for women—an equal chastening of sexuality, which is to say its masculinizing: "No longer by an appeal to sensuality, but rather by economic independence earned through work will the woman bring about her equal status with the man. The woman's value or lack of value will no longer fall or rise according to the fluctuation of sensuality. Then velvet and silk, flowers and ribbons, feathers and paints will fail to have their effect. They will disappear" (*SV* 103). It must be said that the childless Loos—who was married several times, each time to a young woman—showed little interest in reproduction (see also note 81).

42. In *Style in the Technical and Tectonic Arts* (1860), Semper writes: "*The beginning of buildings coincide with the beginning of weaving.* The wall is that architectural element that formally represents and make visible the *enclosed space as such,* absolutely, as it were, without reference to secondary concepts" (Gottfried Semper, *The Four Elements of Architecture and Other Writings,* trans. Harry Francis Mallgrave and Wolfgang Herrmann [Cambridge: Cambridge University Press, 1989], 254). Semper participated in the Ringstrasse project—he codesigned the Burgtheater.

43. Loos, "Heimat Kunst" (1914), in *Sämtliche Schriften,* vol. 1, 339. As Kenneth Frampton points out in "In Spite of the Void," Loos often adds a further (protective) division between front and back (*Labour, Work and Architecture,* 212). Again, his writings are dominated by a rhetoric of truth as transparency, but "the principle of cladding" can be understood as a device of concealing, of material used as mask, even as ornament: "The law goes like this: we must work in such a way that a confusion of the material clad with its cladding is impossible. That means, for example, that wood might be painted any color except one—the color of wood" (*SV* 67). On this point see Harry Mallgrave on "The Legacy of Semper," in his introduction to *The Four Elements of Architecture,* 43.

44. Ernst Haeckel, *Generelle Morphologie der Organismen* (Berlin: Georg Reimer, 1866), vol. 1, 300. See also Stephen Jay Gould, *Ontogeny and Phylogeny* (Cambridge, Mass.: Harvard University Press, 1977), especially 76–85.

45. I borrow the term "sociogenetic law" from the great historian Norbert Elias, who proposes it, with reservations, in the first volume of *The Civilizing Process* (1939). See Norbert Elias, *The History of Manners,* trans. Edmund Jephcott (New York: Urizen Books, 1978). In "Ornament and Education" (1924), Loos holds to this thesis just as boldly: "Every child has to repeat the development that took mankind thousands of years" (*AL* 184).

46. Among other texts, see Sigmund Freud, *A Phylogenetic Fantasy* (1915 manuscript), trans. Axel and Peter Hoffer (Cambridge, Mass.: Harvard University Press, 1987); and Sándor Ferenczi, *Thalassa: A Theory of Genitality* (1923), trans. Henry Bunker (London: Karnac Books, 1989). See also Frank J. Sulloway, *Freud, Biologist of the Mind* (New York: Basic Books, 1979). The notion of recapitulation was used by several modernists to support speculations about cultural evolution, and the new art and the new man necessary to its modern stage (see chapter 3).

47. And it would remain so in modernist discourse, yet there the child and the primitive (often joined by the insane) are revalued as ideals of purity, not markers of degeneration (see chapter 5). On this point, Loos remains within the prior discourse. He also associates women with these two—though not, it seems, the Jew, as was common enough at the time (e.g. in Otto Weininger). For a survey of the discourse of degeneration, see Dennis Pick, *The Faces of Degeneration* (Cambridge: Cambridge University Press, 1989).

48. Max Nordau, *Degeneration* (Lincoln: University of Nebraska Press, 1993), 18. The text is dedicated to Lombroso. In my reading of the Loos literature, there is some mention of Lombroso but none of Nordau, despite the fact that Loos often uses the term that Nordau made famous (as in the title of the 1908 essay "Cultural Degeneration")—though he was probably influenced here by Nietzsche instead. Of course, the Nazis put the discourse of degeneration to their own purpose.

49. Regression in Freud is at once temporal (a reversion to a past psychic stage, e.g. oral, anal), topographic (a reversion to another psychic system), and formal (a reversion to a less complex, less structured mode of expression). See Jean Laplanche and J.-B. Pontalis, *The Language of Psychoanalysis,* trans. Donald Nicholson-Smith (New York: W. W. Norton, 1973), 386–388. For the association, through regression, of the primitive and the pre-Oedipal, see chapter 1.

50. This thought is not so aberrant in modernist discourse: in Mondrian and Malevich, for example, the cross is also treated as the primary mark and, with its axes gendered, as the primordial act.

51. His "first battle cry against ornament," as Loos put it in 1930, came in an early review of coaches (July 3, 1898):

> Let us briefly review a few chapters of the history of civilization. The lower the cultural level of a people, the more extravagant it is with its ornament, its decoration. The Indian covers every object, every oar, every arrow with layer upon layer of ornament. To see decoration as a sign of superiority means to stand at the level of the Indians. But we must overcome the Indian in us. . . . To seek beauty only in form and not in ornament is the goal toward which all humanity is striving. . . . In all the professional schools the crafts are reduced to the level of the Indians. (*SV* 40)

And again in "Ladies' Fashion": "The lower the culture, the more apparent the ornament. Ornament is something that must be overcome. The Papuan and the criminal ornament their skin. The Indian covers his paddle and his boat with layers and layers of ornament. But the bicycle and the steam engine are free of ornament. The march of civilization systematically liberates object after object from ornamentation" (*SV* 102). As Reyner Banham wrote of Loos: "It seems doubtful . . . whether the purity of Pure Form ever really interested him as anything other than a symbol of purity of mind" (*Theory and Design in the First Machine Age* [Cambridge, Mass.: MIT Press, 1981], 96).

52. In effect, Loos declares as impossible the Art Nouveau attempt "to win back these [new] forms through ornament" (Benjamin). Le Corbusier recapitulates this development as follows: "During these last years we have witnessed the successive stages of a development: with metallic construction, the separation of *decoration from structure*. Then the fashion for expressing the construction, the sign of a new construction . . ." (Le Corbusier, *The Decorative Art of Today* [1925], trans. James Dunnett [Cambridge, Mass.: MIT Press, 1987], 99). And in "Functionalism Today," an essay that focuses on Loos, Theodor Adorno writes: "Criticism of ornament means no more than criticism of that which has lost its functional and symbolic signification. . . . The ornaments . . . are often actually vestiges of outmoded means of production" (*Oppositions* 17 [Summer 1979], 30–41).

53. Loos, *Schriften,* 268. On this separation, see in particular Gravagnuolo, *Adolf Loos;* and Alan Colquhoun, *Modern Architecture* (Oxford: Oxford University Press, 2002).

54. See especially William Pietz, "The Discourse of the Fetish," *Res* 9 and 13 (Spring 1985, 1987); and Emily Apter and William Pietz, eds., *The Fetish as Cultural Discourse* (Ithaca: Cornell University Press, 1993). Once again in *The Decorative Art of Today,* Le Corbusier echoes Loos: "Decoration; baubles, charming entertainment for a savage," etc.; "the passage from the age of subjection to the age of creation—the history of civilization, as also the history of the individual," etc. (85, 118).

55. "The false prophets [of nineteenth-century eclecticism] could only recognize a product by how it was decorated, so ornament became a fetish for them; they substituted this changeling by calling it style" (*AL* 106).

56. Karl Kraus, *Dicta and Contradicta,* trans. Jonathan McVity (Urbana: University of Illinois Press, 2001), 11. Here metaphors are ornamental to language, perverse in the Loosian sense of superficial, rather than irreducible to language in a deManian sense, say, which would render language as intrinsically perverse as sexuality is for Freud.

57. For example, in *The Theory of the Leisure Class* Veblen writes: "This process of selective adaptation of designs to the ends of conspicuous waste, and the substitution of pecuniary beauty for aesthetic beauty, has been especially effective in the development of architecture" (quoted in Le Corbusier, *The Decorative Art of Today,* ix).

58. Freud, "Character and Anal Erotism," in *On Sexuality,* trans. James Strachey (London: Penguin, 1977), 209–215. As Erich Fromm and Norman O. Brown have suggested, "the anal character" and "the Protestant ethic" are hardly incompatible; they might be two aspects of one subject formation. See Norman O. Brown, *Life and Death: The Psychoanalytic Meaning of History* (Middletown, Conn.: Wesleyan University Press, 1959).

59. As for civilization and reaction formation, Rudy Giuliani, the former mayor of New York, acted out this relation brilliantly in his response to the "Sensation" show at the Brooklyn Museum in 2000: "I would ask people to step back and think twice about civilization. Civilization has been about trying to find the right place to put excrement, not on the walls of museums" (as quoted by Hans Haacke in his artwork *Sanitation* [2000]).

60. As we have seen, this separation is overdetermined. It also involves an exception, for, as Adorno writes in "Functionalism Today," "the very existence of art, judged by the criteria of the practical, is ornamental," on which grounds, by Loosian logic, it should be expunged, if it were not already preserved apart.

61. My purpose here is less to read Loos by the book of Freud than to suggest that Freud is as fantastic on these matters as Loos. Kraus was no friend of psychoanalysis (one of his famous aphorisms is "psychoanalysis is the mental disease of which it thinks it is the cure"); Wittgenstein was not either. See Thomas Szasz, *Anti-Freud: Karl Kraus's Critique of Psychoanalysis and Psychiatry* (Syracuse: Syracuse University Press, 1990); and Jacques Bouveresse, *Wittgenstein Reads Freud,* trans. Carol Osman (Princeton: Princeton University Press, 1995).

62. Schorske, *Fin-de-Siècle Vienna*, 209.

63. Freud, *Three Essays on the Theory of Sexuality*, in *On Sexuality*, 118. In the first version of *Three Essays* the pre-Oedipal is not yet differentiated in this way; it is so only by the time of "The Infantile Genital Organization" (1923).

64. Freud, *Three Essays*, 104. This note glosses a 1916 text ("'Anal' und 'Sexual'") by Lou Andreas-Salomé.

65. Ibid.

66. Freud, "Character and Anal Erotism," 211.

67. Sándor Ferenczi, "The Ontogenesis of the Interest in Money," in John Halliday and Peter Fuller, eds., *The Psychology of Gambling* (London: Penguin, 1974), 267.

68. Ernest Jones, *Papers on Psychoanalysis* (Boston: Beacon Press, 1961), 413–437. See also Karl Abraham: "coprophilia either becomes sublimated into pleasure in painting, modeling, and similar activities, or proceeds along the path of reaction-formation to a special love of cleanliness" ("Contributions to the Theory of the Anal Character" [1921], in *Selected Papers of Karl Abraham*, trans. D. Bryan and A. Strachey [New York: Basic Books, 1954], 371).

69. See especially "Creative Writers and Day-Dreaming" (1908) and "Two Principles of Mental Functioning" (1911).

70. See Abraham, "A Short Study of the Development of the Libido, Viewed in the Light of Mental Disorders" (1924), in *Selected Papers*, 418–501. Perhaps this division also informs the distinction between renunciation and sublimation.

71. See especially "A Coat of Whitewash, the Law of Ripolin," in *The Decorative Art of Today*: "We would perform a moral act: *to love purity!* . . . Once you have put ripolin on your walls you will be *master of yourself* . . ." (188). For a brilliant discussion of these issues, see Mark Wigley, *White Walls, Designer Dresses: The Fashioning of Modern Architecture* (Cambridge, Mass.: MIT Press, 1995).

72. Loos quoted by Benjamin in "Karl Kraus," 272. His implication is that to destroy the historicist impurity of the nineteenth century is to preserve the neoclassical nobility of tradition.

73. Freud: "The excremental is all too intimately and inseparably bound up with the sexual; the position of the genitals—*inter urinas et faeces nascimur*—remains the decisive and unchangeable factor" ("The Tendency to Debasement in Love" [1912], in *On Sexuality*, 259).

74. Ferenczi, "The Ontogenesis of the Interest in Money," 267.

75. There are very few purely white walls in Loos (unlike in Le Corbusier): his exteriors are off-white at best, and his interiors are often lushly colored.

76. Sigmund Freud, "Forward," in John G. Bourke, *The Scatologic Rites of All Nations* (New York: American Anthropological Society, 1934), viii. Freud continues in a line of thought that, again, is completed in *Civilization and Its Discontents* (more on this below). Bourke gives the motive for his work in its first sentence—so that "the progress of humanity upwards and onward might best be measured" (xv).

77. Freud in Bourke, *The Scatologic Rites*, ix.

78. Perhaps Loos was acquainted with such folklore, or even its psychoanalytic elaboration.

79. Freud, *Civilization and Its Discontents*, 52, 59–60. Like the anal, these notes are repressed, as it were, pushed to the bottom of the page, but in a sense they also return to dominate it.

80. In the allegory of the first cross in "Ornament and Crime," it is as if the vertical male periodically succumbs (almost tragically regresses) to the horizontal female, in a literal fall that can only be partly excused on the basis of reproduction. Here, too, it is as if the male is pitted against, but also steeped in, the female. This masculinity is under enormous strain, which is why it is hysterical in its own way, as it is in other cases taken up in this book (see especially chapters 1 and 3).

81. Like Freud, I repress my wildest speculation in a note. Might ornament be associated in Loos not only with excrement but also, tacitly, with the genitals? This allegory of the first or-

nament as the sign of sex intimates as much: not only is ornament erotic in origin but, conversely, the genitals are merely ornamental when they are not dedicated to the reproductive function. (In a review of furniture [June 19, 1898], Loos argues his idea of beauty in relation to function, and suggests that women are beautiful first and foremost for purposes of sexual attraction, and are otherwise ornamental.) In the Freudian narrative of the dawn of man, the genitals become shameful with the advent of a sexuality that exceeds reproduction. Just as the (actual) penis must be played down so that the (symbolic) phallus might be inflated in power, so ornament is sacrificed by Loos to the greater glory of architecture—as if it, like the phallus, can assume its power as grand signifier only if it is abstracted, only if it is "veiled" (as Lacan puts it). On the logic of this sublation, see chapters 3, 6, and 7.

82. Freud, "On Transformations of Instinct as Exemplified in Anal Erotism," in *On Sexuality,* 295–302. Of course, this symbolic fluidity might (also) be his. As early as 1897, Freud wrote to Wilhelm Fliess: "I can hardly tell you how many things I (a new Midas) turn into—excrement." See Sigmund Freud, *The Origins of Psychoanalysis,* trans. James Strachey (New York: Basic Books, 1954), 240 and note.

83. Janine Chasseguet-Smirgel, *Creativity and Perversion* (New York: W. W. Norton, 1984), 3, 5. Note in passing how many gestures of the avant-garde are staged in anal-excremental terms in order to offend—but in effect, finally, to support?—the proper subject of modernism. See chapter 1; see also chapter 5 of my *The Return of the Real* (Cambridge, Mass.: MIT Press, 1996).

84. For Chasseguet-Smirgel, perversion is thus a *père-version,* a turning away from the father, too; see *Creativity and Perversion,* 1–12. See also chapters 3 and 6.

85. These levels might be thought with the help of different theorists: Georges Bataille, Mary Douglas, Julia Kristeva, Pierre Bourdieu. . . .

86. To recapitulate: As early as a 1897 review of the School of Applied Arts, Loos argued that "competition" between arts and crafts can only produce confusion of the two, with both "cheated by this kind of behavior" (*SV* 88). As we have seen, this argument is at the core of his subsequent critiques of the Secession, the Werkstätte, and the German Werkbund. For his later texts on art and craft, see "Cultural Degeneration" (1908); on art and industry, see "The Superfluous" (1908); and on art and architecture, "Architecture" (1910).

87. This world is "thalassal" in the sense explored in chapter 1.

88. Walter Benjamin, *Charles Baudelaire: A Lyric Poet in the Era of High Capitalism* (London: New Left Books, 1973), 106.

89. "I am an opponent of the trend," Loos writes in a review of interiors (June 5, 1898), "that considers it to be especially desirable that a building has been designed with everything in it—down to the coal scoop—by the hand of one architect" (*SV* 27). He also once wrote that "the walls [alone] belong to the architects," and for his interiors he tended to recommend reproductions of English furniture. In *Modern Architecture*, Alan Colquhoun argues that "Art Nouveau was both the prototype and the antitype of modernism": prototype in that it updated the nineteenth-century model of the *Gesamtkunstwerk;* antitype in that it was pledged to medium-specificity and professional disciplinarity (12–33).

90. In 1925, in Paris, Loos delivered lectures on "The Man of Modern Nerves." On Art Nouveau and neurasthenia, see Silverman, *Art Nouveau in France,* 102, 105–106. Dolf Sternberger has provocative things to say about Art Nouveau in this regard (see Walter Benjamin, *The Arcades Project,* ed. Howard Eiland and Kevin McLoughlin [Cambridge, Mass.: Harvard University Press, 1999], 549–550).

91. Kraus, *Werke,* vol. 3 (Munich, 1965), 341. Note that nothing is said of absolute autonomy, only provisional distinctions. *Spielraum* is literally "play room," but it might also be translated, idiomatically, as "wiggle room."

92. This notion of empathic subjectivism suggests another discursive connection in 1908, neither causal nor casual, with Wilhelm Worringer in *Abstraction and Empathy,* published in the same year (see chapter 3). Is this "running-room" between chamberpot and urn, use value and art value, closed again, in a different way, by the 1917 urinal-become-fountain of Duchamp? Or is it always-already about-to-be-closed—and reopened once more? Perhaps this is one aspect of the dialectic of "modernism" and "avant-garde" that we have lost today; see my *Design and Crime (and Other Diatribes)* (London: Verso, 2002).

93. The association of ornament and tattooing runs back at least to Semper; it also appears in Owen Jones, W. R. Lethaby, and others.

94. Benjamin, "Paris, Capital of the Nineteenth Century," 154.

95. See Adorno, *Kierkegaard: The Construction of the Aesthetic* (1933), trans. Robert Hullot-Kentor (Minneapolis: University of Minnesota Press, 1989), and Benjamin, *Charles Baudelaire* and *The Arcades Project*. Together they track a gradual withdrawal of the bourgeois subject throughout the nineteenth century, Benjamin explicitly so. There is a vast literature on this "interiorization" of the subject: it is bound up with the "civilizing process" for Norbert Elias, with metropolitan life for Georg Simmel, with urban shock for Benjamin, with rentier leisure for Adorno, and so on.

96. Benjamin, "Paris, Capital of the Nineteenth Century," 154.

97. Ibid., 154–155. In this account, the "derealization" of the public sphere prompts the fetishization of the private sphere.

98. Musil, *The Man without Qualities,* 158–159.

99. Ernst Bloch, *Heritage of Our Times,* trans. Neville and Stephen Plaice (Berkeley: University of California Press, 1991), 209.

100. The classic critique of transparency in modern architecture is Colin Rowe and Robert Slutzky, "Transparency: Literal and Phenomenal," *Perspecta* 8 (1963).

101. Henry-Russell Hitchcock, *Architecture: Nineteenth and Twentieth Centuries* (Harmondsworth: Penguin, 1958), 473.

102. Massimo Cacciari, *Posthumous Men: Vienna at the Turning Point,* trans. Rodger Friedman (Stanford: Stanford University Press, 1996), 84.

103. Colquhoun, *Modern Architecture,* 78. See also Risselada, ed., *Raumplan versus Plan Libre.*

104. As noted above, the building was highly controversial—legend has it that the emperor refused to look upon it—but it was also decorous in all the ways sketched here.

105. See Banham, *Theory and Design,* 90. See also his "Ornament and Crime: The Decisive Contribution of Adolf Loos" (1957), in *A Critic Writes: Essays by Reyner Banham,* ed. Mary Banham et al. (Berkeley: University of California Press, 1996).

106. Tristan Tzara, "D'un certain automatisme du goût," *Minotaure* 3–4 (December 1933), 84. The notion of automatism would have appalled Loos; it is the subjectivism of Art Nouveau taken to a higher power.

107. Ibid. Tzara: "From the cave (for man used to live inside the earth, 'the mother'), through the Eskimo yurt, an intermediate form between the grotto and the tent (remarkable instance of uterine construction entered through vaginal shapes), through to the conical or semispherical hut with a pole of sacred character at its door, the dwelling place symbolizes prenatal comfort" (84). Matta, who once worked in the Le Corbusier office, also argued for an intrauterine architecture five years later in *Minotaure* 11 (May 1938). For more on surrealist architecture, see my *Compulsive Beauty* (Cambridge, Mass., MIT Press, 1993); Anthony Vidler, *The Architecture of the Uncanny* (Cambridge, Mass.: MIT Press, 1992); and Colomina, *Privacy and Publicity.* There are, of course, feminist ripostes to these fantasies in the work of Luce Irigaray, Louise Bourgeois, and others.

108. Salvador Dalí, "L'Âne pourri," in *Le Surréalisme au service de la révolution* 1 (July 1930). The title of this article alone nicely condenses what is most improper, most un-Loosian.

109. Salvador Dalí, "De la beauté terrifiante et comestible, de l'architecture Modern style," *Minotaure* 3–4 (December 1933), 71.

110. Ibid.

111. For an excellent discussion of this project, see Colomina, *Privacy and Publicity.* This is not to say that there is no masculine presence on the inside. On the contrary, the "feminine" display of some interior might be staged in part for "male" desire: if exhibitionism is renounced on the exterior, its double, voyeurism, might be pronounced in the interior. With its bands of white and black, the Baker house is also, in its own way, tattooed.

112. Harry Francis Mallgrave, "Adolf Loos: Ornament and Sentimentality," in Nadir Lahiji and D. S. Friedman, eds., *Plumbing: Sounding Modern Architecture* (New York: Princeton Architectural Press, 1997), 131. "What I want in my rooms," Loos writes in 1924, "is for people to feel substance all around them, for it to act upon them, for them to know the enclosed space, to feel the fabric, the wood, above all to perceive it sensually . . ." (quoted in Risselada, ed., *Raumplan versus Plan Libre,* 139–140).

113. Benjamin, *The Arcades Project,* 459.

114. Even more than Tzara, Bataille is the anti-Loos, as one might expect of this dissident within modernism who celebrated eroticism, waste, and the *informe*—and was condemned (by Breton) as the "excremental philosopher" (see Denis Hollier, *Against Architecture,* trans. Betsy Wing [Cambridge, Mass.: MIT Press, 1989]). But there is also a point where these antitheses meet. For all his commitment to "civilization," Loos also registers its cost in "discontent," even perhaps in nihilism. In this regard there might be some truth to the avant-gardist reading of Loos after all, as Adorno suggests: "Even the highly cultivated aesthetic allergy to kitsch, ornament, the superfluous, and everything reminiscent of luxury has an aspect of barbarism, an aspect—according to Freud—of the destructive discontent with culture" (Theodor Adorno, *Aesthetic Theory,* trans. Robert Hullot-Kentor [Minneapolis: University of Minnesota Press, 1997], 61).

115. See the structurally similar opposition between primitive and urban dweller proposed by Wyndham Lewis in his short text "The New Egos," discussed in chapter 3. At this point in the essay Loos recaps "Ornament and Crime," and suggests that history is based too much on art history and not enough on physical anthropology à la Semper—i.e. that it is based too much on ornamental objects that survive simply because they are not used.

116. Frampton, *Modern Architecture,* 94.

117. Le Corbusier also looked to neoclassicism, yet he sought to reconcile it not with craft but with the machine.

118. "It is not our style; our time did not give birth to it," Loos remarks, typically, in 1898 (*SV* 104). For Loos, the craftsman and the engineer bespeak the modern style without ornament,

beyond ornament; and they do so naturally, almost unconsciously: the modern style speaks through the materials and techniques that they express. On this point, see his 1908 essay "The Superfluous."

119. Here, too, Le Corbusier follows Loos: "We would like to be *appropriate,*" he insists in *The Decorative Art of Today* (183).

120. This has a nasty ring to our ears. The demand for purity in modernism at large, and in Loos in particular, is indeed troublesome. But a slippage from the aesthetic to the political is problematic, as is an anachronistic overreaction: that is, we should hesitate to project subsequent histories—from Nazi exterminations to "ethnic cleansings" today—onto rhetorical positions that precede them.

121. This mausoleum for the art historian Max Dvořák (1921) is the only project for a tomb completed by Loos, though he did sketch a cube for his own tomb in 1931 (see *AL* 56). The Dvořák tomb was to consist of blocks of Swedish black granite, set in the form of an elongated cube with a stepped pyramid at a height of nearly twenty feet. This primordial form—which alludes to the great tomb built at Halicarnassus in 353 BCE for King Mausolos (from which the term "mausoleum" derives)—was to be penetrated by simple rectangles for door and window, and to be decorated on the inside with frescoes by Kokoschka (on whom Dvořák had written sympathetically): again the rigorous separation of interior and exterior, of art and architecture—though here in a structure that, according to Loos, art and architecture also share.

122. For example, it is there, outside the city, that Antigone is forced to go when her brother is refused burial as an enemy of the state. For Giambattista Vico, burial was a sine qua non of civilization:

> [To realize] what a great principle of humanity burial is, imagine a feral state in which human bodies remain unburied on the surface of the earth as food for crows and dogs. Certainly this bestial custom will be accompanied by uncultivated fields and uninhabited cities. Men will go about like swine eating the acorns found amidst the putrefaction of their dead. And so with good reason burials were characterized by the sublime phrase "compacts of the human race"

(*foedera generis humani),* and with less grandeur were described by Tacitus as "fellowships of humanity" *(humanitatis commercia).*

The New Science of Giambattista Vico (1725), trans. T. G. Bergin and M. H. Fisch (Ithaca: Cornell University Press, 1970), 55.

3 PROSTHETIC GODS

1. The very insistence on the separation attests to its difficulty: already in the Enlightenment man is modeled on machine (e.g. *l'homme-machine* of La Mettrie), and in the nineteenth century as a "human motor." See Anson Rabinbach, *The Human Motor: Energy, Fatigue and the Origins of Modernity* (New York: Basic Books, 1990).

2. The passage in question is the epigraph of my book: "Man has, as it were, become a kind of prosthetic God. When he puts on all his auxiliary organs he is truly magnificent; but those organs have not grown on to him and they still give him much trouble at times" (*Civilization and Its Discontents,* trans. James Strachey [New York: W. W. Norton, 1961], 43). In a short paper of 1953 ("Some Reflections on the Ego," *International Journal of Psychoanalysis* 34), Jacques Lacan writes of "*Homo psychologicus*" as "the product of our industrial age." "It is almost as if the two were actually conjoined," Lacan remarks of psychological man and industrial machine. "Its mechanical defects and breakdowns often parallel his neurotic symptoms. Its emotional significance for him comes from the fact that it exteriorizes the protective shell of his ego as well as the failure of his virility" (17). Below I will speak to both tropes, "defects and breakdowns" and "protective shell."

3. Perhaps this uncertain status was part of its anxious attraction. See Victor Tausk, "On the Origins of Schizophrenia in the 'Influencing Machine'" (1919), essential reading for the modernist imaginary of the machine (*The Psychoanalytic Quarterly* 2 [1933]).

4. See Marshall McLuhan, *Understanding Media: The Extensions of Man* (New York: McGraw-Hill, 1964). See also see Mark Seltzer, *Bodies and Machines* (New York: Routledge, 1992), especially the Introduction. In chapter 7 of my *The Return of the Real* (Cambridge, Mass.: MIT Press, 1996) I track this logic in critical discourse on technology in the 1930s, 1960s, and 1990s.

5. I point to other modernist and critical positions on technology below, but most remain with the double logic of a fantasy of a Frankensteinian dismemberment of the body (pronounced in Marx) versus a fantasy of its futurist phallicization (pronounced in Marinetti, as we will see). In his account of technology as both amputation and extension, McLuhan expresses this logic exactly. McLuhan was influenced by Wyndham Lewis: he sought Lewis out in St. Louis in the early 1940s, published an essay on his work in 1944, and founded a journal in homage to *Blast* called *Counterblast*. What continuities regarding technological shock, art, subjectivity, and politics might be found between "the new ego" proposed by Lewis in *Blast* 1 (1914) and "the extensions of man" traced by McLuhan in *Understanding Media* (1964)?

6. On this return see especially Kenneth E. Silver, *Esprit de Corps: The Art of the Parisian Avant-Garde and the First World War, 1914–1925* (Princeton: Princeton University Press, 1989).

7. Or was this deadness a strange new version of liveness? I return to this paradox below. Neoclassicism and machinism cannot be strictly opposed in European art of the 1920s, certainly not as representations of the body as whole versus fragmentary. Machinic figures were often made whole through armoring, while neoclassical ones were often fractured—so many "scarecrows," as Theodor Adorno once remarked of the neoclassicism of Stravinsky, "damaged and disempowered by a patched-up arrangement of dreams" (*Musikalische Schriften,* vols. 1–3, ed. Rolf Tiedemann [Frankfurt: Suhrkamp Verlag, 1978], 391). Sometimes, too, machinic and neoclassical figures were combined, not only in much art on the right (e.g. Mario Sironi) but also in some art on the left (e.g. Fernand Léger). In his caustic way, Lewis captured the convergence of these uncanny tendencies as so many symptoms of reification: "That is what is afoot," he wrote in a 1934 text titled "Power-Feeling and Machine-Age Art," "the *living* statue—which comes upon the scene hand-in-hand with the robot-man—the herd machine-minders mingling, ithout recognition of a difference, with the herd of Hoffman [*sic*] puppets" ("Power-Feeling and Machine-Age Art," *Time and Tide* [October 1934]; reprinted in *Wyndham Lewis on Art,* ed. Walter Michel and C. J. Fox [New York: Funk & Wagnalls, 1969], 287). In "The Mirror Stage" (1936/49) Lacan describes the body-ego image as "automaton" and "statue"—figures similar to the machinic and neoclassical specters of the 1920s that also ambiguate between the whole and the fragmentary (*Écrits,* trans. Alan Sheridan [New York: W. W. Norton, 1977], 2, 3).

———

8. Of course, these futures differed from regime to regime, as did the subjects interpellated by them, and different styles developed accordingly. Futurist technophilia is overdetermined in this regard: part masculinist fantasy, part political allegory, it was also driven by a desire to compensate for relative underdevelopment. The vorticist situation was quite different. "We've had machines here in England for a donkey's years," Lewis once told Marinetti. "They're no novelty to *us*" (*Blasting and Bombardiering* [1937; London: Calder & Boyars, 1967], 34; hereafter abbreviated *BB*). Here I focus on the machine as fantasy; even when it figures "objectivity," there is a strong subjective dimension.

9. László Moholy-Nagy in *Ma* (May 1922), reprinted in *Moholy-Nagy: An Anthology*, ed. Richard Kostelanetz (New York: Praeger, 1970), 186. Again, this mapping is very schematic; the relation of Dada to constructivism is more complex, especially in its Berlin version.

10. On this complementarity, see Jean Baudrillard, *For a Critique of the Political Economy of the Sign*, trans. Charles Levin (St. Louis: Telos Press, 1981), 185–203; and my "The Future of an Illusion," in David Joselit, ed., *Endgame* (Boston: Institute of Contemporary Art, 1986).

11. See Jeffrey Herf, *Reactionary Modernism: Technology, Culture, and Politics in Weimar and the Third Republic* (Cambridge: Cambridge University Press, 1984). Like many of the wartime generation, both men were influenced by Georges Sorel, particularly his *Reflections on Violence* (1908), a text of great influence on emergent fascisms (it was first translated into English by T. E. Hulme, a vorticist associate). Futurism and vorticism constitute avant-gardes that might be described as Sorelian: both partake of the Sorelian imperative to mythologize events and to activate images, often of violence. Lewis discusses Sorel in *The Art of Being Ruled* (1926), and the program of his 1937 autobiography, *Blasting and Bombardiering*, is pure Sorel: "I have set out to show how war, art, civil war, strikes and coups d'état dovetail into each other" (*BB* 4). The Sorelian dimension of modernism is noted by Mark Antliff in "Fascism, Modernism, and Modernity," *Art Bulletin* (March 2002).

12. Walter Benjamin, "The Work of Art in the Age of Mechanical Reproduction," in *Illuminations*, ed. Hannah Arendt, trans. Harry Zohn (New York: Schocken Books, 1969), 242; Wyndham Lewis, "The New Egos," *Blast* 1 (June 20, 1914 [Santa Rosa: Black Sparrow Press, 1981, 141]; hereafter abbreviated *B*). How close is this "new ego" to "the second consciousness

. . . outside the sphere of pain" proposed by Ernst Jünger in "Über den Schmerz" (Ernst Jünger, *Blätter und Steine* [Hamburg: Hanseatische Verlagsanstalt, 1934], 200)? I return to Jünger in chapter 4.

13. Might the surrealist figures register the return of this body, once repressed and now displaced, with the actual mutilation of the male body now projected as the imaginary castration of the female body? More generally, both Dadaist and surrealist figures also partake in the modernist attack on traditional values of sublimated beauty epitomized in the female nude.

14. This was the brief attraction of futurism for Gramsci. In "Marinettti the Revolutionary," an unsigned article in *L'Ordine Nuovo* (January 5, 1921), he wrote: "What remains to be done? Nothing other than to destroy the present form of civilization. . . . The Futurists have carried out this task in the field of bourgeois culture. They have destroyed, destroyed, destroyed. . . . *They have grasped sharply and clearly that our age, the age of big industry, of the large proletarian city and of intense and tumultous life, was in need of new forms of art, philosophy, behaviour and language.*" Just two years later he wrote to Trotsky: "The Italian Futurist movement completely lost its character after the war. . . . The most prominent representatives of pre-war Futurism have become Fascists" (*Selections from Cultural Writings,* ed. David Forgacs and Geoffrey Nowell-Smith, trans. William Boelhower [Cambridge, Mass.: Harvard University Press, 1985], 51–52; original emphasis).

15. Freud, *The Ego and the Id,* trans. James Strachey (New York: W. W. Norton, 1960), 16.

16. See *Écrits,* 16, 14.

17. Suggestive in this regard is the account of fascism offered by Alice Yeager Kaplan in *Reproductions of Banality: Fascism, Literature, and French Intellectual Life* (Minneapolis: University of Minnesota Press, 1986). Kaplan describes fascism as a "polarity machine" whose ideological power lies in its binding of traditional opposites of left and right, revolutionary and conservative, populist and elitist, modern and antimodern, technological and primitive. In a sense, this binding is inscribed in the etymology of the term: in the *fasces,* the rods wrapped around an ax as a symbol of power in Rome; in the *fascia,* the tissue that binds muscles; and in other cognates to do with the strapping of energies of different sorts. Apparent in the paranoid nature of fas-

cist politics (especially when faced with the threat of communist revolution), such binding is also active in the spectacular nature of fascist cultures—above all in the libidinal binding of the masses to the symbols of the party and the figure of the leader in the erosion of old identifications with bourgeois institutions. This binding speaks to the extreme volatility of fascism: just as binding is doubled by unbinding, so the fascist will to absolute discipline is countervailed by the fascist desire for sublime transgression—at the level of the individual body and the body politic alike. Both futurism and vorticism exhibit a similar tension between binding and unbinding, discipline and transgression, at the level of the subject. Perhaps one function of these movements was to manage this tension aesthetically. See also Jeffrey T. Schnapp, *Staging Fascism: 18 BL and the Theater of Masses for Masses* (Stanford: Stanford University Press, 1996); and David Trotter, *Paranoid Modernism* (Oxford: Oxford University Press, 2001).

18. Lewis, *Tarr* (London: Penguin, 1982), 312.

19 F. T. Marinetti, *Selected Writings,* ed. R. W. Flint (New York: Farrar, Straus and Giroux, 1972), 41; hereafter abbreviated *M*. Of course, aggressivity is also pronounced in Lewis—in his prose and art, in his protagonists and personae.

20. Obviously it functioned in other ways for them as well—for example, as a model of social organization; but that use is not specific to them, or indeed to fascism.

21. See Otto Rank, *The Myth of the Birth of the Hero* (1914; New York: Random House, 1959), esp. 65–96.

22. See Freud, "On Transformation of Instincts as Exemplified in Anal Erotism" (1917), in *On Sexuality,* ed. Angela Richards (Harmondsworth: Penguin, 1977). For Marinetti, old Italy, especially Venice, is cloacal in another way. In a sense, he evokes such historical stages, individual and national, in order to break with them, to allow a futurist identity to emerge from them. In "Against Past-Loving Venice," a leaflet dropped from the Clock Tower in Venice on July 8, 1910, Marinetti writes: "We renounce the old Venice . . . *cloaca maxima* of passéism. We want to cure and heal this putrefying city, magnificent sore from the past. . . . We want to prepare the birth of an industrial and military Venice. . . . Let us hasten to fill in its little reeking canals" (*M* 55).

23. For another example of this techno-primitive combination, see Le Corbusier, *L'Art déco-ratif d'aujourd'hui* (Paris: Éditions G. Crès, 1925), especially chapter 8, where the machine is re-garded as a "negro god."

24. Freud, "On the Sexual Theories of Children" (1908), in *On Sexuality,* 197.

25. See his "memory" of a factory beach in "Tactilism" (1924), a kind of Portrait of the Artist as the Birth of Venus-as-Vulcan: "I was naked in a sea of flexible steel that breathed with a vir-ile, fecund breath. I was drinking from a sea-chalice brimming with genius as far as the rim. With its long searing flames, the sun was vulcanizing my body" (*M* 110). It is as if Marinetti secretly identified with Vulcan as a crippled (castrated) god who imaginatively forges perfect (phallic) bodies. This "vulcanizing" is also evocative of the Freudian "baking" of the epidermis into the "protective shield" (more on this below). It is a persistent trope in fascistic visions of the subject (see, for example, *Sun and Steel* by Yukio Mishima).

26. This is how Constance Penley describes the operation in science fiction in "Time Travel, Primal Scene, and the Critical Dystopia," in *The Future of an Illusion: Feminism, Film, Psycho-analysis* (Minneapolis: University of Minnesota Press, 1990). Freud discusses the fantasy of being one's own father in "A Special Type of Object-Choice Made by Men" (1910).

27. Thus in "Against *Amore* and Parliamentarianism": "I confess that before so intoxicating a spectacle [the take-off of a Blériot plane] we strong Futurists have felt ourselves suddenly de-tached from women, who have suddenly become too earthly, or, to express it better, have be-come a symbol of the earth that we ought to abandon" (*M* 75). Marinetti oscillates between identification with the machine and desire for it, which confuses his sexual positioning throughout his work (more on this below).

28. This fantasy follows the one in note 25. Marinetti has other avatars of such creation out-side the female body: e.g. Mafarka, the hero of his novel *Mafarka le futuriste* (1909), and "the multiplied man" proposed in *War, the World's Only Hygiene* (1911–15). On Mafarka, see Kap-lan, *Reproductions of Banality,* 78–92; and Barbara Spackman, "Mafarka and Son: Marinetti's Ho-mophobic Economics," *Modernism/Modernity* 3 (1994): 89–107; and on autogenetic tropes in modern aesthetics in general, see Susan Buck-Morss, "Aesthetics and Anaesthesia: Walter Ben-jamin's Artwork Essay Reconsidered," *October* 62 (Fall 1992).

———

29. This crossing of the natural and the technological has its own logic, as Andreas Huyssen suggests: "The most complete technologization of nature appears as a re-naturalization, as a progress back to nature. Man is at long last alone and at one with himself" (*After the Great Divide* [Bloomington: University of Indiana Press, 1986], 71).

30. Lewis is also misogynous, but in the classical way: he resents women because they threaten him with what he is not. For an excellent discussion of misogyny in Lewis, see Lisa Tickner, "Men's Work? Masculinity and Modernism," *differences* 4, no. 3 (Fall 1992). For an excellent discussion of misogyny in Marinetti, especially in its homosocial dimension, see Spackman, "Mafarka and Son: Marinetti's Homophobic Economics."

31. Lacan, *Feminine Sexuality,* trans. Jacqueline Rose (New York: W. W. Norton, 1982), 84. "If the penis were the phallus," the psychoanalyst Eugénie Lemoine-Luccioni writes, in the wittiest gloss on the difference between the bodily thing and the primary signifier, "it would have no need of feathers or ties or metals"; that is, men would have no need of ceremonial regalia ("feathers"), business suit ("ties"), military uniforms ("medals"), and so on—and certainly no need of the vulcanized body desired by Marinetti or, as we will see, the armored hide proposed by Lewis. See Eugénie Lemoine-Luccioni, *La Robe: essai psychanalytique sur le vêtement* (Paris: Seuil, 1983), 34.

32. Male-female difference cannot be mapped directly onto human-machine difference here: a third term, homo-technological perhaps, overcodes these oppositions. I return to some of these questions in chapter 6.

33. For an incisive discussion of the "Technical Manifesto," see Jeffrey Schnapp, "Propeller Talk," *Modernism/Modernity* 3 (September 1994): 153–178. In the "Work of Art" essay, Benjamin also poses a relation between shock and tactility, but obviously with different hopes for the new subject of technology.

34. See *Beyond the Pleasure Principle,* trans. James Strachey (New York: W. W. Norton, 1961), 18–27; hereafter abbreviated *BPP.* As with the long-discredited Lamarckian thesis, what is important here is the fantasmatic resonance of this idea, not its scientific validity. On the influence on Freud of Lamarck as well as Haeckel (from whom Freud adopted "the biogenetic law" whereby ontogeny recapitulates phylogeny, as discussed in chapter 2), see Stephen Jay Gould,

Ontogeny and Phylogeny (Cambridge, Mass.: Harvard University Press, 1977), 155–164; and Frank J. Sulloway, *Freud, Biologist of the Mind* (New York: Basic Books, 1979), 259–264.

35. See note 2.

36. The protective shield is one of the great fictions of modern(ist) thought—and not only in Freud and Benjamin. The Lamarckian notion is active in the discourse on shock at the turn of the century, too, as in Georg Simmel's famous text on "The Metropolis and Mental Life" (1903): "The metropolitan type of man . . . develops an organ protecting him against the threatening currents and discrepancies of his external environment"—the organ of "intellectuality" (*The Sociology of Georg Simmel,* ed. Kurt H. Wolff [New York: Macmillan, 1950], 410). Thirty years later, Ernst Jünger writes of a more extreme evolution of "artificial organs of perception" in which "seeing [becomes] an act of aggression," and "consciousness" "an *object* . . . outside the sphere of pain" (*Blätter und Steine,* 200). Marinetti and Lewis are somewhere between Simmel and Jünger chronologically and ideologically.

37. Here Marinetti turns to triumph the "consolation" offered the hero stiffened by terror before the castrative Medusa: the good news is that "he is still in possession of a penis"; the bad news is that he is now stone. See Freud, "Medusa's Head" (1922), in *Sexuality and the Psychology of Love,* ed. Phillip Rieff (New York: Macmillan, 1963), 212–213; see also chapter 7. For a provocative argument concerning the corollary of the position presented here—that "self-preservation, in its capitalist form, manifests the death drive"—see John Brenkman, *Culture and Domination* (Ithaca: Cornell University Press, 1987), 166–173. In the same moment as Marinetti, Hugo Ball pointed toward the necessary critique of this position: "The modern necrophilia. Belief in matter is a belief in death. The triumph of this kind of religion is a terrible aberration. The machine gives a kind of sham life to dead matter." And in relation to a text by his wife, Emmy Hennings, he also speaks of "the corpse's instinct for self-preservation" (*Flight from Time* [1927], trans. Ann Raimes [New York: Viking Press, 1974], 4, 95).

38. Again, I follow here the famous critique of Marinetti at the end of the "Work of Art" essay: "[The] self-alienation [of mankind] has reached such a degree that it can experience its own destruction as an aesthetic pleasure of the first order" (Benjamin, *Illuminations,* 242). This is also how I understand the "most violent Futurist symbol" in *War, the World's Only Hygiene:*

In Japan they carry on the strangest of trades: the sale of coal made from human bones. All their powder works are engaged in producing a new explosive substance, more lethal than any yet known. This terrible new mixture has as its principal element coal made from human bones with the property of violently absorbing gases and liquids. For this reason countless Japanese merchants are thoroughly exploring the corpse-stuffed Manchurian battlefields. . . . Glory to the indomitable ashes of men, that come to life in cannons! My friends, let us applaud this noble example of synthetic violence. (*M* 82)

39. Indeed, sometimes the fetish reinscribes castration in its very form (Freud offers the example of a support belt, a prosthesis that renders ambiguous whether its wearer—importantly here a man—has a penis or not). See "Fetishism" (1927), in *On Sexuality,* 351–357.

40. See Catherine Millot, *Horsexe,* trans. Kenneth Hylton (New York: Autonomedia, 1990). In her Lacanian account, "the [male] transsexual aims to incarnate The Woman," that is, to be the phallus (42). So contemptuous of castration is this transsexual that (s)he undergoes it to be free of it, only "through surgery to realize that castration is an evil without remedy," that (s)he has "confuse[d] the organ with the signifier" (141).

41. As it does, perhaps, in some fantasies of animated morphing (and in some realities of bio-engineering?) today. I discuss a very different kind of surrender of the penis for the phallus in chapters 6 and 7.

42. Millot, *Horsexe,* 99.

43. Sándor Ferenczi, *Thalassa: A Theory of Genitality* (1923; London: Karnac Books, 1989), 16. In *Understanding Media,* McLuhan approaches the notion of autotomy when he thinks extensions of the body as "auto-amputations" of particular organs under technological strain. Like the Freudian notion of a protective shield, the Ferenczian idea of a "thalassal regression" to an oceanic womb might have more to say about male fantasy than biological science (as we saw in chapter 1). And it is not incommensurate with technological motifs, as is suggested here by the interwar German philosopher Adrien Turel: "This technical prosthetic system, which is a typically masculine achievement, can only be compared with the prenatal, complete enclosure in

the body of the mother" (Adrien Turel, *Technokratie, Autarkie, Genetokratie* [1934], quoted in Peter Sloterdijk, *Critique of Cynical Reason,* trans. Michael Eldred [Minneapolis: University of Minnesota Press, 1987], 459).

44. In a line that looks past Jünger to Paul Virilio, Marinetti writes: "The projectile's very personal path is a thousand times more interesting to us than human psychology" (*M* 98). The initial version of this chapter was drafted soon after the first Gulf War; the final version was finished immediately following the second Gulf War.

45. Leo Bersani, *The Freudian Body* (New York: Columbia University Press, 1986), 38–39. See also the discussion in chapter 1 above.

46. Ibid., 70. For an account concerning modern art and Assyrian sculpture (which also interested Lewis), see Leo Bersani and Ulysse Dutoit, *The Forms of Violence* (New York: Schocken Books, 1985), where the tension between an impulse to stasis and an impulse to movement is crucial.

47. In other words, his rhetorical violence might be not only an inciting of violence but a shielding from it—or an inciting that is also a shielding. Then again, this notion of prophylaxis might serve to justify any representation of violence. As we will see, Lewis is also concerned with "blasting," and his satire might function as bombast does in Marinetti—as a partial release.

48. This echoes the cultural program announced eleven years before in the first manifesto: "We establish *Futurism* because we want to free this land from its smelly gangrene of professors, archaeologists, ciceroni, and antiquarians. . . . Why poison ourselves? Why rot?" (*M* 42)

49. This is an appropriation of a Bolshevist pledge to electrify the Soviet Union; a poster by Gustav Klucis shows Lenin the electrifier bestriding the country. On related matters, see Christine Poggi, "Dream of Metallized Flesh: Futurism and the Mass Body," *Modernism/Modernity* (September 1997); Cinzia Sartini Blum, *The Other Modernism: F. T. Marinetti's Futurist Fiction of Power* (Berkeley: University of California Press, 1996); and Emily Braun, *Mario Sironi and Italian Modernism: Art and Politics under Fascism* (Cambridge: Cambridge University Press, 2000).

50. Andrew Hewitt argues that this corporal politics "strains between an ideal of discipline and an ideal of liberation," in "Fascist Modernism, Futurism, and 'Post-Modernity'" (in Richard J. Golsan, ed., *Fascism, Aesthetics, and Culture* [Hanover: University Press of New England, 1992], 49). See also Andrew Hewitt, *Fascist Modernism* (Stanford: Stanford University Press, 1993).

51. See Jeffrey Schnapp, "Heads of State," *Art Issues* (Fall 1992), 24. See also his *Staging Fascism*.

52. Yet here again is a rub: with his "square crashing jaws and "scornful jutting lips" (*M* 158), Mussolini projects the other, castrative aspect of the fetish as well. "Paradoxical as it may seem," Schnapp writes, "the Fascist phallus is, like Freud's Medusa, at once hyperphallic and castrating" ("Heads of State," 27). Was this castrative aspect "castrated" in turn in the mutilated body of the hanged Mussolini?

 Mussolini dropped Marinetti when his modernism became problematic politically, but his imaging of Mussolini remained important. We might understand it along the lines of the body politics examined by Claude Lefort in *L'Invention démocratique* (Paris: Fayard, 1981; translated as *The Political Forms of Modern Society,* ed. John B. Thompson [Cambridge, Mass.: MIT Press, 1986]). For Lefort, there are three paradigmatic stages of the libidinal relation of subjects to leaders in the modern West. The first is the king of the ancien régime held to possess a double body, at once mortal and immortal, patterned after the double body of Christ (here Lefort draws on Ernst Kantorowicz, *The King's Two Bodies* [1957]). The kingdom is also conceived as a body that the king both images (in the familiar synecdoche "I am France") and directs as its head. Thus when the democratic revolution decapitates the king, it also decapitates the old image of the body politic, and its coherence begins to fall apart. "Power appears as an empty place," Lefort writes. "Unity cannot now efface social division" (*Political Forms,* 303). For Lefort, totalitarianism emerges as a belated "attempt to resolve [the] paradoxes" of this empty place of power. The metaphorics of the double body is resurrected by the figure of "the egocrat," who guarantees "the representation of the People-as-One." But the representation depends on two things: "the integrity of the body" and "the incessant production of enemies" (298–299). (In this regard, the Schawinsky image is a partial recovery of the image of the sovereign in Hobbes's *Leviathan*.)

 How different is the "Futurist Fascism" figured by Marinetti? It, too, reinstates the double body of leader and nation in an imaginary coherence of the two. It, too, sees democracy as an empty place of power; and it, too, requires enemies of the state within and without.

And in both regimes, the machine is used as an image of social organization. Yet there are also crucial differences. For example, in "Futurist Fascism" the machine is not productivist and proletarian (a distinction must be drawn, as Schnapp suggests in *Staging Fascism,* between *mechanization* as a figure of the subject in functional mesh with the social factory, and *metallization* as a figure of the subject in imaginary identification with the military nation), and the fascist leader is not an egocrat to identify with but a "phallocrat" to bind with. (In this regard, a further contrast can be made between the body politics of Mussolini and Hitler.) For more on the despot body and the mass subject, see Kenneth Dean and Brian Massumi, *First and Last Emperors* (New York: Autonomedia, 1992); Michael Warner, "The Mass Public and the Mass Subject," in Bruce Robbins, ed., *The Phantom Public Sphere* (Minneapolis: University of Minnesota Press, 1993); and my "Death in America," in Annette Michelson, ed., *Warhol* (Cambridge, Mass.: MIT Press, 2002).

53. Lewis seems aware, as Marinetti does not, that this ego is "hysterical." The association of the crowd and the unconscious as "feminine" threats runs throughout Lewis, as it does in crowd discourse from Le Bon through Freud. Lewis is ambivalent about the crowd, for it can also serve as a site of "mobilization." In *Blasting and Bombardiering* (1937) he recalls the wartime crowds: "So periodically we shed our individual skin, or are apt to, and are purged in big being. An empty throb. . . . Does not the Crowd in life spell death?. . . The Crowd is an immense anaesthetic towards death, such is its immemorial function" (*BB* 79–80). This "death" that is an "anaesthetic towards death" is fundamental to Lewis on art and subjectivity.

If in Marinetti the new ego is a man-machine that emerges from feminine waters, in Lewis it is a "hysterical wall" set up against the same. Lacan alludes to the unconscious symbolism of the masculinist ego in the "Mirror Stage": "the formation of the *I* is symbolized in dreams by a fortress, or a stadium—its inner arena and enclosure, surrounded by marshes and rubbish-tips, dividing it into two opposed fields of contest where the subject flounders" (*Écrits,* 5). This symbolism suggests a fairy tale of patriarchy, an almost phylogenetic feudalism inscribed in the structure of Western masculinity.

54. Wyndham Lewis quoted in Douglas Goldring, *South Lodge* (London: Constable, 1943), 65. For the vorticists, futurism was just close enough to this point to miss it entirely. Pound: "Futurism is the disgorging spray of a vortex with no drive behind it, dispersal" (*B* 153). Art history also tends to miss the difference between the movements at this crucial point.

55. Fredric Jameson deploys a revised version of the Lyotardian notion of "the libidinal apparatus" *(le dispositif pulsionnel)* in *Fables of Aggression: Wyndham Lewis, the Modernist as Fascist* (Berkeley: University of California Press, 1979).

56. Wyndham Lewis, *The Art of Being Ruled* (New York: Harper & Brothers, 1926), reprinted in *Wyndham Lewis: An Anthology of His Prose,* ed. E. W. F. Tomlin (London: Methuen, 1969), 210; hereafter abbreviated *WLA.* This is actually a citation of Julien Benda. For similar reasons, Lewis attacks the modernist cults of the child and the primitive too.

57. Wilhelm Worringer, *Abstraction and Empathy,* trans. Michael Bullock (New York: International Universities Press, 1953), 13; hereafter abbreviated *AE.* This text is often discussed in relation to expressionism, but vorticism answered to the Worringerian will to abstraction more radically (expressionism is more empathic in a Worringerian sense than vorticism). This also points to another difference between vorticism and futurism. The notion of empathy might have passed into futurism through Benedetto Croce (who discusses Lipps in his *Aesthetics* [1909]); in any case, an eclipse of distance between subject and object is fundamental to futurism. This is one reason why Lewis refers futurism to impressionism, and dismisses both as realisms.

58. For Worringer, the "intermediate stage" between the two poles, which resolves them in an ideal form, is the "Northern artistic volition," especially as manifest in German Gothic, which resonated at the time with German expressionism. This art history according to "race psychology" (see note 60) brought Worringer close to Nazism.

59. See Thomas Ernest Hulme, *Speculations* (1924; London: Routledge & Kegan Paul, 1987), 75–109; hereafter abbreviated *S.* Its epigraph is pure Worringer: "The fright of the mind before the unknown created not only the first gods, but also the first art." On Hulme, see especially Miriam Hansen, "T. E. Hulme, Mercenary of Modernism or, Fragments of Avant-Garde Sensibility in Pre-World War I Britain," *ELH* 47 (1980), 335–385.

A crucial medium of ideas for vorticist circles, Hulme was first influenced by Bergson; he then translated Sorel *(Reflections on Violence);* and upon meeting Worringer in Berlin, he embraced his philosophy of art. Like several vorticists and futurists, Hulme died in the war he had welcomed. In *Blasting and Bombardiering,* Lewis recounts a tempestuous relationship

complicated by the fact that Hulme preferred the work of Jacob Epstein. For these details, see Paul Edwards, *Wyndham Lewis, Painter and Writer* (New Haven: Yale University Press, 2000); as well as Robert Ferguson, *The Short Sharp Life of T. E. Hulme* (London: Allen Lane, 2002).

60. The Worringerian model is informed by a developmental logic that ranks cultures according to a racialist hierarchy. Residual in the discipline of art history as developed in the late nineteenth century, this racialism was pronounced in Lewis. But it did not contradict his primitivism: opposed to the modernist cult of "the primitive," he nonetheless insisted that "the art-instinct is permanently primitive" (*B* 33).

61. For example, in "A Review of Contemporary Art" (published in *Blast* 2, July 1915), Lewis writes: "It may be objected that all the grandest and most majestic art in the world (Egyptian, Central African, American) has rather divested man of his vital plastic qualities and changed him into a more durable, imposing and in every way harder machine; and that is true. This dehumanizing has corresponded happily with the unhuman character, the plastic, architectural quality, of art itself" (43). Here the connection to these other arts is made through "the unhuman" more than the abstract.

62. Lewis strove to combine these two figures in his own protagonists and personae. "We are primitive mercenaries in a modern world" (*B* 30), he wrote in *Blast* 1. And Eliot once commented that in Lewis "we recognize the thought of the modern man and the energy of the cave-man" (T. S. Eliot, review of *Tarr* by Wyndham Lewis, *The Egoist* [September 1918]: 106).

63. Jameson locates "the inner logic" of his novels in a related tension between the sheer energy of his sentences and the violent closure of his narratives (Jameson, *Fables of Aggression,* 30).

64. This effect corresponds to the reading of the play by Pound: "the fury of intelligence baffled and shut in by circumjacent stupidity" ("Vorticism," *Fortnightly Review* [1 September 1914: 470]). And this reading in turn suggests that "the spatial" can serve as an abstraction for "the social," as it sometimes does in Lewis.

65. In a short play of the same title published in *Blast,* Lewis writes of the fate of "personality": "It is the one piece of property all communities have agreed it is illegal to possess. When mankind cannot overcome a personality, it has an immemorial way out of the difficulty. It becomes it. It imitates and assimilates that Ego until it is no longer one. . . . This is success" (*B* 66).

———

66. This becoming-inorganic is paralleled in the early work of Max Ernst, who seems to respond to a similar drive in a different way (see chapter 4). Like other Dadaists and surrealists, Ernst played with another form of hardening also developed in Lewis—a becoming-insect of the body—but in a way that inverts its use there: first to mock the becoming-machine of man, and second to explore the imbrication of death in sexuality (thus the significance of the surrealist motif of the praying mantis, the female of which kills the male in mating). The classic texts in the surrealist milieu are by Roger Callois: "La Mante religieuse," *Minotaure* 5 (February 1934), and "Mimétisme et psychasthénie légendaire," *Minotaure* 7 (June 1935); see also chapter 5. In the latter text, Caillois thinks the convulsive possession of the subject by space, which is what Lewis feared.

Lewis was fascinated by insects (his library contained an annotated copy of *Ants, Bees and Wasps* by John Lubbock), which he often used, like machines, to figure his ideal of aggressive armoring. In "The Artist Older Than the Fish," he glosses an account by J. H. Fabre, a French entomologist for whom all action was driven by instinct:

> Fabre describes the creative capabilities of certain beetles, realizable on their own bodies; beasts with a record capacity for turning their form and colour impulses into living flesh. These beetles can convert their faces into hideously carved and detestable masks, can grow out of their bodies menacing spikes, and throw up on top of their heads sinister headdresses, overnight. Such changes in their personal appearance, conceived to work on the psychology of their adversaries, is possibly not a very profound or useful invention, but it is surely a considerable feat. Any art worth the name is, at the least, a feast of this description. The New Guinea barred and whitewashed masks are an obvious parallel.

Wyndham Lewis, *The Caliph's Design* (1919), ed. Paul Edwards (Santa Barbara: Black Sparrow Press, 1989), 66; hereafter abbreviated *CD*.

67. Among other commonalities, Worringer and Freud shared a psychophysiological model of development, and both were driven by an epistemological mandate to correlate new discourses—here art history and psychoanalysis—with the principles of biology and/or physics. In this regard, the primary reference for Freud was Fechner; for Worringer it was Lotze. It is perhaps no surprise that Robert Smithson was interested in both Worringer and Lewis; see chapter 7.

68. Along the way, the drive to self-destruction at its core is sometimes expressed as a drive to master others—a drive often manifested by Lewis the artist, impresario, and man.

69. In the same period, Lewis writes of his fiction similarly: "Upwards from the surface of existence a lurid and dramatic scum oozes and accumulates into the characters we see" (Wyndham Lewis, "Inferior Religions" [1917/27], in *The Complete Wild Body,* ed. Bernard Lafourcade [Santa Barbara: Black Sparrow Press, 1982], 152; hereafter abbreviated *WB*). As "expressions of the conservative nature of living substance," Freud notes the return of certain fish to spawn, the migration of certain birds, and the recapitulation inscribed in embryology (*BPP* 30–31).

70. Lewis defines the Tyro as "an elementary person; an elemental, in short" (Wyndham Lewis, *Tyros and Portraits* [Leicester Galleries, April 1921]; reprinted in *WB* 353.

71. In a private note, Hulme all but images the eye as the point at which the death drive is driven home: "The eyes, the beauty of the world, have been organised out of faeces. Man returns to dust. So does the face of the world to primeval cinders" (*S* 227). Ironically, Lewis became blind in later life.

72. Wyndham Lewis, *Men without Art* (London, 1934; Santa Rosa: Black Sparrow Press, 1987), 99; hereafter abbreviated *MWA*.

73. See Sigmund Freud, *Jokes and Their Relation to the Unconscious* (1905), trans. James Strachey (New York: W. W. Norton, 1963), chapter 7, as well as his 1928 essay on humor.

74. Baudelaire called this convulsive aspect "the satanic" in laughter, an old guise that Lewis often affected (Charles Baudelaire, "On the Essence of Laughter" [1855], in *The Painter of Modern Life and Other Essays,* ed. and trans. Jonathan Mayne [London: Phaidon Press, 1964], 147–165).

75. His pictorial ambition to "bury Euclid deep in the living flesh" is explicit enough (*Wyndham Lewis on Art,* ed. Michel and Fox, 40). Compare this note of Walter Benjamin: "Exposure of the mechanistic aspects of the organism is a persistent tendency of the sadist. One can say that the sadist sets out to substitute for the human organism the image of machinery" (*Passagen-Werk,* ed. Rolf Tiedemann [Frankfurt: Suhrkamp Verlag, 1982], 465–466).

76. As for the first transvaluation: "[Vorticism] was not an asylum from the brutality of mechanical life. On the contrary it identified itself with the brutality, in a stoical embrace" (*Wyndham Lewis the Artist from "Blast" to Burlington House* [London: Laidlaw & Laidlaw, 1939], 78). As for the second:

> When *on joue sa vie,* it is not so much the grandeur of the spectacle of destruction, or the chivalrous splendour of the appointments, as the agitation in the mental field within, of the organism marked down to be destroyed, that is impressive. It is that that produces "the light that never was on land or sea", which we describe as "romance". Anything upon which that coloration falls is at once transfigured. And the source of light is within your own belly. (*BB* 115)

As I have stressed, my reading considers Lewis at his most extreme.

77. This "narrow escape" is indeed one definition of the sublime in Kant and Burke. Marinetti, for his part, seeks not to sublimate shock into the sublime but to arrest it there. Thus in a letter to Severini from the front (November 20, 1914): "I believe . . . that the greatest war, lived with intensity by Futurist painters, can produce real convulsions in their sensibility and spur them towards a brutal simplification of very clear lines such as to strike and incite the reader in the same way that battles strike and incite" (quoted in Raffaele Carrieri, *Futurism,* trans. Leslie van Renssalaer Whie [Milan: Edizioni del Milione, 1963], 158).

78. "What liberates metaphor, symbol, emblem from poetic mania, what manifests its power of subversion, is *the preposterous*" (Roland Barthes, *Roland Barthes by Roland Barthes* [New York: Hill & Wang, 1977], 81).

79. Wyndham Lewis, *The Tyro: A Review of the Arts of Painting, Sculpture and Design* 2 (London: Egoist Press, 1922), 27.

80. See note 7.

———

4 A BASHED EGO

1. The Kapp Putsch occurred in Dresden in March. The classic text on the "bachelor machine" is Michel Carrouges, *Les machines célibataires* (Paris: Arcanes, 1954). Carrouges, however, does not consider these Ernst works.

2. Jacques Lacan, "The Mirror Stage as Formative of the Function of the I," in *Écrits,* trans. Alan Sheridan (New York: W. W. Norton, 1977), 15.

3. Jacques Lacan, "Aggressivity in Psychoanalysis," in *Écrits,* 16. This seems to be a double bind: on the one hand, the subject arrives at coordination, keeps the fragmented body at bay, through aggressivity; on the other, aggressivity also calls up the very images of the fragmented body that threaten the subject.

4. In *Écrits* Lacan reports that, a day after he first delivered the "Mirror Stage" in Marienbad in 1936, he spent a day at the Berlin Olympics, later transformed into a Nazi spectacle of the body by Leni Riefenstahl in her film *Olympiad* (239). For more on these connections, see chapter 8 of my *The Return of the Real* (Cambridge, Mass.: MIT Press, 1996), where I suggest that this Lacanian formulation encrypts a fascist male subject. This might be to generalize this subject as the subject *tout court,* but that might be what Lacan did.

5. Klaus Theweleit, *Male Fantasies,* 2 vols., trans. S. Conway, E. Carter, and C. Turner (Minneapolis: University of Minnesota Press, 1987–89). Of course, there are many theories of fascist subjectivity—some psychoanalytic, some not—from Freud (*Group Psychology and the Analysis of the Ego*) and Wilhelm Reich (*The Mass Psychology of Fascism*) through Theodor Adorno et al. (*The Authoritarian Personality*) to Deleuze and Guattari (*Anti-Oedipus*) and Theweleit. However controversial he may be (for example, his theory does not attend to fascist women), Theweleit is most suggestive in relation to Ernst. Concerned with the unformed or deformed ego, he uses object-relations theory more than he does Freud and Lacan. Contra Freud, he questions whether the fascist subject ever passes through the Oedipus complex; and contra Lacan, he takes up the Deleuze-Guattari polemic against a conception of desire as founded in lack. Nevertheless, Theweleit is also indebted to both Freud and Lacan.

6. Theweleit: "I can think of no single psychoanalytic term developed with reference to the psychotic child that could not equally be applied to a behavioral trait of the 'fascist' male. In

both, object relations are equally impossible: both are distanced from the libidinal, human object world. Both have an 'interior' that is chaoticized, saturated with aggression: both fear that their boundaries will disintegrate on contact with intense external vitality" (*Male Fantasies*, vol. 2, 220). Theweleit draws on Michael Balint and Margaret Mahler here (the term "basic fault" is hers); see in particular Margaret Mahler, *On Human Symbiosis and the Vicissitudes of Individuation* (New York: International Universities Press, 1970).

7. Theweleit, *Males Fantasies,* vol. 1, 418; original emphasis.

8. Theweleit: The Freikorps soldier "rediscovers his boundaries only as a killer" (*Male Fantasies,* vol. 2, 38). On this dynamic of binding and unbinding, see chapter 3 above.

9. The phrase "inner experience" derives from Ernst Jünger, *Der Kampf als inneres Erlebnis* (1922). The mystical importance of the front for the fascist cannot be overestimated. In "Theories of Fascism" (1930), a review of an essay collection on the war edited by Ernst Jünger, Benjamin remarks that the loss of World War I came to be treated as "the innermost essence" of Germany (Walter Benjamin, *Selected Writings, Volume 2: 1927–1934,* ed. Michael Jennings et al. [Cambridge, Mass.: Harvard University Press, 1999], 312–321).

10. Ernst von Salomon quoted in Theweleit, *Male Fantasies,* vol. 2, 179. Solomon was an accessory to the murder of the prominent Jewish politician and financier Walter Rathenau. In Freikorps literature Theweleit notes a persistent version of the trope of man coupled with machine, the (machine) gun as whore, the sadism of which Hans Bellmer explores in his *Machine Gunneress in a State of Grace* (1937). See chapter 4 of my *Compulsive Beauty* (Cambridge, Mass.: MIT Press, 1993).

11. Ernst Jünger quoted in Theweleit, *Male Fantasies,* vol. 2, 179; and Jünger, "Photography and the 'Second Consciousness,'" in Christopher Phillips, ed., *Photography in the Modern Era* (New York: The Metropolitan Museum of Art, 1989), 207. This formulation again recalls Marinetti; in a sense it is the "cold," Nordic complement to his "hot," Mediterranean version, with this crucial difference: the likes of Jünger put it into practice. On such "political algodicies of the solid block, strength-through-joy, iron front, shoulder-to-shoulder, steel-ego, reconstruction ego type," see Peter Sloterdijk, *Critique of Cynical Reason,* trans. Michael Eldred (Minneapolis: University of Minnesota Press, 1987), here 460. See also Jeffrey Herf, *Reactionary*

Modernism: Technology, Culture, and Politics in Weimar and the Third Reich (Cambridge: Cambridge University Press, 1984).

12. Ernst in an interview with Patrick Waldberg, "La Partie de Boules: Die Boules-Partie," in *Max Ernst in Selbstzeugnissen und Bilddokumenten* (Hamburg, 1969), 35; Max Ernst, *Beyond Painting* (New York: Wittenborn & Schultz, 1948), 14. The latter includes several texts, most published in surrealist journals, the earliest of which dates from 1927.

13. Some historians date his first encounter with Freud texts to 1911, others to 1913. For his possible use of Kraepelin, see Elizabeth R. Legge, *Max Ernst: The Psychoanalytic Sources* (Ann Arbor: UMI Press, 1989), 11–16; she also lists other recent texts on his connections to psychoanalysis. *Jokes* might have inflected his Dadaist play with neologisms in titles and inscriptions, and *Dreams* his notion of the surrealist image as a picture puzzle of broken meanings. As Sander Gilman has noted, the "mythopoesis of mental illness . . . dominated the German intellectual scene in the opening decades of the twentieth century." See Sander Gilman, *Difference and Pathology: Stereotypes of Sexuality, Race and Madness* (Ithaca: Cornell University Press, 1985), 217–238.

14. In a reprise of a passage in *Beyond Painting,* Ernst writes in "Notes pour une biographie":

> Near Bonn there was a group of gloomy-looking buildings that in many respects recalled the Sainte-Anne Hospital in Paris. In this "home for the mentally ill" students could take courses and practical seminars. One of these buildings contained an astonishing collection of sculptures and paintings by the involuntary inhabitants of this frightful place—particularly figures made of breadcrumbs. They profoundly moved the young man, who was tempted to see strokes of genius in them and who decided to explore the vague and dangerous regions on the margins of insanity. Only later, however, was he to discover certain "procedures" that helped him penetrate into this "no-man's land."

Max Ernst, *Écritures* (Paris: Le Point du jour, 1970), 20. In *The Discovery of the Art of the Insane* (Princeton: Princeton University Press, 1989), John MacGregor questions the veracity of this statement (278).

———

15. The first two characteristics are noted by Hans Prinzhorn in his *Artistry of the Mentally Ill,* trans. Eric von Brockdorff (Vienna: Springer Verlag, 1972), 48, 60.

16. I have framed this issue in terms of intention, but it need not be the case. Ernst is in the position of both analyst and analysand here.

17. I am indebted for much information here to Werner Spies, *Max Ernst Collages: The Invention of the Surrealist Universe,* trans. John William Gabriel (New York: Harry N. Abrams, 1991); Wulf Herzogenrath, ed., *Max Ernst in Köln* (Cologne: Rheinland Verlag, 1980); William Camfield, *Max Ernst: Dada and the Dawn of Surrealism* (London: Tate Gallery, 1991); Ludger Derenthal and Jürgen Pach, *Max Ernst* (Paris: Casterman, 1992); and Charlotte Stokes, "Rage and Liberation: Cologne Dada," in Charlotte Stokes and Stephen Foster, eds., *Dada Cologne Hanover* (New York: G. K. Hall, 1997). This chapter also benefited from a close reading by Matt Witovsky.

18. "German intellectuals can neither pee nor shit without ideologies," Ernst writes Tristan Tzara on February 17, 1920 (quoted in Spies, *Max Ernst Collages,* 270). And it is often said that Ernst is not political, not even in his Dada days in Cologne; yet, like the Berlin Dadaists, he has exhibitions closed and publications seized by the police.

19. Ernst, "Biographical Notes," in *Beyond Painting,* 31; Spies, *Max Ernst Collages,* 48. He also meets Hugo Ball and Emmy Hennings in Munich at this time, and begins to correspond with Tzara by December 1919.

20. Ernst publishes Picabia in his new Dadaist publication *Bulletin D.* For the now-familiar associations of his early collages with Duchamp and Picabia, see Spies, *Max Ernst Collages;* and Camfield, *Max Ernst.* Ernst claimed that his interest in mechanical elements stemmed from wartime experiences more than from those Dadaists (Spies, 33).

21. Ernst, "Biographical Notes," in Camfield, *Max Ernst,* 294. Philipp also painted Max in uniform, replete with the Iron Cross that he won in the war. Apparently, Max would paint out the Cross on visits home, and Philipp would paint it back in.

22. However, they might be related to the early collages that Schwitters made from printing rejects.

23. Gilles Deleuze and Félix Guattari, *Anti-Oedipus: Capitalism and Schizophrenia* (1972), trans. Robert Hurley, Mark Seem, and Helen Lane (New York: Viking, 1977), 31.

24. See Wolfgang Schivelbusch, *The Culture of Defeat: On National Trauma, Mourning, and Recovery,* trans. Jefferson Chase (New York: Metropolitan Books, 2003). In effect, Ernst delivers his own little "stabs in the back" with these images.

25. Hugo Ball, *Flight Out of Time* (1927), trans. Ann Raimes (New York: Viking, 1974), 65. "Hypertrophic" is a term used sarcastically by Picabia and Tzara in relation to poetry and painting respectively.

26. I associate this strategy of mimetic adaptation or exacerbation with the great challenge of Marx: "petrified social conditions must be made to dance by singing them their own song" (Karl Marx, "A Contribution to the Critique of Hegel's Philosophy of Right, Introduction," in *Early Writings,* ed. T. B. Bottomore [New York: McGraw-Hill, 1964], 47; translation modified). It is also akin to "kynical irony" as discussed by Sloterdijk in *Critique of Cynical Reason;* I borrow the term "bashed ego" from him (see 391–409). There are fragments of a theory of mimetic exacerbation in Benjamin and Adorno. See, for example, Theodor Adorno, *Aesthetic Theory,* trans. Robert Hullot-Kentor (Minneapolis: University of Minnesota Press, 1997): "Art is modern art through mimesis of the hardened and alienated." For more on this strategy, see my "Dada Mime," *October* 105 (Summer 2003); and chapter 5 below.

27. Ernst quoted in Werner Spies, ed., *Max Ernst: A Retrospective* (Munich: Prestel Verlag, 1991), 21.

28. On this distinction, see chapter 8.

29. See Sigmund Freud, *Beyond the Pleasure Principle* (1920), trans. James Strachey (New York: W. W. Norton, 1961), 6–7, 23–27.

30. Ball, *Flight Out of Time,* 54. "But since it turns out to be harmless," Ball adds, "the spectator begins to laugh at himself about his fear." This points to the limitations of mimetic adaptation (more on this below).

31. Spies sees in the figure on the right the letters "MAX"; see *Max Ernst Collages,* 72.

32. Perhaps the French-German salad also speaks to Ernst's "schizo" position at this time: suspended between various avant-gardes, oriented to Paris but stranded in Cologne. Again, this internationalism would also be provocative in the ferociously anti-French climate of postwar Germany.

33. In an announcement in *Die Schammade* for *Fiat modes,* a work discussed below, Ernst is described as *der Gebärmutter methodischen Irrsinns,* literally "the uterus of methodical madness."

34. There is a sociological use of this trope as well. For example, Norbert Elias uses it to think the development of a military-industrial body in *The Civilizing Process* (1939), trans. Edmund Jephcott (New York: Urizen Books, 1978). Concerned with armoring as a psychic phenomenon, Theweleit is ambivalent about this sociological account: on the one hand, he speaks of "the technization of the body"; on the other, he argues that "it has nothing to do with the development of machine technology" (*Male Fantasies,* vol. 2, 202, 162).

35. I intimated above that his postwar "resuscitation" as Dadamax mimed an autistic defense, and that his "self-constructed little machines" recalled autistic systems. Such machinic systems are sometimes found in the art of the mentally ill gathered by Prinzhorn, but he did not theorize them as such (see chapter 5). Long afterward, the psychotherapist Bruno Bettelheim began to do so in a controversial case study of a boy named Joey, whose autism was marked by an apprehension of his body as "run by machines." These machines, which Joey represented in a way sometimes reminiscent of the Ernst collages, served both to drive him and to protect him, as a "defensive armoring" against dangers from within and without. However, this armoring placed Joey in a double bind, for he also needed periodic release from it, a release that came in the form of catastrophic "explosions." These explosions left him, in the depths of his autism, with the fear that he had no body left at all, that its waste was everywhere, that he lived in a "world of mire." (Theweleit detects a related double bind, and a similar fear of "mire," in his fascist subjects.) The machines were thus attempts to abject this world, to reestablish his boundaries. Needless to say, they were hardly satisfactory, and "his defensive armoring ended in total paralysis." See Bruno Bettelheim, *The Empty Fortress: Infantile Autism and the Birth of the Self* (New York: Free Press, 1967), 233–339.

36. I return to this eroticization in chapter 5. Here is one passage concerning his overpainted collages (Ernst repeats it with variations for his other techniques):

———

One rainy day in 1919, finding myself in a village on the Rhine, I was struck by the obsession which held under my gaze the pages of an illustrated catalogue showing objects designed for anthropologic, microscopic, psychologic, mineralogic, and paleontologic demonstration. There I found brought together elements of figuration so remote that the sheer absurdity of that collection provoked a sudden intensification of the visionary faculties in me and brought forth an illusive succession of contradictory images, double, triple and multiple images, piling up on each other with the persistence and rapidity which are peculiar to love memories and visions of half-sleep. (*Beyond Painting,* 14)

On this "primal scene" of aesthetic creation, see chapter 3 of my *Compulsive Beauty.*

37. Renowned for her romantic adventures, Marie Laurencin attempted to get Ernst a visa at this time—without success. See Uwe Schneede, *Max Ernst* (London: Thames & Hudson, 1972), 21.

38. The formulation is that of the critic Patrick Waldberg; see Ernst, "Biographical Notes," in Camfield, *Max Ernst,* 285.

39. Tristan Tzara, "Dada Manifesto," in Robert Motherwell, ed., *The Dada Painters and Poets* (Cambridge, Mass.: Harvard University Press, 1989), 78. In this respect, the Dadaist (anticapitalist) vision of "the engineer" is very different from the (pro-communist) constructivist vision: the former is a figure of reification that works down from society to the subject; the latter is a figure of idealization that moves from the subject to society at large. Ernst does not share the interest in constructivism shown by some Dadaists, especially in Berlin. Indeed, his *Self-Constructed Little Machine* is quite other to "the man with a movie camera" imagined by Dziga Vertov in his 1929 film, say, just as his self-portrait *The Punching Ball or the Immortality of Buonarroti* is quite other to the famous El Lissitzky self-portrait *The Constructor* (1924).

40. Ball, *Flight Out of Time,* 117 (May 23, 1917). The "cubist" novella by Carl Einstein titled *Bebuquin, the Dilettantes of the Wondrous* (1912), is perhaps influential here as well; Ball: "Carl Einstein's *Dilettanten des Wunders* shows the way" (*Flight Out of Time,* 10). On the ambivalence of the artist-as-dandy, see my *The Return of the Real* (Cambridge, Mass.: MIT Press, 1996), 121–122.

41. In this collage an inscription alludes to *furchtlose verrichtungen,* or "fearless performances," which suggests *fruchtlose verrichtungen,* or "fruitless performances" (in all these titles, even the letters fail to "rise up" as capitals). A related figure is titled *Chilisalpeterlein;* saltpeter was an old treatment for syphilis.

42. Kaja Silverman, "Masochism and Male Subjectivity," *Camera Obscura* 17 (May 1988), 51. Silverman elaborates the strategy of phallic divestiture in *Male Subjectivity at the Margins* (New York: Routledge, 1992). George Baker discusses it in relation to Francis Picabia in *The Art Work Caught by Its Tail* (Cambridge, Mass.: MIT Press, forthcoming).

43. Ball: "What we call Dada is a farce of nothingness in which all higher questions are involved; a gladiator's gesture, a play with shabby leftovers, the death warrant of posturing morality and abundance"(*Flight Out of Time,* 65 [June 12, 1916]).

44. Spies, *Max Ernst Collages,* 79.

45. Ursula Dustmann suggests "maggoty shame" in Herzogenrath, ed., *Max Ernst in Köln,* 118. Again, this is especially corrosive in the context of the pervasive shame following the loss of the war.

46. There are many images of transvestitism in Dada beyond the Baargeld self-portrait, and they take on different valences (in Hannah Höch, for example, the effect is one of phallic empowerment). Phallic concerns run through other Ernst collages and photocollages of the time. In one (figure 155 in Spies, *Max Ernst Collages*), a man gazes at an amorous couple with a massive corn cob between his legs and a bear by his side; in another (figure 156), a man in drag gazes up at two hunks of meat that hang above a seductive woman on a chaise-longue.

47. This fantasy of creation *ex nihilo* is a strong current in modernist sculpture from Constantin Brancusi through David Smith; in a sense, Ernst mocks it here.

48. Or so Ernst told Spies (in *Max Ernst Collages,* 58).

49. See Ernst, *Beyond Painting,* 16. Like the unconscious, the surrealist image, visual as well as verbal, is often neologistic in this way.

50. Freud, "Medusa's Head, " in Phillip Rieff, ed., *Sexuality and the Psychology of Love* (New York: Collier Books, 1963), 212. I return to this paradoxical logic in chapters 6 and 7. It is again at work in the first Ernst collage-novel, *La Femme 100 têtes* (1929), in which "100," *cent,* sounds like *sans,* "without." One might also argue that this multiplication disperses the penile form, drains away whatever phallic force it might possess. And yet this, too, might partake of what Jacques Derrida has called "the logical paradox of the apotropaic: castrating oneself already, always already, in order to be able to castrate and repress the threat of castration, renouncing life and mastery in order to secure them; putting into play by ruse, simulacrum, and violence just what one wants to preserve" (*Glas,* trans. John P. Leavey, Jr., and Richard Rand [Lincoln: University of Nebraska Press, 1986], 46).

51. See Eugénie Lemoine-Luccioni, *La Robe: Essai psychanalytique sur le vêtement* (Paris: Seuil, 1983), 34. I discuss the penis/phallus distinction further in chapters 3 and 6.

52. For the most part, it seems, the mother is elided in this aggression against the father, though *Farewell My Beautiful Land of Marie Laurencin* might be one exception.

53. Lukács discusses "second nature" in the nearly contemporaneous *The Theory of the Novel,* written in 1914–15 but published in 1920: "This second nature is not dumb, sensuous and yet senseless like the first: it is a complex of senses—meanings—which has become rigid and strange, and which no longer awaken interiority; it is a charnel-house of long-dead interiorities" (*The Theory of the Novel,* trans. Anna Bostock [Cambridge, Mass.: MIT Press, 1971], 64).

54. Perhaps in a work like *Phallustrade* Ernst anticipates the dolls of Bellmer. (Ernst and Bellmer did not meet until later; for a short time during World War II they were interned together as German aliens in France.)

55. Similarly the overpaintings, Rosalind Krauss has argued, suggest "a visual model that is at one and the same time the complete reversal of traditional perspective and the total refusal of its modernist alternative" ("The Master's Bedroom," *Representations* 28 [Fall 1989], 66). In the final lithograph the figure is but a gadget hanging like a puppet from a pulley contraption, and in the penultimate image the phrase "Towards the New Art?" is followed by two Ds (most likely for Dada) that are falling down.

56. See Anson Rabinbach, *The Human Motor* (New York: Basic Books, 1990): "The psycho-technical movement in Germany experienced its greatest influence in the early 1920s" (278). This was more rhetorical than actual: in the 1920s, "only 1 per cent of industry was actually rationalized along Ford's and Taylor's lines" (Schivelbusch, *The Culture of Defeat,* 280).

57. Georg Lukács, *History and Class Consciousness,* trans. Rodney Livingstone (Cambridge, Mass.: MIT Press, 1986), 89. "With the modern 'psychological' analysis of the work process this rational mechanization extends right into the worker's 'soul'" (88).

58. *"bedecktsamiger stapelmensch nacksamiger wasserformer ('edelformer') kleidsame nervatur auch !umpressnerven!" The Hat Makes the Man* is an overpainting of found and collaged images, with some hats inverted. *The Sandworm Who Reties Her Sandal* (1920) is its female complement: here Ernst inverts an illustration of two rows of bonnets, and paints it over in such way as to create a world in which human hats in a magazine have become sandworms on a dune. The implication is that fashion now penetrates nature with its fetishistic form of (in)animation, that its "sex appeal of the inorganic" (to use the Benjaminian formula of the commodity fetish) reproduces on its own.

59. See Siegfried Kracauer, *The Mass Ornament,* trans. Thomas Y. Levin (Cambridge, Mass.: Harvard University Press, 1995).

60. A Frankensteinian twist on the modern worker-subject is almost explicit in the photo-collage *Anatomy as Bride* (1921; Spies, *Max Ernst Collages,* 174), a kind of mechanical *cadavre exquis.* (Spies claims that "these plate-prints are the first compositions in twentieth-century art to be based on the serial principle" [45].) They might also comprise an early instance of the horizontal reorientation of the image as a sort of quasi-random operation that, according to Leo Steinberg, was fully achieved only in "the flat-bed picture-plane" of Robert Rauschenberg over thirty years later (again, the kind of "schizophrenic" mind that Steinberg sees projected there is also intimated here). See Leo Steinberg, *Other Criteria* (New York: Oxford University Press, 1972), 55–91.

61. Walter Benjamin, *Illuminations,* ed. Hannah Arendt, trans. Harry Zohn (New York: Schocken Books, 1969), 176–178. Benjamin met Ball and Emmy Hennings in 1918 in Bern.

62. Perhaps this strange geography was influenced by his experience of the front (during the war, Ernst also worked on military maps).

63. This resurfacing might also figure a return of the repressed, and it might be here, in these overpaintings, that Ernst initiates the search for spatial analogues of the unconscious, its archaeology (or geology), that he pursues in his surrealist work (see chapter 5).

64. In a sense, this overpainting is his version of *The Bride Stripped Bare by Her Bachelors, Even* (1915–23) (which Ernst could not have seen at the time), for it, too, presents two (dis)connected zones with implications of frustrated desire.

65. See Rabinbach, *The Human Motor,* passim. Once more Ernst works this vision of entropy procedurally, for even as some of the overpaintings evoke a disinterring of figures *from* the ground, others evoke a leaching of figures *into* the ground, again in a general wearing away of the world. For Michel Serres, Turner is the great painter of the world as motor (or, in his terms, the world become furnace), for in his landscapes "matter and color triumph over line, geometry, and form"(Michel Serres, "Turner Translates Carnot," in *Hermes: Literature, Science, Philosophy* [Baltimore: Johns Hopkins University Press, 1982], 57). In turn, Ernst is the great painter of the world as motor grown cold.

66. Rabinbach: "The war seemed to be the apotheosis of the dance of entropy and energy: the enormous power and force of the universe unleashed in the service of death and destruction—a fitting end to the century of thermodynamics" (*The Human Motor,* 259).

67. Theodor Adorno, "Spengler after the Decline," in *Prisms,* trans. Samuel and Shierry Weber (Cambridge, Mass.: MIT Press, 1981), 67, 69.

68. Freud, *Beyond the Pleasure Principle,* 30. The move "beyond painting" that Ernst proposes at this time might be seen as the aesthetic correlative to the move "beyond the pleasure principle" that Freud postulates also at this time.

69. On this score, these works look ahead to the caustic deployment of entropy against conventional fictions of order—subjective, artistic, and historical—that Robert Smithson devised in the 1960s (see chapter 7).

70. See note 26.

71. Ball, *Flight Out of Time,* 66 (June 12, 1916); Sloterdijk, *Critique of Cynical Reason,* 441.

72. Yet this limitation is less personally chosen than historically determined, a matter of objective constraints placed on political possibility. In this regard, if the Dadaists mimed "the bliss of the epileptic," they hardly possessed the cure. "In the nights of annihilation of the last war the frame of mankind was shaken by a feeling that resembled the bliss of the epileptic," Benjamin writes in "One-Way Street" (1928). "And the revolts that followed it were the first attempt of mankind to bring the new body under its control. The power of the proletariat is the measure of its convalescence" (*Reflections,* trans. Edmund Jephcott [New York: Harcourt Brace Jovanovich, 1978], 94).

5 Blinded Insights

1. Today this particular trio of exotics might strike us as odd, but at the time they were seen as necessary guides in the modernist search for "primal beginnings in art" (Paul Klee). Straightaway, then, we face the old modernist paradox that artistic primacy and expressive immediacy were pursued through the mediation of representations as complex as psychotic images, tribal objects, and the drawings of children.

2. See Cesare Lombroso, *Genio e follia* (Milan, 1864); translated into French in 1889, English in 1891, and German in 1894. On the historical reception of the art of the mentally ill, see especially John MacGregor, *The Discovery of the Art of the Insane* (Princeton: Princeton University Press, 1989).

3. Of course, the very distinction between internal and external is also at stake in paranoia. See Sigmund Freud, "Psychoanalytic Notes on an Autobiographical Account of a Case of Paranoia (Dementia Paranoides)," in Phillip Rieff, ed., *Three Case Histories* (New York: Collier Books, 1963); Emil Kraepelin, *Dementia Praecox and Paraphrenia,* trans. R. M. Barclay (Huntington, NY: Robert E. Krieger, 1971); and for Eugen Bleuler, *Dementia Praecox, or the Group of Schizophrenias,* trans. J. Zinken (New York: International Universities Press, 1950). In *Anti-Oedipus,* Deleuze and Guattari oppose schizophrenia and paranoia too, which they also relate to limits—crises—in the social order, but there is an anti-Freudian voluntarism in this great text, residual from the antipsychiatric movement of the 1960s, that I do not share.

4. Hans Prinzhorn, *Artistry of the Mentally Ill,* trans. Eric von Brockdorff (New York: Springer Verlag, 1972); hereafter abbreviated *AMI.*

5. For Prinzhorn this "configurative process" is universal, but many works in the *Artistry* are historically specific—with particular German script, personae (e.g. Wilhelm II), institutions, and so on.

6. As early as 1921, a Hamburg professor named Wilhelm Weygrandt used a condemnatory juxaposition of insane and modernist art, a device extended by Paul Schultze-Naumburg in *Kunst und Rasse* in 1935 and then, of course, in *Entartete "Kunst"* in 1937. In 1933 the Nazis installed Carl Schneider as director of the Heidelberg clinic; it was he who provided materials for the 1937 exhibition. Schneider became scientific director of the Nazi extermination program of mental patients, and many of the patients in the Prinzhorn collection met this fate. See Bettina Brand-Claussen, "The Collection of Works of Art in the Psychiatric Clinic, Heidelberg—from the Beginnings until 1945," in Brand-Claussen et al., eds., *Beyond Reason: Art and Psychosis—Works from the Prinzhorn Collection* (London: Hayward Gallery, 1996).

7. Already in the *Artistry* Prinzhorn sees the danger here: "Such comparisons . . . are vulgar and sensational . . . it is superficial and wrong to infer an equality of the underlying psychic conditions from external similarities" (*AMI* 271).

8. This tension between Kantian and Hegelian imperatives—between, say, "configuration" and "drive"—was felt throughout the discipline of art history. Incidentally, Prinzhorn took his doctorate in 1908, the same year that a fellow Lipps student, Wilhelm Worringer, published his influential dissertation *Abstraction and Empathy* (see chapter 3).

9. On this point Brand-Claussen is severe but exact: "Prinzhorn's notion of unconscious creativity stands revealed as a case of Expressionist wishful thinking" (*Beyond Reason,* 12).

10. The notion of an insight that stems from a blindness is drawn, of course, from Paul de Man, *Blindness and Insight* (Minneapolis: University of Minnesota Press, 1971).

11. As we have seen, Prinzhorn warns against this equation between image and psyche at the end of the *Artistry* (see note 7). At the outset, however, he claims it: "we therefore posit the

realm of expressive facts, in which psychical elements appear directly and are apprehended equally directly, without the juxtaposition of any intellectual apparatus" (*AMI* 13). At other moments he is less sure: "what and how much of the psyche expresses itself in such an autocratic world of form?" (*AMI* 72). This uncertainty appears irreducible in many psychoanalytic accounts of art—including, perhaps, my own here.

12. Paul Klee, *The Inward Vision,* trans. Norbert Guterman (New York: Harry Abrams, 1959), 5.

13. Felix Klee, *Paul Klee: His Life and Work in Documents* (New York: George Braziller, 1962), 184. The ambiguity between "still" and "again" is telling of the difficulty of placing this vision temporally.

14. Ibid.; Paul Klee, *Tagerbücher 1898–1918* (Stuttgart: Verlag Gerd Hatje, 1988), no. 905, 320–322.

15. Oskar Schlemmer, *The Letters and Diaries of Oskar Schlemmer,* ed. Tut Schlemmer (Middletown, Conn.: Wesleyan University Press, 1972), 83. Klee might also have seen a selection of the collection in January 1921 at Zinglers Kabinett in Frankfurt, where he would show a year later.

16. Felix Klee, *Paul Klee,* 183; quoted from Lothar Schreyer, *Erinnerungen an Sturm und Bauhaus* (Munich: Langen & Müller, 1956). How much we can trust this memory of a conversation is open to dispute.

17. Walter Benjamin, "Karl Kraus" (1931), in *On Reflections,* trans. Edmund Jephcott (New York: Harcourt Brace Jovanovich, 1978), 273. His allegorical account appears in "Theses on the Philosophy of History" (1940), in *Illuminations,* trans. Harry Zohn (New York: Schocken Books, 1969), 257–258. There are many accounts of this angel, among them O. K. Werckmeister, "Walter Benjamin, Paul Klee, and the Angel of History," *Oppositions* (Fall 1982): "He first saw it as an allegory of metaphysical experience, then of opposition, and finally of survival in the midst of a historical catastrophe where texts and images were no longer of any use" (115).

18. This particular work is not in the *Artistry,* but related images are included. For one image Knüpfer provided this gloss (as extrapolated by Prinzhorn): "The large circle with the wreath

of rays is intended to be a monstrance, as we know from other drawings, to which the tiny body is a handle. At the same time the circle is the face of a clock, the sun, and the face of the little man according to the inscription represents the lamb of God, i.e., Christ, with whom Knüpfer usually identifies himself, so that we have to assume at least five or six meanings" (*AMI* 174). As readers of Judge Schreber know, rays often figure paranoid influence, as do the birds in the image that speak to him. Also quintessentially paranoid is the identification with Christ, more on which below.

19. Jean Dubuffet, *Prospectus et tous écrits suivants* (Paris: Gallimard, 1967); "Art Brut in Preference to the Cultural Arts" (1949), trans. Paul Foss and Allen S. Weiss, *Art & Text* 27 (December-February 1988), 33.

20. Dubuffet, "Honneurs aux valeurs sauvages," *Prospectus,* vol. 1, 213.

21. Dubuffet, "Positions anticulturelles," in *Prospectus,* vol. 1, 94; *Jean Dubuffet* (New York, 1960), 2.

22. By his own later admission: "I quite agree that no art form exists that is not in some way dependent on cultural givens" (*L'Homme du commun à l'ouvrage* [Paris: Gallimard, 1973], 439). On such gambits see Griselda Pollock, *Avant-Garde Gambits 1888–1893* (London: Thames & Hudson, 1992).

23. Dubuffet, "Art Brut in Preference," 33.

24. Michel Foucault, "A Preface to Transgression," in *Language, Counter-Memory, Practice,* ed. Donald F. Bouchard (Ithaca: Cornell University Press, 1977), 30. The essay first appeared in "Hommage à Georges Bataille," *Critique* 195–196 (1963).

25. Both in horror and in delight, the body is sometimes transformed into a kind of sex machine, often with sacramental or sacrilegious overtones—and sometimes both at once.

26. Dubuffet as quoted by MacGregor in *The Discovery of the Art of the Insane,* 303. For a graphic account of this apprehension of crisis in the symbolic order, see chapter 7 below.

27. This speculation was first proposed in chapter 4. My line of thought here is indebted to Eric Santner's brilliant text *My Own Private Germany: Daniel Paul Schreber's Secret History of Modernity* (Princeton: Princeton University Press, 1996). "The social and political stability of a society as well as the psychological 'health' of its members," Santner writes,

> would appear to be correlated to the efficacy of these symbolic operations— to what we might call their *performative magic*—whereby individuals "become who they are," assume the social essence assigned to them by way of names, titles, degrees, posts, honors, and the like. We cross the threshold of modernity when the attenuation of these performatively effectuated social bonds becomes chronic, when they are no longer capable of seizing the subject in his or her self-understanding. The surprise offered by the analysis of paranoia . . . is that an "investiture crisis" has the potential to generate not only feelings of extreme alienation, anomie, and profound emptiness, anxieties associated with *absence;* one of the central theoretical lessons of the Schreber case is precisely that a generalized attenuation of symbolic power and authority can be experienced as the collapse of social space and the rites of institution into the more intimate core of one's being. The feelings generated thereby are, as we shall see, anxieties not of absence and loss but of overproximity, loss of distance to some obscene and malevolent presence that appears to have a direct hold on one's inner parts. (xii)

In this regard, the art of the mentally ill does possess an immediacy, but an immediacy less to the symbolic (to an artistic essence) than to the real (to a primal condition that the symbolic screens from us and for us). Perhaps one can view this art diagnostically after all—but in relation to a sick symbolic order.

28. As we have seen, Prinzhorn oscillates between these readings. According to Brand-Claussen: "The whole avant-garde concept of willfully violating pictorial convention—a practice that emerged unscathed from any amount of hostile comparisons with the art of the mentally ill—finds its ultimate expression in Prinzhorn's model, according to which the autistic, mad artist makes visible, in the '*unio mystica* with the whole world,' what it is that marks out the genuine artist" (*Beyond Reason,* 14).

29. Max Ernst, *Beyond Painting* (New York: Wittenborn & Schultz, 1948), 13; hereafter abbreviated *BP. Beyond Painting* consists of several fragments, versions of which were first published in surrealist journals from the late 1920s through the middle 1930s. The phrase "to escape the principle of identity" is a quotation from a review by Breton of a 1921 show of early Ernst collages (*BP* 177).

30. Max Ernst, "Notes pour une biographie," in *Écritures* (Paris: Le Point du Jour, 1970), 20.

31. André Breton, "Artistic Genesis and Perspective of Surrealism" (1941), in *Surrealism and Painting,* trans. Simon Watson Taylor (London: Macdonald, 1972), 64. Of course, the allusion to Lautréamont is to his "chance encounter of a sewing machine and an umbrella on a dissecting table" that surrealism adopted as its motto, and the allusion to Rimbaud is to his "alchimie du verbe" in *A Season in Hell,* which Ernst terms "the miracle of total transfiguration" in *Beyond Painting.*

32. For more on the primal scene in Ernst, see my *Compulsive Beauty* (Cambridge, Mass.: MIT Press, 1993), from which a few paragraphs here are adapted.

33. Compare Prinzhorn on one of his masters: "He composes completely passively, almost as a spectator" (*AMI* 143). Here again there might be echoes of the passivity of Schreber.

34. Ernst alludes to it in *Beyond Painting* (*BP* 7), as does André Breton in *L'Amour fou;* so too, for that matter, does Prinzhorn in the *Artistry* (*AMI* 18–19).

35. See Rosalind Krauss, "The Master's Bedroom," *Representations* 28 (Fall 1989). "What is projected here is a visual field that is not a latency, an ever renewed upsurge of the pure potentiality of the external, but instead a field that is already filled, already—to say the word—readymade" (65). On the staging of the image in a way that seems to burn away its support, see Victor Burgin, "Diderot, Barthes, *Vertigo,*" in *The End of Art Theory* (Atlantic Highlands, NJ: Humanities Press International, 1986). As we saw in chapter 1, the apparent burning away of the support produces an oeneric intensity (as in the Wolf Man), yet the image remains a palimpsest, a screen made up of multiple screens. In a sense, if late modernist abstraction suggests a "strictly optical" space (according to Clement Greenberg), the overpaintings suggest a "strictly psychical" space.

36. Compare the transformational illogic of the Prinzhorn master, August Natterer, discussed in chapter 7. For Krauss, the closest analogue of the overpaintings is the screen memory, "an apparatus by means of which vision is retrojected, projected after the fact onto the fully saturated ground of the readymade" ("The Master's Bedroom," 69).

37. This aesthetic was later made programmatic, almost rote, in the "paranoid-critical method" of Salvador Dalí. *Beyond Painting* can be read as a passage from Dadaist strategies that mime pre-Oedipal regression to surrealist stories of Oedipal riddling. In his work of the early 1920s, Ernst does pass from late Dadaist collages sometimes evocative of a primal scene to early surrealist paintings that are often Oedipal in theme. He also moves from the autistic persona "Dadamax" to the hybrid figure "Loplop," who functions sometimes as an external superego (especially when identified with a castrative father). In a sense, Ernst moves from a position of Dadaist negativity to one of surrealist redemption, an aesthetic of restorative self-fashioning more than of "convulsive identity."

38. Dubuffet favors the animalistic over the mechanistic, while Klee sometimes combines the two, as in his well-known *Twittering Machine* (1922).

39. Freud, "Psychoanalytic Notes on an Autobiographical Account of a Case of Paranoia," 174. This process is also at work in the images of August Natterer discussed in chapter 7.

40. See Erwin Panofsky, *Perspective as Symbolic Form* (1924–25), trans. Christopher Wood (New York: Zone Books, 1991). Here, too, Klee perverts an old project of his own, set nearly twenty years before in summer 1902: "Spiritualization of landscape, mingling of its psyche with human sensibility" (Felix Klee, *Paul Klee*, 8).

41. Roger Caillois, "Mimicry and Legendary Psychasthenia" (1937), *October* 31 (Winter 1984), 30; original emphasis. For other such evocations, see Louis A. Sass, *Modernism and Madness* (New York: Basic Books, 1992).

42. Sometimes these two operations—dissolution into space and projection of space—seem to occur at once, as in some images by the Prinzhorn master Heinrich Welz, who may have influenced Klee. See James Smith Pierce, "Paul Klee and Baron Welz," *Arts Magazine* (September 1977).

43. Freud liked to associate the system-building of paranoia with philosophy: "a paranoiac delusion is a caricature of a philosophical system," he writes in *Totem and Taboo* (1913; trans. James Strachey [New York: W. W. Norton, 1950], 73). Did he sense that the analogy might run the other way too? Might the systematizing of madness in psychoanalysis be a defense against madness? There is a paranoid dimension in much postwar French philosophy as well—the alienation of the gaze in Sartre and Lacan, the power of surveillance in Foucault, and so on—but its stake is different. As suggested above, perhaps the very critique of the subject in such philosophy is also a secret mission to rescue it. "In paranoia," Leo Bersani has argued, "the primary function of the enemy is to provide a definition of the real that makes paranoia necessary. We must therefore begin to suspect the paranoid structure itself as a device by which consciousness maintains the polarity of self and nonself, thus preserving the concept of identity" ("Pynchon, Paranoia, and Literature," in *Representations* 25 [Winter 1989], 109).

44. This understanding is echoed in a 1936 essay "The Art of the Mentally Ill" by the Viennese psychoanalyst and art historian Ernst Kris, who visited the Prinzhorn collection. Influenced by Freud on paranoia, Kris was critical of the Prinzhorn idealization of this art, which he read instead as a failed project of "restitution." See his *Psychoanalytic Explorations in Art* (New York: Schocken Books, 1964).

45. There is another tension between machinic representations: some seem designed to shore up a damaged ego, to defend against schizophrenic self-dissolution, along the lines discussed above; others to depict paranoid fantasies of external control, along the lines proposed by Viktor Tausk, a Viennese associate of Freud, in his 1919 paper "On the Origin of the Influencing Machine" (*Psychoanalytic Quarterly* [1933], reprinted in *Zone* 6 [1992]). According to Tausk, the "influencing machine" is a projection of an organ (usually the genitals) or the body in such a way that it "appears as an outer enemy, a machine used to attack the patient" (*Zone,* 562). Graphic examples are the "proofs" (*Beweisse*) drawn by Jakob Mohr, who was indeed diagnosed as paranoid. In one drawing he is literally wired to the machine held by an enemy—perhaps an indication of the technological nature of this particular construction in paranoia.

46. See note 27. On the double bind in relation to schizophrenia, see Gregory Bateson, *Steps to an Ecology of Mind* (New York: Ballantine Books, 1972). I return to this condition in chapter 7.

6 A Little Anatomy

1. I refer to the classic essay by Laura Mulvey, "Visual Pleasure and Narrative Cinema" (1975). There are exceptions to this rule; however, most of these images are of women by women, such as the self-portraits in various guises by Claude Cahun. On Cahun see especially Rosalind Krauss, *Bachelors* (Cambridge, Mass.: MIT Press, 1999).

2. See Sigmund Freud, "Fetishism" (1927), in *On Sexuality,* ed. Angela Richards (Harmondsworth: Penguin, 1977).

3. As one might expect, the fetish is the dominant model of the surrealist object as well. On this score see, among other texts, chapter 2 of my *Compulsive Beauty* (Cambridge, Mass.: MIT Press, 1993).

4. In its beginnings surrealism was influenced less by Freud than by the French psychiatrist Pierre Janet, from whom André Breton borrowed the notion of "psychic automatism" used in his first "Manifesto of Surrealism" (1924). See *Manifestoes of Surrealism,* trans. Richard Seaver and Helen Lane (Ann Arbor: University of Michigan Press, 1972).

5. Hans Bellmer, *Die Puppe* (Karlsruhe, 1934, n.p.). I adapt parts of this first section from chapter 4 of *Compulsive Beauty.* See also Sue Taylor, *Hans Bellmer: The Anatomy of Anxiety* (Cambridge, Mass.: MIT Press, 2000); and Therese Lichtenstein, *Behind Closed Doors: The Art of Hans Bellmer* (Berkeley: University of California Press, 2001).

6. Sigmund Freud, "Medusa's Head," in Phillip Rieff, ed., *Sexuality and the Psychology of Love* (New York: Collier Books, 1963), 212. See also chapters 3 and 4 above. The figure of a headless woman as phallus enters surrealism through Ernst (as in his overpainting *The Pleiades,* 1920).

7. See Rosalind Krauss, "Corpus Delicti," in Jane Livingston, ed., *L'Amour fou: Photography and Surrealism* (New York: Abbeville Press, 1985), 86.

8. Freud describes how little Hans, frustrated by non-answers to his questions about birth, took "the analysis into his own hands" and, in a "brilliant symptomatic act," ripped open a doll (*The*

Sexual Enlightenment of Children, ed. Phillip Rieff [New York: Collier Books, 1963], 123). See also Charles Baudelaire, "A Philosophy of Toys" (1853), in *The Painter of Modern Life and Other Essays,* ed. Jonathan Mayne (London: Phaidon Press, 1964); and Rainer Maria Rilke, "On the Wax Dolls of Lotte Pritzel" (1913–14), in *Selected Works* (London: Hogarth Press, 1954). The Pritzel dolls are the very dolls that first inspired Bellmer.

9. Sigmund Freud, "Some Psychical Consequences of the Anatomical Distinction between the Sexes" (1925), in *On Sexuality,* 336.

10. Bellmer, *Die Puppe.* An illustration in this text shows a disembodied eye peering through this mechanism, "plundering the charms" of the doll.

11. Bellmer quoted from an interview with Peter Webb in Webb, *Hans Bellmer* (London: Quartet Books, 1985), 34.

12. Ibid., 38.

13. Bellmer quoted in the exhibition catalogue for "Le Surréalisme en 1947" (Paris: Galerie Maeght, 1947).

14. See Sigmund Freud, "The Economic Problem of Masochism" (1924). This is his later account of masochism.

15. Bellmer quoted in Webb, 177.

16. Bellmer, *Die Puppe,* n.p. As Paul Foss writes of the second doll: "What is this 'thing' or composite of things but the gaze pulled to pieces by the eyes, an open combinatory of spatial visions?" ("Eyes, Fetishism, and the Gaze," *Art & Text* 20 [1986], 37).

17. Sigmund Freud, "On Transformations of Instinct as Exemplified in Anal Erotism" (1917), in *On Sexuality,* 296.

18. See chapter 4 of *Compulsive Beauty.*

19. Janine Chasseguet-Smirgel, *Creativity and Perversion* (New York: W. W. Norton, 1984), 2. See also chapters 2 and 4 above.

20. Chasseguet-Smirgel, *Creativity and Perversion*, 78.

21. For a relevant discussion of a different breaking up of woman-as-fetish, see Laura Mulvey, "A Phantasmagoria of the Female Body: the Work of Cindy Sherman," *New Left Review* 188 (July/August 1991). And on the fetish and the part-object in surrealism and beyond, see Mignon Nixon, "Posing the Phallus," *October* 92 (Spring 2000).

22. Bellmer, *Petite anatomie de l'inconscient physique, ou l'Anatomie de l'image* (Paris, 1957), n.p.

23. Roland Barthes, "La Métaphore de l'oeil," *Critique* 196 (August-September 1963); translated as a critical epilogue to Georges Bataille, *Story of the Eye* (London: Penguin, 1982), 118–127, here 125. In some sense, this crossing of metaphor and metonymy—or, in the Freudian terminology of the dream, of condensation and displacement—*is* the dream logic of surrealism.

24. In "L'Esprit moderne et le jeu des transpositions" (*Documents* 8 [1930]), Bataille privileges this perverse kind of metonymic "analogues-antagonisms" (not named as such) over the neurotic sort of metaphorical "transpositions" or sublimations that he finds in Bretonian surrealism.

25. We encountered this logic in another guise in chapter 3; but there Marinetti wanted to occupy this position, which leads to even more volatile contradictions than those faced by the surrealists, who wanted only to adore it.

26. In a sense, these images bring anamorphosis to the center of the picture. Perhaps the most famous anamorphic image is the distorted skull in Hans Holbein's *The Ambassadors,* which Lacan reads as a phallus in *The Four Fundamental Concepts of Psycho-Analysis* (ed. Jacques-Alain Miller, trans. Alan Sheridan [New York: W. W Norton, 1981], 85–92). Some of the surrealist images also evoke both skull and phallus, with effects that are anxious and joyous, castrative and replete at once.

27. Krauss, "Corpus Delicti," in *L'Amour fou,* 74. On Caillois, see chapter 5 above. The spatial *un*forming of the body is only one aspect of these images; another, perhaps more important, is their phallic *in*forming, or so I will suggest below. Perhaps the two are not so opposed.

———

28. Jacques Lacan, *Feminine Sexuality,* trans. Jacqueline Rose (New York: W. W. Norton, 1985), 83.

29. Jacques Lacan, "Desire and the Interpretation of Desire in *Hamlet*" (1959), in *Yale French Studies* 55/56 (1977), 28.

30. Lacan, *Feminine Sexuality,* 84. "Ideal or typical" here means "heterosexual."

31. Ibid.

32. See in particular Kaja Silverman, "The Lacanian Phallus," *differences* 4.1 (1992); and Jane Gallop, *Reading Lacan* (Ithaca: Cornell University Press, 1985). There is slippage in Lacan even in his articulation of the difference between phallus and penis. How can men "protect" the phallus, for example, if they are not assumed to have it in the first place?

33. Lacan, *Feminine Sexuality,* 84.

34. Bretonian surrealists entertained this collapse primarily through an identification with the hysteric; Bataillean surrealists primarily through an embrace of the *informe;* on this score, see *Compulsive Beauty.*

35. On specular idealization, see Silverman, "The Lacanian Phallus." "There is a good deal of slippage in Lacan," Silverman writes there, "not only between the phallus and the penis, but between the phallus in its symbolic capacity and the phallus in its imaginary capacity. The erect penis seems to represent both, in the one case as that which no fully constituted subject can any longer 'be,' and which is consequently 'veiled' or lacking, and in the other as that which only the male subject can 'have'" (97).

36. In some accounts Matisse, not Picasso, is credited with this identification. See Anne Chave, *Shifting the Bases of Art: Constantin Brancusi* (New Haven: Yale University Press, 1994), 93.

37. In "On Narcissism: An Introduction" (1914), Freud associates narcissism with the vain introspection of beautiful women, but in this case such narcissism is only a relay for the greater narcissism of men. In this respect, surrealism corrects the phallic trouble that, as we saw in chap-

ter 4, Ernst and others act out in Dadaist work; the surrealist "phallustrade" is very different from the one that Ernst suggests there.

38. Krauss, "Photography in the Service of Surrealism," in *L'Amour fou,* 35. The examples given by Breton of the veiled-erotic are indeed objects-become-signs: a limestone deposit that looks like an egg, and a mandrake root that evokes Aeneas carrying Anchises.

39. Lacan, *Feminine Sexuality,* 82: "The phallus is the signifier of this *Aufhebung* itself, which it inaugurates (initiates) by its own disappearance."

40. Breton, *Mad Love,* trans. Mary Ann Caws (Lincoln: University of Nebraska Press, 1987), 87; original emphasis. As we saw in chapter 5, Ernst seconds this proposal in *Beyond Painting,* and finds analogies for such a "screen" especially in his overpaintings. See Max Ernst, *Beyond Painting* (New York: George Wittenborn, 1948), 11.

41. See Lacan, *The Four Fundamental Concepts of Psycho-Analysis,* 76. I return to the question of the screen in chapter 7.

42. Ernst, *Beyond Painting,* 8; original emphasis.

43. In a 1966 paper delivered at Johns Hopkins University, Lacan wrote: "The best image to sum up the unconscious is Baltimore in the early morning"—but surely he also had in mind Paris three decades before ("Of Structure as an Inmixing of an Otherness Prerequisite to Any Subject Whatever," in Richard Macksey and Eugenio Donato, eds., *The Structuralist Controversy* [Baltimore: Johns Hopkins University Press, 1972], 189). Lacan knew several surrealists and refers to surrealism often in his writings; indeed, he once noted its importance "in the unveiling of man's relationship with the symbolic" (quoted in David Macey, *Lacan in Contexts* [London: Verso, 1988], 55).

44. See the surrealist essays collected in Salvador Dalí, *Oui 1: la révolution paranoïaque-critique* (Paris: Éditions Denoël, 1971).

45. Breton, *Mad Love,* 15; original emphasis.

46. Ibid. The "Hotel" in the distance in *Marshal Ney* might be understood as one uncanny version of an original home.

47. Lacan, *The Four Fundamental Concepts of Psycho-Analysis,* 51.

48. Ibid., 53–64.

7 Torn Screens

1. This redemptive idea of art and culture seems transhistorical, but its emergence is historical: it becomes pervasive only with the displacement of religious hope onto aesthetic experience in romanticism, and this particular ritual of the museum is also a product of that age. Many of the concerns of this chapter are not properly art-historical; in fact, some are alarmingly metaphysical. But I don't think they can be simply dismissed as such.

2. As one might expect, the literature on Medusa is vast. For literary background, see especially Tobin Siebers, *The Mirror of Medusa* (Berkeley: University of California Press, 1983); for artistic background, see especially Jean Clair, *Méduse* (Paris: Éditions Gallimard, 1989). A useful anthology of texts, ancient to contemporary, is also now available: *The Medusa Reader,* ed. Marjorie Garber and Nancy J. Vickers (New York: Routledge, 2003). This chapter benefited greatly from an incisive reading by Julian Myers.

3. See Claude Lévi-Strauss, "The Structural Study of Myth" (1955), in *Structural Anthropology,* trans. Claire Jacobson (New York: Basic Books, 1963), which includes this classical formulation: "Since the purpose of myth is to provide a logical model capable of overcoming a contradiction (an impossible achievement if, as it happens, the contradiction is real), a theoretically infinite number of slates [i.e. permutations] will be generated, each one slightly different from the others. Thus, myth grows spiral-wise until the intellectual impulse which has produced it is exhausted" (229).

4. The paradoxes continue: on the one hand, for example, no one can look upon Medusa; on the other, her visage is represented everywhere in Greece—on clothes and jewelry, coins and furniture, and so on. In "The Gorgon, Paradigm of Image Creation" (1993), the classicist Françoise Frontisi-Ducroux discusses these paradoxes in terms of Medusan "iconopoesis" (ex-

cerpted in *The Medusa Reader,* 262–266). Medusa "becomes a bearable sight because it is an *eikon*," Frontisi-Ducroux writes, "and it is the iconicity of the Medusa which the reflection sequence reveals" (264). Might her head be to the Greek tradition of the apotropaic image what Veronica's veil is to the Byzantine tradition of the iconic image?

5. Jean-Pierre Vernant and Pierre Vidal-Naquet, *Myth and Tragedy in Ancient Greece,* trans. Janet Lloyd (Cambridge, Mass.: MIT/Zone Books, 1988), 191.

6. Ibid., 192.

7. Ibid., 190–195. Here, too, there is perhaps a twinning: Athena is also rendered as manly, but her "fusion of genders" is a proper—virtuous—one. (Just as there is a bit of Medusa in Athena, there is also a bit of Athena in Medusa: for example, her blood is not only poisonous but curative as well, a "pharmakon" in the sense developed by Derrida.) Along with the fusion of genders in Medusa, recall that there is an inversion in her body, too, from genitals to face and from vagina to neck. In a sense, this is reminiscent of the bodily transpositions in psychotic representations as seen in chapter 5.

8. Jean-Pierre Vernant, *Mortals and Immortals,* ed. Froma I. Zeitlin (Princeton: Princeton University Press, 1991), 137.

9. Vernant and Vidal-Naquet, *Myth and Tragedy,* 195.

10. Vernant, *Mortals and Immortals,* 137–138. The translation reads "exchange of gazes," but the original is *croisement*. "In Gorgo's face a kind of doubling process is at work. Through the effect of fascination, the onlooker is wrenched away from himself, robbed of his own gaze, invested as if invaded by that of the figure facing him, who seizes and possesses him through the terror its eye and its features inspire" (137). Here Medusa also bears a conflicted relation to Narcissus—as a form of identification based, paradoxically, on repulsion rather than seduction by the image—and this connection is implicit in some elaborations of the myth in literature. Of course, identification is shot through with alienation in the Lacanian account of "the mirror stage."

11. Ibid.; emphasis added.

12. Ibid., 147.

13. Ibid. Here it is as though looking aesthetically (or scientifically) were an apotropaic version of looking primordially: we meet the intensity of our own gaze in sublimated form. The emphasis on "sympathy" also suggests a basis of mimesis in magic, of an apotropaic logic of "like produces like."

14. Vernant, *Myth and Tragedy,* 192. "Gorgo marks out the boundary of the world of the dead. To pass that frontier is to become, oneself, beneath her gaze and in her image, what the dead are—empty heads without strength, heads shrouded in night."

15. Jacques Lacan, *The Seminar of Jacques Lacan: Book II: The Ego in Freud's Theory and in the Technique of Psychoanalysis, 1954–1955,* trans. Sylvana Tomaselli (New York: W. W. Norton, 1991), 164.

16. This view of primordial indifference is the opposite of the Gauguinian vision discussed in chapter 1. Jean Laplanche argues that symbolic concentration per se has an apotropaic effect, that any gathering into image, theme, or narrative helps to structure anxiety. See *Problématiques II/Castration-Symbolisations* (Paris: Presses Universitaires de France, 1980), 66. Perhaps "Medusa" is an originary instance of such concentration.

17. Wolfgang Kayser, *The Grotesque in Literature and Literature* (1957), trans. Ulrich Weisstein (New York: Columbia University Press, 1981), 188.

18. At least this is the legend; see Louis Marin, *To Destroy Painting,* trans. Mette Hjort (Chicago: University of Chicago Press, 1995), 97–125, here 99. In some ways this text is proleptic of some of my concerns here. At least on matters of Medusa, Poussin and Rubens are on the same—classical, Athenan—side.

19. Ibid, 100. For related effects in recent art, see the title essay of my *The Return of the Real* (Cambridge, Mass.: MIT Press, 1996).

20. In *The Romantic Agony,* Mario Praz, who discusses the poem, terms this romantic beauty "the Beauty of the Medusa." See *The Romantic Agony* (1933), trans. Angus Davidson (London:

Oxford University Press, 1970), 23–52. Praz also cites the moment in Goethe's *Faust* (1808) when Faust mistakes Gretchen in a beautiful Medusan guise: "What ecstasy, and yet what pain!/ I cannot bear to let this vision go." Praz comments: "through the lips of Faust speaks the whole of Romanticism" (27).

21. Nietzsche, *The Birth of Tragedy,* trans. Francis Golffing (New York: Doubleday, 1956), 97; abbreviated hereafter *BT.* Nietzsche sums up his essay as follows:

> how the Dioynsiac and Apollonian elements, in a continuous chain of creations, each enhancing the other, dominated the Hellenic mind; how from the Iron Age, with its battle of Titans and its austere popular philosophy, there developed under the aegis of Apollo the Homeric world of beauty; how this "naïve" splendor was then absorbed once more by the Dionysiac torrent and how, face to face with this new power, the Apollonian code rigidified into the majesty of Doric art and contemplation . . . the true end toward which that evolution moved . . . the dramatic dithyramb and Attic tragedy. (*BT* 35–36)

Visual art does seem to be placed on the side of redemptive sublimation only (perhaps there is a trace of Hegel on classical sculpture here).

22. In *The World as Will and Representation* (1819), an important source for Nietzsche, Schopenhauer is even more suspicious of the "principle of individuation," which he regards as the principal delusion of "the veil of Maya," in a world governed by the "egoism" of the will.

23. Golffing translates *Versöhnung* with the stronger term "pacification."

24. See Sigmund Freud, "Medusa's Head," in Phillip Rieff, ed., *Sexuality and the Psychology of Love* (New York: Collier Books, 1963), 212–213; and chapter 6 above.

25. Freud, "Medusa's Head," 212–213. "The erect male organ also has an apotropaic effect," Freud continues, "but thanks to another mechanism. To display the penis (or any of its surrogates) is to say: 'I am not afraid of you. I defy you. I have a penis.'" The *Perseus* of Canova seems to evoke both apotropaic effects.

26. Hélène Cixous, "The Laugh of the Medusa" (1975), in Elaine Marks and Isabelle de Cour-tivron, *New French Feminisms* (New York: Schocken Books, 1981), 255. I don't see laughter in most representations of Medusa (but then most representations are made by men); nevertheless, there are some openings to feminist readings. In the mirror-shield of Caravaggio, for example, the horror expressed by Medusa might be taken to stem less from her appearance than from her outrage—at her own decapitation. So, too, if Freud is correct to read her snakes as penile sym-bols, the terror of Medusa might figure not castration so much as phallic power, in which case Medusa might represent the phallic woman—to be punished as such.

27. This is how Freud describes the fetish in "Fetishism" (1927), also in *Sexuality and the Psy-chology of Love.*

28. Cixous, "The Laugh of the Medusa," 255. On the marginalization of women in "civiliza-tion," see chapter 1, note 7, and chapter 6.

29. Jacques Lacan, *The Four Fundamental Concepts of Psycho-Analysis,* trans. Alan Sheridan (New York: W. W. Norton, 1981), 76; hereafter abbreviated *FC.* More precisely, what enables us to see is our interrupting of this "iridescence" with our bodies, our carving out of light a trajec-tory of sight—a point drawn from Merleau-Ponty. Especially important here is his *The Visible and the Invisible,* published posthumously in February 1964, at the time of these seminars.

30. For Vernant, Medusa is born of the night, while for Lacan she is all light, but the contra-diction is only apparent, for these are two forms of the same blindedness. Incidentally, the fact that for Lacan Medusa represents the gaze, and not vision, might be in keeping with her an-cient representation: although often depicted in art, her eyes are never described in literature; in some sense her entire visage—its horrific confusion—is her gaze.

31. In *Being and Nothingness,* Sartre also writes of this relay of looks, but there it is intersubjec-tive, between two viewers. In effect, Lacan dehumanizes this gaze, and primordializes it in the process. Subsequent theorizations of the gaze that subjectivize it—as male, white, postcolonial, etc.—do not strictly follow Lacan in this respect. On "the denigration of vision in twentieth-century French thought," see Martin Jay, *Downcast Eyes* (Berkeley: University of California Press, 1993).

32. See Jean-François Lyotard, *Les TRANSformateurs DUchamp* (Paris: Galilée, 1977), 133–138. For a different motivation of the Duchamp diorama, see Rosalind Krauss, *The Optical Unconscious* (Cambridge, Mass.: MIT Press, 1993), 111–114.

33. As often in Lacan, it is mostly heuristic, and in my reading it serves to mediate the primary realms of Lacanian topology: the imaginary, the symbolic (these two are not separate here), and the real.

34. Perhaps Lacan has in mind the famous hall of portraits of the Doges as well. Another instance in this "communal" ordering might be the Dutch group portraiture of Rembrandt and Hals.

35. For reflections on related matters, see Norman Bryson, *Vision and Painting: The Logic of the Gaze* (New Haven: Yale University Press, 1983); and Kaja Silverman, *The Threshold of the Visible World* (New York: Routledge, 1996).

36. This is not to say that the phallic shield figured in the Medusa myth and the image screen proposed by Lacan are one and the same, only that Lacan seems to align the two. His immediate source regarding Medusa is Roger Caillois. In *The Four Fundamental Concepts* Lacan refers to *Méduse et cie* (Paris: Gallimard, 1960), in which Caillois discusses mimicry in insects; this little book influenced Lacan especially on questions of visuality and spatiality. Caillois treats Medusa only briefly, in anthropological terms of "the evil eye"; and, like Vernant, he sees her as a primordial form of mask, with powers both "offensive and defensive." Sartre also mentions Medusa in passing in *Being and Nothingness,* yet only as an allegory of objectification under the look of the other. Further afield, in *Autobiography of a Schizophrenic Girl,* "Renée" describes the real in Medusan terms as "a country, opposed to [everyday] reality, where reigned an implacable light, blinding, leaving no place for shadow; an immense space without a boundary, limitless, flat . . . I called it the 'Land of Light' because of the bright illumination, dazzling, astral, cold, and the state of extreme tension in which everything was, including myself" (Marguerite Sechehaye, ed., *Autobiography of a Schizophrenic Girl* [New York: New American Library, 1970], 19). See also Louis A. Sass, *Madness and Modernism: Insanity in the Light of Modern Art, Literature, and Thought* (New York: Basic Books), especially 43–74.

37. "Composition" is a telling term here. The distinction between expressive preemption and Apollonian pacification might be a way to inflect familiar oppositions in art history: Caravaggio versus Poussin, Delacroix versus Ingres, and so on.

38. The auditor is Moustapha Safouan. As we saw with the *Medusa* of Caravaggio, *trompe-l'oeil* can also disturb *dompte-regard*. On this phenomenon in postwar painting, see the title chapter of my *The Return of the Real*.

39. In this sense, to sublimate is not to damp down so much as it is to distill; this is close to the way Leo Bersani rewrites the notion—through Laplanche more than Lacan. See chapters 1 and 8.

40. Lacan does not strictly ontologize the real as horrific and the gaze as Medusan. At one point he associates the gaze with "the evil eye" and the evil eye with "the eye filled with voracity"; this leads him to assert that the "hypnotic value" of the picture lies in its ability to appease this "appetite" (*FC* 115). This description begins to evoke a human subject, especially so when Lacan refers this "voracity" to envy. "*Invidia* comes from *videre,*" he writes, as if to imply that the gaze is invidious because it is shot through with envy from our earliest age. Here Lacan cites the *Confessions* of Saint Augustine, where he recalls his murderous feelings when, as a little boy, he sees his baby brother at his mother's breast: "He was not old enough to talk," Augustine writes of his infantile self, "but whenever he saw his brother at the breast he would grow pale with envy." Perhaps Augustine cast an envious look at his brother that embittered him as well. (This recalls "Envy" as depicted by Giotto in the Arena Chapel: an old woman whose tongue snakes out of her mouth and circles back to bite her eyes. Here it is as though the eyes and the snakes of Medusa have become one, as, more importantly, have Medusa and her victim.) The boy is not jealous; he doesn't want the milk. He is envious; he desires what the other has, and that is union with the maternal breast. The breast is the first lost object in the Freudian scheme of things, and the primary *objet petit a* in the Lacanian scheme, the primary object-cause of desire. This is why Lacan pictures the young Augustine as "pale before the image of a completeness closed upon itself," a completeness that he enjoyed once and his little brother enjoys now (*FC* 116). In this account, the Medusan gaze seems to be our own invidious look projected onto the other (recall that in Vernant it is our gaze "that is captured in the mask of Medusa"). In short, in the figure of Medusa, our voracious desire is radicalized as monstrous, and in this form of the primordial alien it seems to demand "taming" and "civilizing."

41. Subsequently this term became very important in film theory. In "Barbara Kruger and the Medusa Effect," Craig Owens calls suture "the Medusa Effect": "specular ruse, imaginary identification of seer and seen, immediacy, capture, stereotype (*Medusa Reader,* 207). Again, in this regard the Medusa myth is close to the Narcissus story. Might this sense of "arrest" be a way to rethink the ideal of "absorption" long advanced by Michael Fried in modern art?

42. Lacan discusses the anamorphosis in Hans Holbein's *The Ambassadors,* in which a phallic skull—"the subject as annihilated"—becomes visible to the side of (in a sense behind) the screen of objects in the painting, "all symbolic of the sciences and arts" (*FC* 88–89).

43. Two examples leap to mind in fiction: one involves a subject on the brink of death, the other a subject in yet another in-between world. In his great story "The Death of Ivan Ilych" (1886), Tolstoy begins with his protagonist, the public prosecutor Ivan Ilych, already dead. His colleague Peter Ivanovich is triumphal because "it is he who is dead and not I," yet he is also irked by "the very tiresome demands of propriety" that he must now meet. He performs the obligatory acts of respect (such as a visit to the widow), but they fail to block the recognition that he too must die, and he rushes back to the distraction of his card game. Here we see death from the perspective of an onlooker stirred from an everyday denial of its reality. Tolstoy resumes with the life of Ivan Ilych, which is "most simple and most ordinary and therefore most horrible." A magistrate who lived "within limits," deferential to authority, committed to a "decorous life," Ivan Ilych is a "new man" of "moderate liberalism" and "enlightened citizenship." He marries, has children, is promoted, always careful to parcel out his life according to "pleasures of ambition," "vanity," and "playing bridge." However, one day, atop a ladder to hang a new drape in a new house, Ivan Ilych slips and falls. He thinks nothing of the accident until he senses "a queer taste in his mouth," along with "some discomfort in his left side." Soon enough, "there was no deceiving himself: something terrible, new, and more important than anything in his life, was taking place within him of which he alone was aware."

Only his peasant servant Gerasim and young son Vasya show the stricken man any sympathy. His wife resents his illness; his doctor treats him like "an accused person," all others simply want to be released "from the discomfort caused by his presence." Once oblivious to death, Ivan Ilych is no longer "screened" from it, which is precisely how he imagines it—as an ineluctable, ultimate *It:*

> *It* would come and stand before him and look at him, and he would be petrified and the light would die out of his eyes, and he would again begin asking himself

whether *It* alone were true. . . . And what was worst of all was that *It* drew his attention to itself not in order to make him take some action but only that he should look at *It,* look it straight in the face: look at it and, without doing anything, suffer inexpressibly. . . . And suddenly *It* would flash through the screen and he would see it. . . . He would go to his study, lie down, and again be alone with *It:* face to face with *It.* And nothing could be done with *It* except to look at it and shudder.

This *It* escapes all figuration except the Medusan: *It* appears as a flash through a screen, as a gaze that fixes his vision, dims its light, and petrifies him. That the others treat this *It* as an "almost indecorous incident" torments Ivan Ilych further: "they all became afraid that the conventional deception would suddenly become obvious and the truth become plain to all." He is anguished by his own complicity in this deception, in this screening, but even now he cannot relinquish it. "'Maybe I did not live as I ought to have done,' it suddenly occurred to him. 'But how could that be, when I did everything properly?'" However, at the point of death this propriety appears far worse than petty to him, and the screen is revealed as a shabby cover for a symbolic order riddled with holes.

My other example also involves a subject *in extremis*—indeed, two such subjects. In *The Body Artist* (2001) Don DeLillo is concerned with the relation between heightened perceptions and disturbed psyches. The novel begins:

Time seems to pass. The world happens, unrolling into moments, and you stop to glance at a spider pressed to its web. There is a quickness of light and a sense of things outlined precisely and streaks of running luster on the bay. You know more surely who you are on a strong bright day after a storm when the smallest falling leaf is stabbed with self-awareness.

Immediately the effect of time distended is both produced and pondered; the passage suggests that it can prompt an intense consciousness of the world, but also an oblivious immersion in the self. A fitful conversation follows between a husband and a wife, an ex-filmmaker named Rey Robles and a "body artist" named Lauren Hartke. They exchange the broken language of habit and distraction as they breakfast in a rented house in the country. Then, very abruptly, we learn that Robles, whose "subject is people in landscapes of estrangement," has committed suicide in Manhattan.

The second chapter is devoted to Hartke in grief, which, in a reversal of the opening of the novel, deadens her to the world and blurs her sense of self: "Everything is slow and hazy and drained and it all happens around the word *seem*." For hours on end she watches a computer feed of a small road outside a Finnish town, which seems to represent her feeling of dislocation. Gradually Hartke senses that she is not alone, that a person of indeterminate age, even of indeterminate being, is in the house with her. Neither boy nor man, this alien foundling exists "outside the easy sway of either/or," almost outside sexual difference and social definition altogether, and DeLillo describes him in schizophrenic terms: "He had no protective surface. He was alone and unable to improvise, make himself up." Hartke discovers that his relation to language is attenuated, that "he lived in a kind of time that had no narrative quality," both "here and there, before and after":

> Time is the only narrative that matters. It stretches events and makes it possible for us to suffer and come out of it and see death happen and come out of it. But not for him. He is another structure, another culture, where time is something like itself, sheer and bare, empty of shelter. . . . It is a kind of time that is simply and overwhelmingly there, laid out, unoccurring, and he lacks the inborn ability to reconceive this condition.

"It is not able" are the first words that he offers Hartke, and, odd though they are, they are also somehow exact: the indefinite "it," the passive construction, the general incapacity. She becomes fascinated with his condition, at once completely present in the world and utterly "defenseless against [its] truth." More, in her grief—but also, perhaps, as a "body artist"—she identifies with his condition, which seems to "violate the limits of the human," characterized by the loss of narrative articulations of time and space produced by a break-up of language or, in her case, a drowning in grief. Both of them live in a state of "as if." Slowly Hartke discovers a disturbed mimicry in his broken speech: she hears echoes of her past conversations with her husband. Half in mourning, half in research, she tapes his words; at the same time she "works her body hard," as if to push the "limits of the human" physically as well as linguistically. She seems driven to approach his literal relation to the world, at once intense and broken; and eventually this imperative takes the form of a performance titled "Body Time" that includes snippets of his language, sounds of an answering machine, and clips of the Finnish road. "Hartke clearly wanted her audience to feel time go by," a critic friend writes of her performance, "viscerally, even painfully."

Here DeLillo points to a definitive ambiguity in body art that might also be a generative contradiction. On the one hand, such performances insist on the sheer presence of the body, its materiality, factuality, reality; and in this respect body art is part of the old avant-gardist project to obliterate aesthetic distance and to reunite "art" and "life." On the other, such performances use the body as a default medium in a way that marks it as a field of signs or symptoms. Often the crux of body art seems to lie in this difficult shuttling between outright presence and improvised representation, or, more exactly, between indexical markings of the actual body (right here, right now, before your eyes) and its transformation into a semiotic field. Perhaps this ambiguity of the body as both natural flesh and cultural artifact is irreducible, and body art only confronts us with the ambivalence of this condition. In any case, in the shuttling between reality and representation in this art, language often breaks up against the body, as it were, in a way that dislocates the subject. Rather than the desired gathering of the self into presence, there is a schizophrenic scattering: this is what Hartke seems to detect in her guest and to replicate in her performance. And in this dislocation another kind of real—the real as discussed in this chapter—is sensed. (Susan Stewart offers other instances of a close encounter with the real in literature in "Coda: Reverse Trompe-l'oeil / The Eruption of the Real," in *Crimes of Writing* (New York: Oxford University Press, 1991, 273–290.)

44. Hans Prinzhorn, *Artistry of the Mentally Ill* (1922), trans. Eric von Brockdorff (Vienna: Springer Verlag, 1972), 159–171, here 159–160. Prinzhorn calls him "Neter."

45. Prinzhorn: "[Natterer] explains the cracking of his knees as telephone calls by which the devil down below is always notified of his whereabouts" (ibid., 160).

46. Just as the phallic shield and the image screen are related but not identical (see note 36), the same is true of the image screen and the screen in this vision: the first is a screen that filters; the second is a screen that, projected, is projected upon. The fear is that it doesn't filter enough, and it doesn't.

47. Again, see Marin, *To Destroy Painting.* This impulse and that confusion are often registered in twentieth-century art: for example, in Miró, Lucio Fontana, Asger Jorn, the décollageists. . . .

48. As I observe in the title essay of *The Return of the Real,* it is as if such art wanted the gaze to shine, the object to stand, the real to exist, in all the glorious horror of its pulsatile desire, or at

least to evoke this sublime condition. On the summoning of Medusan tropes in moments of political crisis, see the classic essay by Neil Hertz, "Medusa's Head: Male Hysteria under Political Pressure," *Representations* 4 (Fall 1983).

49. This is the title of an essay by Clement Greenberg, written in 1948 in the midst of the drip paintings, and reprinted in *Art and Culture* (Boston: Beacon Press, 1961). The flat, "all-over" aspect of these paintings put the easel-picture conventions of illusionistic, dramatic space under great pressure, Greenberg argues here—in a way proleptic of the concerns of his later antagonists (more on whom below). For example, "the very notion of uniformity is anti-aesthetic," Greenberg writes. "The 'all-over' may answer the feeling that all hierarchical distinctions have been, literally, exhausted and invalidated; that no area or order of experience is intrinsically superior, on any final scale of values, to any other area or order of experience" (157).

50. For the notion of opticality, see Michael Fried, *Art and Objecthood* (Chicago: University of Chicago Press, 1998), 19–23.

51. Harold Rosenberg, "The American Action Painters" (1952), in *The Tradition of the New* (Chicago: University of Chicago Press, 1959), 23–39.

52. Allan Kaprow, *The Blurring of Art and Life* (Berkeley: University of California Press, 1993), 7.

53. Fried, *Art and Objecthood,* 224–225. Note that intimated here is a topos—"conditions of seeing"—that other artists would explore in other ways, usually beyond the frame of painting (see note 68).

54. Ibid., 227–228. T. J. Clark questions whether *Cut-out* was ever completed by Pollock in *Farewell to an Idea* (New Haven: Yale University Press, 1999), 351. For a rich reading that also develops the notion of scotomization in Pollock, see Briony Fer, *On Abstract Art* (New Haven: Yale University Press, 1997), 93–107.

55. In this light, these figures (they seem to number four or five) evoke—almost as if to resolve—the graceful dancers of the late Matisse and the gaze-intensive *demoiselles* of the early Picasso.

56. It is for this reason, Fried would argue in "Shape as Form: Frank Stella's Irregular Polygons" (1966), that Stella and Noland stressed the shaped canvas—to keep this optical erosion of the picture plane in check (*Art and Objecthood,* 77–99).

57. Sigmund Freud, "Psychogenic Visual Disturbance According to Psychoanalytical Conceptions" (1910), in *Character and Culture,* ed. Phillip Rieff (New York: Collier Books, 1963), 55.

58. See Fried, *Art and Objecthood,* 219, 168. Fer: "It is this quality of the cut that modernist opticality ultimately displaces and disavows" (*On Abstract Art,* 106).

59. Ibid., 229.

60. Ibid., 119–120. This formulation is from an essay, "The Achievement of Morris Louis," first published in *Artforum* in February 1967.

61. Robert Morris, *Continuous Project Altered Daily* (Cambridge: MIT Press, 1993), 54.

62. Ibid., 41.

63. Ibid.

64. "To think that painting has some inherent optical nature is ridiculous," Morris writes contra Fried. "It is equally silly to define its 'thingness' as acts of logic that acknowledge the edges of the support. The optical and the physical are both there. Both Pollock and Louis were aware of both" (ibid., 43).

65. Ibid., 46.

66. Lucy R. Lippard, *Changing: Essays in Art Criticism* (New York: E. P. Dutton, 1971). Lippard calls this corporeal evocation a "body-ego," a reading that Anne Wagner, Briony Fer, and Mignon Nixon have complicated in recent essays. See Mignon Nixon, ed., *Eva Hesse* (Cambridge, Mass.: MIT Press, 2002). See also Richard Williams, *After Modern Sculpture: Art in the United States and Europe, 1965–1970* (Manchester: Manchester University Press, 2000).

67. Lippard, *Changing,* 104.

68. Morris, *Continuous Project,* 57. Again, this is at once related and opposed to the "conditions of seeing" that are foregrounded in Louis et al. This third way between painting as "opticality" and painting as "arena" nevertheless retains painting as its primary reference. For many minimalists and postminimalists, who began as painters, the move into three dimensions was a way to pressure painting more than to develop sculpture. They were driven by a great suspicion of the pictorial—for its spatial illusionism (e.g. Donald Judd), its Gestalt imagery (e.g. Richard Serra), and so on—but also, perhaps, for its ability to "arrest" (to "absorb") the viewer. They wanted to activate the viewer in space, and this might be construed as the positing of a ritual dramaturgy counter to that of Canova at the Met—that is, of the traditional museum—with which I began.

69. Anton Ehrenzweig, *The Hidden Order of Art* (Berkeley: University of California Press, 1967), 19.

70. Morris, *Continuous Project,* 61.

71. Robert Smithson, *The Writings of Robert Smithson,* ed. Nancy Holt (New York: New York University Press, 1979), 89–90.

72. Ibid., 168.

73. Ibid., 111.

74. Ibid., 109.

75. Ibid., 113. Of course this is extreme: Medusa read through the science fiction that Smithson loved. But there is a point to underscore here as well—that any representation of the real, of what cannot be represented, is bound to disappoint—to risk, in effect, horror-genre cliché. Conveniently here, I overlook the final shots of the film, which show the camera and the projector: Smithson returns us to the actual scene of production and reception in a materialist move that keeps his own metaphysical tendencies in check.

8 A MISSING PART

1. Freud discusses these instinctual doubles and psychic reversals in "Instincts and their Vicissitudes" (1915), and we also saw them at work, in a different way, in the dolls of Hans Bellmer in chapter 6.

2. Robert Gober, "Interview with Richard Flood," in Lewis Biggs, ed., *Robert Gober* (Liverpool and London: Serpentine and Tate Galleries, 1993), 8–14. This interview is extended in Richard Flood, ed., *Robert Gober: Sculpture + Drawing* (Minneapolis: Walker Art Center, 1999), 121–143, here 122, 125; this catalogue includes a thoughtful survey by Flood ("The Law of Indirections") as well. I date categories of work here to their first appearance.

3. See Dolf Sternberger, *Panorama of the Nineteenth Century,* trans. Joachim Neugroschel (New York: Urizen Books, 1977 [1936]); as well as Stephan Oetermann, *The Panorama: History of a Mass Medium* (New York: Zone Books, 1997). There is scarcely a form more alien to modernist art than the diorama.

4. Gober, "Interview with Richard Flood."

5. The question then is: how to sustain enigma in *interpretation*? Enigma is bound up with desire, and this volatile compound invites an interpretive interest that is also erotic, "epistephilic." It is a Freudian commonplace that our primary investigations are driven by sexual curiosity, and Gober evokes this fundamental riddling in our lives. The question is how to interpret his riddling in a way that does not eradicate it. One way that Gober sustains enigma in the work is through its very fabrication: his objects often look like readymades, but they never are. Thus the readymade is at once invoked *and* suspended, and one effect is that authorial origin is not flatly disavowed so much as slightly disturbed—just enough to be rendered enigmatic (more on this below).

6. Freud added another primal fantasy, an intrauterine one, which might serve psychically as a salve to the other, traumatic fantasies, especially of castration, to which it only seems anterior. See, among other texts, "The Sexual Enlightenment of Children" (1907), "On the Sexual Theories of Children" (1908), "Leonardo da Vinci and a Memory of His Childhood" (1910), and "The History of an Infantile Neurosis" (1914/18). For the relation of primal fantasies to surrealist aesthetics, which Gober elaborates, see chapter 3 of my *Compulsive Beauty*

(Cambridge, Mass.: MIT Press, 1993). Of course, then and now, the notion of primal fantasy, let alone the hypothesis of seduction, is very controversial. For a recent intervention in the debate, see Mikkel Borch-Jacobsen, "Neurotica: Freud and the Seduction Theory," *October* 76 (Spring 1996).

7. "The whole of the trauma comes *both* from within and without," Jean Laplanche and Jean-Bertrand Pontalis write in relation to seduction in particular. "From without, since sexuality reaches the subject from *the other;* from within, since it springs from this internalized exteriority, this '*reminiscence* suffered by hysterics' (according to the Freudian formula)." See "Fantasy and the Origins of Sexuality" (1964), in Victor Burgin, James Donald, and Cora Kaplan, eds., *Formations of Fantasy* (London: Metheun, 1986), 5–34, here 10. This remains the best explication of the primal fantasy.

8. On these conventions see Meyer Schapiro, "On Some Problems in the Semiotics of Visual Art: Field and Vehicle in Image-Signs" (1969), in *Theory and Philosophy of Art: Style, Art, and Society* (New York: George Braziller, 1994).

9. Laplanche and Pontalis, "Fantasy and the Origins of Sexuality," 26.

10. These terms are not only contemporary: Gober often uses traces of the outmoded (another surrealist interest) in his work. The clothes in particular seem redolent of the 1950s, the decade of his birth and/or the time of his father (the trousers, socks, and shoes recall office and/or recreation wear). These traces reflect not only on gender (and desire) but also on generation (and love or fear); they can work to tie the two sets of affect together.

11. André Breton, *Manifestoes of Surrealism,* trans. Richard Seaver and Helen R. Lane (Ann Arbor: University of Michigan Press, 1972), 21.

12. Breton writes of his image, "decided," he tells us, by "previous predispositions": "Here again it is not a matter of drawing, *but simply of tracing*" (ibid., 21; original emphasis). If this is a third model of picture-making, it might be asked, how could it be relevant to the objects of Gober? It is so precisely because, as quasi-fantasmatic scenarios, his dioramas are more pictorial than sculptural. Recently, advanced art has undergone a pervasive (re)pictorializing not only of the sculptural also but of the theatrical (in the sense of Michael Fried), a (re)pictorializing in which the space of installation is treated as fictive, semi-virtual or, again, quasi-fantasmatic, a space of

psychological projection at odds with the space of bodily reflexivity as conceived by most pioneers of installation art in the 1960s and 1970s.

13. André Breton, *Nadja,* trans. Richard Howard (New York: Grove Press, 1960), 11–12.

14. See Jean Laplanche, *New Foundations for Psychoanalysis,* trans. David Macey (Oxford: Basil Blackwell, 1989). Laplanche questions the Lacanian insistence on the unconscious structured as a language; his signifiers can be "verbal, nonverbal, and even behavioral," as long as they are "pregnant with unconscious sexual significations" (126). And they may be enigmatic for the other, too: "As I see it, enigma is defined by the fact that it is an enigma even for the one who sends the enigma" (Jean Laplanche, *Seduction, Translation, Drives,* trans. Martin Stanton [London: Institute of Contemporary Arts, 1992], 57). In a sense, Gober evokes—identifies with—both positions, that of the child and that of the mother; or rather, he seems to move between them (recall his notion of the image as an infant to be nursed). For a suggestive account of Caravaggio in terms of the enigmatic signifier, see Leo Bersani and Ulysse Dutoit, *Caravaggio's Secret* (Cambridge, Mass.: MIT Press, 1998).

15. This affect might be related not only to what Freud called the helplessness (*Hilflosigkeit*) of the infant in the traumatic event, but to what the surrealists called the availability (*disponibilité*) of the artist before the uncanny (and also to what Keats called the negative capability of the poet in inspiration). Lacan captures this state between anxiety and ecstasy with the ambiguous phrase *en souffrance,* which suggests both suspension and sufferance—a condition also evoked by such precedents of Gober as Jasper Johns and Andy Warhol. See Jacques Lacan, *The Four Fundamental Concepts of Psycho-Analysis,* trans. Alan Sheridan (New York: W. W. Norton, 1981), 56.

16. Laplanche, *New Foundations,* 126. This ventriloquism acts out, comically, a problem fundamental to psychoanalysis—that the subject is already assumed in the theorization of its emergence. For a critique of Freud along these lines, see Mikkel Borch-Jacobsen, *The Freudian Subject,* trans. Catherine Porter (Palo Alto: Stanford University Press, 1988).

17. Just as the Bretonian image of "a man cut in two by a window" looks ahead to the paintings of René Magritte, this object looks back to them, as do several slides in a work that has long served Gober as an image-repertoire, *Slides of a Changing Painting* (1982–83), in which a single painting was recorded through many permutations. As with some Magrittes, it might be argued that this object is not enigmatic enough, that it is so literal as to be sadistic. I would claim

as much about *Man Coming Out of Woman* (1993–94), in which a male leg with shoe and sock emerges from the vagina of a spreadeagled woman truncated in a corner, a work that could be deemed heterophobic. Its counterpart is a piece in which the leg of a child emerges from the anus of a man, in a scenario that recalls what Freud termed "the cloaca theory" of birth held by children who imagine that men can have babies too (see chapter 3). This is a fantasy that seems to interest Gober (more on this below).

18. Sigmund Freud, "Three Essays on the Theory of Sexuality" (1905), in *On Sexuality*, ed. Angela Richards (London: Penguin, 1977), 145.

19. See chapter 2 of *Compulsive Beauty*. Yet another title for the sculpture is *Hands Holding the Void*. Of course Lacan, a young initiate of surrealism, did understand the paradoxical formula of its object, at least eventually, and his account of the *objet petit a* informs mine here.

20. All the truncated legs cannot help but convey loss. For me the legs with drains evoke a loss in the self, while the legs with candles evoke a loss of an other; but, again, the difficulty of this distinction is also at issue. Along with such artists as Felix Gonzalez-Torres and Zoë Leonard, Gober answered the call for an art of mourning that might complement an activism of militancy made by Douglas Crimp in his "Mourning and Militancy," *October* 51 (Winter 1989).

21. Flood reduces such elaborations to "critical gamesmanship" ("Interview with Richard Flood," 128), and so diminishes this significance of Gober, who indeed demurs: "But it was always my artistic nature and talent to work with diverse images whose meanings interweave, and that's what I keep doing." Apart from Duchamp and Giacometti, one thinks again of Magritte, especially his simulacral scenes of fantasy, as well as of Johns and Warhol.

22. Marcel Duchamp, "Apropos of 'Readymades'" (1961), in *The Essential Writings of Marcel Duchamp*, ed. Michel Sanouillet and Elmer Peterson (London: Thames & Hudson, 1975), 141.

23. For a suggestive typology of modern sculpture in which the models of readymade and part-object are opposed, see Rosalind Krauss, "Sherrie Levine: Bachelors," in *Bachelors* (Cambridge: MIT Press, 1999).

24. Long ago, Michel Leiris captured this surrealist aspect of Giacometti in a way that resonates with "the memories remade" of Gober:

There are moments that can be called *crises,* the only ones that count in a life. These are moments when abruptly the outside seems to respond to a call we send it from within, when the exterior world opens itself and a sudden communion forms between it and our heart. . . . Poetry can emerge only from such "crises," and the only worthwhile works of art are those that provide their equivalents. I love Giacometti's sculpture because everything he makes is like the petrification of one of these crises, the intensity of a chance event swiftly caught and immediately frozen, the stone stele telling its tale. And there's nothing deathlike about this sculpture; on the contrary, like the real fetishes we idolize (real fetishes, meaning those that resemble us and are objectivized forms of our desire) everything here is prodigiously alive—graciously living and strongly shaded with humor, nicely expressing that affective ambivalence, that tender sphinx we nourish, more or less secretly, at our core." (*Documents,* vol. 1, no. 4 [1929], 209–210)

25. Gober quoted in *Parkett,* no. 27 (March 1991).

26. The Gober sinks evoke other mysteries, those of the washroom, a place associated with an underground, a basement, or a cellar, which is a recurrent location in Gober. Like the bathroom, the washroom is a place of initiation, but here the father is the spirit that presides over its secret ceremonies. In a commentary on his first sink, Gober remarked: "The basement is basically where my father lived, and I think, in a non-dark way, you learn as a young boy unconsciously about being a person and a man from your father" ("Interview with Richard Flood," 130). However, the very insistence on the "non" here suggests that this initiation might also have a dark side, that this space might be one of reclusion, if not of repression, that menaces the familial house—and, as we know, the divided house is another obsessive image in Gober.

27. I presume her to be white, but why should I? For that matter, why do I presume the absent bride to be female? (In some collaged pages from the *New York Times,* Gober has slipped his own body into the bridal wear advertised there.) Thus do these images catch us out in ideological assumptions, a tripping-up from which Gober is not always exempt. When he used the wallpaper of the two men in a collaboration with Sherrie Levine at the Hirshhorn Museum in 1990, museum employees of African-American descent found the imagery offensive and racist. In a subsequent conversation at the museum, Gober reported: "One man described it to me quite vividly as, 'We got the nigger, now we can go to sleep' " (Robert Gober, "Hanging Man, Sleeping Man," *Parkett,* no. 27 [March 1991], 90, 91).

———

28. Here enigma might serve, problematically, to forestall answers as well as to complicate them. The best gloss on this installation might be the extraordinary meditation on racial and sexual trauma in William Faulkner's *Absalom! Absalom!* (1936). In a similar spirit, Flood mentions Kate Chopin's "Désirée's Baby" (1897) and Jean Rhys's *Wide Sargasso Sea* (1966).

29. Lacan, *The Four Fundamental Concepts of Psycho-Analysis* (seminar given in February 1964), 77. In *The Optical Unconscious* (Cambridge, Mass.: MIT Press, 1993), Rosalind Krauss complements this Lacanian account of perspective, of difference in vision, with a Sartrian reading that complicates the position of the viewer on this side of the diorama, in the public space of the museum: not only is our gaze inflected by sexual difference, but as viewers in a public space we are under the gaze of others, caught in the act of the Peeping Tom (which, retrospectively at least, is the position of us all in the primal scene). Yet, even as there is shame in this looking, there is pleasure too—the pleasure not only of the voyeur but of the reciprocal figure, the exhibitionist. Might we not also identify with the exhibitionistic position of the mannequin, even as we gaze at her voyeuristically? As I suggested at the outset, this reciprocity is often put into play by Gober, as is that of sadism and masochism.

30. This demonstration came to Gober through the feminist postmodernist art of Sherrie Levine, Barbara Kruger, Cindy Sherman, and others.

31. Gober, in "Interview with Richard Flood," 125.

32. In a diorama of 1994–95, Gober does evoke gas chambers and mass graves: it consists of a pile of truncated legs (with socks and sandals) behind bars, the central ones bent in a belated promise of escape.

33. The legs planted with candles recall the haunting dream, told by Freud and repeated by Lacan, of the father who falls asleep while his dead son lies in the next room. In the dream the father imagines, in a self-reproach, that the room is on fire and that he has failed once again to save his son, who appears to admonish him: "Father, can't you see I'm burning?" In this case "Father" might also read as "Brother" or "Lover."

34. Gober, in "Interview with Richard Flood," 133.

35. Flood, "The Law of Indirections," 12; Gober, in "Interview with Richard Flood," 128.

36. See Helen Molesworth, "Stops and Starts," *October* 92 (Spring 2000).

37. There is nothing ambiguous in this regard about its manifesto: *Anti-Oedipus* (1972), trans. Robert Hurley, Mark Seem, and Helen R. Lane (New York: Viking, 1977). My investment in the psychoanalytic model of desire might be, in part, an investment in the pathos of loss, and this might be at work in melancholia in general: that is, sometimes the melancholic attachment might be to the pathos of loss more than to the object lost; sometimes it might be this pathos that is difficult to surrender.

38. For example, a 1995 installation in Basel featured doors and walls that were doubled (the split house again), and dead leaves and crumpled cans that appeared in drains.

39. David Joselit read it in this way: "Gober suggests that both bodies and things have been let go, allowed to slip into oblivion" ("Poetics of the Drain," *Art in America* [December 1997], 66).

40. Gober, in "Interview with Richard Flood," 137.

41. Ibid., 142, 141. "She didn't think the Virgin Mary was specifically the Virgin Mary. She thought she was perhaps a stand-in for motherhood. And then she had a hole in her stomach where the baby would have been. The coins had my birth date. There was the man with the baby who was maybe giving birth. Those were her reasons."

42. See note 6. Contrast this fantasy with one intimated by a work made in 1991, again at the height of the AIDS epidemic: a collaged newspaper with a one-paragraph report from 1960 about a six-year-old boy named Robert Gober who had drowned in a pool in Wallingford, Connecticut—his age and home at the time.

43. Gober, in "Interview with Richard Flood," 142. "It is an enormous relief to the individual psyche," Freud wrote in his critique of religion, "if the conflicts of its childhood . . . —conflicts which it has never wholly overcome—are removed from it and brought to a solution . . ." (*The Future of an Illusion* [1927], trans. James Strachey [New York: W. W. Norton, 1961], 30).

44. Laplanche, *New Foundations,* 45. For Laplanche the crucial aspect of the enigmatic signifier is not its meaning but its address—its "power to signify *to.*"

45. Gober, in "Interview with Richard Flood."

46. See chapter 5 of my *The Return of the Real* (Cambridge, Mass.: MIT Press, 1996), where I discuss it in terms of "the obscene."

47. In *Caravaggio's Secrets,* Bersani and Dutoit argue that the enigmatic signifier locks the primal couple of parent and infant in a relationship of paranoid fascination that is then replicated in other relationships throughout life. And they explore the particular ways that Caravaggio plays pictorially with such fascination—on occasion, to offer potential forms of release from it.

48. Gober, in "Interview with Richard Flood," 124.

Index

Page numbers in boldface indicate illustrations.